MILTON
AVERY

Milton Avery, c. 1945

MILTON AVERY

BARBARA HASKELL

WHITNEY MUSEUM OF AMERICAN ART
in association with
HARPER & ROW, PUBLISHERS, New York
Cambridge, Philadelphia, San Francisco, London
Mexico City, São Paulo, Sydney

Dates of the exhibition:

Whitney Museum of American Art
New York, New York
September 16–December 5, 1982

Albright-Knox Art Gallery
Buffalo, New York
May 21–July 10, 1983

Museum of Art, Carnegie Institute
Pittsburgh, Pennsylvania
January 15–March 6, 1983

The Denver Art Museum
Denver, Colorado
July 27–September 4, 1983

Fort Worth Art Museum
Fort Worth, Texas
March 22–May 8, 1983

Walker Art Center
Minneapolis, Minnesota
September 18–October 30, 1983

This book was published on the occasion of the exhibition "Milton Avery" at the Whitney
Museum of American Art, supported by grants from Sperry Corporation and the National Endow-
ment for the Arts. The publication was organized at the Whitney Museum by Doris Palca, Head,
Publications and Sales; Sheila Schwartz, Editor; James Leggio, Associate Editor; and Sarah Trotta,
Secretary.

Designer: C. Linda Dingler

Typesetter: TriStar Graphics

Printer: Princeton Polychrome Press

Binder: A. Horowitz & Sons

FIRST EDITION

Library of Congress Cataloging in Publication Data

Haskell, Barbara.
 Milton Avery.

 (Icon editions)
 Bibliography: p.
 Includes index.
 1. Avery, Milton, date. 2. Painters—United
States—Biography. I. Avery, Milton, date.
II. Title.
ND237.A85H37 1982 759.13 82-47547 AACR2
ISBN 0-06-433320-5 (Harper & Row) 83 84 85 86 10 9 8 7 6 5 4 3 2
ISBN 0-06-430121-4 (Harper & Row: pbk.) 83 84 85 86 10 9 8 7 6 5 4 3 2
ISBN 0-87427-040-5 (Whitney Museum of American Art)

Sperry Corporation is pleased to join with the National Endowment for the Arts in sponsoring the exhibition "Milton Avery" at the Whitney Museum of American Art.

Since Sperry is a high technology corporation, we understand the importance of creative genius and value the opportunity to support this retrospective. Like many great artists, Milton Avery's work did not fit into convenient aesthetic categories, and thus his art did not receive the critical acclaim that it deserves. The time has come to rectify this oversight.

With this fine exhibition at the Whitney, the public will have a unique opportunity to witness an artistic vision that resists definition and, at the same time, inspires profound admiration. This is a rare privilege, and one that we at Sperry take great pride in sharing.

GERALD G. PROBST
Chairman and Chief Executive Officer
Sperry Corporation

CONTENTS

FOREWORD

In presenting the largest retrospective of the work of Milton Avery since his death in 1965, the Whitney Museum of American Art offers the public an opportunity to study the achievements of an artist who has often been neglected by critics and scholars because his art cannot be easily labeled or categorized. An independent thinker, Avery pursued his own aesthetic interests, which were often at odds with the dominant styles of the time. During the flood of enthusiasm for American Scene painting in the 1930s, his work was criticized for being too abstract. When abstraction received critical acclaim in the 1950s, Avery was generally ignored because he refused to abandon all references to natural forms. In spite of the fact that his extraordinary abilities as a colorist strongly influenced several of the Abstract Expressionists—notably Mark Rothko, Adolph Gottlieb, and Barnett Newman—he never achieved a stature comparable to theirs during his lifetime.

Barbara Haskell, curator of the exhibition, has uncovered many facts about Avery's life which offer new insights into his development as an artist. With the same tenacity with which she approached her research for the monographs on the life and works of Arthur Dove and Marsden Hartley, she has conducted an exhaustive effort to relate Avery's work to the factual details of his life. Her disciplined method of documenting the biography of an artist provides a foundation for research upon which she and others can build.

During the three years required to research and organize the exhibition and publication, Milton Avery's widow, Sally Avery, has been extremely generous, offering support and encouragement and giving much of her time. The project has, naturally, been of enormous interest to her, but she

has shown commendable professional restraint in allowing others to make critical judgments in situations where her own response might differ because of her affection for the artist and his work. She has the great respect of all of us who recognize her commitment to the work of Milton Avery.

The Whitney Museum is also grateful to Sperry Corporation and the National Endowment for the Arts for their assistance. Finally, we are indebted to the lenders to the exhibition, both museums and private collectors, whose cooperation made possible this important retrospective.

<div align="right">

TOM ARMSTRONG
Director

</div>

ACKNOWLEDGMENTS

A project of this scope requires the aid of a great many people—especially so in the present case where Avery's exceptional prolificacy made determining the whereabouts of his work a formidable task. I am fortunate to have had an extraordinary level of cooperation from the galleries that handled his work over the years. Grace Borgenicht has been particularly generous in making her records and related documents available to me. I am grateful both to her and to her staff—especially Lois Borgenicht, Curt R. Marcus, and Roberto White—for the thoroughness and unflagging good humor with which they answered our innumerable questions and responded to our requests. Donald, Florence, and Mark Morris are equally to be thanked for providing information and material from their files and for arranging much of the necessary Detroit area photography. They extended themselves in every way to ensure that I saw and received data on the large number of Avery works in Detroit collections. Their company, good meals, and their insights into Avery and his work were invaluable. Marianne Friedland played a similarly important and hospitable role in Toronto and I am grateful to her as well. Also helpful were Douglas Webster (Yares Gallery); Marie Withers (Lunn Gallery); Timothy Walsh (Andrew Crispo Gallery); Leslie Waddington and Janet Yapp (Waddington Galleries Ltd.); Dolly Fiterman; Thomas Gibson; Barbara K. Lewis (Richard Gray Gallery); Alan Fink and Leslie Foss (Alpha Gallery); Paule Anglim; and Sid Sachs (Makler Gallery).

I deeply appreciate the cooperation and encouragement of my colleagues at the Whitney Museum of American Art. Tom Armstrong's enthusiastic support and commitment to the project from its inception has meant a great deal to me. Patterson Sims has been a helpful and encouraging colleague in various phases of the exhibition and book preparation, as have Jennifer Russell, Palmer Wald, Jane Heffner and Nancy McGary.

Special thanks are due the Museum's publications department. The insights and editorial advice offered by Sheila Schwartz contributed enormously to the quality of the book, as did James Leggio's fastidious editing and Doris Palca's diplomatic supervision of the book's production. The en-

thusiasm of Cass Canfield, Jr., of Harper & Row for the publication of this book is also greatly appreciated.

Especially valued is the assistance provided by my immediate staff, without whose commitment and hard work neither the book nor the exhibition could have been realized. Since the project's inception three years ago, many individuals have worked with me to assemble biographical and bibliographical data. In particular I would like to thank Sarah Crandall, Jody di Vito, James Donnelly, Peter Freeman, George Greos, Kristie Jayne, Polly Lubell, Peggy Merrill, Eliza de Sola Mendez, Sydney Waller, Eliza Webb, Lisa Weber and Karl Willers. Dana Friis-Hansen took responsibility for organizing the bibliography and exhibition history into its present form and for resolving outstanding bibliographical questions. I am deeply grateful to him and to Suzanne Dickerson, whose thoroughness and professionalism in handling the myriad details concerning loans and the assembly and preparation of catalogue material were absolutely essential to the smoothness and success of the project.

Many individuals gave of their time to show me their collections and to share with me their ideas and remembrances about Avery; to them—particularly to March Avery Cavanaugh, Aaron Berkman, Martin Dibner, Nathan Halper, Alex Katzman, Annalee Newman, and Wallace Putnam—I extend deep thanks. I am equally grateful to Leon Botstein, who read the manuscript and offered valuable editorial suggestions; to Elizabeth Hoke for investigating Avery's association with the Connecticut League of Art Students; to Marla Price for answering several bibliographical questions from her own research on Avery; to Edwin E. Stein for providing information on Avery's career at the School of the Art Society of Hartford; and to Richard Wiles, who spent countless hours researching the genealogy of the Avery family.

To the lenders—whose commitment to Avery and to sharing his art with the public overrode their understandable reluctance to part with cherished works for an extended period—I am unequivocally grateful. Without their generosity and support, an exhibition of this scope would have been impossible.

Finally, my greatest debt is to Sally Michel Avery, whose unwavering commitment to Milton Avery's art was integral to making this exhibition and book not only possible, but immensely rewarding. She has shared her ideas and time with me with a grace and generosity of spirit for which I am deeply grateful. I thank her for her friendship and for her support.

B. H.

In order to paint one has to go by the way one does not know. Art is like turning corners; one never knows what is around the corner until one has made the turn.

—Milton Avery

MILTON AVERY

Milton Avery lived and worked as if to avoid biography. He left no significant autobiographical remnants. He wrote virtually nothing; participated in no organizations; and spoke with such reticence that scant oral testimony was recorded. He seemed to have had no will to express himself in any way other than painting—"Why talk when you can paint?" was his oft-quoted remark.[1] Yet even his paintings elude biographical interpretation; although they draw upon a narrow and consistent repertoire of images, they remain opaque, revealing little about the painter himself. As a result, information about Avery's life is often inaccurate and sketchy. The kind of environment in which he grew up, his family's structure, even his father's name—these are questions which have either never been addressed or have been answered incorrectly.[2] Biographical quests are valuable only insofar as they offer insight into how art is generated—how personal and psychological factors affect an artist's development; how prevailing aesthetic and intellectual concerns influence the work. In Avery's case, we now know that he was eight years older than previously thought and was far better trained as an artist.[3] The revised view of him that emerges gives new insight into the development of his paintings and their relationship to the art of his time. That his masterful late paintings were executed when he was in his seventies rather than his sixties, for example, lends them marked distinction in the American pictorial tradition, where such late achievement is rare. That his artistic training took place in an earlier decade than once assumed makes his adoption of modernism more remarkable; that his training was of longer duration makes his later singularity of purpose as an artist and his devotion to a personal aesthetic vision more comprehensible.

Born in 1885, Milton Avery came of age aesthetically in an era inhospitable to advanced art. Looking back on American artistic development at

the turn of the century, we see the ambitious variety of approaches with which artists struggled to forge individual styles; what we cannot see is the isolation in which they often had to work. We fail to recall the ignorance and the hostility to modernist painting which persisted in America until after World War II. Avery was a solitary presence in this environment, coming to terms with advanced painting notions without critical support. He arrived in New York City in 1925—when the lingering psychological and political crises generated by World War I were pushing artists away from modernism. Working with total commitment to his own ideals, Avery combined an engagement with purely aesthetic issues with a loyalty to the observed motif. In so doing, he bridged the gap between realist and abstract art. That he initially did this in the twenties and thirties, when subject matter and "realist" painting were paramount and, later, in the forties and fifties, when they were suspect, attests to the independence of vision which he sustained throughout his life. Despite the advantages of conforming to prevailing taste, he remained aloof from the stylistic and ideological struggles that raged around him. His reluctance to position his work within the confines of a single style or rhetorical posture confounded critics and probably delayed the acknowledgment of his deserved place in the history of twentieth-century American art.

But fellow artists and select critics appreciated and were affected by Avery's spectacular ability to handle color. As one of the first and most accomplished American exponents of color and its structural function, Avery paved the way for later generations of American colorists. Applying thin layers of paint, he created chromatic harmonies of striking subtlety, delicacy, and invention. The range and originality of his achievement established him unequivocally as one of America's greatest color poets. Yet Avery was also a rigorous draftsman who contained his color within lean and tight pictorial structures. He distilled out of his subjects everything extraneous, retaining only the essential idea. His simplified, spare forms were locked together into compositions which, while seemingly effortless, were so finely balanced that to change even one shape or color saturation would destroy the equilibrium of the whole.

Yet Avery brought more to his paintings than mere formal invention. He imbued familiar subjects—landscapes, still lifes, scenes of daily life—with an iconic timelessness. And he depicted the immediate world around him with a gentleness that few artists equaled. His domestic scenes and still lifes portray a world free of anger and dissonance, a world of harmony and composure. Perhaps the most powerful Avery works are those that reveal his deep response to nature, for he was one of the finest American landscape

painters of this century. His landscapes convey the grandeur of nature—but a nature whose character is arcadian rather than alien and threatening. One feels looking at an Avery landscape or seascape that the highest human experience is being alone and at peace with the land and the sea.

Milton Avery was descended from English immigrants who settled initially in New England in the early eighteenth century and whose offspring pioneered north-central New York between the Catskill and Adirondack mountains. The county histories of the region suggest that the original members of the Avery family were relatively affluent and held respected positions in their communities for several generations. But neither Milton's father, Russell N. Avery, nor his grandfather, Harlow, is mentioned in local records, an indication that the artist's immediate progenitors were less prominent than many of their collateral relatives.[4] At Milton's birth, his father was employed as a tanner in the village of Sand Bank, a provincial and remote community inland from Lake Ontario which boasted a tannery, a saw mill, and a chair factory. Russell and his wife, Esther March, a woman from nearby Williamstown, raised four children in Sand Bank: George, Minnie, Fabian, and Milton.[5] Milton, the youngest child, was born in 1885, when Sand Bank was still a village and had yet to be incorporated as the town of Altmar.

Tanning and lumber dominated the economy in that region of New York State until the 1880s, when the tanning industry underwent a radical change as chemical extracts replaced bark as the essential processing agent.[6] The subsequent closing of several tanneries in the northern part of the state may have led Russell Avery to move with his family in 1898 to a two-family house in the village of Wilson Station, Connecticut, a rural suburb adjacent to East Hartford.[7] Avery's father worked there for seven years as a tanner until his death in a freak wood-chopping accident in 1905. That Russell was held in higher esteem than usually accorded a simple laborer is suggested by the length of his obituaries and the newspaper reports of his funeral, which took place in Altmar; the *Hartford Daily Times* described him as a man who "had the respect of the community," while the *Pulaski Democrat* noted that the flowers sent were the "finest ever seen in Altmar."[8]

Russell Avery's death did not drastically change the family's living pattern. Even before, everyone in the family had lived together and contributed to the household income: George, the oldest Avery son, had died before the family moved to Connecticut, but Milton and Fabian, along with

their sister, Minnie, her husband and two daughters, all lived in the Wilson Station home.[9] The economic necessity of living in the same house became even more acute after Russell's death. And when Fabian married in 1910, he and his wife, Mabel, and their subsequent two children remained in the family home as well. Despite their more prosperous ancestors, the Averys were working-class: Milton's brother Fabian and his brother-in-law, George Sargent, were truckmen, and Milton had been obliged to begin working in local factories by the time he was sixteen.[10]

The year his father died, Milton was still drifting from job to job in East Hartford factories without evident direction or career ambition. But his positions as aligner, assembler, latheman, and mechanic were neither satisfying nor lucrative. When he came across a magazine advertisement for a correspondence course promising that money could be made in lettering, he decided to pursue it as a career possibility.[11] He enrolled in a lettering class at the Connecticut League of Art Students, an informally organized night school for men founded by Charles Noel Flagg in 1888.[12] The League charged no tuition and offered no formal instruction; it was simply one large room in downtown Hartford to which students had free access at night. Instruction consisted of drawing from models or antique casts and receiving individual criticism several times a week from Flagg or from Albertus E. Jones, who became director of the League after Flagg's death in 1916.[13] According to Avery's later account, the lettering class was discontinued after one month, but Flagg persuaded him to enroll in the life-drawing class for the remainder of the term as an alternative.[14] For Avery, art school may have provided, for the first time, an environment outside his family in which he felt comfortable. He began going to the League in the evenings after working an eight-hour factory shift. By 1911, when Avery was twenty-six, his conversion to art was complete, for in that year he was listed in the *Hartford City Directories* as an artist whose place of employment was the League, an indication that he had saved enough money to take time off from work in order to paint.[15] That Avery became fascinated by art from the moment he was introduced to it seems clear. What is less explicable, given his background as a factory worker from a working-class family, is his immediate and total embrace of a profession with so few remunerative prospects. But whatever his motivation, his will to paint was irreversible; once committed, he remained resolute about a career as an artist—even after 1915, when the financial pressure to support his family became intense.

In that year Milton became the sole adult male in a household of nine women.[16] His brother Fabian had died suddenly in 1913, leaving Milton as his mother's last surviving son. Two years later, his sister's husband died.

Even before these deaths, Avery had been surrounded primarily by women. Esther Avery never remarried after Russell's death in 1905, and from that time on the family was dominated by women, all of whom lived in the same house and all of whom doted on Milton. After the death of the other adult males in the family, the women around Avery acted even more protectively toward him. This pattern of living in a household of women who supported and believed in him was one he found again through his marriage.

The death of his father, two brothers, and brother-in-law, all before his thirtieth birthday, engendered in Avery a profound sense of the transitory nature of life. He responded to this sense of temporality with an unrelenting compulsion to work, as if work itself would provide a deliverance from the terrors of everyday reality, a feeling which corresponded to the Puritan notion that work accounted for life's essential meaning. Painting was Avery's work; he approached it with utter dedication, eliminating all unrelated activities and interests. Routine and discipline became his means of combating uncertainty. His sense of discipline pushed him to rise at the same early hour each morning and paint or sketch most of the day. Because Avery viewed painting as a duty, his approach was that of an artisan and his attitude without pretension or agony. He likened himself to a shoemaker—working every day, regardless of mood or inspiration.[17] Avery was known to scoff at artists who complained about lacking sufficient inspiration or who used moodiness to camouflage lack of discipline. A jingle he frequently sang around the house later in life reflected the equation he made between the imperative to work and mortality: "Work, for the night is coming when man's work is done."[18]

Despite his being thrust into the role of provider for a family of eleven, Avery's commitment to painting—once made—never wavered. Still, since the only other income for the entire family came from a nursing job held by Fabian's widow, necessity demanded that Avery continue to find lucrative employment, however menial. Even so, finances were strained. In 1915 the family was forced to move into a four-family house in East Hartford, in a lower middle-class neighborhood on one of the main thoroughfares into the city.[19] In order to paint in the daytime, Avery eventually found employment at the Travelers Insurance Companies, where he worked the night shift as a file clerk from 1917 to 1922.[20] Working from 6 P.M. to midnight not only allowed Avery to paint during the day, but also to transfer in

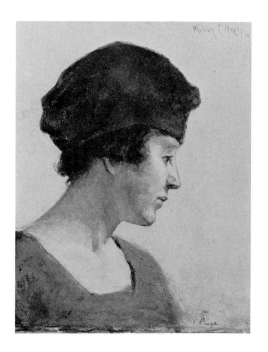

1918 from the Connecticut League of Art Students to the School of the Art
Society of Hartford, whose daytime program of formal instruction he felt
would give him better training. It apparently did, for in 1919 Avery won two
top awards from the school: best painting in the portrait class and best draw-
ing in the life class (1, 2).[21] By this time Avery had been attending art school
for at least eight years, a far longer time than previously thought. Just why
he stayed in art school until he was thirty-four is uncertain. Financial respon-
sibility to his family may have kept him from regarding art as a means of
earning a living, or perhaps he lacked at this time the drive and self-confi-
dence that could push him to strike out on his own. Whatever the reason,
the fact remains that his formal training was relatively lengthy. This changes
our understanding not only of his achievement in art school, but of the
subsequent development of his work. No longer can his paintings of the
1920s be seen as those of an impressionable, "self-taught" talent superficially
emulating aspects of the work he saw around him; rather, they must be
viewed as the work of a mature artist seriously and intelligently confronting
the art of his contemporaries.

 During the first two decades of the twentieth century, the Hartford
art community was typically provincial; it was for Avery and his fellow stu-
dents the full extent of their art world, curtailing exposure to any art not

heralded by local luminaries. Here Avery and his contemporaries were introduced to the work of the academic artists who exhibited at the National Academy of Design in New York, but they were kept totally ignorant of European modernism. They were oriented toward *plein-air* landscape painting; their idols were George Inness and the American Impressionists Ernest Lawson and John Twachtman.[22]

Avery's earliest paintings reflect this conservative atmosphere. Executed in densely brushed dark tones, they showed the lingering influence of Flagg, whose style had earned him the position of unofficial portrait painter of Connecticut. Typical of Avery's works from this period are the portrait of his mother dating from around 1916 and the 1919 portrait for which he won highest honors in his painting class (3, 1).

Avery quickly moved from portraits to a group of landscape paintings executed between 1920 and 1925 in the countryside around Hartford where he sketched with various artist friends. From the American Impressionists

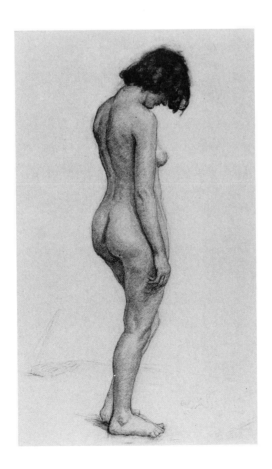

2.
Drawing for which Avery was awarded prize for best work in life-drawing class at the School of the Art Society of Hartford, Spring 1919. Whereabouts unknown

3.
Portrait of the Artist's Mother, c. 1916
Oil on canvas, 48 x 30 inches
(121.9 x 76.2 cm). Collection of Henry Fox

Avery acquired not only a sensitivity to place and atmosphere but also the idea of capturing a single instant in nature. These canvases resembled those of Lawson, whose work impressed Avery in this period by the luminosity achieved with layer upon layer of variegated color.[23] Using the light, sun-drenched palette of the Impressionists, Avery appropriated Lawson's technique of applying colors with brushes and a palette knife and then blending them together on the canvas with his fingers to create shiny, enamel-like surfaces. This allowed the brushstrokes and heavy impasto to assume a structural significance independent of the three-dimensionality produced by light/dark contrasts. Comparing Lawson's painting *Farmhouse, Connecticut* (4) with Avery's *Tree in Meadow* of 1921 (5) reveals an identical painting technique, as well as a similar sense of organization—an open area in the foreground and middle ground of the canvas blocked by a commanding central form. As for Twachtman, his overall decorative treatment of the picture surface—as in *Snow Bound* of 1885 (6)—although not as significant an influence, was assimilated by Avery in compositions such as *Gloucester Dawn* (7). Twachtman was intrigued by the tonal effects created by adding white pigment to his palette and might have enhanced Avery's appreciation of the mellowing effects of this color.

Considering the developments in abstraction that had occurred in the earlier part of the century and the revolution in subject matter brought about by The Eight, Avery's works from the early twenties appear traditional and conservative. Yet they clearly foreshadow his mature style. Looking at these landscapes, it is apparent that from the beginning Avery's fascination with color focused on the effects of layered pigment—not with the way colors are broken up into separate hues and then reconstructed in the eye, but with the creation of a single tone through the actual layering of colors on the canvas. Furthermore, the muted palette and simplified shapes in these paintings constitute the hallmarks of Avery's mature work. Avery's *Moon over Marsh* (8) from this period and his 1957 *White Moon* (9) are related not only in subject matter and palette but in conception and sensibility as well. Avery avoided emotional drama and narrative content in both works in order to concentrate on the paintings' purely visual properties—specifically color. In both works the blending of closely valued hues evokes a kindred mood of tranquility. Size notwithstanding, the major difference between these early and late works lies in the thick impasto of the one and the thin washes of the other.

By the mid-1920s Avery had grown dissatisfied with densely textured pigment. He felt disappointed with friends' responses to his Hartford paintings, realizing that the attention paid to the surface quality of the paint overshadowed his central concern—color.[24] Consequently, he gradually

4.
Ernest Lawson
Farmhouse, Connecticut, n.d.
Oil on canvas, 18 x 24 inches
(45.7 x 61 cm). Private collection

5.
Tree in Meadow, 1921
Oil and wax on board, 16¼ x 19
inches (41.3 x 48.3 cm). Collection
of Sally M. Avery

6.
John Henry Twachtman
Snow Bound, 1885
Oil on canvas, 25¼ x 30⅛ inches
(64.1 x 76.5 cm). The Art Institute of
Chicago; Friends of American Art
Collection

7.
Gloucester Dawn, c. 1921
Oil on board, 18 x 21¾ inches
(45.7 x 55.2 cm). Collection of
Sally M. Avery

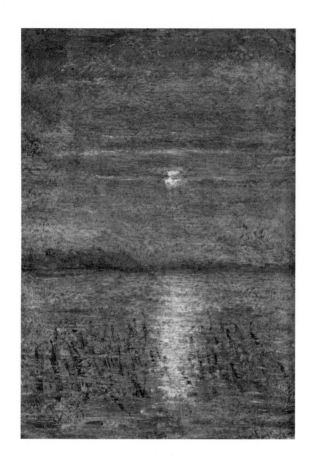 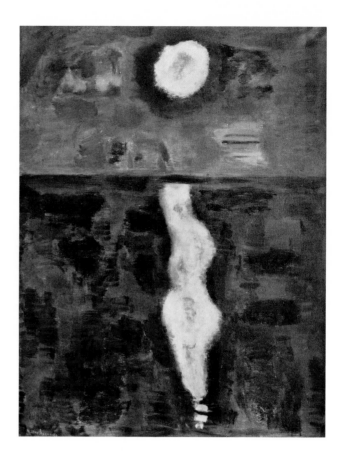

abandoned the impastoed, palette-knife technique adopted from Lawson in favor of broadly painted areas of color applied with a brush. In so doing, he liberated the effects of color from surface structure. This focus on color *per se* became Avery's lifelong preoccupation; by the early 1930s he was identifying it as his principal concern in discussions with friends.[25] The development of color harmonies came to dominate Avery's art; regardless of the structural and technical phases through which his painting evolved, his maturation as a colorist proceeded autonomously and without interruption.

In contrast, the technical and compositional evolution of Avery's art was never consistent, especially at this early stage. Although a painterly style characterized his output by the early 1920s, examples of the earlier palette-knife technique reappeared sporadically until 1926. The habit of pursuing several stylistic approaches at one time became increasingly pronounced as Avery's career progressed. Often by the time he had explored one aspect of style to his satisfaction, he would already have begun pursuing another and the two manners would overlap, thus making generalization about the character of his work in any given period difficult. For example, he intermittent-

8.
Moon over Marsh, c. 1919
Oil on board, 9 x 6½ inches
(22.9 x 16.5 cm). Collection of
Sally M. Avery

9.
White Moon, 1957
Oil on canvas, 50 x 38 inches
(127 x 96.5 cm). Milton Avery Trust,
New York

24

ly employed flat planes of arbitrary color as early as 1932, while still primarily involved with illusionistic modeling; not until the early 1940s did this more abstract style predominate.

During the last years Avery attended art school and immediately following his formal training, he summered in the art colony of Gloucester, Massachusetts. He gradually gained sufficient respect within the community so that by the summer of 1924 he was offered free studio space and accommodations in a rooming house. His living situation that summer proved one of the most fortuitous of his life, because directly across the hall a young woman, Sally Michel, had also taken a room for the summer. Just out of high school and intoxicated by the romantic myth of the young aspiring artist, she immediately attracted the attention of the handsome older artist.[26] Sally seemed to radiate the energy and optimism of youth, and her habit of rising early and leaving with her canvas and equipment for an entire day of painting impressed Avery; in the paint-splattered young woman who did not return until evening he saw a disciplined and serious commitment to painting, much like his own. Avery, considerably Sally's senior, represented for her the ideal of the struggling artist. A bond formed between them as they discovered how perfectly their personalities complemented one another. The innocent summer idyll gradually evolved into romance. It was probably at this point that Avery obscured the date of his birth.[27] Having fallen in love with Sally, he did not want anything to come between them, and he might have feared that his age would inhibit her feelings toward him and certainly those of her parents. He was thirty-nine in 1924. Subtracting several years from his age made him a more appropriate match for a young woman in her early twenties.

Sally returned to her parents' home in Brooklyn at the end of the summer; it was not until the following spring that Avery managed to follow her to New York City. Here he suddenly found himself in the center of twentieth-century art in America. His immediate attention focused on Sally but the background of their courtship was the museum and gallery world of New York. Avery courted Sally for the next year, much to the chagrin of her orthodox Jewish parents, who considered him an inappropriate suitor. Sally Avery recalls that an older man wearing a sport coat with a frayed collar and saying virtually nothing during his introduction failed to impress her parents as someone who would properly support their youngest daughter. But Sally, having found in Milton the man she wanted to marry, was

rebellious. On May 1, 1926, without notifying either family, she and Milton went to the Brooklyn courthouse and were married.[28]

Marrying Sally was the most decisive event in Avery's life and career. Sally guided their relationship in a manner that created a supportive environment in which he could work freely, unimpeded by economic or social responsibilities. The comfort of a woman who was also provider and fellow artist seemed a natural yet somehow magical extension of the home environment in which he had lived before meeting Sally. For Sally the marriage was the romantic dream come true of a life devoted to art. She recognized the genius in Avery and seemed willing to do anything to provide a secure atmosphere in which he could work. The lack of competitive ambition or self-confidence which may have accounted for Avery's remaining in art school until he was thirty-four was counteracted by Sally's drive and energy. She insisted on being the one to earn a living so that he could concentrate on painting. Even teaching was eliminated as a job possibility because Sally strenuously objected, believing it would be a waste of Avery's time. Through her sister, the art editor of *Progressive Grocer,* a small-circulation magazine, Sally found work as a freelance illustrator, an occupation which could be pursued at home and thus allow her to remain with Avery both day and night. Their entire lives revolved around art; rising at six in the morning, they would often draw or paint straight through until dinner. Sally was as gregarious as Avery was taciturn and was so attuned to his thoughts that she became his spokesman, articulating his ideas and expanding upon his cryptic comments. Her support extended into every area of their lives: she eliminated virtually all mundane distractions; if she was out, Avery would generally not even answer the telephone. Years later Frederick Wight characterized the Averys' marriage as "a fusion of will and interests which seems at most to divide itself into complementary functions rather than two people. Avery had reserved for himself the essential of painting. Sally Avery provided for everything else."[29]

They made their first home in 1926 in a one-room walk-up in Lincoln Arcade, a former office building on Broadway at Sixty-fifth Street that had become a studio complex for artists.[30] The amenities were few: the bathroom was down the hall and meals were cooked on a hot plate. The Averys' social life during these years centered on activities in the building, and the artists there—Wallace Putnam, Aaron Berkman, Vincent Spagna, all of whom Avery had known in Hartford, and Gershon Benjamin, a Romanian painter—gradually formed their coterie. Because their finances were limited, entertainment was usually self-generated. In the evenings, they would go to each other's studios or to sketch classes at the Art Students League, where,

for five dollars a month, they could spend as much time as they liked. The Averys could seldom afford movies; instead, Milton would read aloud at night. When reading to himself, he selected mystery stories, but reading out loud involved the beauty of language, and over the years their reading list included Melville, Proust, Thoreau, Wallace Stevens, and T. S. Eliot—ambitious choices for a man with a relatively limited academic background.

The Averys' remarkable partnership impressed their friends with its singularity of purpose; it represented for that community of struggling artists an example of unwavering dedication and belief. Yet that dedication was accompanied by a warm openness to the fellow artists who would often drop by the Averys' apartment, knowing they were welcome. The Avery home became a meeting place for artists seeking stimulating conversation and a congenial atmosphere. Although the Averys' own lives as artists were seldom free of struggle and disappointment, their optimism and their commitment to art gave others courage.

The Averys' first years together generated sweeping changes in Milton's art as Sally's support and an avalanche of new influences encouraged him to venture into a different series of paintings. For the next ten years he experimented with the styles of those painters whose work he saw in New York, while at the same time evolving his own personal aesthetic. The accepted critical concept of Avery as a self-taught, naive painter, oblivious of the art produced around him is misleading. Avery was vastly curious about art: he read from cover to cover every art magazine he could find, and he and Sally spent every Saturday going to galleries and museums. From these aesthetic encounters, he evolved his independent vision.

The art community in New York in 1925 was entirely different from that which Avery had known in Hartford. Living in Hartford, he had missed the initial wave of European avant-garde influences that had generated the abstract movement in American art during the first two decades of the century. By the time Avery arrived in New York, modernism had collapsed. After World War I a general mood of distrust and cynicism had developed about American participation in European affairs and European styles; by 1920 even those artists who had earlier responded to European modernist innovations had renounced abstraction and retreated into more realistic styles. Of the early modernists, only Arthur Dove maintained a consistent commitment to abstraction. In the disillusioned postwar period, Alfred Stieglitz, the charismatic champion of the American avant-garde, had closed his

"291" gallery and suspended publication of his vanguard magazine, *Camera Work*. Although he later opened a second exhibition space (the Intimate Gallery), by the time Avery arrived in New York in 1925, Stieglitz's fervor for modernism had waned, as had the influence of his gallery and those artists associated with it.

Not surprisingly, given his schooling, Avery was initially drawn to more conservative artists working within the academic tradition. His training in Hartford had focused on sketching from a model or plaster casts, and in his early years in New York he continued this discipline at the Art Students League, where he and Sally spent many of their evenings. The League was the stronghold of the realist tradition—its students and faculty included most

10.
Sun Worshippers, 1931
Oil on canvas, 26 x 33 inches
(66 x 83.8 cm). Yares Gallery,
Scottsdale, Arizona

of the prominent members of the American academic art community. Although formal instruction was not given in the sketch classes, Avery was exposed to the dominant attitudes at the League, expressed at that time by Kenneth Hayes Miller and Yasuo Kuniyoshi. These artists represented the League's two approaches to subject matter: artists around Kuniyoshi—Jules Pascin, Bernard Karfiol, Alexander Brook—painted still lifes or posed interior figure compositions, while the contingent of painters around Miller—Walt Kuhn, Isabel Bishop, Guy Pène du Bois—sought to capture the daily lives of urban Americans. During the 1920s, the work of these two groups dominated the American art community, being exhibited regularly in most of the leading New York galleries—Daniel, Downtown, Frank K. M. Rehn, Valentine, and Montross—as well as at the Whitney Studio Club, one of the few non-commercial exhibition spaces available to American artists.

Avery's paintings from his first year in New York generally followed the painterly mode of his Hartford works, but he soon abandoned this approach as the various artistic styles he saw in the city began to affect him. The most immediate change that occurred in his work was his replacement of the light-drenched palette of his earlier paintings with the somber tones characteristic of American academic realism. As his colors darkened, his surfaces became less dense. Even before his arrival in New York, Avery had stopped using the thickly impastoed, palette-knife technique of his Impressionist paintings. Now his experimentation with the possibilities of color accelerated as he began to use matte pigments, brushed onto the canvas in thin layers with a stiff brush. In *Sun Worshippers* (10), for example, this scumbling technique blurred individual strokes and created an overall textured softness. Although he was using heavy-bodied paint, rather than the transparent paint he would use in his mature work, Avery's thin application of pigment revealed bits of the canvas ground, especially around the perimeters of shapes, thus allowing the bare canvas to function as color. During this period, Avery became convinced that mixing more than three colors together obscured their clarity, a belief he maintained throughout his career.[31]

With his move to New York Avery started to paint from sketches, rather than to work directly from nature as he had done previously. This allowed him to expand his scale since he was no longer restricted to a canvas size he could easily transport. The sketches, with occasional color notations, were straightforward visual recordings of the subject; they varied little in style and technique throughout his career. After adding gouaches and watercolors to his repertoire in 1927, Avery's working procedure became more elaborate. Thereafter he generally sketched on location—usually in the summer—and from an assortment of sketches he would later choose one to de-

 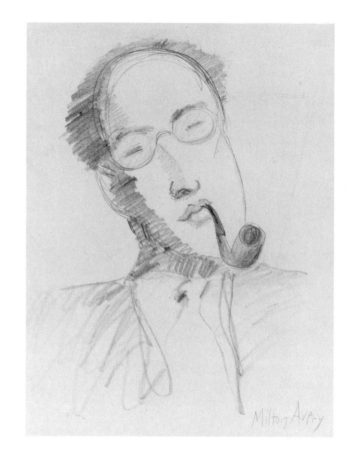

velop into a watercolor. When the time came to make a painting, he would select a watercolor to transcribe onto the canvas, sometimes sketching the structure of the entire painting with charcoal before beginning to paint, other times merely using the watercolor as a visual referent. Often, years would elapse between the original watercolor idea and the finished painting; the watercolor version of Avery's 1960 *Bathers by the Sea,* for example, was executed in 1948 (74, 98).

Due to Avery's lifelong habit of sketching everything around him, his subject matter became a kind of diary of his activities. Although he enjoyed the company that frequently gathered at his apartment in the twenties and early thirties, he seldom contributed to the conversations and his proclivity for sketching rather than talking on these occasions became well known. When friends came over to visit, they became portrait subjects (11, 12, 13); lacking guests, he sketched Sally and, later, his daughter, March. His group portraits reflected his excursions into the world outside his apartment— Coney Island, the circus, vaudeville, sports events, and Central Park.

11.
Portrait of Mark Rothko, 1933
Oil on canvas, mounted on masonite, 22½ x 16 inches (57.2 x 40.6 cm). Museum of Art, Rhode Island School of Design, Providence; The Albert Pilavin Collection; 20th-Century American Art

12.
Mark Rothko, c. 1933
Pencil on paper, 11 x 9 inches (27.9 x 22.9 cm). Collection of Dr. and Mrs. Marvin Klein

Avery's portraits and figure compositions were typical of the work that dominated the New York art scene in the twenties: his close-cropped individual portraits isolated against flat backgrounds (13) related to the academic paintings of artists at the Art Students League (14), while his figure groups (16) were similar to the urban genre paintings of artists later identified with the American Scene. In general, Avery's desire to represent the subjects of the single portraits as recognizable individuals necessitated conventional renderings; consequently, his one-figure portraits remained relatively academic. In contrast, his group scenes provided an anonymity that lent itself to abstraction.

Along with occasional still lifes, these two portrait categories dominated Avery's output until 1935, when he reintroduced landscapes into his repertoire of themes. By this time group genre subjects outnumbered single portraits, although Avery continued producing portraits through 1943, when he executed perhaps his most successful characterization, that of his friend and fellow artist Marsden Hartley (27).[32] Thereafter, Avery's single-figure imagery was confined either to anonymous depictions or to the self-portraits which he painted throughout his career in the absence of other subjects.

13.
Woman in Wicker Chair, 1929
Oil on canvas, 40 x 30 inches
(101.6 x 76.2 cm). Milton Avery Trust,
New York

14.
Ernest Fiene
Concetta, 1926
Oil on canvas, 40¼ x 30¼ inches
(102.2 x 76.8 cm). Whitney Museum of
American Art, New York; Gift of
Gertrude Vanderbilt Whitney 31.193

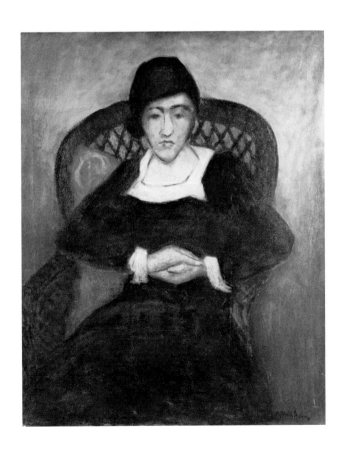

15.
Coney Island Sketches, 1931
Pencil on paper, 17 x 14½ inches
(43.2 x 36.8 cm). Collection of
Sally M. Avery

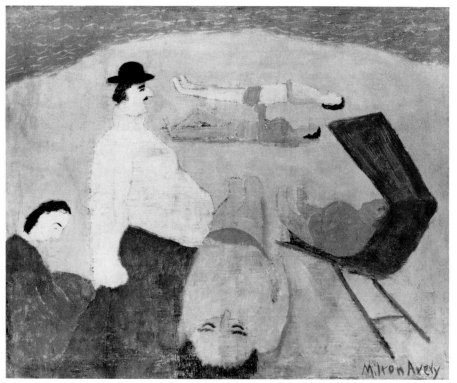

16.
Coney Island, 1933
Oil on canvas, 26 x 33 inches
(66 x 83.8 cm). Milton Avery Trust,
New York

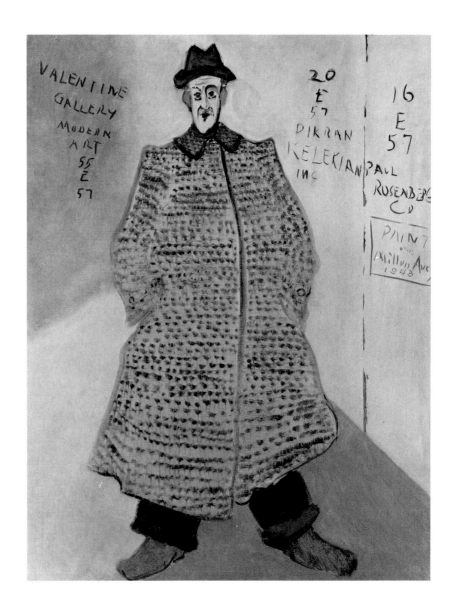

17.
Avery on 57th Street, 1943
Oil on canvas, 36 x 28 inches
(91.4 x 71.1 cm). Andrew Crispo Gallery,
New York

Avery introduced elements of humor into these self-portraits and ear-
ly genre scenes through scale distortion, exaggerated color, and caricature.
Although often compared in reviews of the thirties to the comic illustrations
of James Thurber, Avery's humor is neither satirical nor biting; rather, it
takes the form of a gentle playfulness, revealing the wry, New England
humor friends came to expect from him.[33] The comic exaggeration of the
portly man in *Coney Island* of 1933 (16) or the childlike self-parody in *Avery
on 57th Street* of 1943 (17), for example, allowed Avery to explore serious
formal considerations without appearing ponderous. As his work developed,
these droll caricatures gave way to a more subtle, formal caprice.

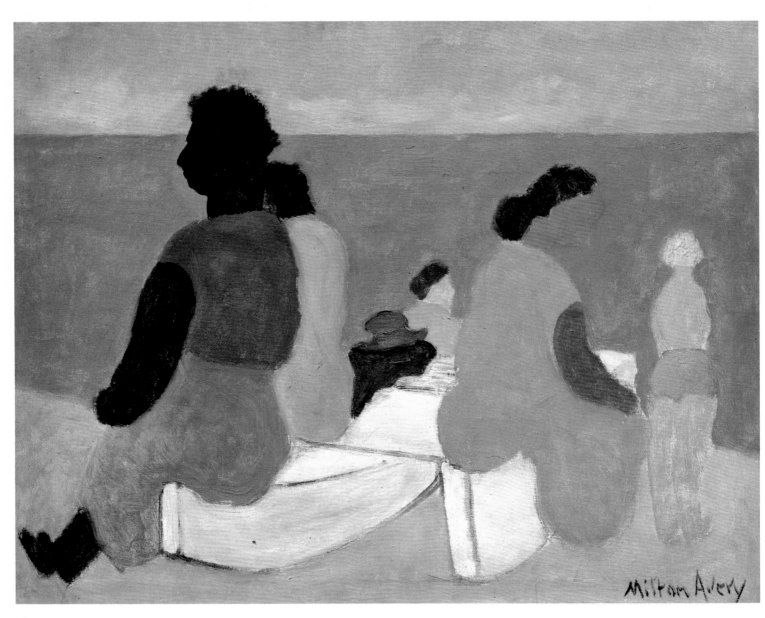

18.
Sitters by the Sea, 1933
Oil on canvas, 28 x 36 inches (71.1 x 91.4 cm). Private collection

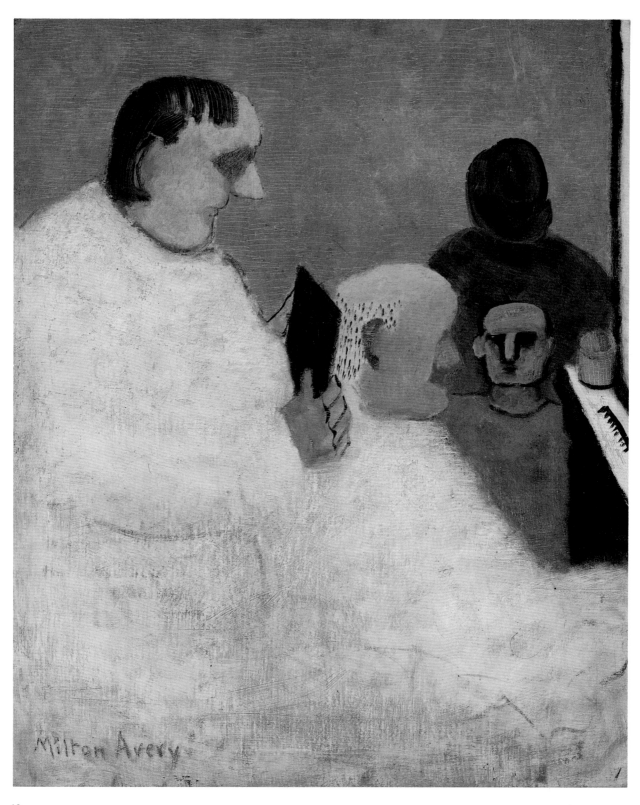

19.
Barbershop, 1936
Oil on canvas, 30 x 25 inches (76.2 x 63.5 cm). Grace Borgenicht Gallery, New York

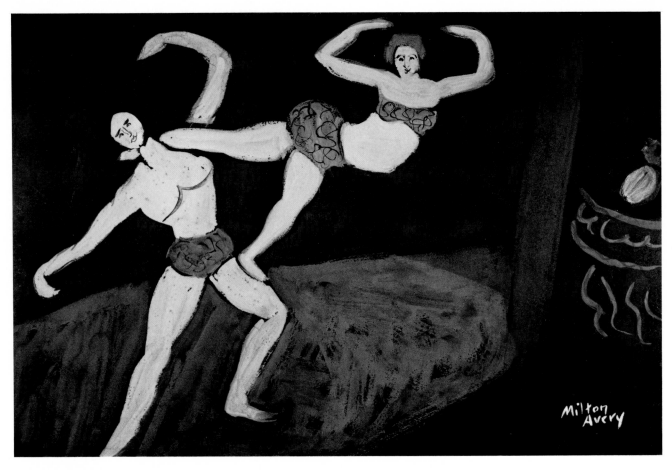

Avery's first genre scenes appeared in the gouaches he began in the summer of 1927. Executed on dark construction paper which he cut in half to save money, they were far looser and more adventurous than his concurrent paintings, a characteristic of his works on paper that would persist throughout his career. In contrast to the academic subject matter of the single portraits and still lifes which had occupied him in his first two years in New York, the vaudeville performers and beach habitués of the gouaches anticipate by several years the thematic direction his oils would take (20). Eventually Avery's gouaches and watercolors came to have more far-reaching influences on his painting than merely that of subject matter. Because of their necessarily quick brushwork and their lack of pretension, they gave him freedom to experiment. From them, he learned to make decisions rapidly and avoid reworking; to paint with thin pigments in order to duplicate the fluidity and luminosity of the watercolor medium. As he developed his unique color sense, Avery gradually incorporated these watercolor techniques into his oils.

Avery's involvement with the academic artists at the Art Students League would seem to have discouraged his investigation of European art

20.
Acrobats, 1931
Gouache on black paper, 12 x 18 inches (30.5 x 45.7 cm). The Eason Gallery, Santa Fe, New Mexico

styles. But in fact, he was far from closed to the influence of European art, which was still readily available in New York. Galleries such as Valentine, Wildenstein, and Durand-Ruel still exhibited modernist European art on a regular basis, and reproductions of it frequently appeared in certain art journals, especially *Creative Art, Cahiers d'Art,* and *The Arts.* With the founding of the Museum of Modern Art in 1929, European art became even more publicly accessible.

Henri Matisse and Pablo Picasso were the two European artists who exerted the strongest influence on Avery. Matisse's work could regularly be seen at the Valentine Gallery, which mounted an important retrospective of his paintings in 1927. Three years later, Matisse visited the United States to serve on the Pittsburgh International Exposition award jury. His stay in New York was a major public event, generating even more interest in his work. The Averys' habit of spending Saturdays visiting museums and galleries would certainly have taken them to the 1931 Matisse exhibition at the newly opened Museum of Modern Art.

Picasso was the only artist whose work rivaled Matisse's in prestige and public visibility. By 1928 he had had three major exhibitions at Wildenstein & Co. in New York. In 1930, fourteen of Picasso's paintings were included in the important "Painting in Paris" exhibition at the Museum of Modern Art, and throughout the decade his work was exhibited there as well as at the Valentine Gallery and A. E. Gallatin's Museum of Living Art.

The aesthetic Avery evolved during his first years in New York reflected both the European modernism he saw and the work of the American academics with whom he associated. He felt comfortable with this American tradition but he could not embrace its ideological emphasis on subject matter; conversely, the theoretical concerns of the European avant-garde were alien to him, but he was stimulated by its techniques and pictorial freedom. His solution was to advance American academic art by overlaying it with European avant-garde devices, primarily those of Matisse and Picasso. Consequently, he pushed the academic tradition farther in the direction of European modernism than did any of his contemporaries at the Art Students League. Still, compared to the work of the Stieglitz group, Avery's art of the twenties remained conservative and can best be interpreted more as a modernist extension of the academic tradition than as a foray into European painting.

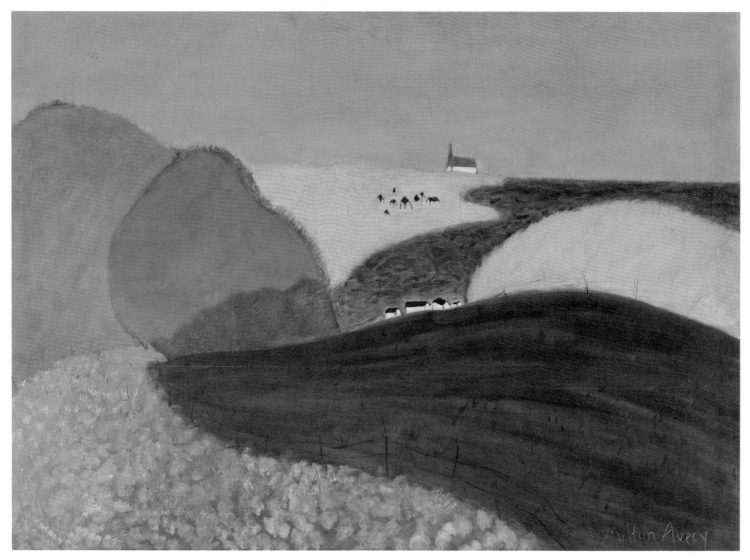

21.
Gaspé—Pink Sky, 1940
Oil on canvas, 32 x 44 inches (81.3 x 111.8 cm). Collection of Mr. and Mrs. Samuel H. Lindenbaum

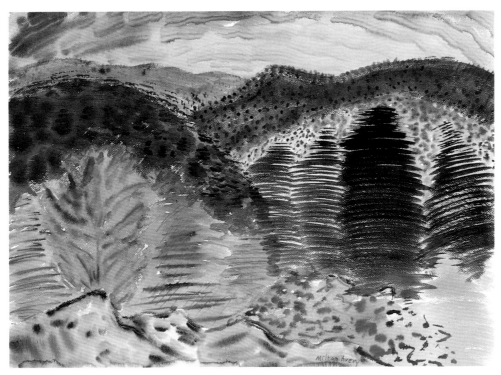

22.
Spring in Vermont, c. 1935
Watercolor on paper, 22 x 30 inches (55.9 x 76.2 cm). Collection of Sally M. Avery

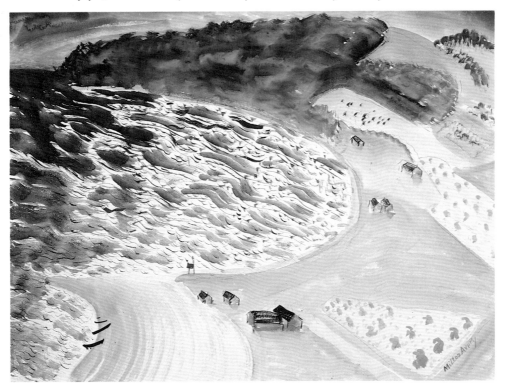

23.
Gaspé Landscape, 1938
Watercolor on paper, 22 x 30 inches (55.9 x 76.2 cm). Private collection

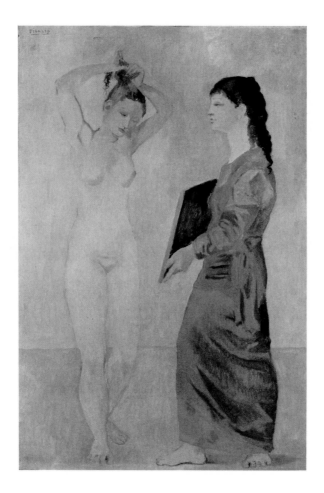

24.
Pablo Picasso
La Toilette, 1906
Oil on canvas, 59½ x 39 inches
(151.1 x 99.1 cm). Albright-Knox Art
Gallery, Buffalo; Fellows for Life Fund

On the whole, Avery's paintings from his first decade in New York—1925 to 1935—reflect the subject matter of the American academics, but the techniques of the Europeans. While early paintings shared stylistic features of shape and design with American academic portraits, by 1930 Avery had begun incorporating aspects of the work of Picasso and Matisse into his paintings. He became fascinated by Picasso's brushy modulation of closely valued colors in such Rose Period paintings as *La Toilette* (24), exhibited at the Museum of Modern Art in 1930, and he adopted a similar layering of color in his own compositions: in *Woman with Mandolin* of 1930 (25), for example, layers of allied hues create the suggestion of brushy, homogeneous color areas reminiscent of early Picasso. Similarly, Matisse's exhibition at the Museum of Modern Art in 1931 had an impact on Avery's work. *Nude Ironing #2* (28) and *Self Portrait* (29), with their strongly modeled forms set against dark and unadorned backgrounds, clearly drew upon the French master's innovations. As Avery's work developed through the thirties, he

came to focus not on Matisse's compositional modes, but on his exploitation of arbitrary color—a characteristic which would become the mainstay of Avery's own art.

Interspersed with the more formative and derivative works of the late twenties and early thirties were isolated paintings which contained the seeds

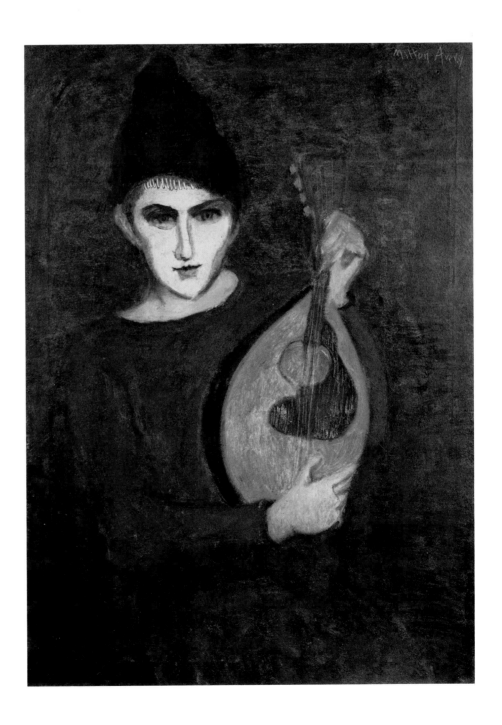

25.
Woman with Mandolin, 1930
Oil on canvas, 33½ x 24½ inches
(85.1 x 62.2 cm). Collection of
Dr. and Mrs. Harold Rifkin

26.
Self Portrait, 1941
Oil on canvas, 54 x 34 inches (137.2 x 86.4 cm). Collection of Roy R. Neuberger

27.
Portrait of Marsden Hartley, 1943
Oil on canvas, 36 x 28 inches (91.4 x 71.1 cm). Museum of Fine Arts, Boston;
Charles Henry Hayden Fund

28.
Nude Ironing #2, 1931
Oil on canvas, mounted on board,
22 x 14 inches (55.9 x 35.6 cm).
Milton Avery Trust, New York

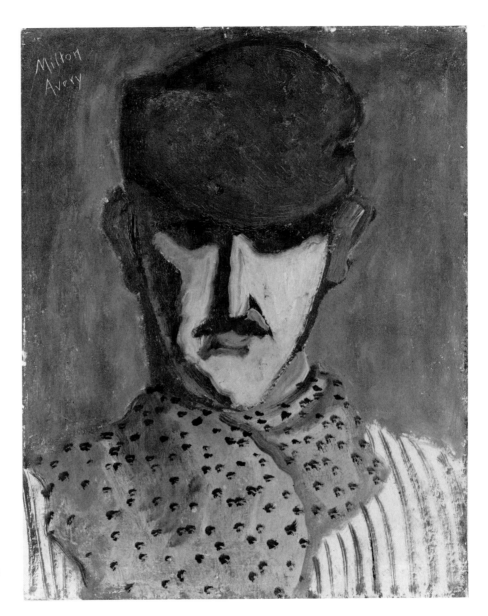

29.
Self Portrait, 1930
Oil on canvas, 19¼ x 15½ inches
(48.9 x 39.4 cm). University of Nebraska
Art Galleries, Lincoln; Howard S.
Wilson Memorial Collection

of Avery's mature style—a style which, despite its French modernist sources, was very much his own. Already apparent by the early thirties was Avery's predilection for compositions based on large, closely modulated color areas. In *Woman with Green Face* (32), he dispensed with illusionistically rounded volumes and modeled forms to create instead the appearance of flat color areas. He achieved this by isolating color into discrete shapes and painting each shape with several closely valued hues, a technique which allowed his tones to blend into seemingly uniform color areas.

In these key works Avery did more than merely evolve a way of

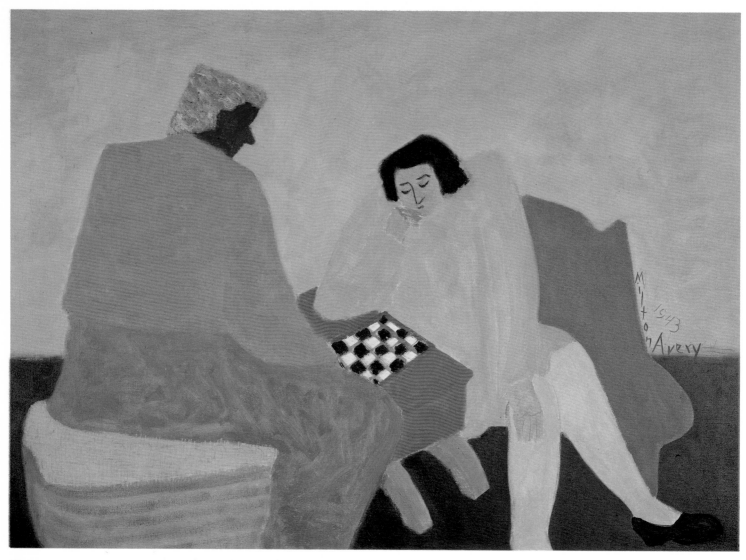

30.
Checker Players, 1943
Oil on canvas, 32 x 44 inches (81.3 x 111.8 cm). Collection of Mr. and Mrs. Herbert Elfers

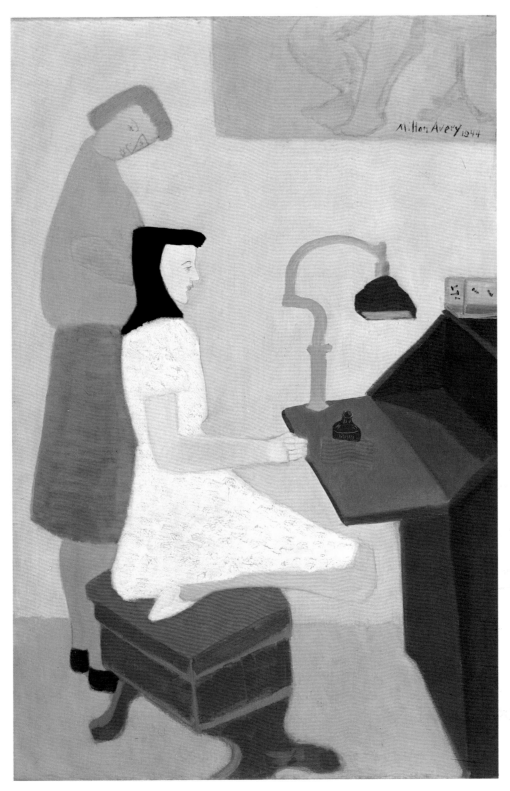

31.
Two Figures at Desk, 1944
Oil on canvas, 48 x 32 inches (121.9 x 81.3 cm). Neuberger Museum, State University of New York
at Purchase; Gift of Roy R. Neuberger

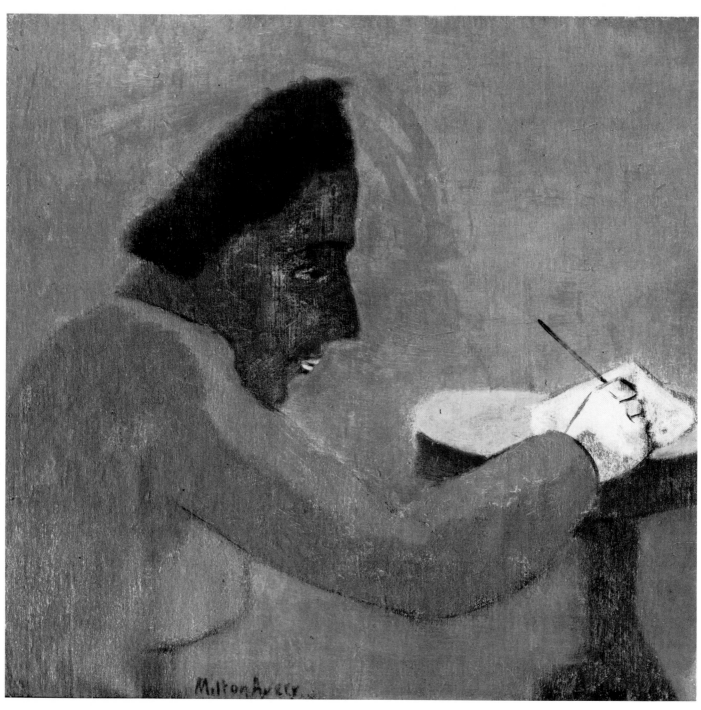

32.
Woman with Green Face, 1932
Oil on canvas, 23 x 24 inches (58.4 x 61 cm). Collection of Constance and Bernard Livingston

painting broad areas of evenly toned color; by treating each shape as a single color area and minimizing the number of shapes in a painting, he flattened and abstracted the images. This metamorphosis of representational elements into flat, interlocking shapes of homogeneous color formed the basis of his mature work. In effect, Avery changed recognizable images into abstract forms which functioned as autonomous equals of the actual objects they depicted. He even treated the space between figures with as much presence as the figures themselves, so that the negative shapes between recognizable forms achieved parity with the forms themselves. In so doing, Avery succeeded in creating a pictorial dynamic between positive and negative shapes, as well as between these shapes and the subject matter. This interplay between recognizable forms and abstract shapes always characterizes Avery's best paintings. Although tentative in their abstraction when compared with later works, his paintings of the early thirties were clearly the progenitors of his mature style. *Sitters by the Sea* (18) shares with late paintings a minimization of detail and flattening of form into large fields of uniform color which lock together as abstract arrangements. Even Avery's characteristic three-tiered division of space into sky/sea/land is already evident in the earlier work. What differentiates the later paintings are their lighter hues and greater homogenization of color within delineated shapes.

Few opportunities existed for lesser-known artists to exhibit their work during the twenties, and from his experience in these years Avery developed his lifelong inclination to show anywhere that offered space. His first chance to exhibit in New York came in 1927 with his participation in the large, non-juried Independents exhibition, a continuation of the open salon established by the Society of Independent Artists in 1917. In 1928 he took work around to various galleries and was included in a show at the Frank K. M. Rehn Gallery. That fall he submitted work to the newly opened Opportunity Gallery, a non-profit organization designed to help young artists gain exposure.[34] Each month a different well-known artist selected the show: the juror for the November 1928 exhibition, Bernard Karfiol, chose both Avery and another unknown artist, Marcus Rothkowitz, who soon after shortened his name to Mark Rothko. The two artists did not meet at the time of the exhibition, but several months later they began what would become an enduring friendship—a friendship that contributed much toward defining the possibilities of Color Field painting in America.[35]

Early critical response to Avery's work was uneven. Henry McBride, the influential art critic for the *New York Sun,* mentioned Avery's name in his write-up of the 1927 Independents exhibition, and, when reviewing the Morton Galleries show two years later, noted that Avery was "a new and

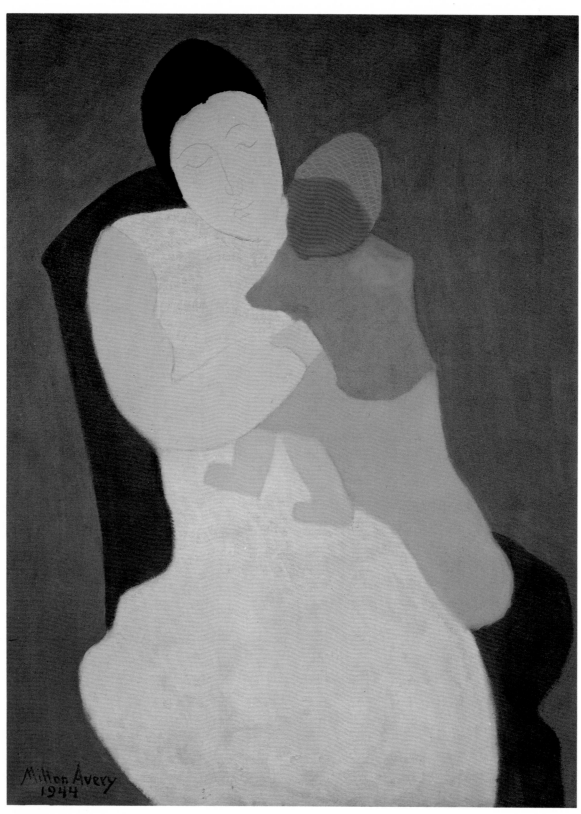

33.
Mother and Child, 1944
Oil on canvas, 40 x 30 inches (101.6 x 76.2 cm). Private collection; Courtesy of Andrew Crispo
Gallery, New York

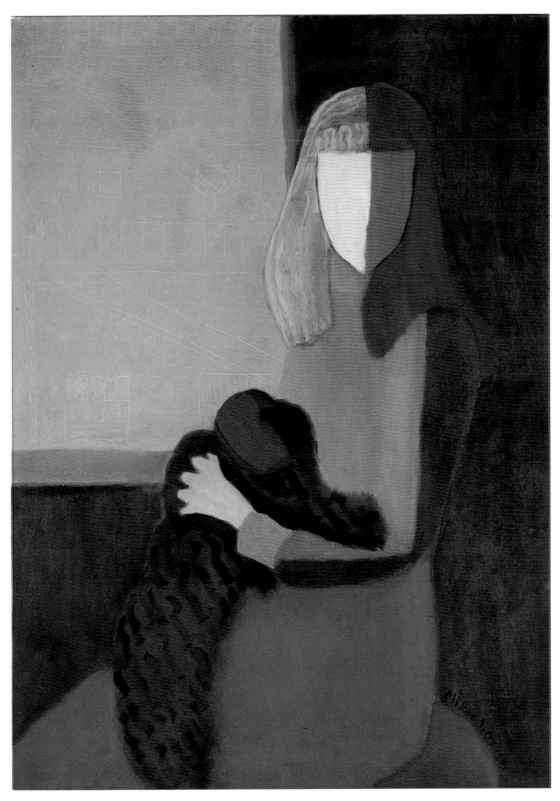

34.
Seated Girl with Dog, 1944
Oil on canvas, 44 x 32 inches (111.8 x 81.3 cm). Collection of Roy R. Neuberger

promising painter. . . . The man has a genuine instinct for painting. Collectors in particular should take a look at his work and see what they think of it."[36] McBride championed Avery's work throughout the thirties and forties; it was McBride, too, who influenced the prestigious Valentine Gallery to take Avery on in 1935.[37] In his columns he continually encouraged collectors to invest in Avery's work, even singling out a painting from the 1933 Independents exhibition that he would have purchased himself had his finances allowed.[38] McBride's astute description of Avery's art in this period could well be applied to his entire career: "It is a fine and natural talent that he has, though not easily defined. He is a poet, a colorist and a decorator; so excellent in each of these diversions that he might exist on any one of them; yet I presume the being a poet will eventually be his strongest claim."[39]

Not all reviewers were as convinced of Avery's achievement. Edward Alden Jewell, art critic for the rival *New York Times,* noted disparagingly that the work Avery exhibited in his 1929 Rehn show "look[ed] best in a dimmish light."[40] In a later review, entitled "Paintings with Baffling Quality on View in Milton Avery's One-Man Show," Jewell expressed bewilderment at what he saw:

> What precisely is the effect it [Avery's color] does produce? That depends upon the observer. The fact that Milton Avery sticks, season after season, to his mysterious—or, as the case may be, his mildly exasperating—paint theories, makes one feel that he is perfectly sincere. These often grotesque and sometimes rather gruesome forms of his must mean something pretty definite to him. . . . But the present reviewer, who doesn't pretend to be able to fathom such painting, suspects that Mr. Avery will, as time goes on, succeed in stating his credo, whatever it be, a little more clearly. He is still in his early thirties, and as his talent matures we shall doubtless find it less difficult to perceive what he is trying to say.[41]

As Avery's aesthetic developed, it placed him increasingly at odds with the stylistic currents that came to dominate American art in the thirties. In keeping with the country's growing isolationism, the majority of painters in the thirties turned against abstraction and what they saw as the internationalism of European art styles. They tried instead to define the American experience as something distinct from the European one. More than ever, the depiction of everyday American subjects dominated the art

scene: Regionalism, the variant of American Scene painting typified by Thomas Hart Benton and Grant Wood, celebrated rural life; the cityscapes characteristic of American Scene painters such as Reginald Marsh and the Soyer brothers showed the poverty and disillusionment of the urban masses; and Social Realist artists such as Ben Shahn and Philip Evergood sought to convey specific political messages about social and economic inequality. Although these groups assumed different attitudes toward the depiction of contemporary conditions, fundamentally all three were oriented toward content.

In this aesthetic environment Avery seemed a maverick. Superficially allied with American Scene painters through his choice of subject matter—urban genre scenes—he was nevertheless uninterested in pursuing content as such. Subject matter to him was always secondary to form and color. While most American artists in the thirties considered style less important than social and political attitudes, to Avery style was everything. In addition, the graphic, relatively illustrational character of American art in this period distinctly contrasted with Avery's increasingly simplified forms and flat planes of color. More and more he felt at odds, pitted against established styles. To his close friends he lamented that "either I am crazy or they are crazy."[42]

However confident Avery was about his work, in such a climate he occasionally lost faith. But Sally was an unflagging and optimistic supporter who served as an antidote to discouragement. She prodded him when he despaired, telling him she did not want to be married to a bad painter.[43] Avery found reassurance in her conviction that his pictures were important and that something would happen with them.

Avery also had the support of the coterie of other artists who came to socialize and see his paintings at his Lincoln Arcade apartment. At dinner time, each person would chip in fifty cents for food and Sally would make hamburgers for all. Avery's habit of painting at least one canvas each day always provided something new to look at and talk about. Rothko and Adolph Gottlieb were frequently among the visitors. At times during the thirties these two artists, eighteen years Avery's juniors, would drop in almost daily to see what he was painting and to talk. Eager for Avery's evaluation of their work, both artists—but particularly Rothko—would invite Sally and Milton to their studios to elicit Milton's comments on their paintings. Avery's dictum—"Why talk when you can paint?"—was reflected by his habit of listening while others spoke. But his occasional remarks were always incisive and highly valued by these artists. Although it is Rothko's later work

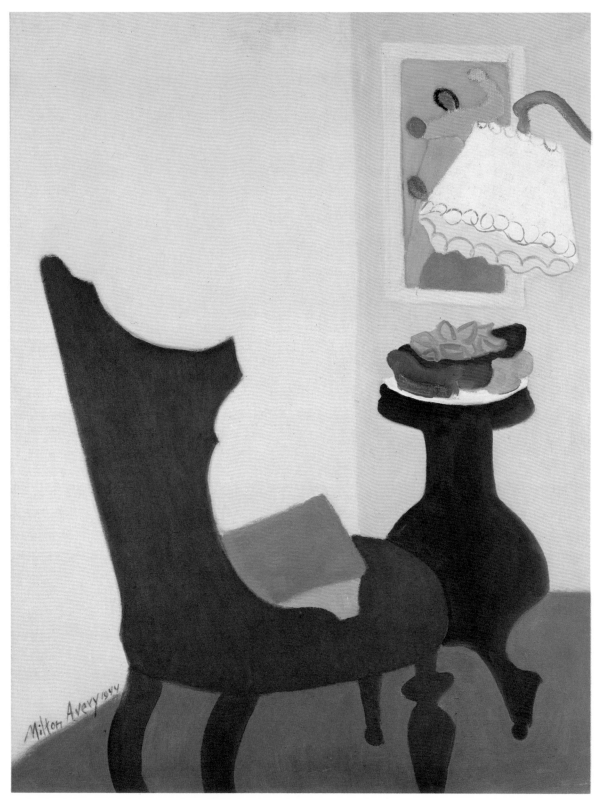

35.
Green Chair, 1944
Oil on canvas, 36 x 28 inches (91.4 x 71.1 cm). Private collection

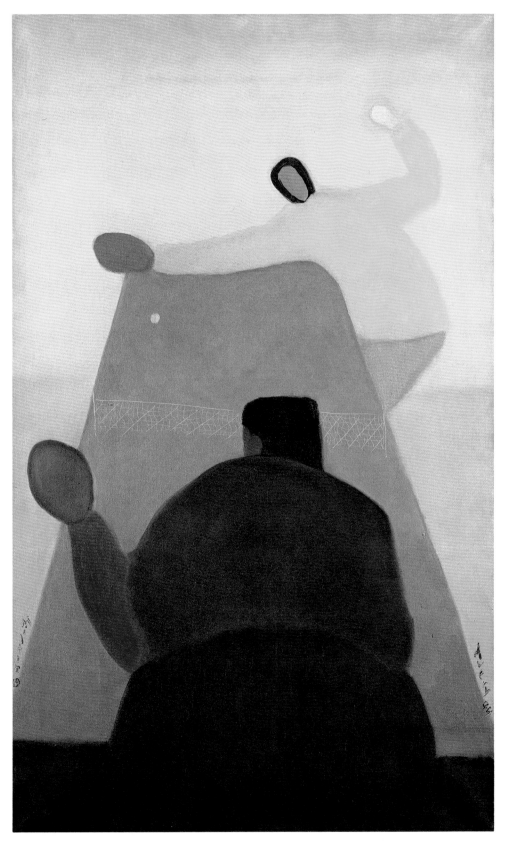

36.
Ping Pong, 1944
Oil on canvas, 46 x 28 inches (116.8 x 71.1 cm). Private collection

that shows most indebtedness to Avery, in the late twenties and thirties both his and Gottlieb's paintings strongly resembled Avery's in the deployment of figures and in the thinly layered, transparent surfaces and muted palette—as evident in Rothko's untitled watercolor (37) and Gottlieb's *The Swimming Hole* (38).

Avery's strength of purpose—his independence and his will to pursue a vision counter to prevailing artistic styles—inspired these younger artists. At a time when the narrative and political aspects of art dominated the American art community, he provided a courageous alternative. In speaking later of Avery's importance to him during this period, Gottlieb acknowledged: "I have always thought he was a great artist. When Social Realism and the American Scene were considered the important thing, he took an aesthetic stand as opposed to regional subject matter. His attitude helped reinforce me in my chosen direction. I always regarded him as a brilliant colorist and draftsman, a solitary figure working against the stream."[44]

Discussions about art in the Avery household revolved around the notion that a painting should be flat and lie on one plane rather than evoke what Avery called photographic depth.[45] He championed simplified, precisely delineated forms and flattened color masses when few were willing to listen. Perhaps Avery's greatest legacy was his ability to abstract the mood of a place or situation with color. Although other Americans had concentrated on color in their paintings, Avery's use of soft, lyrical color to evoke subtle emotion was unique in American art. His simplification of form and luminous color harmonies provided a model for future generations of American colorists. As Alfred Jensen explained when listing Avery as one of the five most important twentieth-century American artists, "Avery brought color to America."[46]

In October 1932 Sally Avery gave birth to a daughter, March, named after Milton's mother's family. The family became even more central to Avery. They moved to Greenwich Village when March was old enough for school so that she could attend the Little Red School House, a grammar school popular among artists and liberal intellectuals in New York. March became a regular portrait subject for Avery throughout her childhood—the depictions of her that were included at the Durand-Ruel Galleries in the 1947 exhibition "My Daughter, March" presented such a broad spectrum of Avery's painting styles that they constituted almost a mini-retrospective.

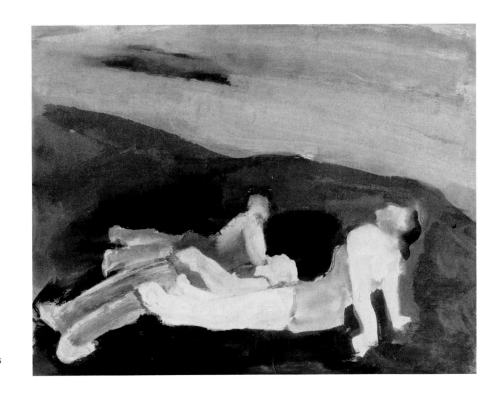

37.
Mark Rothko
Untitled, late 1920s
Watercolor on paper, 12⅜ x 15 inches
(31.4 x 38.1 cm). Estate of the artist

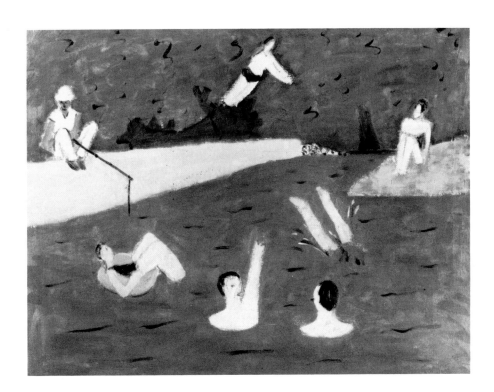

38.
Adolph Gottlieb
The Swimming Hole, 1937
Oil on canvas, 25½ x 34¾ inches
(64.8 x 88.3 cm). Adolph and Esther
Gottlieb Foundation, Inc., New York

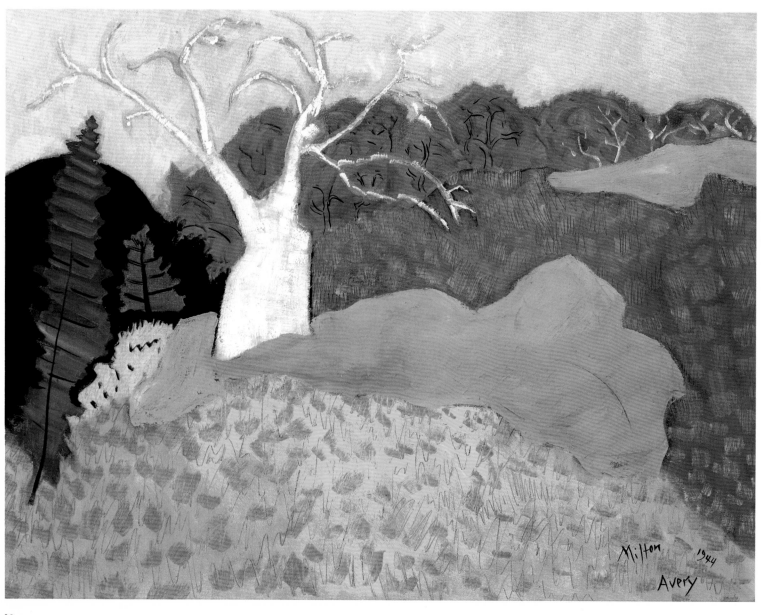

39.
Autumn, 1944
Oil on canvas, 27 x 35 inches (68.6 x 88.9 cm). Collection of Beverly and Raymond Sackler

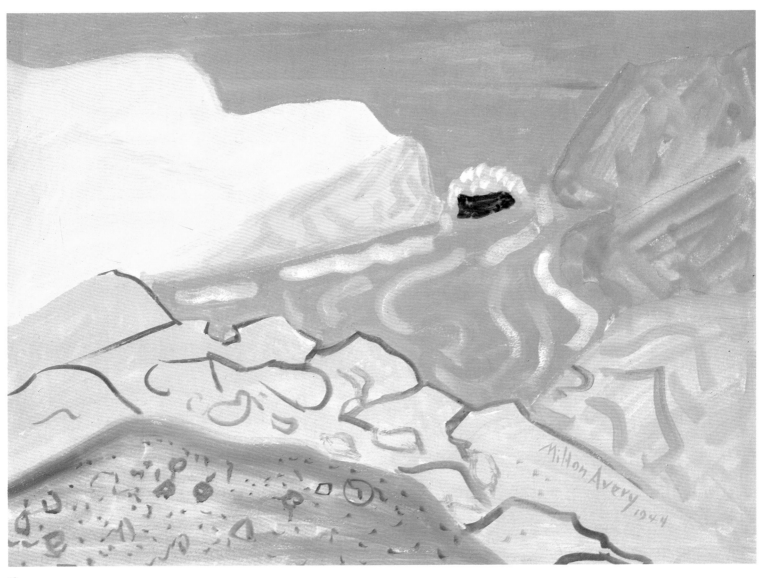

40.
Lavender Sea, 1944
Gouache on paper, 22 x 30 inches (55.9 x 76.2 cm). Collection of Stephen Burakoff

March's physical transformation as she matured made her ideal subject matter for Avery because of his need for constantly changing visual stimuli. Not wanting to repeat the same composition, he continually sought out fresh material from which to generate new compositional ideas. Ironically, the Depression served his needs perfectly. The inability of many families to pay rent or meet mortgage payments during these years left the New York rental market with a devastating glut of vacancies. Desperate for tenants, apartment owners offered elaborate inducements to potential renters. This situation enabled the Averys to leave New York every summer, confident of finding a different apartment when they returned. The summer places they selected were dictated by the availability of inexpensive living accommodations: with the exception of one interlude on the Gaspé Peninsula, they summered from 1930 to 1940 in Gloucester, Massachusetts, and southern Vermont, where they were frequently joined by Rothko, Gottlieb, and Barnett Newman.[47]

Avery's access to these fresh visual environments was significant, for at the core of his approach to painting was a single firm rule: never invent imagery. He would simplify, flatten, distort, or chromatically abstract a landscape, portrait, or interior, but he never introduced elements into the composition which did not exist in the physical world. He would not invent what was not there. This fidelity to his own visual experience almost proved disastrous the first summer in Vermont. It rained continuously for the first three weeks; when it stopped, everything was the same brilliant green. Avery hated it and wanted to leave because he felt it impossible to paint a landscape that had so little color variation. Fortunately, a few sunny days and shoots of new vegetation sufficed to change his mind and Vermont eventually became an important source of fresh imagery. Perhaps the necessity of confronting each day a landscape dominated by one color furthered Avery's sense of the subtlety and power of a single hue. The gentle undulations of the mountains and the variegations in the foliage found their way into paintings such as *Pink Field* (41). Avery had not painted landscape motifs since his Hartford days and these paintings reflected the aesthetic distance he had traveled in the intervening decade. The enamel-like impasto and indistinct, light-drenched forms of his Hartford paintings had given way to matte surfaces and more structured compositions. But in contrast to the precisely delineated, flattened color masses in his New York genre pictures, the shapes in these Vermont landscapes were not crisply differentiated from one another. The pronounced modulation of color values within shapes and the individualization of brushstrokes served a more naturalistic portrayal of space. In place of the abstract relationships developed in his New York paintings

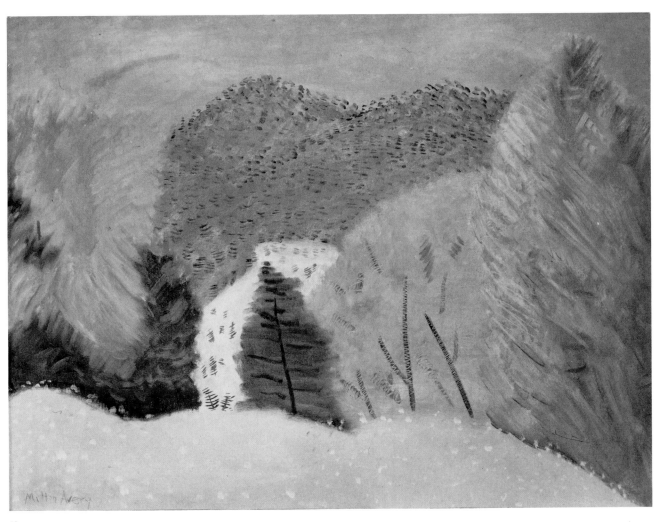

41.
Pink Field, 1935
Oil on canvas, 28 x 36 inches (71.1 x 91.4 cm). Collection of Lady Kleinwort

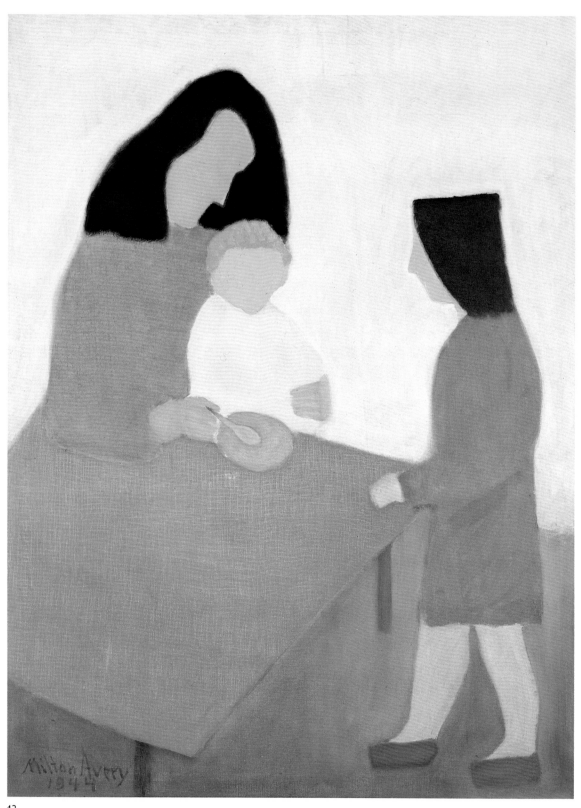

42.
Feeding, 1944
Oil on canvas, 48 x 36 inches (121.9 x 91.4 cm). Collection of Mr. and Mrs. Carl Reiner

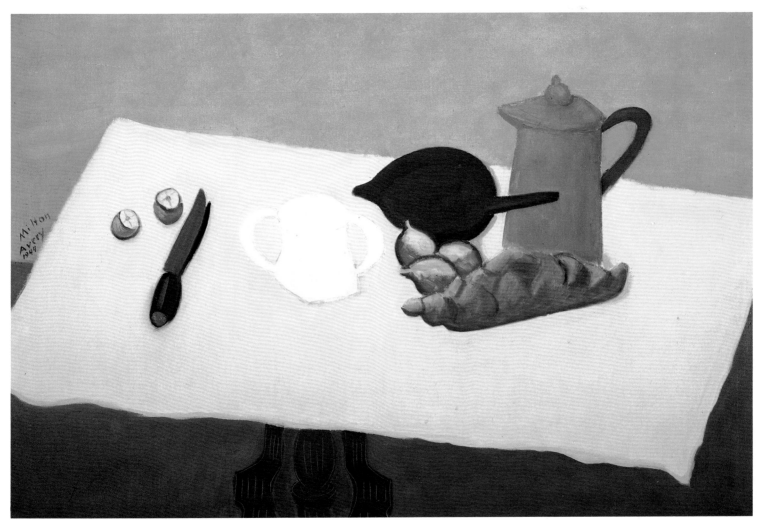

43.
Pink Tablecloth, 1944
Oil on canvas, 32⅛ x 48⅛ inches (81.6 x 124.1 cm). Munson-Williams-Proctor Institute, Utica,
New York; Gift of Mr. and Mrs. Roy R. Neuberger

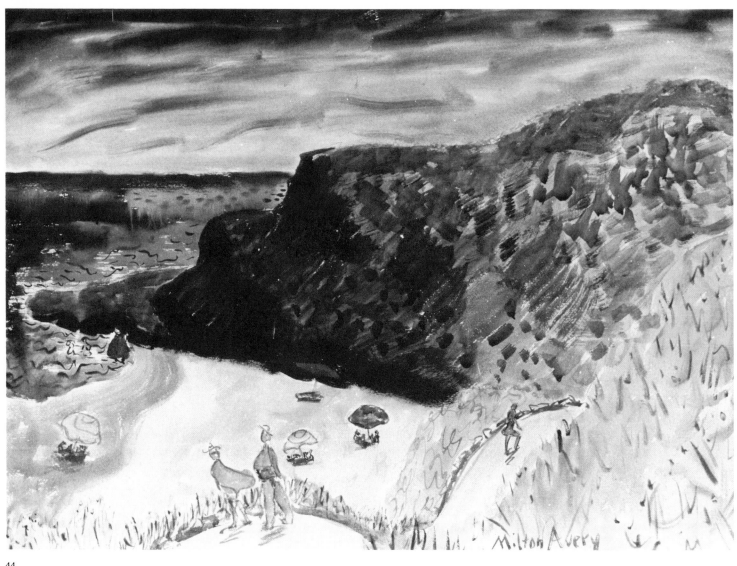

44.
Secluded Beach, 1941
Watercolor on paper, 22 x 30 inches (55.9 x 76.2 cm). Collection of Dr. A. Rubinoff and Ms. Suzanne Giroux

through interlocked, flattened forms, Avery adopted a loose, brushy paint handling which resembled the wash effects of his watercolors. His willingness to reveal more of his process perhaps indicated increasing confidence in his brushwork.

45.
Sparkling Blue Inlet, 1938
Watercolor on paper, 22 x 30 inches (55.9 x 76.2 cm). Collection of Mr. and Mrs. David J. Griff

Despite the aesthetic growth Avery had achieved in his work since 1925, and the genuine though limited critical success of his exhibitions, his first decade in New York went largely unnoticed by the public. He had been included in a number of commercial group exhibitions, but at fifty he had received little real external support. Instead, in an art community sympathetic to Regionalism and American Scene painting, he saw other artists his own

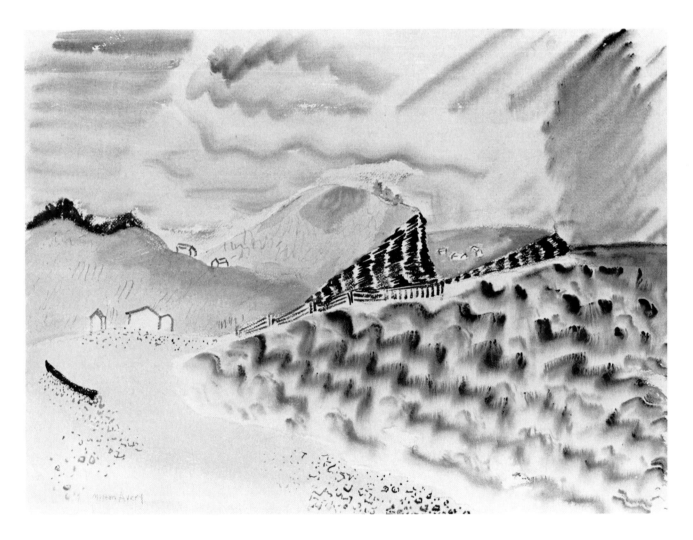

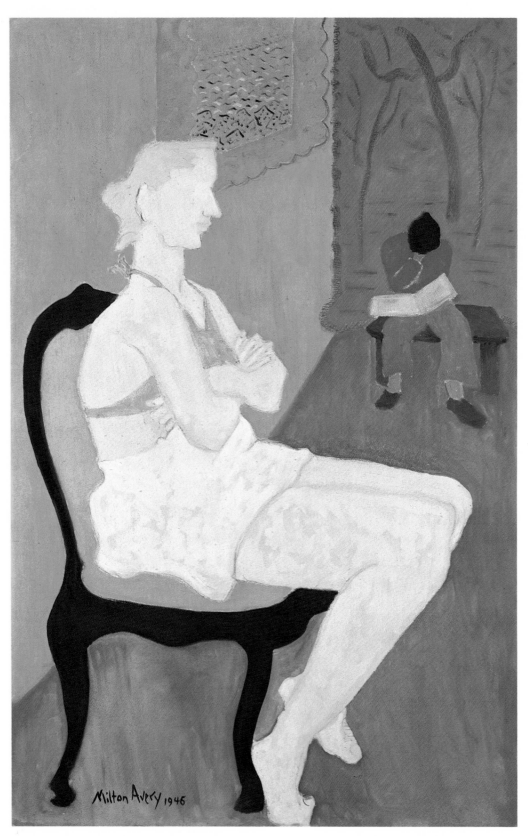

46.
Seated Blonde, 1946
Oil on canvas, 52 x 34 inches (132 x 86.4 cm). Walker Art Center, Minneapolis; Gift of Mr. and Mrs.
Roy R. Neuberger

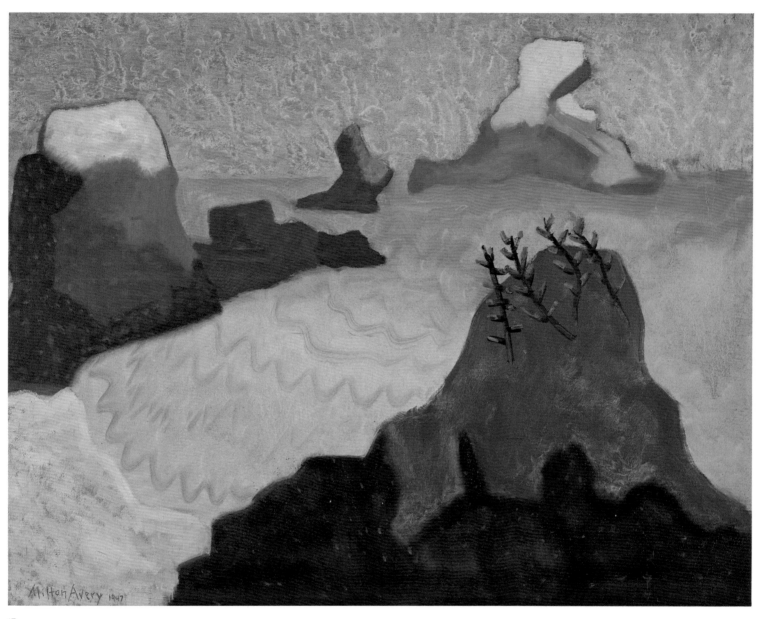

47.
Oregon Coast, 1947
Oil on canvas, 36 x 46 inches (91.4 x 116.8 cm). Collection of Michael Rea

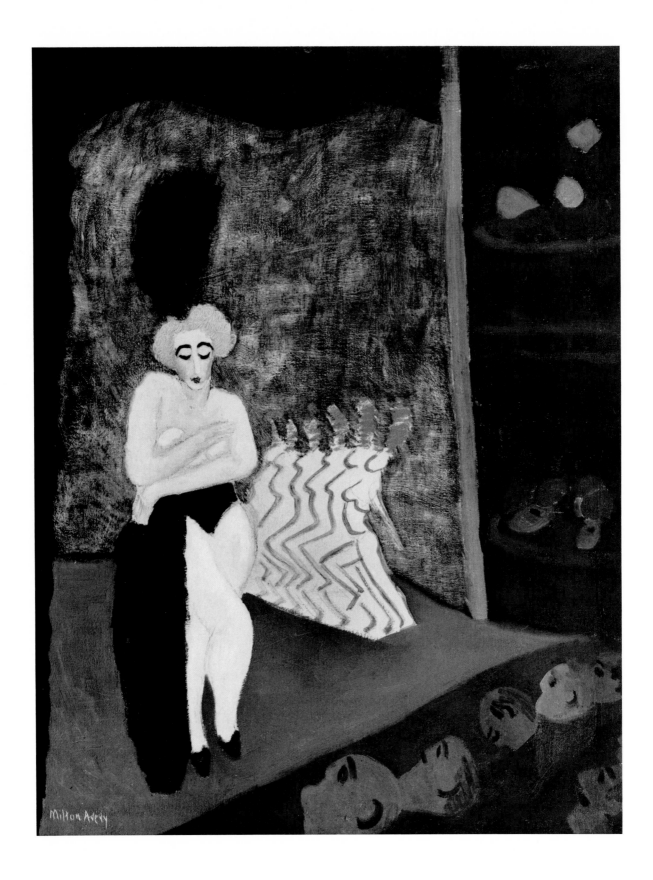

age or younger enjoying immense critical and institutional success. The income generated by Sally's magazine illustrations provided enough money to survive, but only marginally. Often during the twenties and thirties, the family ate peanut butter and Spam for dinner because they could not afford anything else. Forced to be frugal about painting supplies, Avery would often paint over friends' discarded canvases. Since primed canvas was too expensive, the Averys primed unsized cotton duck with rabbit-skin glue and white lead, a procedure which left their house smelling for days.

The financial incentive to capitulate to accepted styles notwithstanding, Avery persevered in his vision of a simplified painting based on color harmonies. Eventually his unique place within the mainstream of American art attracted the attention of Valentine Dudensing, who asked him to join his gallery in 1935. The Valentine Gallery was one of the major galleries on Fifty-seventh Street and included in its exhibition schedule work by such European artists as Matisse, André Derain, Joan Miró, Picasso, Georges Braque, Wassily Kandinsky, Chaim Soutine, and the Americans Stuart Davis, Bernard Karfiol, Reginald Marsh, and Alexander Brook. Avery's first one-man show there, that March, had a major effect on his career. For the first time he had a dealer committed to supporting his work throughout the year. Suddenly, financial prospects seemed brighter.[48] The resulting confidence allowed him to push further in the development of his painting style, and over the next seven years his work displayed an increased devotion to abstraction and a mature mastery of color nuance. He dropped the academic subject matter and occasional modeling that had marked his work in the previous decade, while the layering of closely valued colors that had appeared sporadically before 1935 became a primary focus in compositions such as *Burlesque* (48). In these works Avery created visual fields of textured color by applying thin layers of deep, rich tones within individual color areas. To preserve the effect of thin paint, he often scraped pigment from the canvas, a process which revealed lower coats of pigment or, on occasion, the primed canvas itself. The resonant harmonies he achieved were unparalleled in his earlier work. Writing about the 1935 exhibition at the Valentine Gallery, McBride identified color as Avery's salient characteristic: "He really is a colorist of exceptional ability. When an artist gives you a landscape with a moving and dramatic, but wine-colored sky and then makes you believe literally in the wine-colored sky, it simply means that the artist can do things with color that not every artist can do."[49]

Avery extended his color harmonies even further in the work he produced in 1938, when the family summered on the Gaspé Peninsula, in southeastern Canada. The landscape of the isolated Gaspé region is bathed

48.
Burlesque, 1936
Oil on canvas, 36 x 28 inches
(91.4 x 71.1 cm). Grace Borgenicht
Gallery, New York

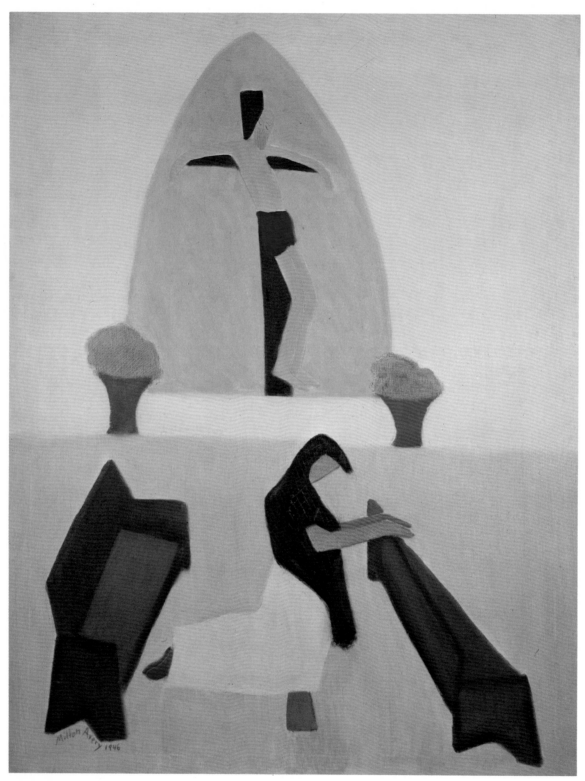

49.
Crucifixion, 1946
Oil on canvas, 44 x 34 inches (111.7 x 86.4 cm). Collection of Sally M. Avery

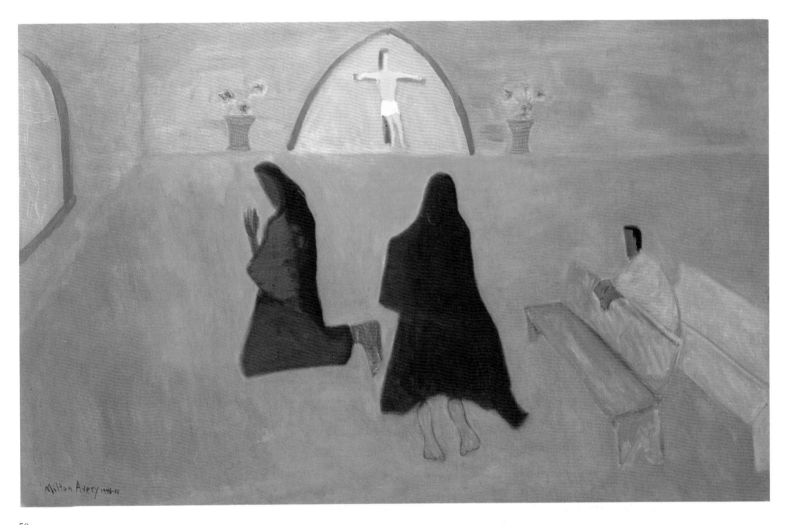

50.
Prayers, 1946–55
Oil on canvas, 36 x 54 inches (91.4 x 137.2 cm). Grace Borgenicht Gallery, New York

in an almost white light, quite different from the sky's usual yellowish cast in the urban regions of the northeastern United States. Avery set out to capture this light and its vibrant color harmonies in the watercolors he executed that summer (23, 45). The result was a unique luminosity of color, distinct from any American art being produced at that time. That these watercolors were executed on more expensive white paper rather than on the usual colored construction paper added to their crisp radiance. Avery spent the next two years translating these watercolors into oil.

By 1940 a discernible shift had taken place in Avery's attitude toward color. The dark palette of his previous work brightened and became more highly saturated. And he consistently introduced colors into his compositions which, while related to reality, were not necessarily naturalistic. The red sky and blue and red fields of *Gaspé—Pink Sky* (21) reflect a mood more than a naturalistic representation of color. Although this use of non-associative color brought Avery closer to abstraction, compositionally he retained the more realistic pictorial structure of his Vermont landscapes—detailed, graphically articulated forms instead of the flat planes of color developed in the early thirties. Rather than simplify his shapes, Avery embellished them with drawing, often using single strokes of paint to represent objects in the landscapes. Not until 1944 would he combine non-associative color with his earlier technique of flattening compositional elements into abstract tonal planes. When he did, he established himself as one of the leading colorists in America.

Matisse remained a major impetus behind this striking adoption of saturated, arbitrary color. Although Avery's awareness of Matisse's work had preceded his affiliation in 1935 with the Valentine Gallery, his new alliance with Matisse's American dealer revitalized his interest in an artist whose sensibilities were much like his own. Matisse had written earlier that "Fauvism came into being because we suddenly wanted to abandon the imitation of the local colors of nature and sought by experimenting with pure color to obtain increasingly powerful—obviously instantaneous—effects, and also to achieve greater luminosity."[50] A similar desire impelled Avery, whose own commitment to color and to form reduction had been firmly established early in his career. But until his contact with Matisse's work, he had not totally embraced the Fauve attitude toward non-associative color, except in isolated paintings (32). Essentially, Matisse's example gave Avery license to extend the concerns he was already pursuing. His color after 1940 became much bolder as he created the mood of a situation by discarding the constraints of naturalistic hues and favoring a saturated, non-naturalistic palette.

The importance both artists gave to color and the simplification of

form inevitably called for critical comparison.[51] Avery discounted any influence, saying that Matisse's work was too hedonistic for his taste.[52] His annoyance at being constantly likened to Matisse and denial of any influence arose from his feeling that the comparison pigeonholed him and prevented people from seeing the unique qualities of his own paintings. Occasionally in compositions from the forties, such as *The Letter* (54), Avery introduced arabesques and linear patterns reminiscent of Matisse, but by the end of the decade he had virtually eliminated this drawing aspect. Subsequent Avery paintings were far more restrained than the detailed, richly ornamented Matisses then being shown in America (51). Nevertheless, while aesthetically different, the two artists remained similar in mood. Matisse's dream of an art "of balance, of purity and serenity devoid of troubling or depressing subject

51.
Henri Matisse
Interior with a Violin Case, 1918–19
Oil on canvas, 28¾ x 23⅝ inches
(73 x 60 cm). The Museum of Modern
Art, New York; Lillie P. Bliss Collection

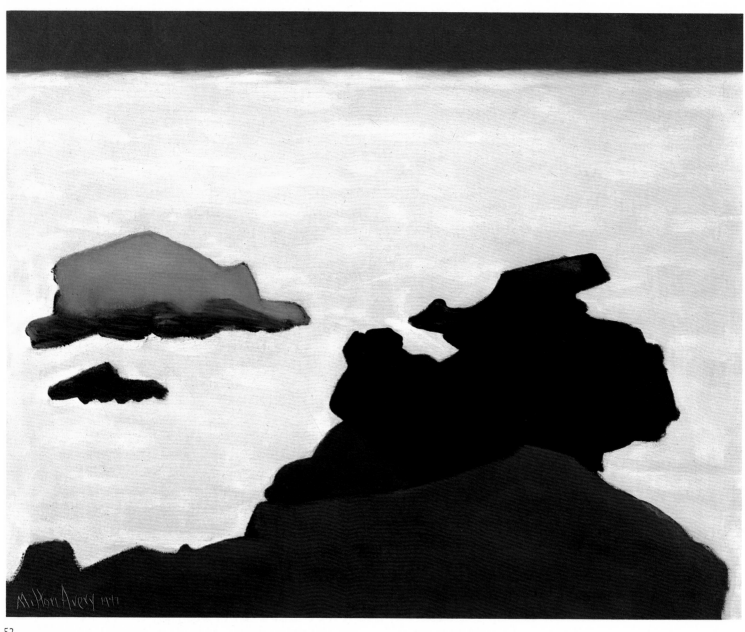

52.
White Sea, 1947
Oil on canvas, 31¼ x 39¼ inches (79.4 x 99.7 cm). Private collection

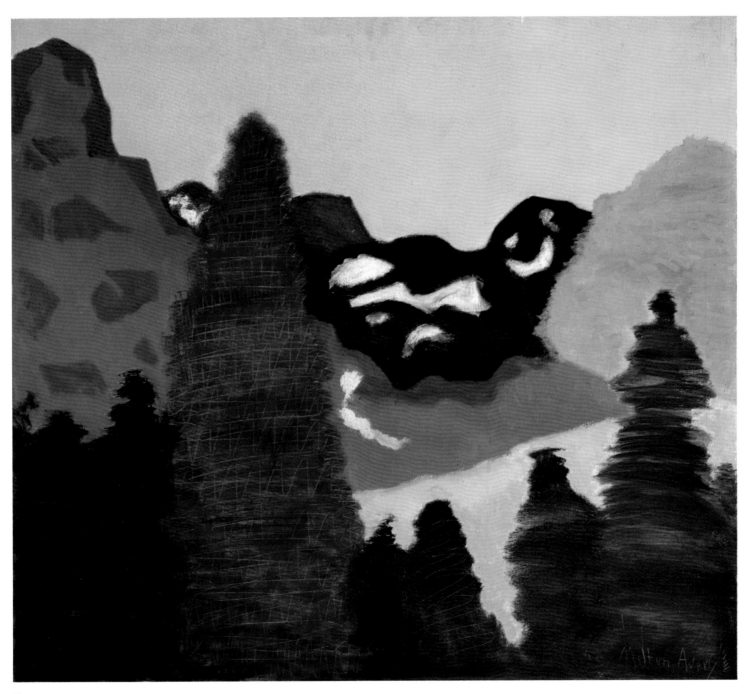

53.
Autumn in the Rockies, 1948
Oil on canvas, 34 x 38 inches (86.4 x 96.5 cm). Private collection

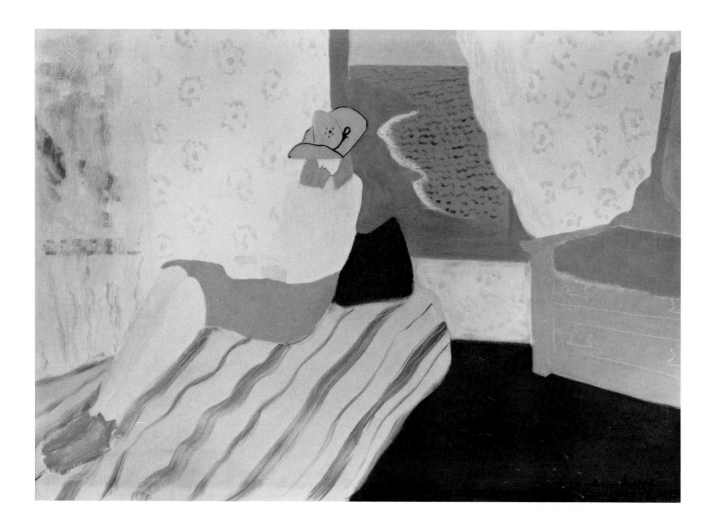

matter, an art which might be . . . like an appeasing influence, like a mental soother, something like a good armchair in which to rest from physical fatigue," could be seen in Avery's own subtle and warmly harmonious paintings.[53] What this reveals is not so much a matter of influence, however, as a shared artistic temperament.

Avery exhibited his work with Valentine Dudensing until 1943, when Paul Rosenberg asked him to join his gallery. Before the war, Rosenberg had operated an important modern art gallery in Paris devoted to nineteenth- and twentieth-century French painting. In his capacity as president of the Art Dealers Association in France he had been instrumental in organizing the attempted boycott of the Nazi sale of "degenerate" art, an effort which placed him in danger with the coming of the Nazi occupation. In June 1940, just days before the Germans entered Paris, Rosenberg fled to

54.
The Letter, 1945
Oil on canvas, 34 x 48 inches
(86.4 x 121.9 cm). Collection of
Mrs. Arthur Belfer

New York, bringing with him an inventory of paintings by such artists as Léger and Braque, as well as over 150 Picassos. Interested in running more than a European gallery, Rosenberg determined to turn his attention to American painters. He began by inviting Max Weber to join the gallery; by 1943 he had added Abraham Rattner and Marsden Hartley to his roster of artists. That Hartley was a member of the gallery was significant; by the early forties the older artist was a fervent champion of Avery's work and had in fact been influenced by it in his own figure compositions of that period. *Fishermen's Last Supper* (58), for example, reveals the dark outlining and blocky handling of forms found in such Avery paintings as *Cleaning Fish, Gaspé* (59).

Rosenberg initially encountered Avery's work through black-and-white reproductions in Parke-Bernet auction catalogues.[54] Thus it was the structure of Avery's work rather than its color which first attracted the dealer, a fact that would be significant when Avery began stripping his forms of everything that seemed to inhibit his color expression. Rosenberg's gallery director, Alex Katzman, persuaded him to make the trek to Avery's studio. After seeing the work, Rosenberg asked Dudensing if they could jointly exhibit it. When Dudensing objected, Rosenberg asked Avery to join his gallery. The incentives for leaving the Valentine Gallery and going to Rosenberg were substantial. Dudensing's artists, although prominent, included many of the academics of the time, while Rosenberg was associated with the most renowned members of European avant-garde. More important, Rosenberg, who did not believe in commissions, proposed buying twenty-five paintings twice a year, a guarantee that promised relief from the Averys' penurious existence.[55] The inducement was sufficient; Avery had his first show at Paul Rosenberg & Co. in June 1943. Rosenberg, having purchased twenty-five of Avery's paintings, apparently asked the Durand-Ruel Galleries to join him in handling Avery. It did, and Avery's works were exhibited from 1944 to 1949 at both galleries. That Durand-Ruel, another of New York's French-oriented galleries, was also attracted to Avery's work is an indication of how striking among Americans Avery's assimilation of the lessons of French modernism was.

Avery's prestige reached a new plateau. That year—1944—his first one-man museum exhibition opened at the Phillips Memorial Gallery in Washington, D. C., and in January 1945 two concurrent exhibitions of his work were held on Fifty-seventh Street—at the Rosenberg and Durand-Ruel galleries. Maude Riley summed up Avery's reputation: "After remaining unnoticed for a good many years Milton Avery has of late become a sort of institution. No one remains ignorant of his past; and while enthusiasm varies,

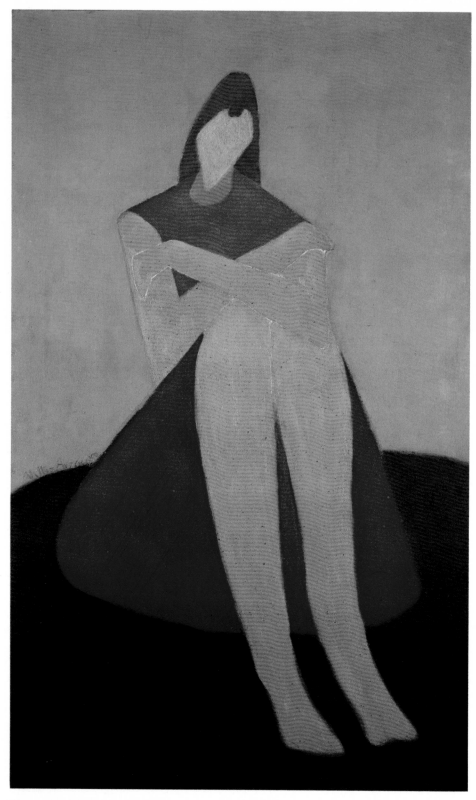

55.
March in Red, 1950
Oil on canvas, 42 x 26 inches (106.7 x 66 cm). Sheldon Ross Gallery, Birmingham, Michigan

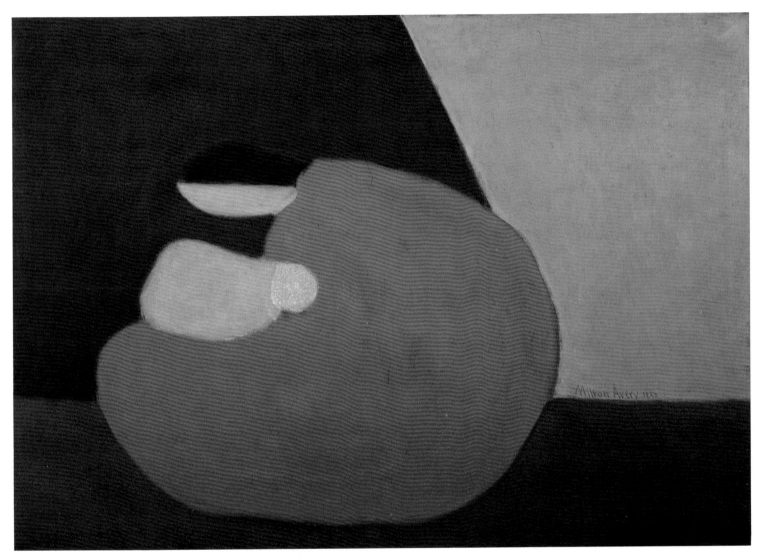

56.
Maternity, 1950
Oil on canvas, 32 x 46 inches (81.3 x 116.8 cm). Collection of Sally M. Avery

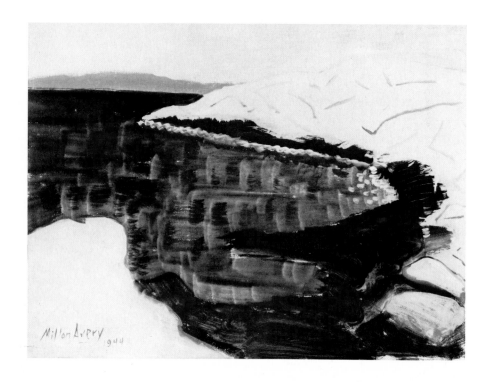

57.
Pink Rocks, Green Sea, 1944
Watercolor on paper, 22 x 30 inches
(55.9 x 76.2 cm). Collection of
Marianne Friedland

a general cordiality prevails in regard to this innocently sophisticated form of picture making."[56]

Despite increased critical recognition, Avery remained a painter's painter in this period, supported by artists and dealers but largely ignored by the established hierarchy of collectors and museums. Even his simultaneous exhibitions at the Rosenberg and Durand-Ruel galleries did not improve his ratings with these art-world luminaries, who felt that the shows simply over-exposed him. Among fellow artists, Avery's association with two major galleries created the impression of a substantial income: rumors had him making as much as 60,000 dollars a year.[57] In fact, sales were so infrequent that Rosenberg would occasionally throw in an Avery painting along with another sale in order to develop interest in his work.[58] At one point in the forties, Alfred H. Barr, Jr., director of the Museum of Modern Art, asked Rothko which American artists he considered the greatest; when Rothko named Avery, Barr laughed.[59] The Whitney Museum of American Art was no more receptive: it was not until 1944 that Avery was included in a Whitney painting Biennial and then only because Rosenberg otherwise threatened to withdraw his other gallery artists from the exhibition.[60]

Joining the Rosenberg gallery had a significant impact on Avery. Association with a gallery of such high standing, with its connection to important French art, gave him a degree of self-confidence he had not previously

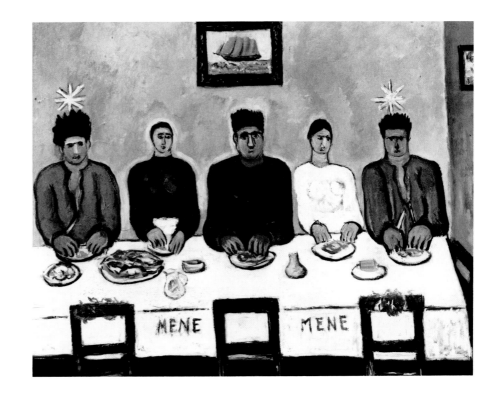

58.
Marsden Hartley
Fishermen's Last Supper, 1938
Oil on academy board, 22 x 28 inches
(55.9 x 71.1 cm). Collection of
Mrs. Hudson D. Walker

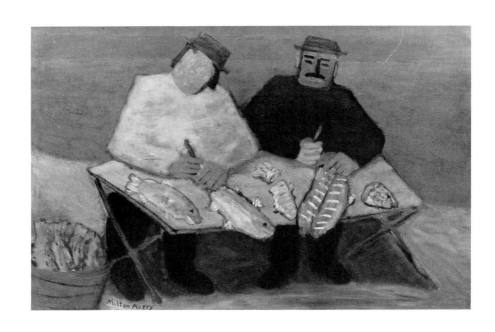

59.
Cleaning Fish, Gaspé, 1940
Oil on canvas, 33¾ x 54 inches
(85.7 x 137.2 cm). Whitney Museum
of American Art, New York; Gift of
Mr. and Mrs. Roy R. Neuberger 50.5

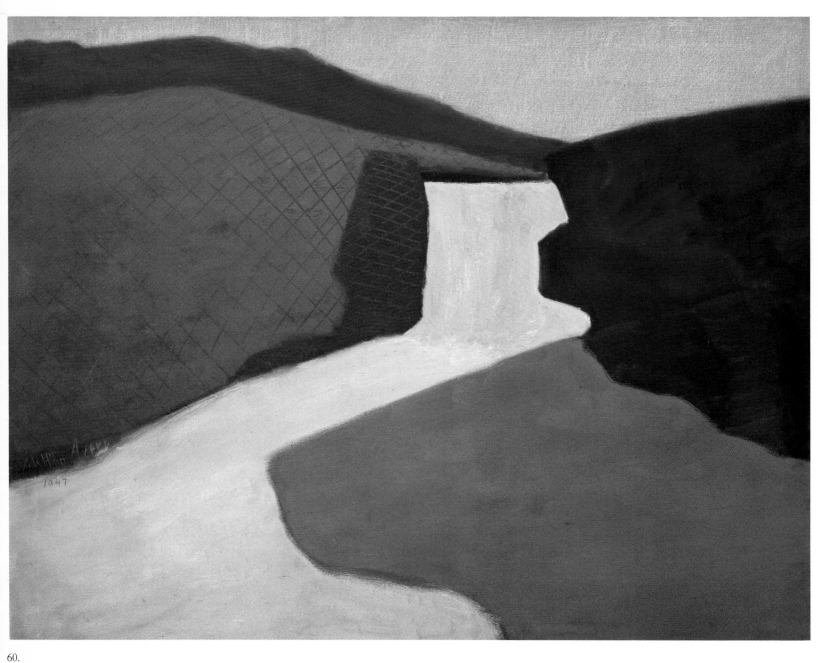

60.
Red Rock Falls, 1947
Oil on canvas, 33⅞ x 43⅞ inches (86 x 111.4 cm). Milwaukee Art Museum;
Gift of Mrs. Harry Lynde Bradley

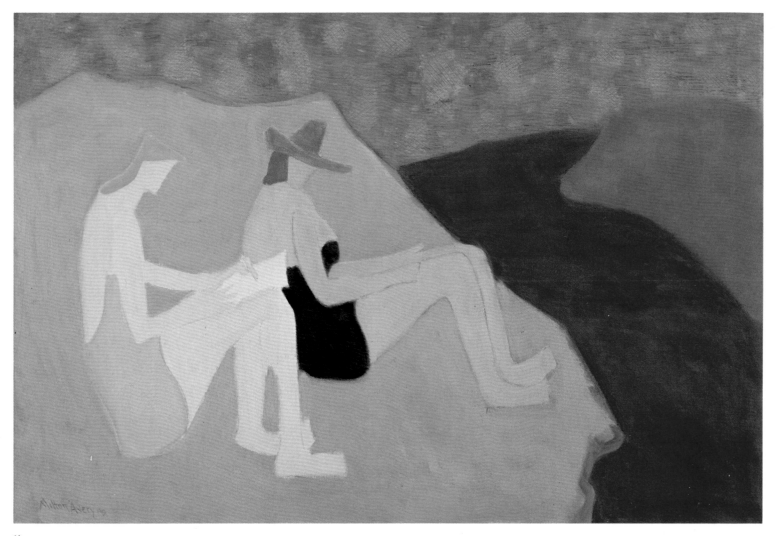

61.
Sketchers by the Stream, 1951
Oil on canvas, 32 x 48 inches (81.3 x 121.9 cm). Collection of Sidney and Madeline Forbes

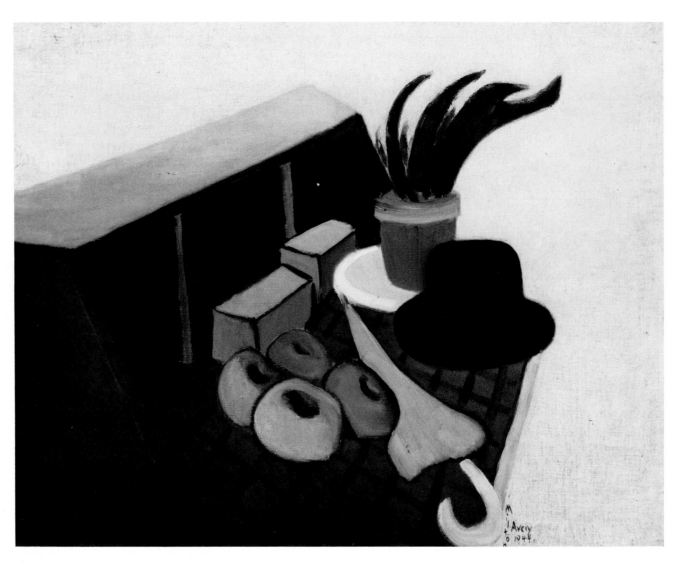

62.
Still Life with Derby, 1944 Oil on canvas, 28 x 36 inches (71.1 x 91.4 cm). Neuberger Museum,
State University of New York at Purchase; Gift of Roy R. Neuberger

felt. In addition, Rosenberg's monetary support freed Avery from the strain of financial uncertainty. And with this encouragement, the pace of Avery's work quickened. Always prolific, he produced in 1944 the largest number of works of any year in his career. But most important was the change that took place in his paintings after joining the gallery. In general, developments in Avery's art had been gradual rather than abrupt, and it sometimes took over a decade for an aspect of his style to reach maturity. Now, however, change was sudden. The graphic detailing and brushy paint application that had dominated his work of the previous six years vanished. In their place were denser, more evenly modulated areas of flattened color contained within crisply delineated forms. Unlike the naturalistic space of the Gaspé land-

63.
Bridge to the Sea, 1944
Oil on canvas, 32 x 48 inches
(81.3 x 121.9 cm). Collection of
Mrs. Sylvia G. Zell

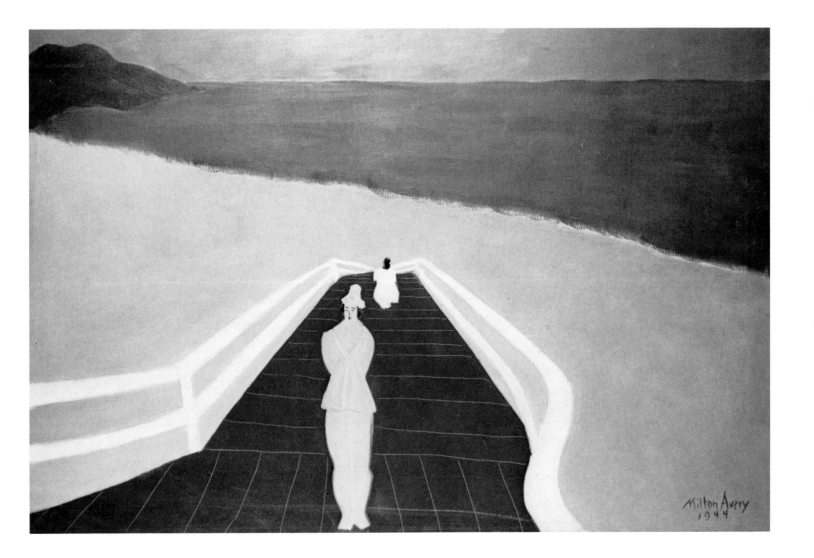

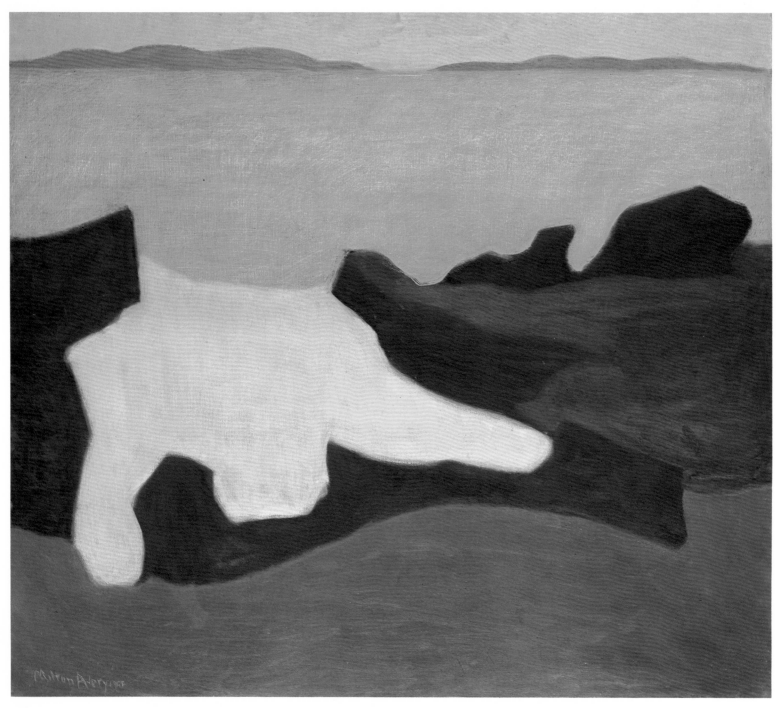

64.
Sunset, 1952
Oil on canvas, 42½ x 48⅛ inches (108 x 122.2 cm). The Brooklyn Museum, New York;
Gift of Roy R. and Marie S. Neuberger Foundation, Inc.

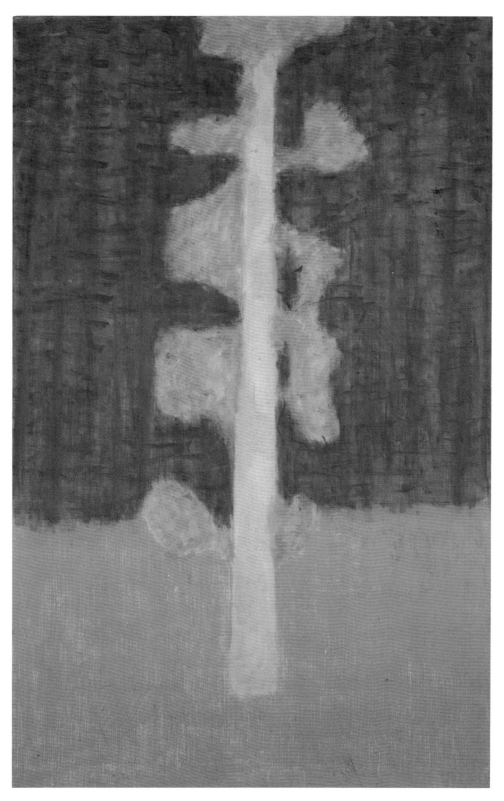

65.
Hint of Autumn, 1954
Oil on canvas, 53 x 34 inches (134.6 x 86.4 cm). Collection of Harold Price

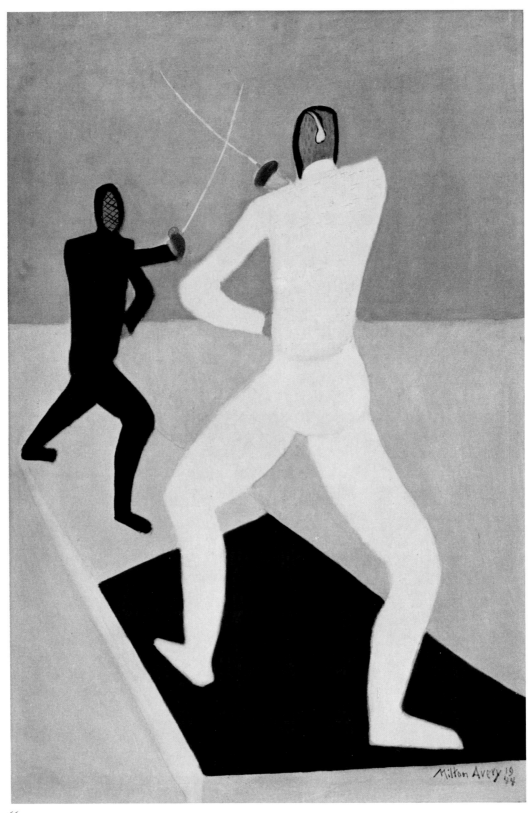

66.
Fencers, 1944
Oil on canvas, 48¼ x 32¼ inches (122.6 x 81.9 cm). The Santa Barbara Museum of Art, California;
Gift of Mrs. Burton G. Tremaine

scapes, the abstract relationships of interlocking shapes in *Fencers* (66) created a much shallower pictorial space, articulated by steep perspective and tilted planes. Avery retained color as the primary vehicle of feeling and expression, but in his increased abstraction he achieved a greater parity between recognizable forms and abstract shapes. In effect Avery combined the non-associative color from his earlier work with the flattening of shape and homogenization of color developed in the early thirties. The mature Avery style was born.

One impetus for the change in Avery's work may have been Paul Rosenberg himself. On Saturday afternoons, Rosenberg's gallery functioned like a salon for all of the gallery artists. If the Averys had not arrived by a certain hour, Rosenberg would often phone and ask them to stop by.[61] Rosenberg injected into these gatherings his own attitudes about painting. He favored taut structure and architectural solidity in paintings and encouraged his artists to embrace his attitudes. According to his son, he did this especially with Avery, for he found in Avery's inclination to work quickly a tendency to let superficial graphic notations signify objects.[62] Given Rosenberg's authoritative presence, his unassailable credentials, and his role as self-appointed arbiter of twentieth-century taste, he undoubtedly affected Avery's perception of himself as an artist. Still, Rosenberg did not directly influence Avery's new mode as much as encourage him to develop the architectonic aspect of his work at the expense of his other concerns. Rosenberg's preference for structural clarity was reflected in the clearly delineated planes of dense, homogeneous color that became typical of Avery's post-1943 paintings which seem to be constructed out of chunks of color. On a less aesthetic and more mundane level, Rosenberg persuaded Avery to date his paintings, citing as precedent Picasso's habit of inscribing all his paintings with a date.[63]

Avery's sudden arrival at his mature style was stimulated not only by Rosenberg, but also by the work of Picasso, which Avery looked at with renewed attention from the beginning of his affiliation with Rosenberg. As with Matisse earlier, it was not the French artist's imagery but his painting technique which impressed Avery. Picasso had been represented exclusively by Rosenberg in Paris. Among the 150-odd Picassos Rosenberg brought with him to New York were a number of canvases from the early thirties similar to *Seated Bather* (69). The smooth surfaces of thinly modulated color divided by precise, but not hard, edges which Picasso had developed in this period particularly fascinated Avery, who had ample opportunity to study Picasso's rich palette and his application techniques in the private showroom Rosenberg maintained on the second floor of his gallery. Avery's subsequent work resembled these Picassos both in the modulation of color and in the

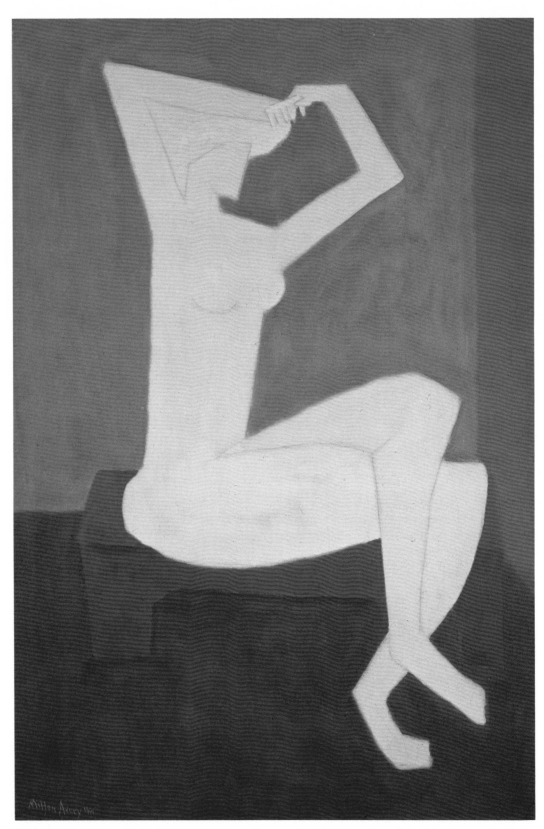

67.
Nude Combing Hair, 1954
Oil on canvas, 50 x 34 inches (127 x 86.4 cm). Collection of Joy Futter

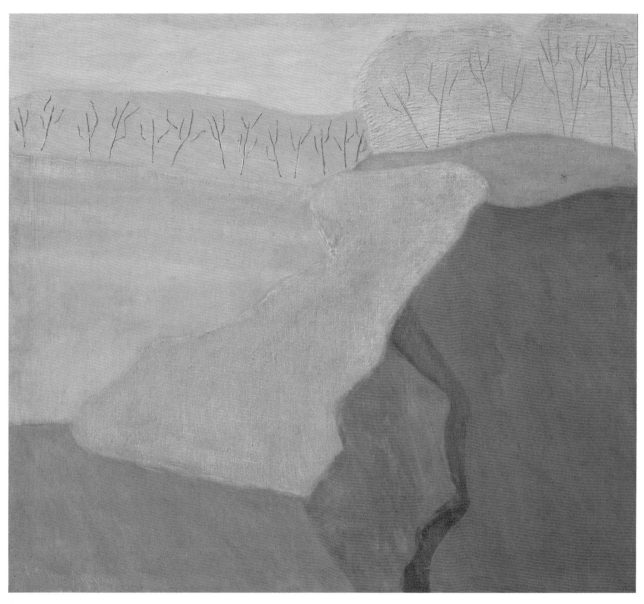

68.
Shapes of Spring, 1952
Oil on canvas, 34 x 38 inches (86.4 x 96.5 cm). Collection of Walter and Lore Kann

91

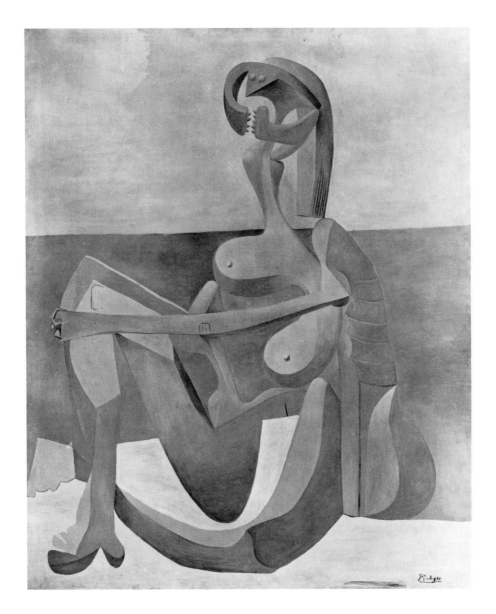

69.
Pablo Picasso
Seated Bather, 1930
Oil on canvas, 64¼ x 51 inches
(163.2 x 129.5 cm). The Museum of
Modern Art, New York; Mrs. Simon
Guggenheim Fund

simplification of figures into geometric yet biomorphic shapes. Paintings such as *Morning Call* (70) still refer to the thin, planar interlocking of Matisse's compositions, but the application of paint and the particular distortion of the figure reflect Avery's renewed engagement with the art of Picasso.

As the forties advanced, Avery's concentration on color and the simplification of shapes became increasingly intense. As before, color created the dominant impression and set the emotional tone, but now Avery's choice of colors and their combination became more striking and daring. Multiple layers of pigment were blended together into evenly toned areas

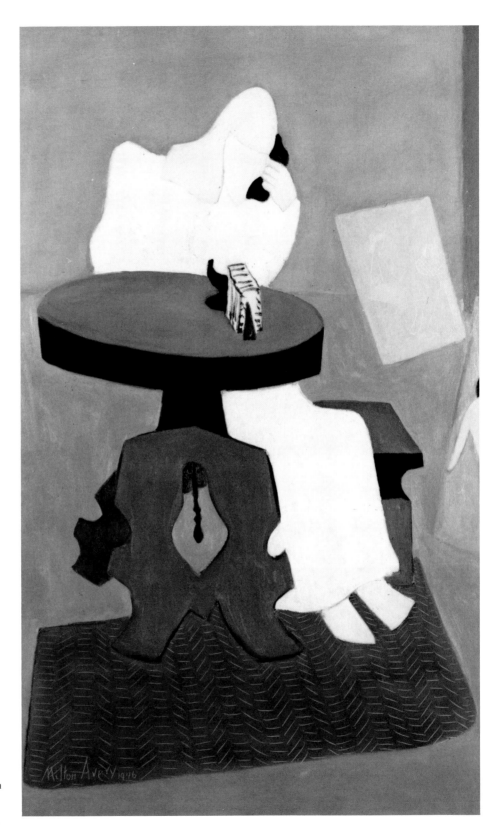

70.
Morning Call, 1946
Oil on canvas, 54⅛ x 34⅛ inches
(137.5 x 86.7 cm). Hirshhorn Museum
and Sculpture Garden, Smithsonian
Institution, Washington, D.C.

71.
Green Seascape, 1954
Oil on canvas, 34 x 52 inches (86.4 x 132.1 cm). Donald Morris Gallery, Birmingham, Michigan

94

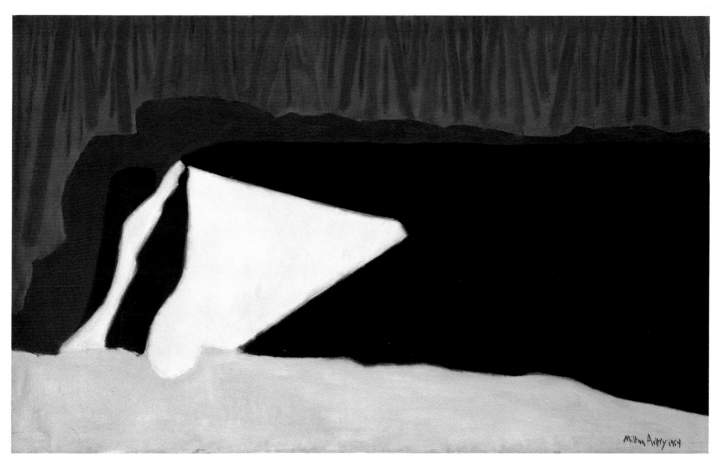

72.
Waterfall, 1954
Oil on canvas, 32 x 52 inches (81.3 x 132.1 cm). Neuberger Museum, State University of New York
at Purchase; Gift of Roy R. Neuberger

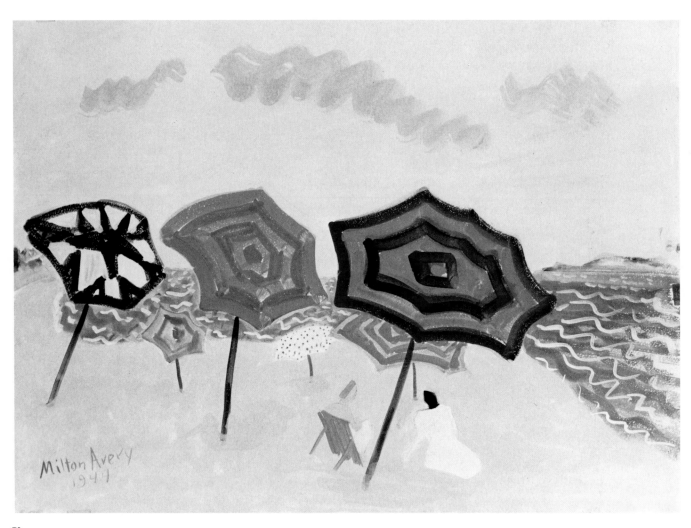

73.
Beach Umbrellas, 1944
Gouache on paper, 22 x 30 inches (55.9 x 76.2 cm). Private collection

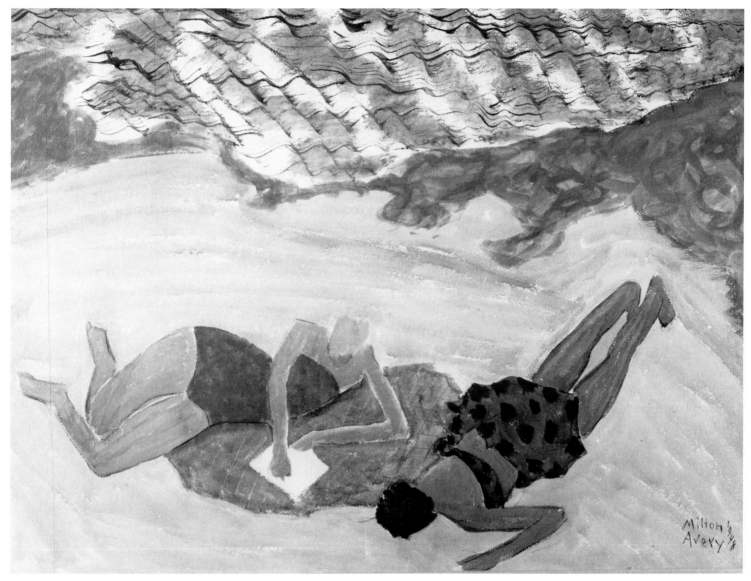

74.
Reader and Sunbather, 1948
Watercolor on paper, 22 x 30 inches (55.9 x 76.2 cm). Collection of Mr. and Mrs. Irwin Nat Pincus

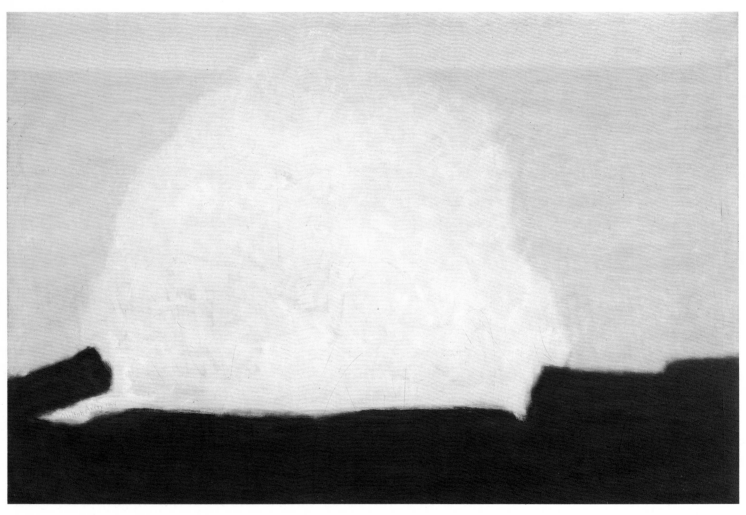

75.
White Wave, 1954
Oil on canvas, 40 x 60 inches (101.6 x 152.4 cm). Milton Avery Trust, New York

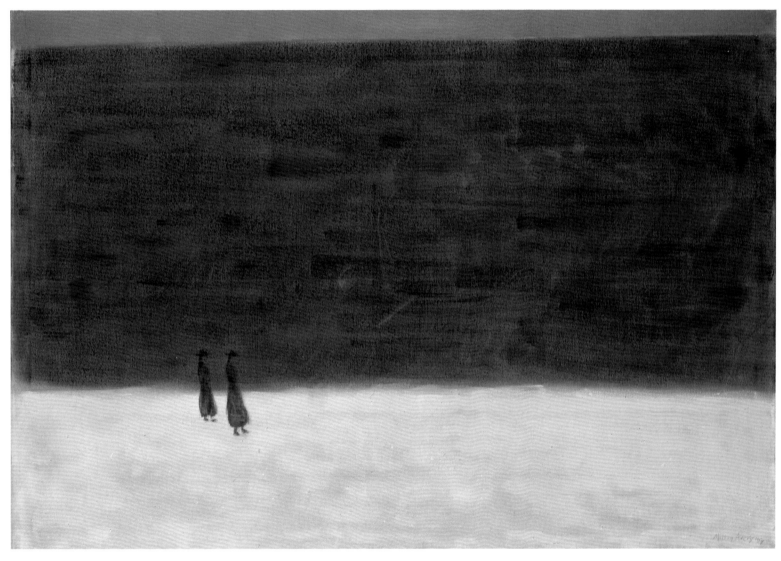

76.
Walkers by the Sea, 1954
Oil on canvas, 42 x 60 inches (106.7 x 152.4 cm). Private collection

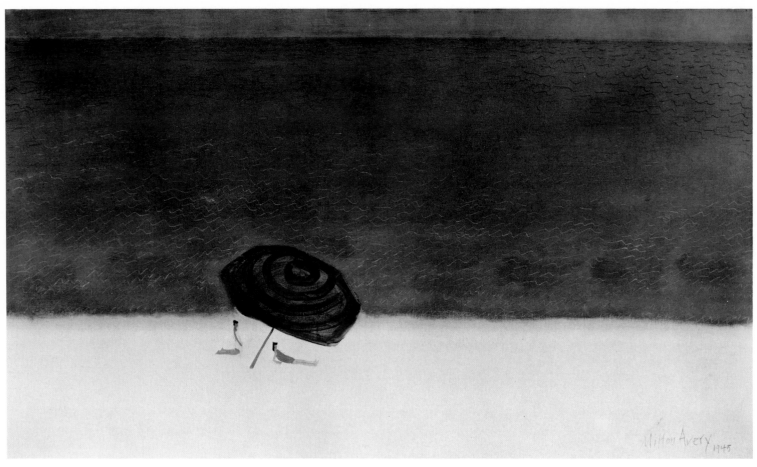

77.
Red Umbrella, 1945
Oil on canvas, 24 x 36 inches (61 x 91.4 cm). Collection of Annalee Newman

100

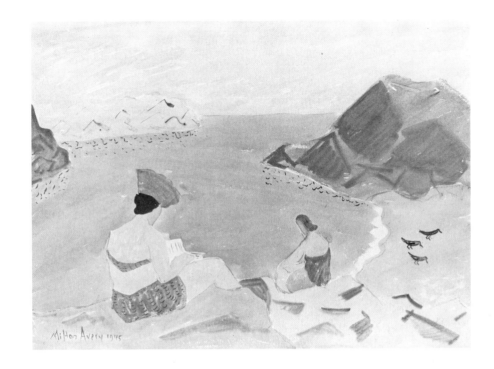

78.
Reader by the Sea, 1945
Watercolor on paper, 22 x 30 inches
(55.9 x 76.2 cm). Collection of Dr. Paul
Vanek

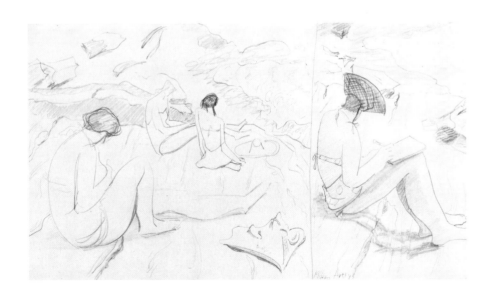

79.
Sketches by the Sea, 1949
Pencil on paper, 9 x 16 inches
(22.9 x 40.6 cm). Collection of
Paul M. Ingersoll

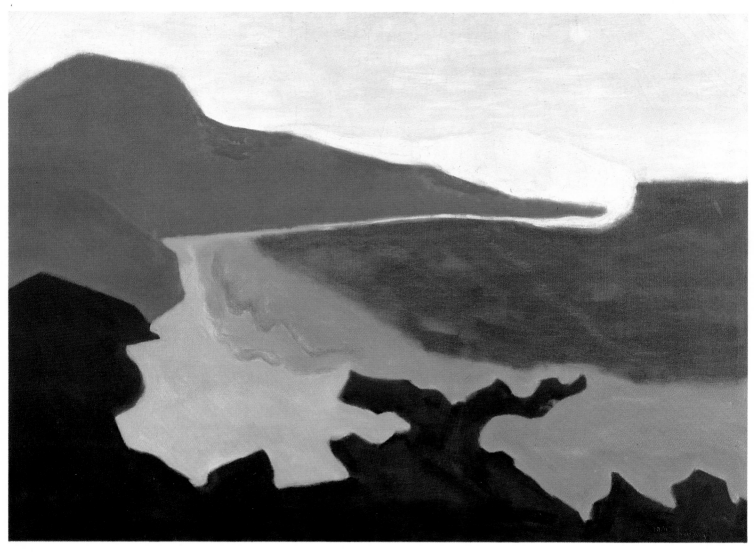

80.
Green Sea, 1954
Oil on canvas, 42 x 60 inches (106.7 x 152.4 cm). The Metropolitan Museum of Art, New York;
Arthur H. Hearn Fund

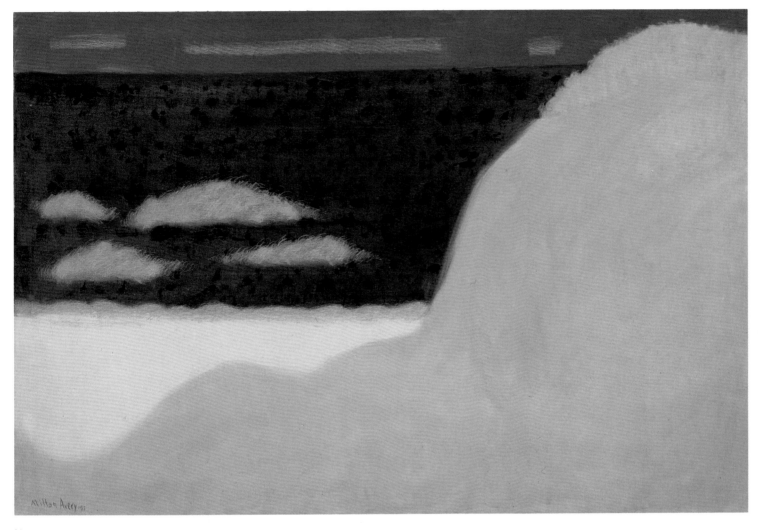

81.
Sea and Sand Dunes, 1955
Oil on canvas, 40 x 60 inches (101.6 x 152.4 cm). Collection of Thos. Marc Futter

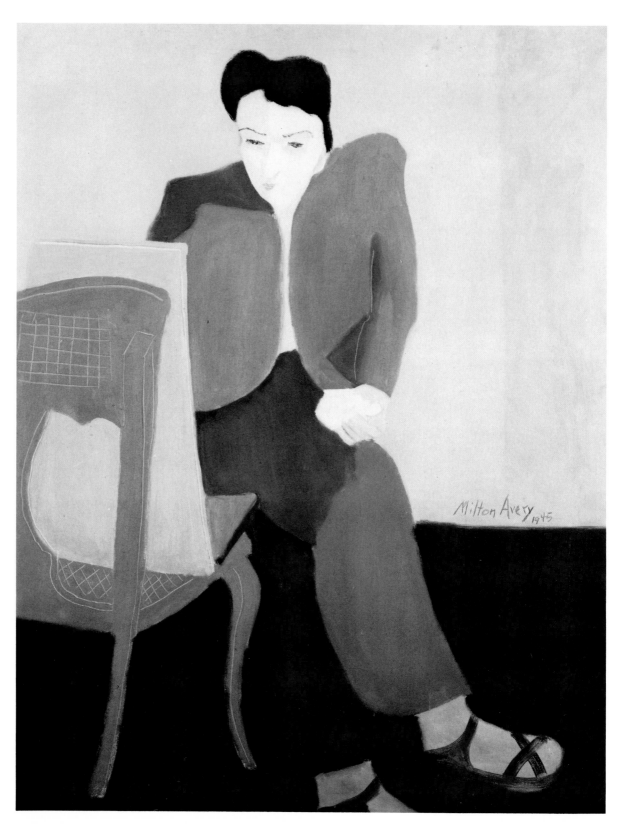

82.
Studious Sketcher, 1945
Oil on canvas, 36 x 28 inches (91.4 x 71.1 cm). The Cleveland Museum of Art;
Contemporary Collection

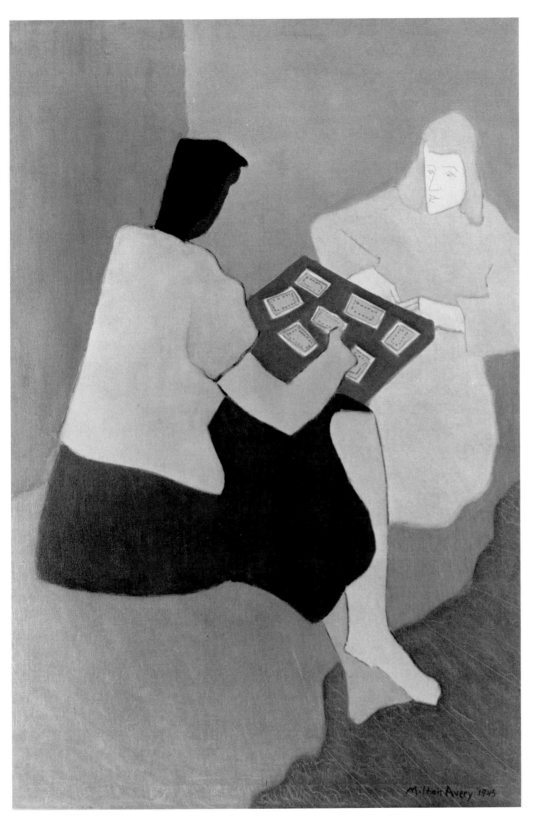

83.
The Card Players, 1945
Oil on canvas, 50 x 34 inches (127 x 86.4 cm). Milwaukee Art Museum;
Gift of Mrs. Harry Lynde Bradley

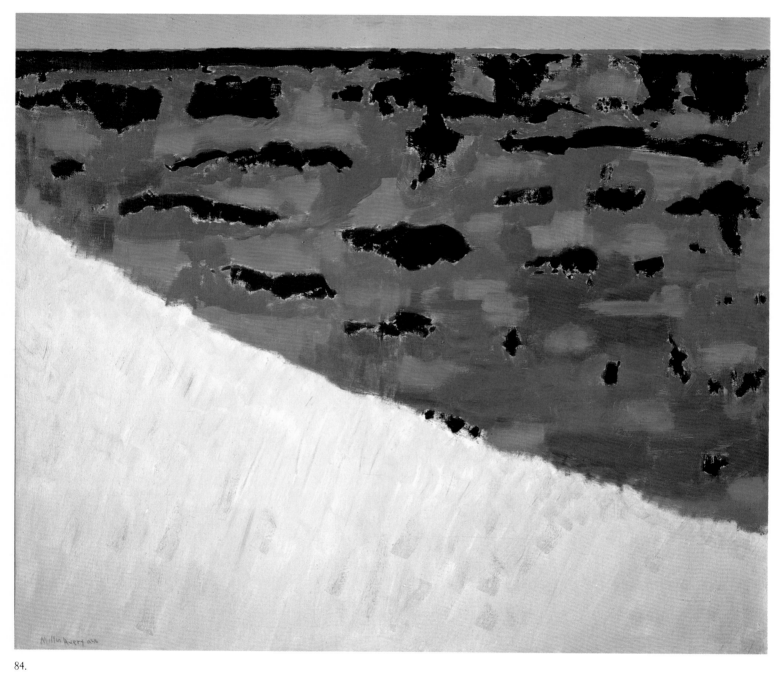

84.
Sea Grasses and Blue Sea, 1958
Oil on canvas, 60⅛ x 72⅜ inches (152.7 x 183.8 cm). The Museum of Modern Art, New York; Gift of friends of the artist

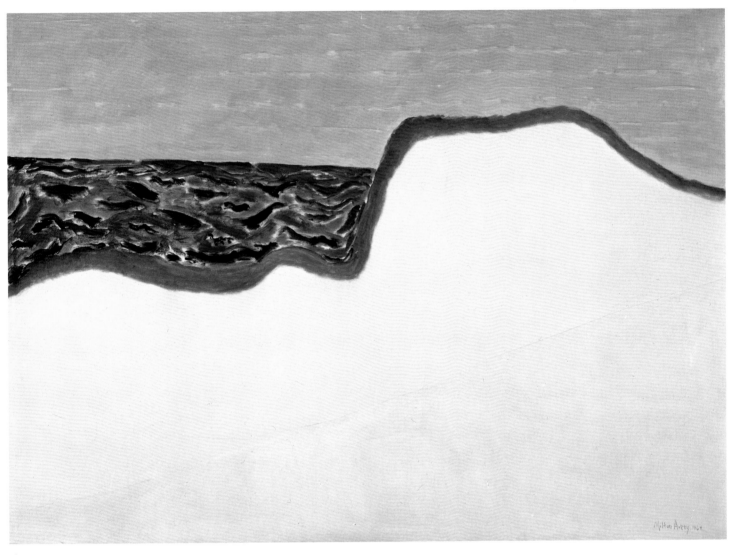

85.
Dunes and Sea II, 1960
Oil on canvas, 52 x 72 inches (132.1 x 182.9 cm). Whitney Museum of American Art, New York;
Promised 50th Anniversary Gift of Sally M. Avery P.14.80

marked by Avery's unmistakable color sense. Within these barely modulated color planes Avery created textures by scratching into the paint with a fork or razor, a process which reduced illusionistic recession by calling attention to the two-dimensional surface of the canvas (86). As a means of heightening awareness of his resonant color harmonies, he stripped his design to essentials and neutralized the picture plane as much as possible by avoiding both "paint quality" and brushwork. To ensure a dry, unobtrusive surface, he mixed his paint with large amounts of turpentine rather than linseed oil and chose canvas that was slightly absorbent and not too rough. He began discarding extreme value contrasts in favor of closely allied color harmonies, a radical departure from the traditional Western modulation of light and dark values used to produce the illusion of space and volume. Space in his paintings came to be determined by the interaction of adjacent hues—not by linear perspective or value contrast.[64] This was a significant innovation for an American artist. As Hans Hofmann noted: "Avery was one of the first to understand color as a creative means. He was one of the first to relate colors in a plastic way."[65] Avery's approach opened new formal possibilities to American painting and exerted a profound influence on the group of younger artists whose work came to focus on the expressive potential of color. Both Rothko and Newman saw in Avery's disavowal of material paint deposits a way to make color evoke the sublime. Throughout the forties both artists continued to turn to Avery's work for inspiration; in 1946, despite their own lack of money, Annalee and Barnett Newman purchased one of Avery's paintings, *Red Umbrella* (77).

As Avery sharply reduced the number of elements in his compositions, shape came to play a role equal in importance to color. Given the nature of his subjects and the spareness of his formal means, Avery's work might easily have become banal were it not for his highly developed pictorial logic—his impeccable and precise arrangement of forms on the canvas. In addition to maintaining pictorial tension, shape came to define pictorial space as Avery's introduction of closely valued color harmonies eliminated the spatial illusionism traditionally created by light/dark contrasts. To suggest space, Avery relied on such depth cues as diagonally thrusting lines and overlapping planes, which he ordered to create a typically shallow space of steep perspective and tilted planes. His vocabulary of shapes continued to be derived from the external world, but in the process of manipulating images for the sake of formal relationships, he transformed them. Although he subjected the human form to the same flattening as landscape motifs, his figure distortions remained more restrained because of the obligation to maintain recognizable associations with human anatomy. Nonetheless, his motivation, even when dealing with the figure, remained the generation of formally en-

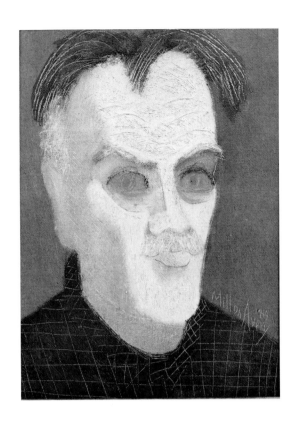

86.
Self Portrait, 1949
Oil on canvas, 12 x 9 inches
(30.5 x 22.9 cm). Collection of
Louis and Annette Kaufman

gaging shapes—a fact which confounded his occasional detractors who saw his figure distortions as failures of draftsmanship.

Avery's abstract treatment of landscape motifs began with his genre paintings of the early thirties. In *Sun Worshippers* (10), for example, the landscape functioned as a ground which simplified figures divided into abstract shapes. In his subsequent Vermont and Gaspé landscapes of the late thirties and early forties, Avery concentrated less on abstract relationships than on naturalistic space and chromatic experimentation; not until 1944 did he refocus on the formal possibilities of flattened shapes. At first he followed his earlier procedure of depicting figures in landscapes, but by 1944 he had removed the figure. Without the limitations imposed by human anatomy, Avery could more freely explore formal possibilities. As a result, his landscapes verge more closely on abstraction than do his figurative pictures.

The landscapes depicted in Avery's work of the forties derived from summer travels, which became more varied as the Averys' income increased, due partly to more frequent painting sales and partly to Sally's illustration job for the *New York Times.*[66] However, the outbreak of war and the subsequent rationing of gasoline curtailed their travel from 1942 through 1945. Consequently, figure paintings dominated Avery's output during these years. But by the end of the decade Avery's desire for new landscapes had been fulfilled by trips to Mexico, California, the Canadian Northwest, and

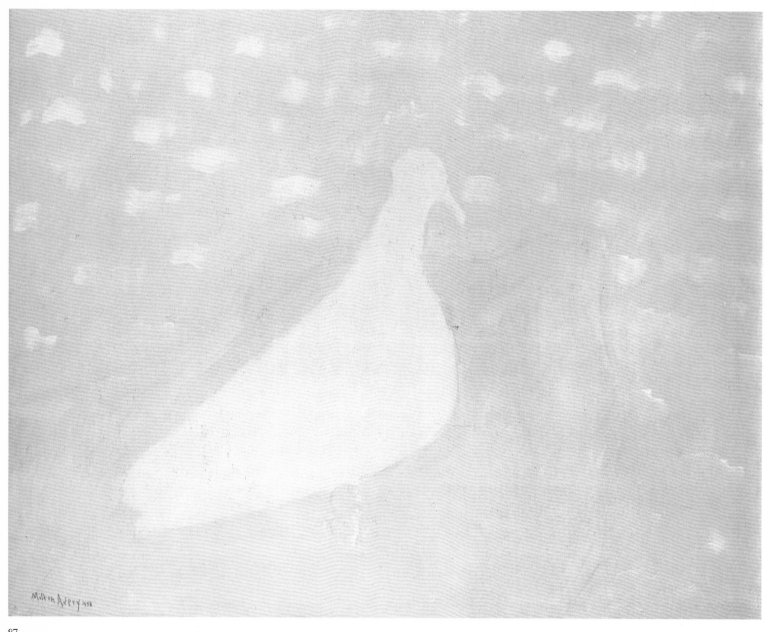

87.
White Gull, 1958
Oil on canvas, 40 x 50 inches (101.6 x 127 cm). Rutland Gallery, London

110

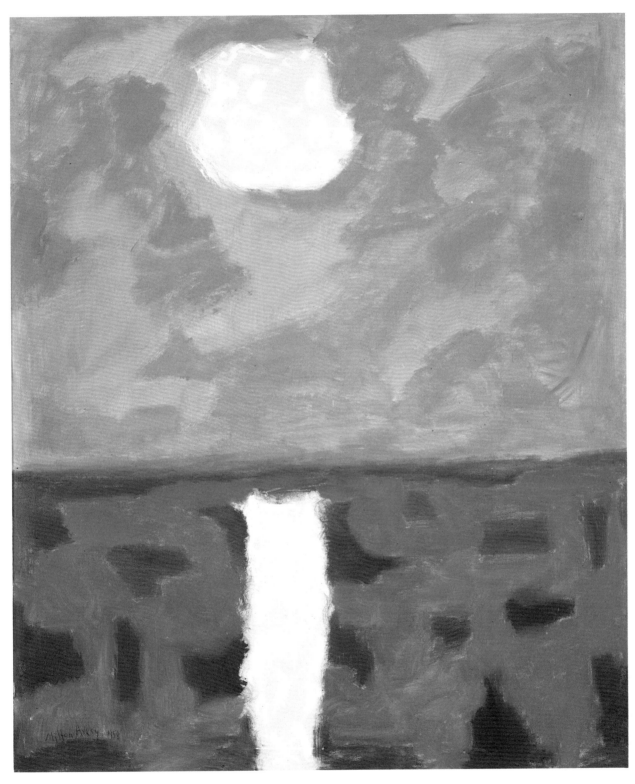

88.
Moon Path, 1958
Oil on canvas, 50 x 42 inches (127 x 106.7 cm). Collection of Mr. and Mrs. Gifford Phillips

Maine, all of which became source material for his paintings of the forties. The family's three-month trip to Mexico in 1946 generated a distinct body of work which relied on the dense planes of single color first introduced in 1944. Deriving its imagery from the country's ceramic figures of Christ, *Crucifixion* (49) resonates with the bright pastel pinks, lavenders, and oranges that colored the Mexican scene. In its atypical coloration it reflected Avery's commitment to capturing the specific moods of particular locales. In subsequent works—*Oregon Coast* (47), for example—Avery achieved greater compositional sophistication with his interlocked landscape elements while simultaneously extending the range of his color harmonies through more subtle modulations of richly valued hues.

In January 1949, at age sixty-three, Avery suffered a major heart attack. For those who believed him to be only fifty-five, the attack seemed premature; but given his real age, the coronary and his subsequent ill health

89.
Rocks by Ebbing Sea, 1944
Watercolor and gouache on paper,
22 x 30 inches (55.9 x 76.2 cm).
Collection of Mr. and Mrs. Donald
Morris

are somewhat more comprehensible. Avery was released from the hospital after six weeks in intensive care, but doctors told Sally privately that his chances of surviving beyond the next three years were remote. Unaware of the doctors' prediction, he lived for another sixteen years, but he never fully recovered and his health remained fragile for the remainder of his life. Although Sally became increasingly protective and saw to it that he limited his activities, he suffered throughout the decade from attacks of angina pectoris—painful chest constrictions that could be relieved only by daily doses of nitroglycerin. He was unable to take even short walks without having to stop and wait for the recurrent spasms to pass. His health deteriorated further as hardening of the arteries set in, aggravating his heart condition and increasing his discomfort.

Avery's confrontation as a young man with the premature deaths of his father and two brothers had already given him a deep-seated sense of the ephemeral character of life. His New England reserve apparently had suppressed outward manifestations of tension, but his heart attack suggests the presence of a deeper anxiety. Underlying Avery's gentle and seemingly placid demeanor was a fierce intensity, evident early on in the obsessive bicycle racing he did as a young man and in his lifelong habit of driving cars at excessively high speeds.[67] In art, it manifested itself in the heavy workload and the ambitious goals he imposed on himself. Despite the surface calm of his pictorial depictions, Avery was impelled by an intense drive to leave something of lasting significance in the world. Not surprisingly, he became depressed after his heart attack; physical weakness and pain contributed to a darkening in his palette, a change his daughter, March, attributed to an overall shift in his mood.[68] Although Avery continued to paint idyllic landscapes and peaceful figure compositions, his more muted color tonalities revealed a deepening of perception and feeling.

Too weak to travel, Avery spent the summer of 1949 in Millbrook, New York, at the house of a friend who had gone to Europe. Unable to sketch outside, he concentrated on still lifes, producing in 1949 an output dominated by arrangements of the Victorian objects and curlicued furniture in his friend's house (92). Avery's physician encouraged Sally to take him to a warm climate that winter; with the help of their friend Martin Dibner, Sally arranged an invitation from the Research Art Colony, a studio-housing complex for writers and painters in Maitland, Florida, outside Orlando. That December they drove to the Colony, where they remained until mid-April.

Avery turned to making monotypes during his stay in Florida because the exertion required for painting and for other types of printmaking was too great. The simplicity of the monotype process ideally suited the physical limitations imposed on his work by his recuperation.[69] It proved a

90.
Speedboat's Wake, 1959
Oil on canvas, 54 x 72 inches (137.2 x 182.9 cm). Collection of Sally M. Avery

91.
Sailfish in Fog, 1959
Oil on canvas, 30 x 50 inches (76.2 x 127 cm). Collection of Mrs. Warren Brandt

92.
Rose and Blue Teapot, 1949
Oil on board, 14 x 18 inches
(35.6 x 45.7 cm). Collection of
Mr. and Mrs. George Berman

fortuitous interlude, for Avery responded immediately to the medium and over the next two years produced an impressive body of nearly 200 prints. But even more significant was the compositional and technical impact on his subsequent paintings of the inherent requirements of the medium itself. Because monotypes require rapid execution, they encouraged a relatively simplified structure devoid of extraneous detail, a quality Avery retained when he resumed painting, the following spring. In addition, the process used in making monotypes—sponging wet, heavily diluted oil paint onto plate glass—was one Avery subsequently adapted to his paintings. His oils became not only markedly thinner and more fluid, but by the late fifties he was using a sponge technique to apply paint.

After their return from Florida, the Averys remained in New York only a few months before setting out for the summer art colony of Woodstock, New York. Avery's stamina gradually returned and the paintings he executed during the summer of 1950 and the following winter at the Research Art Colony showed a renewed vigor and strength of purpose. The experience of his heart attack had convinced him how relatively insignificant were the specific details that distinguish one object from another, and how

93.
Nursing Mother, 1933
Oil on canvas, 36 x 28 inches
(91.4 x 71.1 cm). Collection of
Sally M. Avery

important were interconnections and universalities.[70] As a result, his pictorial focus shifted from the description of individual parts within a composition to the harmony of the whole. Overall tonal harmonies replaced the contrasting color areas typical of his work of the preceding decades. Moreover, although Avery had begun to simplify shape and reduce detail as early as 1944, he now saw such paring down as a means to express the more universal qualities of experience. By broadly generalizing contours, and minimizing shapes and graphic details, he sought to transcend the particular factual accidents of his subjects and capture their universality—whether of individual form or of essential relationships between objects. A comparison of the 1933 and 1950 interpretations of the maternity theme (93, 56) reveals that Avery's treatment became more generalized. The descriptive linearity of the earlier picture suggests a particular characterization, whereas the distilled 1950 version is almost iconic, evoking an archetypal mother-and-child relationship. Eliminating the transitory allowed Avery to retain the final, irreducible constituents of his subjects.

The formal economy of Avery's compositions of the fifties combined with a palette which became richer and more refined as he replaced the

94.
Hills by the Sea, 1960
Oil on canvas, 30 x 40 inches (76.2 x 101.6 cm). Collection of Mr. and Mrs. Murray Bring

95.
Black Sea, 1959
Oil on canvas, 50 x 68 inches (127 x 172.7 cm). The Phillips Collection, Washington, D.C.

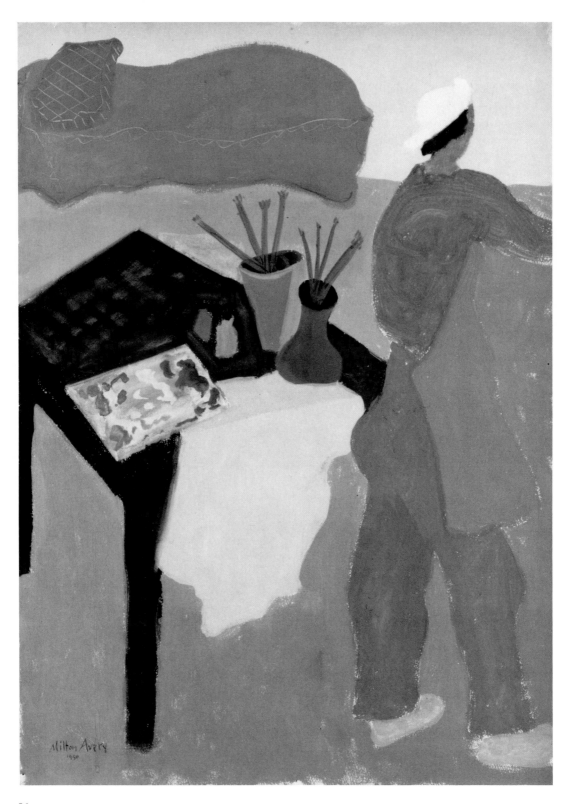

96.
Artist at Work, 1950
Gouache on paper, 30 x 22 inches (76.2 x 55.9 cm). Collection of Mr. and Mrs. Benjamin Frankel

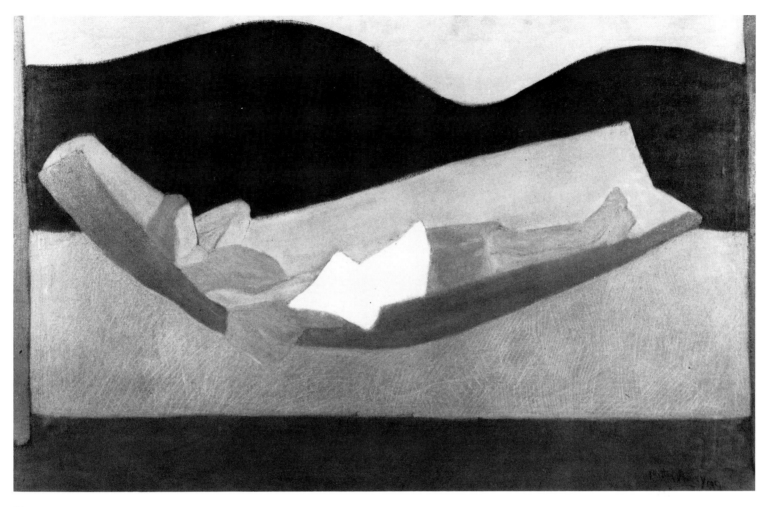

97.
Hammock Reader, 1951
Oil on canvas, 26 x 42 inches (66 x 106.7 cm). The University of Michigan Museum of Art, Ann
Arbor; Gift of Dr. and Mrs. Marvin E. Klein

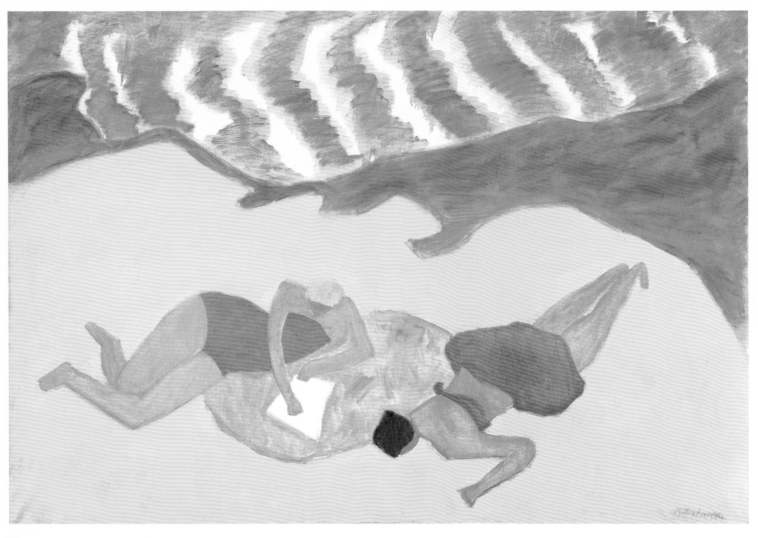

98.
Bathers by the Sea, 1960
Oil on canvas, 50 x 72 inches (127 x 182.9 cm). Collection of Wendell Cherry

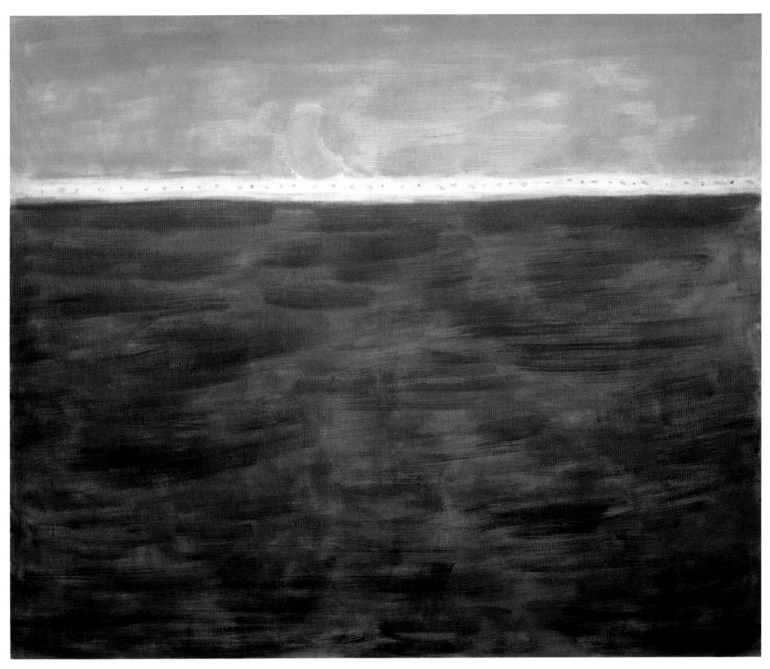

99.
Tangerine Moon and Wine Dark Sea, 1959
Oil on canvas, 50 x 72 inches (127 x 182.9 cm). The Dr. Seymour Rettek Trust, Eric Warren
Goldman, Trustee; on extended loan to the National Gallery of Art, Washington, D.C.

100.
Rosey Nude Asleep, 1950
Monotype, 17 x 22 inches (43.2 x 55.9 cm).
Private collection

vibrant hues of earlier work with quieter, more muted color harmonies. Thin washes of paint applied one over another created veiled, slightly mottled fields of color. Each color was more subtly employed; color combinations became more daring. In *Hint of Autumn* (65) glimpses of tan underpainting show through from beneath overlayed tones of dark green, aqua, and orange, creating unique color mixtures and emphasizing the overall sense of transparency and atmosphere.

As Avery's focus shifted to the interconnections between objects, the boundaries separating forms took on greater significance. Contours, the juncture between one shape and another, had always held special significance for him. He felt one could identify good painting by the way the artist handled edges. In his own work, boundaries were seldom hard or abrupt, but fuzzy and diffuse, a quality he achieved through intricate color transitions at the borders. In the twenties his habit was to underpaint with a dark color which was left exposed around the edges of his shapes so that it functioned as a dark contour line. In the late thirties and early forties, when he adopted a brushier handling of paint, contours became less clearly delineated, with the result that shapes tended to dissolve into one another. Beginning around 1944, when Avery again treated color as coextensive with shape, contour

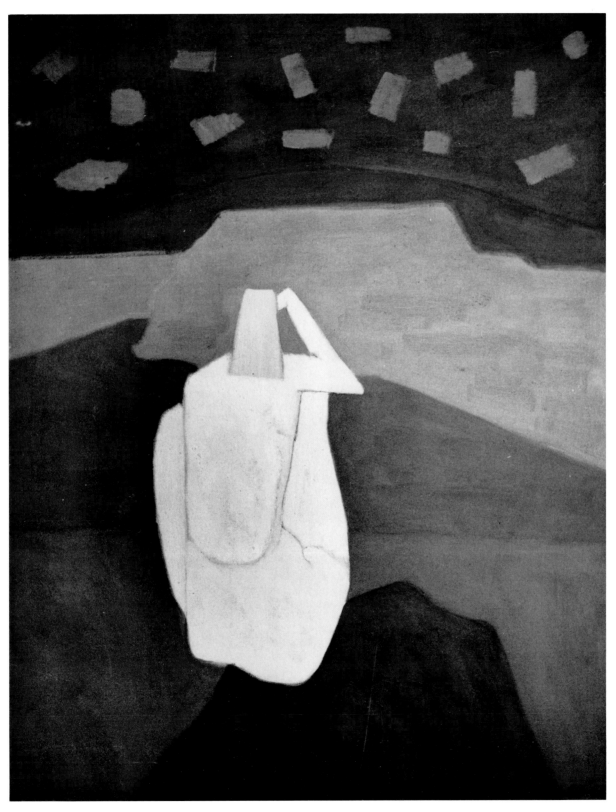

101.
Meditation, 1950
Oil on canvas, 44 x 34 inches (111.8 x 86.4 cm). Private collection

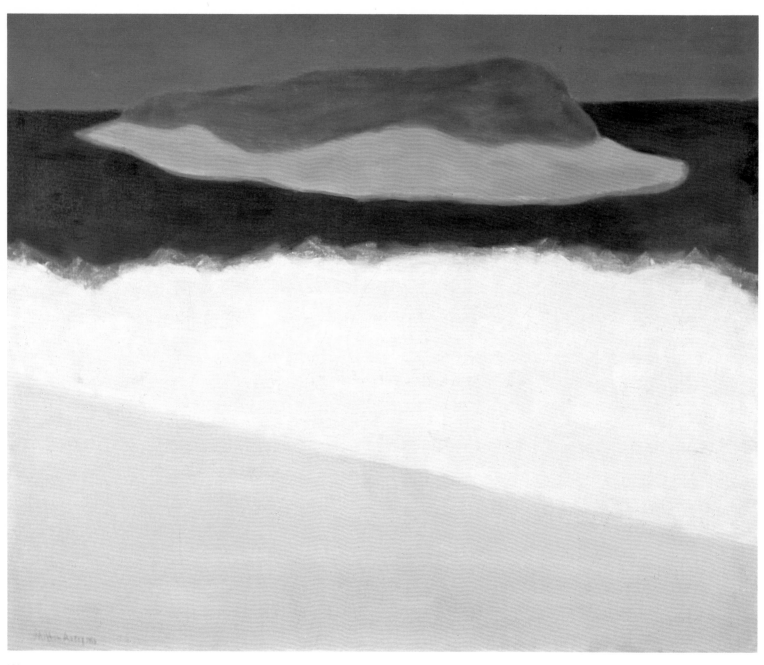

102.
Offshore Island, 1958
Oil on canvas, 46 x 56 inches (116.8 x 142.2 cm). Collection of the Nebraska Art Association; Gift of
Mrs. Thomas C. Woods

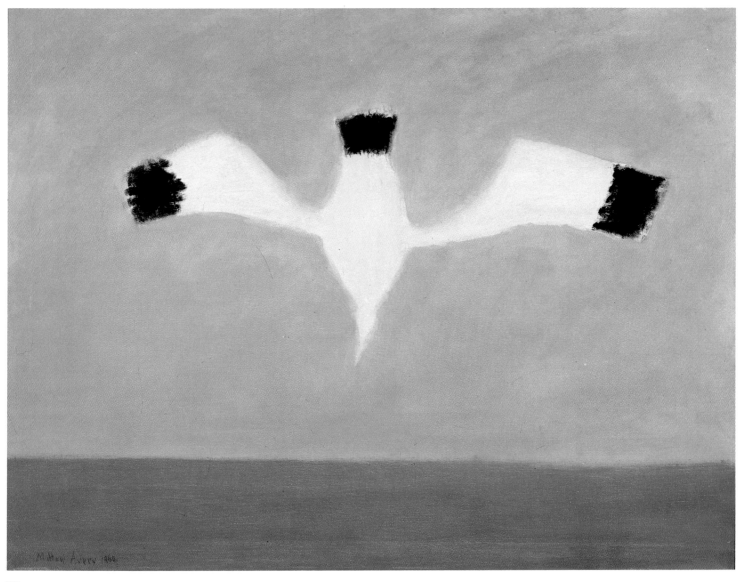

103.
Plunging Gull, 1960
Oil on canvas, 30 x 40 inches (76.2 x 101.6 cm). Collection of Maurice and Margo Cohen

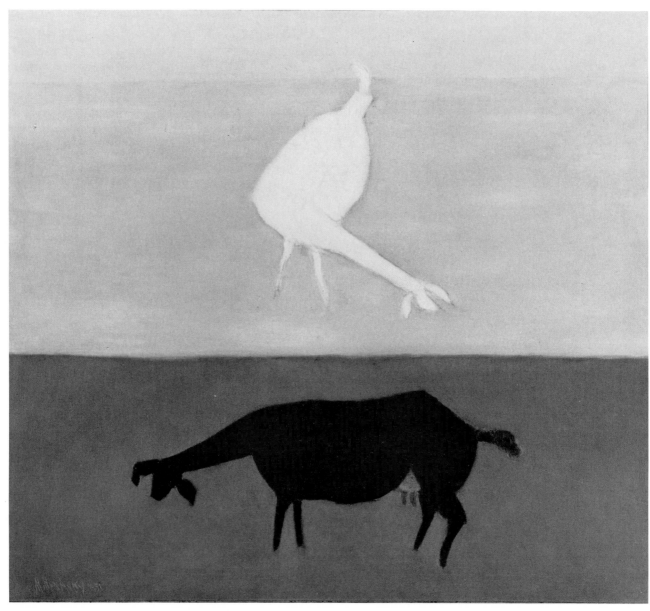

104.
Black Goat, White Goat, 1951
Oil on canvas, 34 x 38 inches (86.4 x 96.5 cm). Private collection

delineations took the form of slivers of color—sometimes similar in hue to the adjacent colors, sometimes different—which produced the sensation of an inner color emanating from between abutting forms. Thus in *Sunset* (64), the glimpses of green underpainting visible around the tan inlet generate an aureole of green light surrounding the inlet. The effect was to create contiguous forms that had no abrupt transitions but instead blended into one another.

The hazy character of Avery's softly edged shapes has parallels in the ideas of Eastern philosophy and among some theoreticians of physics—although Avery himself was probably unaware of them. The concept that objects are not fixed and static, that forms are not discrete, has become an attractive and popular idea associated with both these fields of thought. In this view, Eastern philosophy posits an essential unity of all things in which distinctions between objects are fundamentally illusory, made merely for the sake of convenience. A similar view has been encouraged by speculative debates within science: that objects are composed of a mass of particles all in a state of constant interchange. We indeed perceive objects as stationary, separate forms, but this may not be entirely so. In the case of a cup on a table, for example, we perceive the cup as an object differentiated from both the table beneath it and the air surrounding it. Yet perhaps no precise boundary really exists between the cup and the table—there may be no specific end of the cup or beginning of the table. This notion of an indeterminate reality is one that is reflected in much of twentieth-century art; few artists, however, dealt as specifically with the fugitive nature of borders as did Avery.

Ironically, the aesthetic success of Avery's paintings done after his heart attack came when the critical acclaim of the forties was replaced by critical eclipse. His depression and physical discomfort throughout the fifties were exacerbated by economic hardship. After his return to New York in 1950, following his second winter at the Research Art Colony, Paul Rosenberg informed him of his decision to close Rosenberg & Co. and move to Venezuela. Although he eventually decided against the move, Avery's association with the gallery became tenuous as Rosenberg's son, Alexandre, began to take primary responsibility for running the gallery. Alexandre Rosenberg apparently did not appreciate the growing simplicity of Avery's work, which he felt was careless and superficial. His failure to encourage Avery to remain with the gallery after the Venezuela plan was discarded reflected

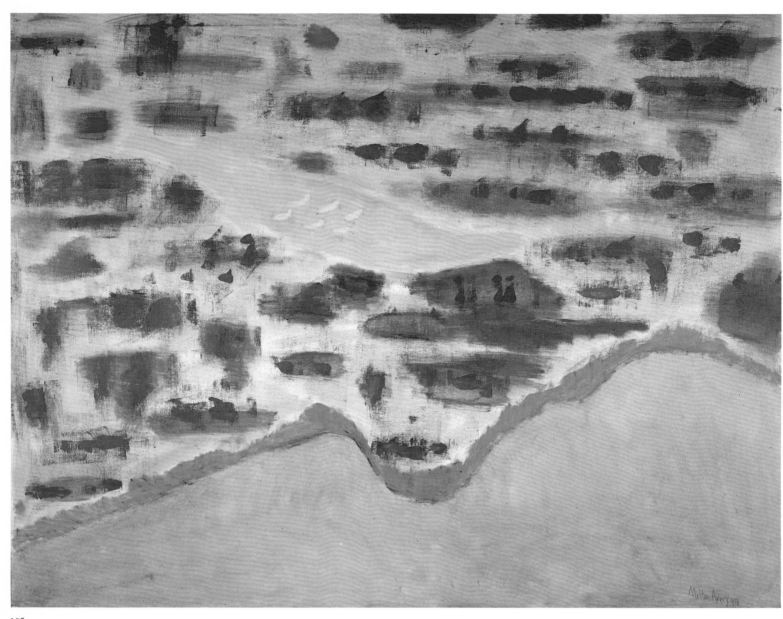

105.
Sandbar and Sea, 1958
Oil on canvas, 50 x 66 inches (127 x 167.6 cm). Milton Avery Trust, New York

130

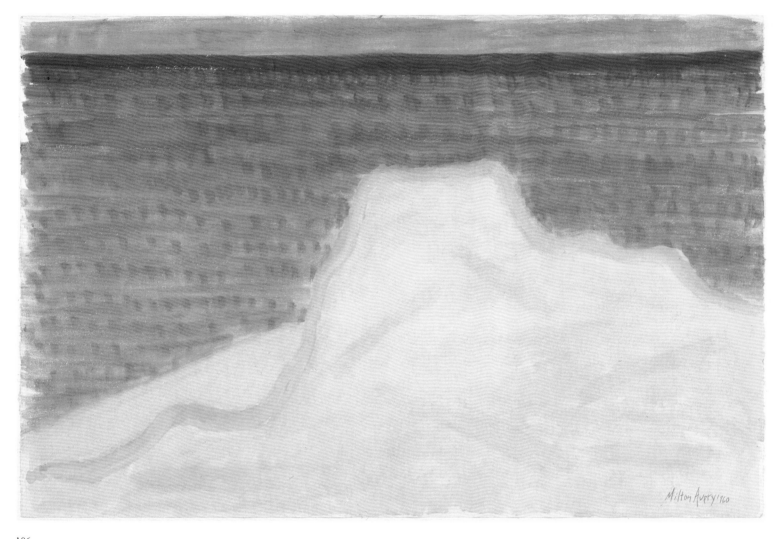

106.
Red Sea, 1960
Oil on paper, 23 x 35 (58.4 x 88.9 cm). Collection of Sanford Schwartz

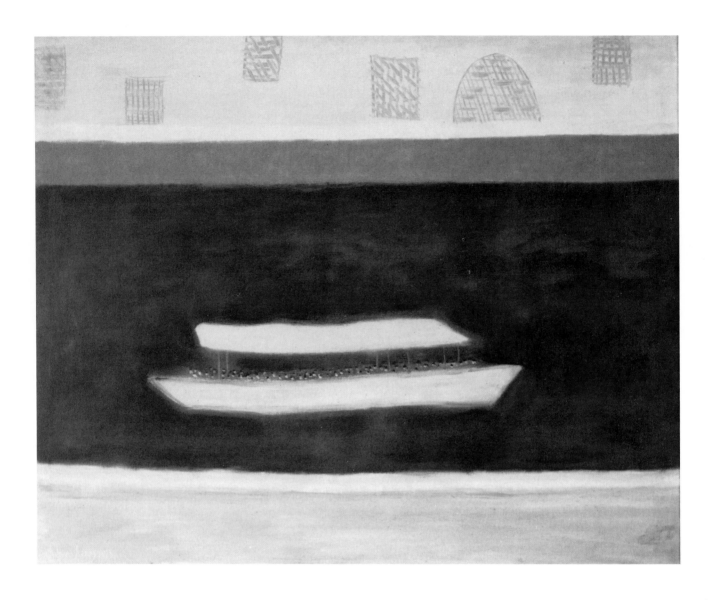

107.
Excursion on the Thames, 1953
Oil on canvas, 40 x 50 inches
(101.6 x 127 cm). Milton and Sally
Avery Arts Foundation, New York

both his father's increasing remove from the gallery and his own ambivalence about handling Avery's work.[71] Although Avery's directness in color and reduction of form would increasingly be recognized by others as the hallmarks of his genius, Rosenberg's attitude left him without a dealer. In the meantime, Grace Borgenicht, an artist herself, had decided to open a gallery to support the American artists she felt were being ignored by collectors and museums. She had met Avery while working at the Laurel Gallery in 1948 when it published his first drypoint portfolio, and she asked him to join her gallery in 1951. The gallery, whose artists included Jimmy Ernst, George Constant, and José de Rivera, established a solid reputation for itself; but because it was new, it had neither the clientele nor the prestige of

Rosenberg's. Furthermore, although supportive as a dealer, Borgenicht did not subscribe to the European system of buying a number of paintings each year from her gallery artists, a policy which left Avery dependent on individual sales—which were simply not forthcoming. One year he earned only fifty dollars. Sally's salary notwithstanding, money was tight and the Averys were again forced to economize. On occasion they were assisted by friends or Sally's brother and, whenever possible, exchanged paintings for such services as dentistry and accounting. But having survived the Depression with optimism, Milton and Sally did not seem to mind their lack of capital; their pleasures remained simple and Avery continued to be indifferent to material

108.
The Seine, 1953
Oil on canvas, 41 x 50 inches
(104.1 x 127 cm). Whitney Museum
of American Art, New York;
Purchase 54.33

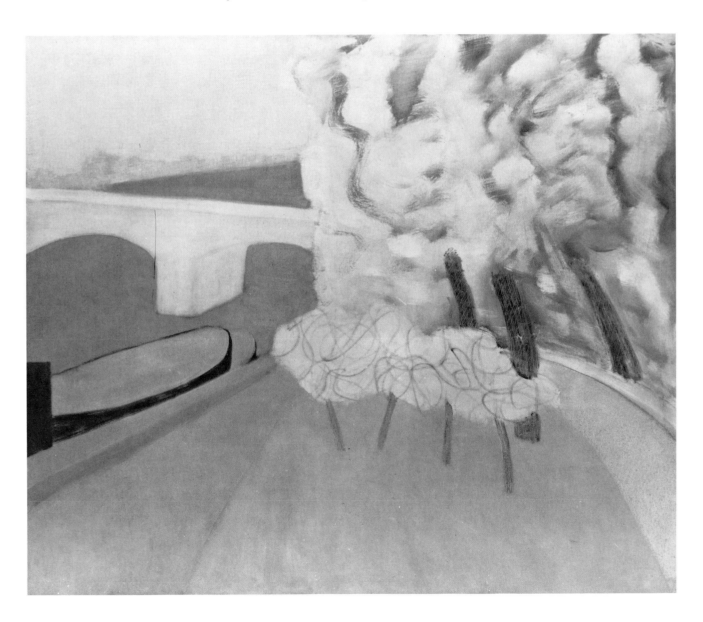

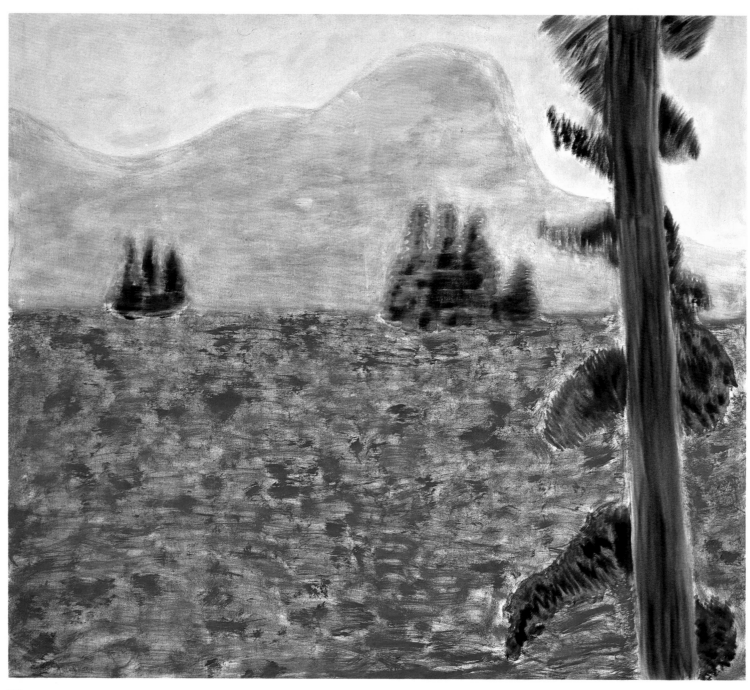

109.
Mountain Lake, 1960
Oil on canvas, 60 x 68 inches (152.4 x 172.7 cm). Milton and Sally Avery Arts Foundation, New York

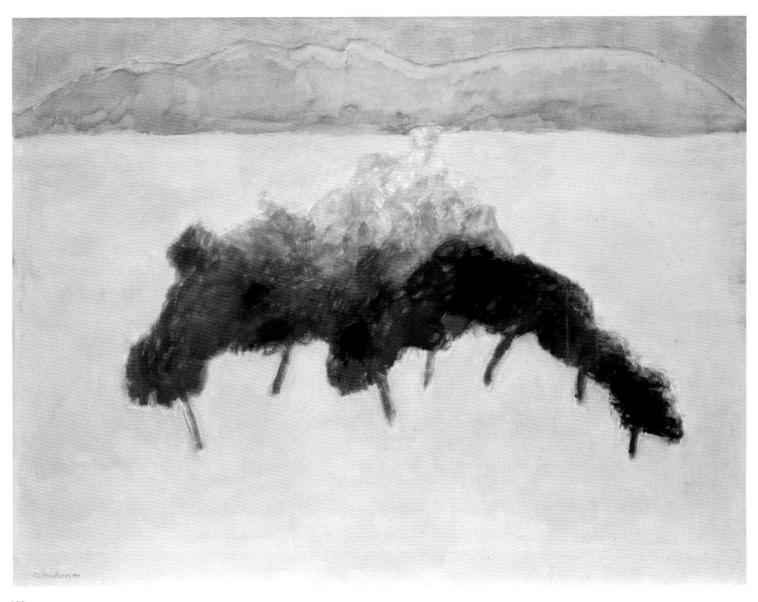

110.
Spring Orchard, 1959
Oil on canvas, 50 x 66¼ inches (127 x 168.3 cm). National Museum of American Art,
Smithsonian Institution, Washington, D.C.; Gift of S. C. Johnson & Son, Inc.

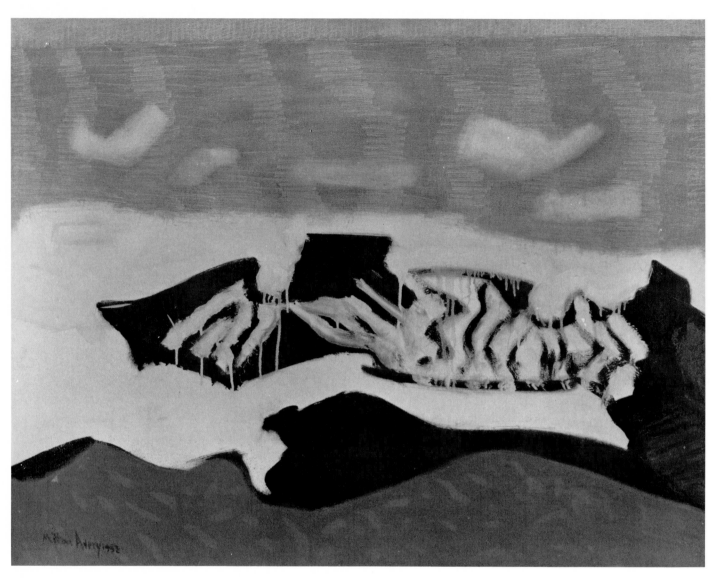

111.
Breaking Sea, 1952
Oil on canvas, 30 x 40 inches (76.2 x 101.6 cm). The Baltimore Museum of Art;
Frederick W. Cone Fund

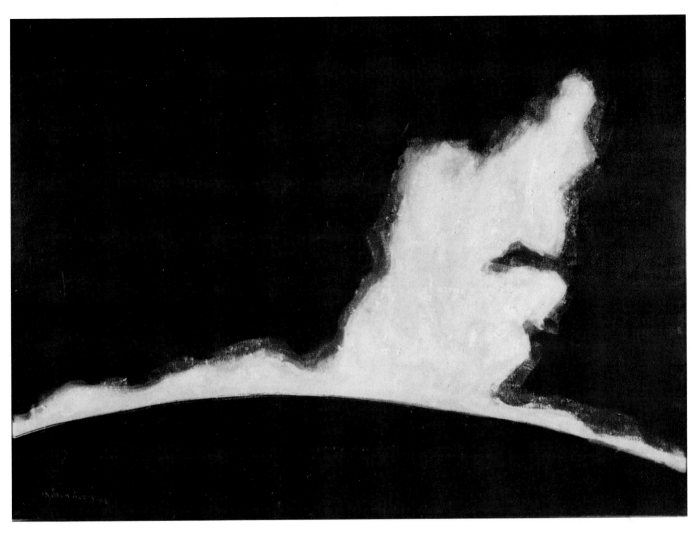

112.
The White Wave, 1956
Oil on canvas, 30 x 42 inches (76.2 x 106.7 cm). Herbert F. Johnson Museum of Art, Cornell
University, Ithaca, New York; Gift of Helen Hooker Roelofs in memory of her father, Elon
Huntington Hooker

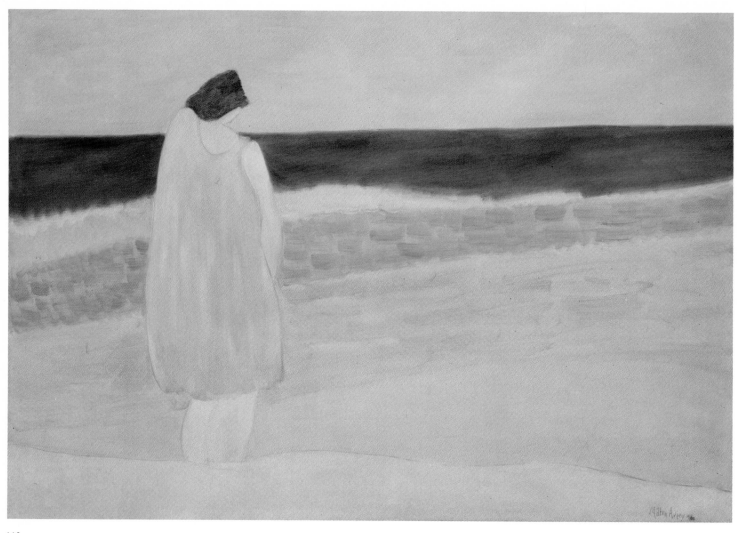

113.
Lone Bather, 1960
Oil on canvas, 50 x 72 inches (127 x 182.9 cm). Milton Avery Trust, New York

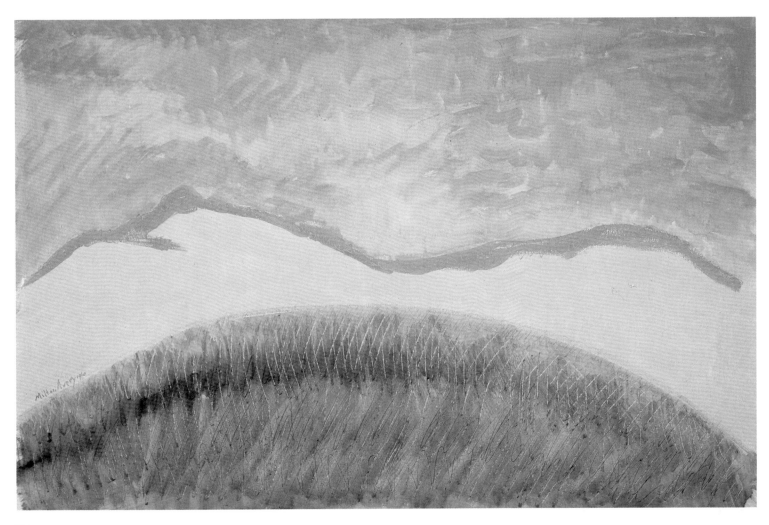

114.
Dunes and Dune Grass, 1960
Oil on paper, 23 x 35 inches (58.4 x 88.9 cm). Marianne Friedland Gallery, Toronto

comforts. He transcended his physical and economic sufferings by focusing exclusively on refining and perfecting his painting.

Avery's fall from critical favor in the fifties was brought about by the acclaim accorded the Abstract Expressionists—many of whom were among the younger artists who had grouped around him in the thirties and forties. Of the two currents in Abstract Expressionism, Avery had been the forerunner of chromatic abstraction. For Rothko, Newman, and Gottlieb, Avery's paintings had provided a model for the expressive possibilities of color. But by 1950 the painters loosely grouped under the rubric of Abstract Expressionism overshadowed everyone else—including Avery. Fashionable criticism championed abstraction, and Avery's commitment to motifs based on observed reality pitted him, once again, against established taste—this time because he was too "realistic." Critics perceived his work as less "advanced" than that of the Abstract Expressionist painters, nearly all of whom by the fifties had banished any hint of representational imagery from their work. Moreover, given an art community attuned to metaphysical content in painting, Avery's harmonious vision of everyday life appeared facile and naive to some; because it celebrated pleasure, many critics did not take it seriously. Although Avery was showing regularly, he was not considered the equal of the celebrated masters of Abstract Expressionism.

As the fifties progressed, Abstract Expressionist painting was shown and discussed more and more widely and featured in key art magazines. Thomas Hess and Harold Rosenberg, two of the most influential critics of the time, promoted the work of gestural or "action" painters such as Jackson Pollock and Willem de Kooning; neither treated Avery as a creator of significant art. Clement Greenberg, the third critic close to the Abstract Expressionists, based his criticism on the formal properties of art, holding that what was important in painting were those characteristics that distinguished it from other media. In the forties he had supported gestural abstraction, while his attitude toward chromatic abstraction had been negative. In 1943 he had criticized Avery, calling him "a 'light' modern who in oil can produce offspring of Marie Laurencin and Matisse that are empty and sweet, with nice flat areas of color. . . . The painting is almost faultless within its limitations, but has been seen before."[72] By 1955, however, Greenberg had grown dissatisfied with gestural abstraction because of its illusionist—and therefore retrograde—components. In a major article entitled " 'American-Type' Painting," he asserted that the most radical development in painting in the previous two decades was chromatic abstraction because it suppressed light/ dark contrasts.[73] Although this had been true of Avery's work for decades, his development as a colorist had progressed simultaneously with his concern

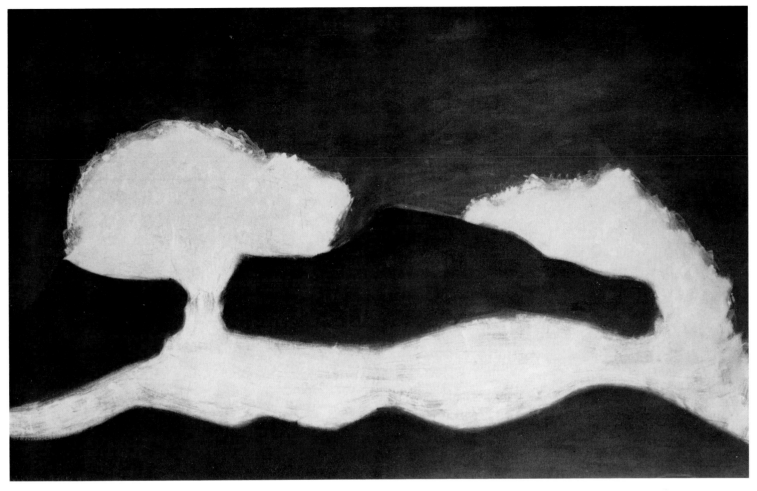

115.
Double Wave, 1955
Oil on canvas, 35¾ x 53 inches (90.8 x 134.6 cm). Private collection; Courtesy of Andrew Crispo
Gallery, New York

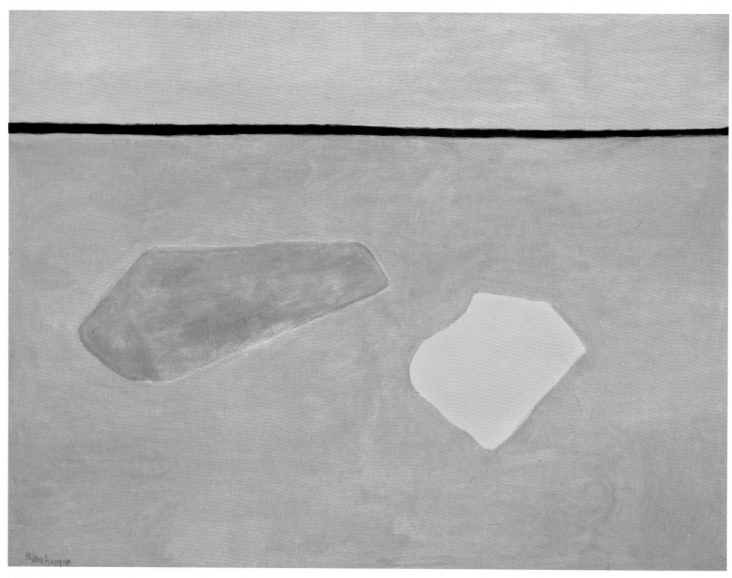

116.
Beach Blankets, 1960
Oil on canvas, 54 x 72 inches (137.2 x 182.9 cm). Wichita Art Museum, Kansas; Gift of S. O. Beren
and Marian L. Beren

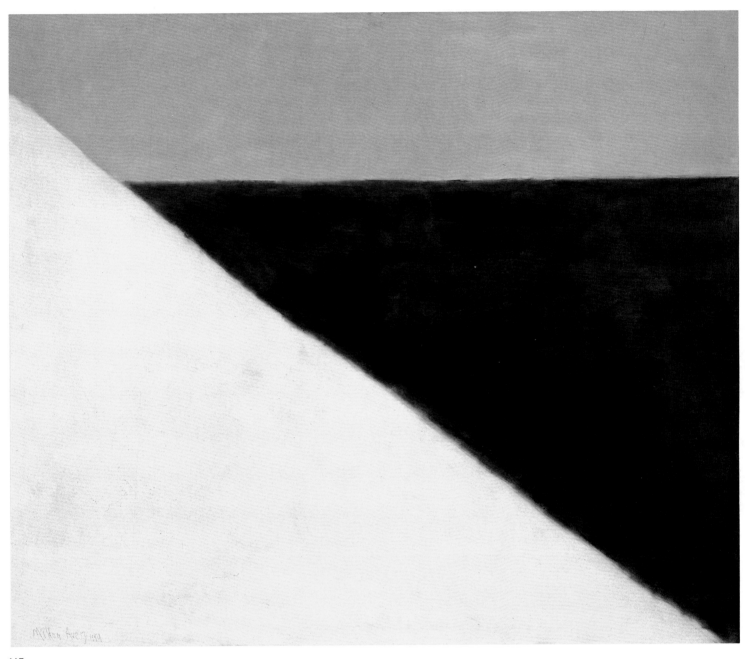

117.
Sand, Sea and Sky, 1960
Oil on canvas, 56 x 70 inches (142.2 x 177.9 cm). The Larivière Collection, Montreal

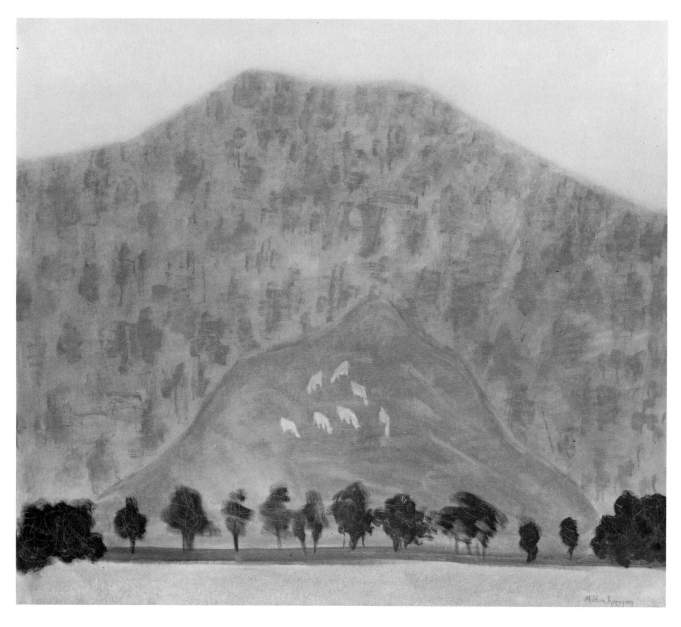

for pictorial space. Moreover, his retention of recognizable imagery—albeit abstracted—caused Greenberg and his followers to overlook him as a major figure. Thus, while the more purely abstract painters—Gottlieb, Newman, Rothko—utilized the kind of color Avery had developed years before, what they achieved with color seemed more revolutionary. Their work fit into an easily interpreted historical progression in which they moved beyond European modernism, whereas Avery's allegiance to representation could not be readily separated from European precedents of the early years of the twentieth century. Consequently, Avery's position suffered, not because of a lack

118.
Upper Pasture, 1955
Oil on canvas, 40 x 52 inches
(101.6 x 132.1 cm). Private collection

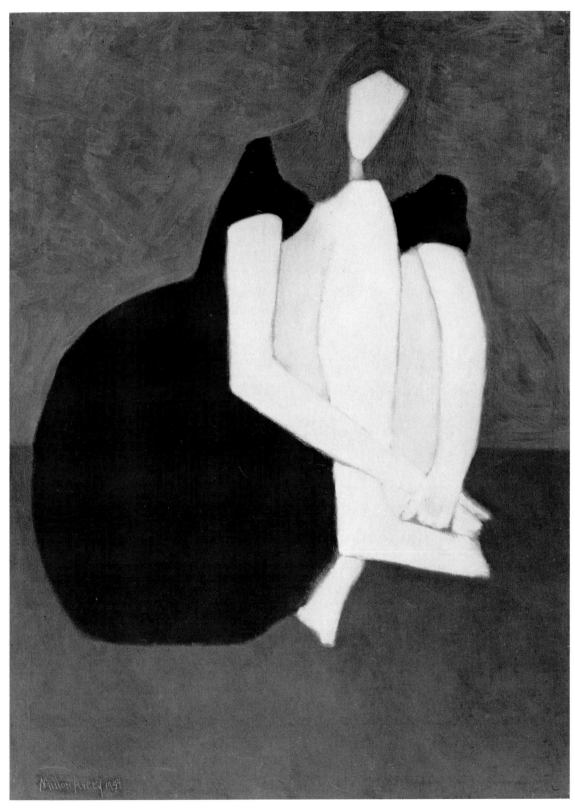

119.
March in Brown, 1954
Oil on canvas, 44 x 32 inches (111.8 x 81.3 cm). Collection of Mr. and Mrs. Philip G. Cavanaugh

in quality or failure to be a seminal figure in the development of color, but from critical circumstance. Even the earlier support of Avery by Rothko, Newman, and Gottlieb, for whom he had been a precursor, abated somewhat as these younger artists developed their own mature styles.[74]

In addition to being denied critical approbation because of his adherence to recognizable forms, Avery failed to become engaged in contemporary theoretical concerns. He was not interested in discussing the intellectual or spiritual aspects of art, and this estranged him from an art world attuned to rhetoric and the redefinition of painting. The formal implications of art outlined by Greenberg were not important for Avery; he had incorporated them into his painting twenty years earlier—but not because he was interested in extending the frontiers of art. By the 1950s he was an older man whose motives for making paintings did not include impressing the art world or changing the course of painting history through theoretical advances. Rather, Avery dedicated himself to perfecting his color harmonies and making more beautiful paintings. Although the fortunes and accolades bestowed on the younger artists rapidly obscured Avery's critical recognition, his steadfast dedication to his own goals as a painter never faltered. Despite the obvious advantages in adopting pure abstraction, Avery's refusal to compromise his vision attested to his unwavering belief in his own aesthetic and in himself as an artist.

The Averys continued to spend their summers outside New York, but in locales not far from the city. In the summer of 1952, however, they journeyed for the first time to Europe. Their three-week trip consisted of a week's stay each in London, Paris, and the French Riviera. Given Avery's earlier interest in seeing the work of other artists, one would have expected him to spend most of his time in museums. But March Avery Cavanaugh remembers her father feeling too weak to both visit museums and sketch outdoors; given the choice, he decided that museum visits were more exhausting and less productive than sketching.[75] The drawings he produced proved a fruitful source of imagery which he translated into paintings such as *Excursion on the Thames* (107) and *The Seine* (108).

The following summers were spent closer to home. In 1953, 1954, and 1956, both Sally and Milton were offered fellowships to the MacDowell Colony in Peterborough, New Hampshire. Established in 1907 as a retreat for writers, composers, and visual artists, the Colony provided studio and living facilities and communal meals. Marcel Duchamp was a Colony guest

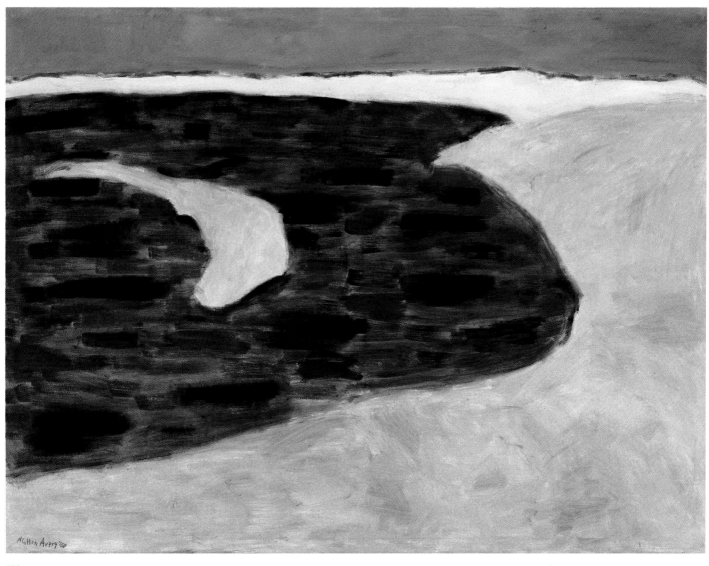

120.
Dunes and Sea I, 1958
Oil on canvas, 54 x 72 inches (137.2 x 182.9 cm). Milton Avery Trust, New York

their first summer there and Avery, who was an avid pool player, taught Duchamp the game. Duchamp was so delighted with his new skill that he joked about printing calling cards that would read: "Marcel Duchamp—pupil of Milton Avery."[76] In the summer of 1955, the Averys went to Yaddo, a retreat near Saratoga Springs, New York, similar to the MacDowell Colony.

In the landscape and figure compositions Avery produced in these years he continued to distill his motifs and enrich his color harmonies. As he grew more secure in his vision, he further eliminated what seemed to him extraneous. "I always take something out of my pictures," he said. "I strip the design to essentials; the facts do not interest me as much as the essence of nature."[77] Avery's ongoing reduction of form was matched by an instinct for increasingly lyrical color. Throughout the decade, surprising and unorthodox juxtapositions of color continued to be his primary expressive focus: as he perfected the technique of layering coats of thin paint onto the canvas, his color effects became ever more luminous. *Sea and Sand Dunes* (81) exhibits the radiance and the refinement of chromatic harmonies that mark Avery's work of the fifties, as well as the overall rhythmic undulations set up by his occasional use of dashes, dots, scrawls, and crosshatching, which he had retained in his work from the late forties.

The summer of 1957 marked a major shift in Avery's approach to painting. He and Sally summered that year in Provincetown, Massachusetts, an artists' summer colony on Cape Cod. While there, he enlarged the scale of his work, a development of decisive importance. Expanding from paintings which were at most 40 by 50 inches to paintings that measured 60 by 70 inches created more potential for the impact of color. Although Sally maintained that Milton began using larger formats because it was relatively easy to order larger stretchers from the nearby frame shop in Provincetown, the large scale adopted by the Abstract Expressionists must have been a factor in Avery's decision. To create an image so large that it would take up the viewer's field of vision—and hence occupy the entire consciousness—had become an effective device of Abstract Expressionism, and Avery could not have been immune to this influence.

Along with this expansion of scale came a further reduction of compositional elements and a heightened degree of abstraction. While Avery was doubtless encouraged to move further toward abstraction by the example of Rothko, Gottlieb, and Newman, his progression was not sudden; precedents for these increasingly abstract works exist in his own early paintings—

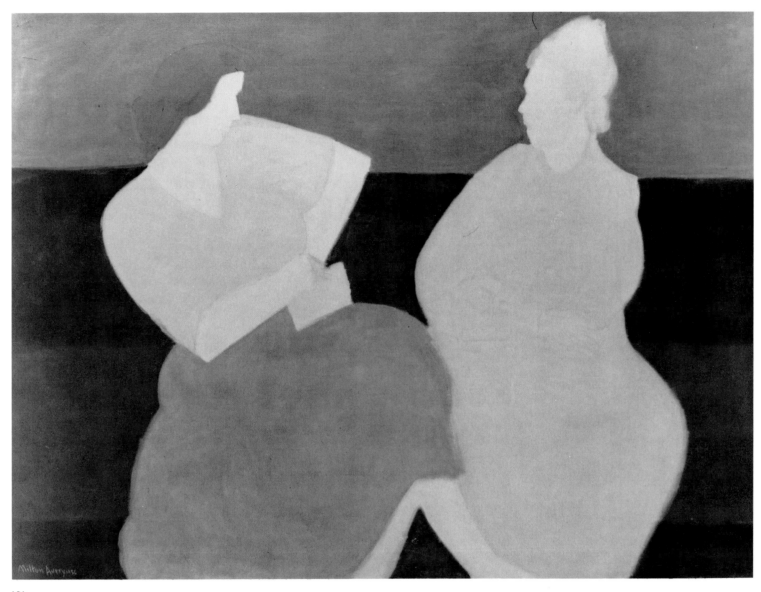

121.
Conversation, 1956
Oil on canvas, 40 x 56 inches (101.6 x 142.2 cm). Museo de Arte de Ponce, Puerto Rico; The Luis A.
Ferré Foundation, Inc.; Donated by the Chase Manhattan Bank

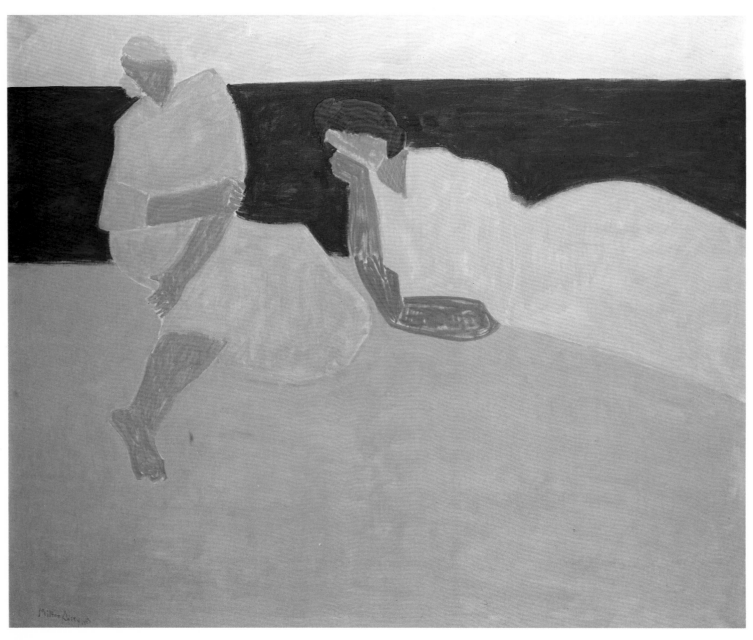

122.
Two Figures by the Sea, 1963
Oil on canvas, 50 x 60 inches (127 x 152.4 cm). Private collection

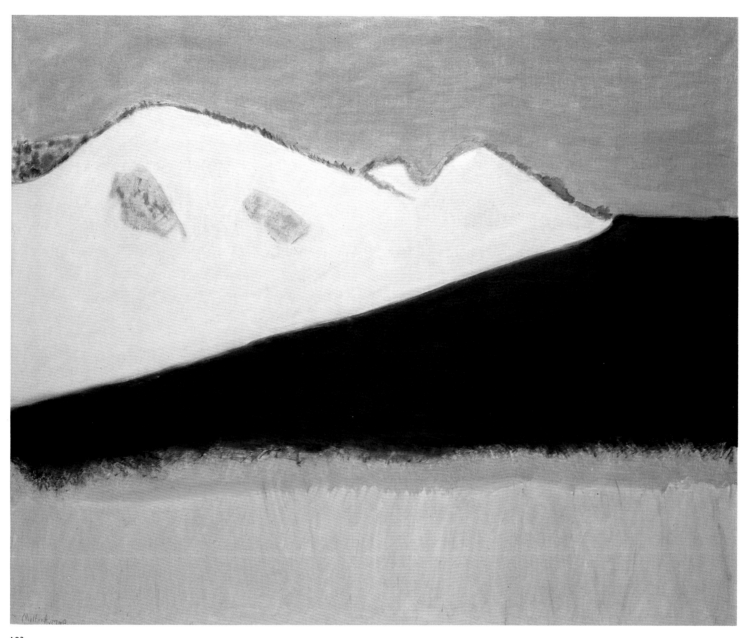

123.
Dark Inlet, 1963
Oil on canvas, 50 x 60 inches (127 x 152.4 cm). Collection of Leslie Waddington

124.
Sand Dunes and Yellow Sky, 1959
Oil on canvas, 66 x 50 inches (167.6 x 127 cm). Milton Avery Trust, New York

those same paintings which had initially inspired the younger artists. As early as 1933, in works such as *Sitters by the Sea* (18), Avery had minimized the number of pictorial elements and graphic details to such an extent that shapes began to function both as referential images and as purely abstract forms. This development became increasingly evident in landscape paintings of the forties and fifties, as Avery exploited the interplay between abstract and representational forms to such an extent that images could be interpreted either as figure or ground. By the late fifties this technique had matured sufficiently to accommodate the large scale of the Provincetown paintings. In *Sand Dunes and Yellow Sky* (124), for example, the black triangle defines the horizon line—the ocean visible through the depression in the sand dunes—but it can also be read simply as an abstract black shape interlocking with an abstract geometry. Read as water, the triangle is perceived as being behind the dunes; read as an abstract shape, it registers on the same plane as the adjacent color areas. Because the shapes never resolve into one reading or another, they impart an element of pictorial wit to the paintings which transcends the humorous caricatures of earlier works. Avery's humor was now formal rather than anecdotal; it concerned itself not with narrative possibilities, but with odd qualities of shape and quirkiness of outline. In manipulating visual effects so that a shape represents two different things simultaneously, Avery played with shape and color the way a punster plays with words. In the process he made a statement about the very nature of painting—the ability of a two-dimensional surface to yield an illusion of three dimensions. Similarly, the subtly modulated surface created by Avery's richly inflected color fields implied atmospheric space; at the same time, his broad configurations of seemingly uniform color suggested flat, cutout forms. The effect was a spatial reading, simultaneously flat and infinite.

On occasion, the perception of a dimensional duplicity hinged on language—on verbal knowledge of the subject. In *Beach Blankets* (116) and *Boathouse by the Sea* (126), Avery distilled forms to such a degree that the painting is initially perceived as an abstract arrangement of shapes, exclusive of recognizable subject. Only the title identifies it with an objective, three-dimensional scene. Thus, in these works, the sense of space is generated not by visual cues, but by verbal definition; the titles have perceptual consequences. By identifying a subject, they arouse associations with familiar images, thus extending the viewer's perception of the painting.

In late paintings such as these, Avery pushed to the farthest limits of pure abstraction without abandoning the traditional convention of working from nature. Rothko's and Newman's art had confirmed that a painting's

125.
Maine Coast, 1956
Oil on canvas, 36 x 46 inches (91.4 x 116.8 cm). Collection of Maurice and Margo Cohen

154

126.
Boathouse by the Sea, 1959
Oil on canvas, 72 x 60 inches (182.9 x 152.4 cm). Milton and Sally Avery Arts Foundation, New York

greatness could reside in its purely formal properties. Although deeply impressed by the achievements of these artists, Avery was not willing to abandon his commitment to representational references by embracing an art-for-art's-sake ideology. Deriving his images from reality provided him with an inexhaustible supply of motifs, continually replenished by the visible world. As a result his formal vocabulary, unlike that of some non-objective painters, was never reduced to a single format, but remained richly varied. "I work on two levels," he had written in 1951. "I try to construct a picture in which shapes, spaces, colors, form a set of unique relationships, independent of any subject matter. At the same time I try to capture and translate the excitement and emotion aroused in me by the impact with the original idea."[78] His work thus remained poised between objective depictions and non-objective aesthetic issues; by anchoring his work in subject matter while simultaneously giving fundamental importance to formal characteristics, Avery reconciled modernism with his own commitment to recognizable imagery.

Avery's process of distilling imagery from external phenomena allied him with the American modernist tradition of Georgia O'Keeffe, Arthur Dove, and Marsden Hartley, whose achievements had been somewhat overshadowed by academics at the Art Students League during the formative years of Avery's career. This tradition identified truth with the facts of experience and sought to extrapolate universal generalities from particular manifestations. The aim of artists embracing this philosophy was truth to objective reality—but truth in its totality, its inner logic, rather than in its visible details. "Nothing is less real than realism," Georgia O'Keeffe wrote. "It is only by selection, by elimination, by emphasis, that we get at the real meaning of things."[79] These artists employed the most advanced formal conventions of their era, but the real subjects of their work were the emotions generated in them by external phenomena, filtered through their own inner visions of the world.

While Avery's landscapes undeniably retained the reverential attitude toward nature which underlay the work of these artists, his involvement with figures and still lifes was more detached than theirs. He was less interested in conveying emotions related to particular circumstances or people or in revealing insights about existing relationships in nature than in creating harmonious compositions. Like the American Precisionists, whose aim was to extract from their urban and industrial subjects a lucid, geometric art, Avery was attracted to what he was painting not for its specific content, but for its potential formal, coloristic, and spatial relationships. He painted whatever was there—the place or person did not matter to him. According to Sally, he was no more attached to her or to March as subject matter than

127.
Interlude, 1960
Oil on canvas, 68 x 58 inches (172.7 x 147.3 cm). Philadelphia Museum of Art; Given by the
Woodward Foundation, Centennial Gifts

to anyone else who might have been around. In *Interlude* (127), for example, he focused not on the emotional interaction of figures but on formal relationships; the psychology of the figures—and his emotional reaction to them—was ultimately subservient to the total design. Thus Avery's paintings, while serving as an inventory of where he was and who and what he saw, do not reveal the emotional nuances of his life.

What they reveal is a mood. When one thinks of an Avery painting one thinks of a world of low-key emotions from which anger and anxiety are absent. His paintings are imbued with a sense of contentment and harmony: nature is not threatening, but is at peace with man; domestic scenes are calm; figures are in repose. Order prevails, as do serenity and restraint, all of which reflected Avery's own personality and the kind of life Sally had made possible. He may have worked with driving intensity to reach self-imposed goals, but he was not a hostile or angry man. His habit of diffusing occasional resentments through humor, plus his New England reserve and the harmony of a family situation that was almost without parallel among artists of his generation, helped him to accept difficult conditions and to paint without anger. Since this tranquility is the underlying quality in Avery's work, it affects the appreciation of his paintings. For those who equate great art only with angst, Avery's achievements remain incomprehensible. As Frederick Wight noted in 1952: "Response to Avery is on a curious basis. It seems to hinge on some attitude for which the paintings are touch-stones—whether one accepts or is humiliated by peace of mind."[80]

As the scale of his paintings increased, the devices for conveying harmony and calm which Avery had introduced after his heart attack became even more accentuated. He eliminated disturbing color contrasts by building chromatic harmonies around closely allied hues, equalizing values so that even complementaries had similar intensity. The homogeneous color areas of previous work now yielded to mottled effects produced either by applying uneven densities of the same color or by brushing strokes of dark color over lighter grounds. The result—shimmering rhythms within color zones. Still, each painting possessed an overall balance in which no shape or color dominated. Favoring pastel colors, Avery tinted his paint with white pigment which imparted a coolness of tone even when colors were highly saturated. This ability to create pastel color harmonies which were voluptuous and opulent was one of the distinguishing features of Avery's late paintings.

Central to Avery's color expression had been his ability to consistently translate the fluid quality of watercolor into oil. From the time he abandoned the palette-knife technique of Lawson, he paid great attention to sur-

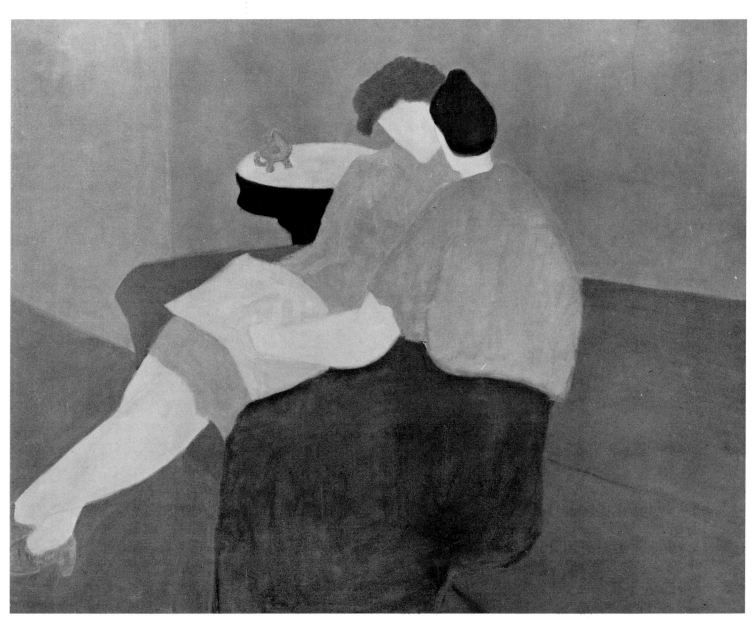

128.
Poetry Reading, 1957
Oil on canvas, 43¾ x 56 inches (111.1 x 142.2 cm). Munson-Williams-Proctor Institute,
Utica, New York

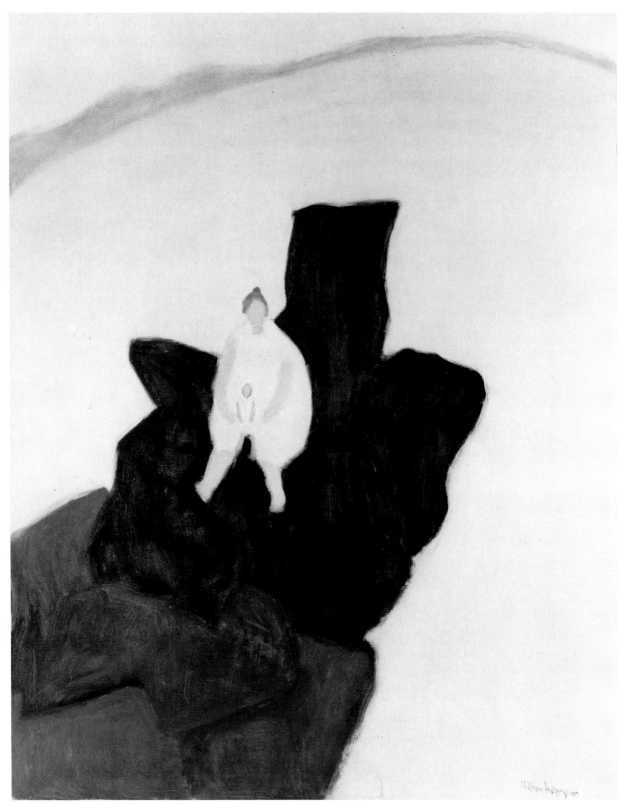

129.
Madonna of the Rocks, 1957
Oil on canvas, 50 x 40 inches (127 x 101.6 cm). Collection of Dr. and Mrs. Martin Weissman

face, minimizing the materiality of paint so that tactile associations did not intrude upon the experience of color. Now to ensure the utmost absorption of paint into the canvas, Avery applied his pigments with great frugality, thinning them only with turpentine in order to maintain the surface dryness he had favored throughout his career. He used so little pigment on these canvases that he joked about being embarrassed when the paint salesman came to his studio because he rarely needed to buy paint.[81] His technique of using rags to modulate multiple layers of color within each shape created a sense of luminosity by allowing light to reflect from the base color up through darker hues. This extraordinary degree of radiance corresponded to the brilliant light in Provincetown, where Avery spent the summers of 1957 through 1960. Stuart Davis said about Provincetown: "On clear days the air and water had a brilliance of light greater than I had ever seen and while this tended to destroy local color it stimulated the desire to invent high intensity color-intervals."[82] Avery captured this chromatic brilliance in late works such as *Tangerine Moon and Wine Dark Sea* (99).

This mastery of coloristic and formal nuance, which reached its pinnacle in Avery's Provincetown paintings, coincided with the growing universality of his imagery, hints of which had appeared after his heart attack in 1949. He abandoned specific references and treated his images as visual expressions of generalized experiences; figures and landscapes no longer referred to specific individuals or locales, but to universal situations. He became less concerned with momentary sensations than with the permanence of what he observed. In earlier paintings Avery captured fleeting moments that occurred at a particular time, in a particular place: the individuals in *Coney Island* of 1933 (16) could never reappear in exactly that same configuration of clothes, hair style, or position. Similarly, Avery's Gaspé landscapes, while simplified, were nevertheless *of* Gaspé. In contrast, *Black Sea* (95), while inspired by the Cape Cod landscape, is not *of* the Cape. It is so general, so completely non-specific that it represents the quintessential breaking wave. *Madonna of the Rocks* (129) avoids any visible reference to Christ and Mary; nor is it identifiable with any specific mother and child. Instead, it becomes a paradigm of an eternally recurring relationship.

Avery's genius lay in his ability to portray moods that stimulate each viewer's consciousness on an almost archetypal level. As the depiction of iconic relationships came to dominate his work, his paintings acquired greater poignancy. In relinquishing the transitory and the specific, Avery bestowed on his subjects a suspended calm. Depictions of group activities—family and friends playing games, making music, relaxing together at the beach—were replaced by a quality of separateness. Figure portrayals were

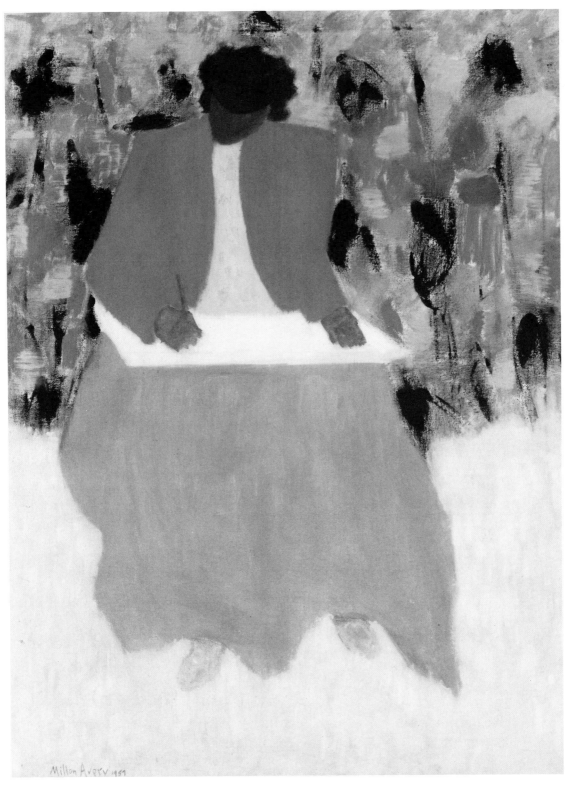

130.
Outdoor Sketcher, 1957
Oil on canvas, 42 x 32 inches (106.7 x 81.3 cm). Collection of Blake Edwards

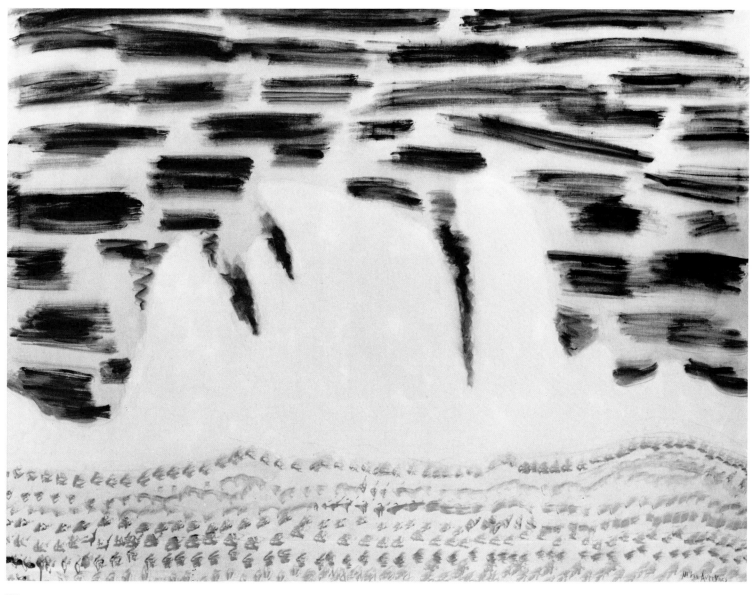

131.
Onrushing Wave, 1958
Oil on canvas, 54 x 72 inches (137.2 x 182.9 cm). Milton Avery Trust, New York

now generally of single figures or of couples isolated in otherwise deserted landscapes (98, 133). This mood of emptiness and quietude extended to his landscapes and seascapes as well; even in these, pictorial incidents seldom intrude upon the limitless expanse of empty space.

As Avery's health deteriorated he introduced a new set of themes into his work which perhaps reflected a heightened awareness of death and the passage of time. One of these new themes was the motif of a lone bird, an image often associated with the soul after death.[83] His 1959 depiction of a single bird flying over the ocean (134) suggested freedom from physical restraint; by 1960 the motif had become one of a bird descending irrevocably to earth (103). Avery's fascination with the borders which separate one object from another was also extended in these works to suggest the transition between dark and light: *Tangerine Moon and Wine Dark Sea* (99) and *Sunset Sails* (138) illustrate a frequent theme from this period—the changing of day into night.

Despite their grandeur, Avery's late paintings evoke the tenderness that people near death often feel for the familiar and ordinary. From the beginning, his method of working—from sketches to watercolors to finished

132.
Bay and Dunes, 1958
Oil on canvas, 50 x 60 inches
(127 x 152.4 cm). Private collection

133.
Yellow Robe, 1960
Oil on canvas, 60 x 50 inches (152.4 x 127 cm). Donald Morris Gallery, Birmingham, Michigan

134.
Flight, 1959
Oil on canvas, 40 x 50 inches (101.6 x 127 cm). Private collection

135.
Dark Forest, 1958
Oil on canvas, 40 x 53 inches (101.6 x 134.6 cm). Collection of Mr. and Mrs. Donald Morris

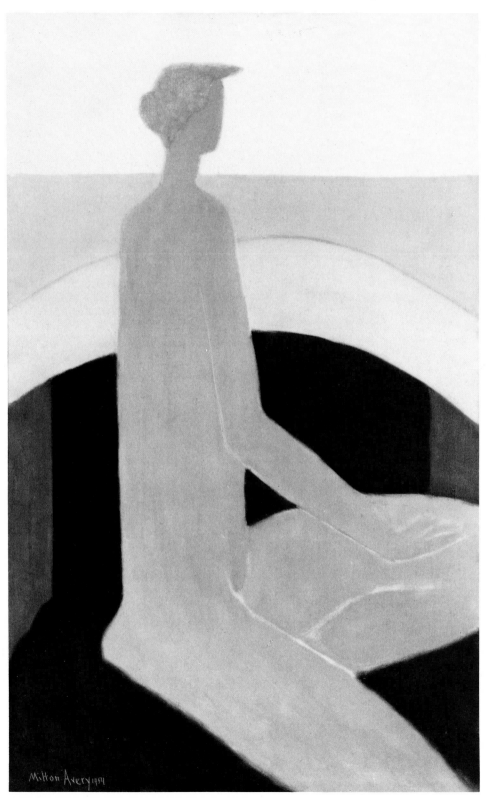

136.
Red Nude, 1954
Oil on canvas, 48 x 30 inches (121.9 x 76.2 cm). Collection of Edward Albee

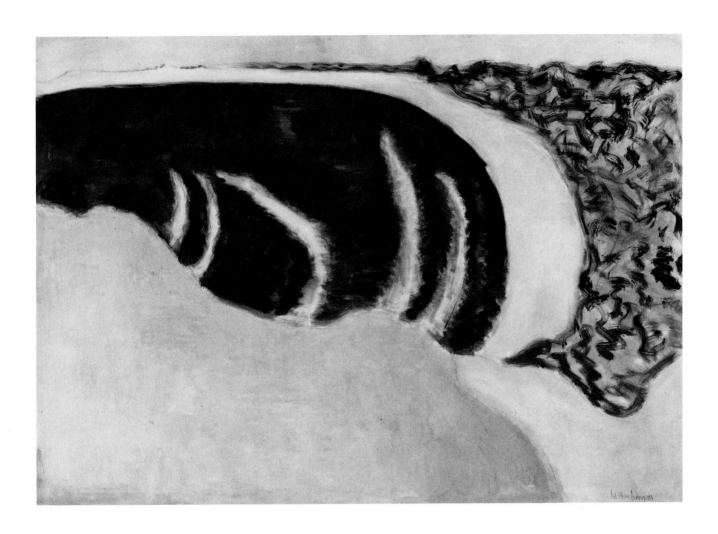

137.
Brown Sea, 1958
Oil on canvas, 50 x 72 inches
(127 x 182.9 cm). Milton Avery Trust,
New York

painting—involved a kind of looking back, which forced him to draw upon and reassess recollections of experiences or places. Consequently, his portrayals are imbued with the kind of intensity William Carlos Williams alluded to when he wrote that "there is no whiteness so white as the memory of white."[84] Toward the end of Avery's life a quality of detachment and nostalgia overlaid his visual memories, as if he were looking back not at specific events, places, or people, but at life itself. In part, Avery achieved this through radically muted color and pictorial distancing. The device of aerial perspective in *Brown Sea* (137) and, elsewhere, the frequent placement of images in the middle ground rather than the foreground of the canvas served to separate the image from Avery's, as well as from the spectator's, space—creating the sensation that the scene was being viewed from afar. By com-

bining these techniques with the veiled, slightly mottled softness of his colors, Avery placed his subjects at an enigmatic distance.

Avery's completion of his first series of these large canvases in 1957 marked a turning point in his critical fortunes. Clement Greenberg saw the work and completely repudiated his earlier disdain. He wrote an article that year in *Arts* in which he publicly acknowledged Avery's importance and called for a full-scale retrospective "not for the sake of his reputation but for the sake of the situation of art in New York. The latest generation of abstract painters in New York has certain salutary lessons to learn from him that they cannot learn from any other artist on the scene."[85] Greenberg's article was the first on Avery's work to be printed in a national magazine and, according to Sally, his support was an important factor in turning the tide for Avery. Suddenly the hesitancy critics had shown toward his work in the early fifties vanished. Over the next few years favorable articles on him appeared in major publications, one of them *Time* magazine. In 1957, the American Federation of Arts chose him as one of twelve artists across the country to honor with retrospectives.[86] Avery's exhibition—his largest and most important show to date—was scheduled for three years later at the Whitney Museum of American Art. His star seemed to be rising; after forty years of working independently, with little outside support, Avery's achievement was finally acknowledged. He returned to Provincetown in 1958 and 1959 full of vigor, and executed a series of canvases which rank among the richest color compositions produced by an American—spare canvases imbued with an undisputed lyrical elegance and poetic grandeur. But just as he seemed to reach his greatest level of self-expression, his physical condition, deteriorating steadily throughout the fifties, became serious. Avery was so weak following his 1959 summer in Provincetown that he could not climb the stairs to his second-floor Greenwich Village walk-up without enormous difficulty. Realizing how grave his condition was, Sally began searching for more comfortable accommodations and found an apartment on Central Park West. But that winter Avery's condition worsened. As the time for his retrospective at the Whitney Museum drew closer, his doctor counseled Sally that Avery was too frail to attend the opening ceremonies and advised their going south to avoid the winter chill; two weeks before the preview, the Averys left for Key West, Florida.

The 1960 retrospective was well received. Yet critics seemed unwilling to view Avery's earlier achievement as commensurate with the daring

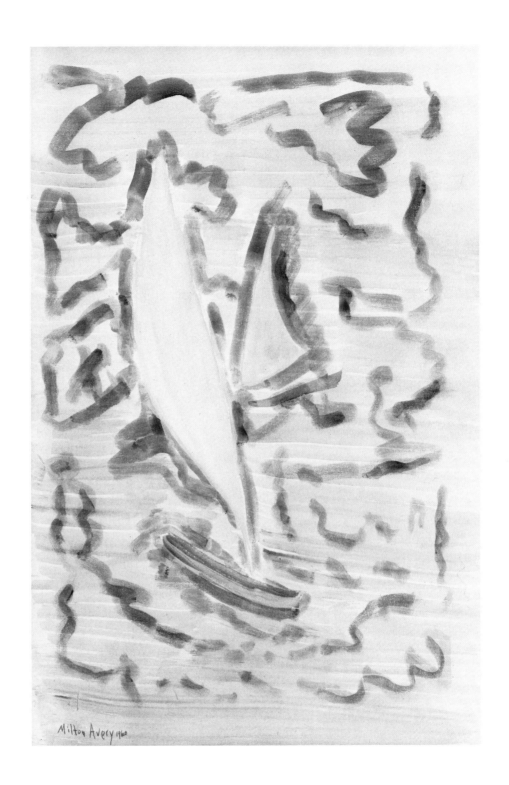

138.
Sunset Sails, 1960
Watercolor on paper, 34 x 22 inches
(86.4 x 55.9 cm). Collection of Ian
Scott Q.C.

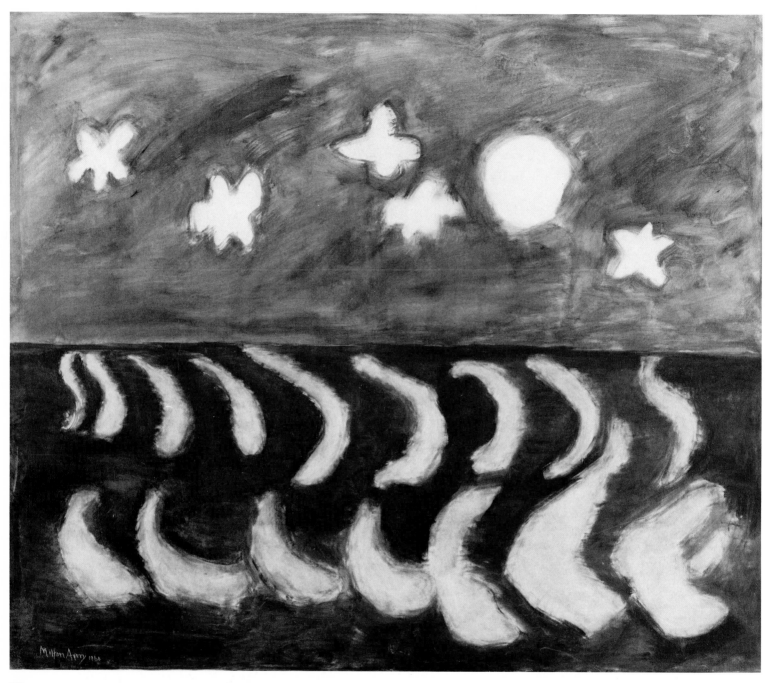

139.
Sea, Moon and Stars, 1960
Oil on canvas, 50 x 66 inches (127 x 167.6 cm). Donald Morris Gallery, Birmingham, Michigan

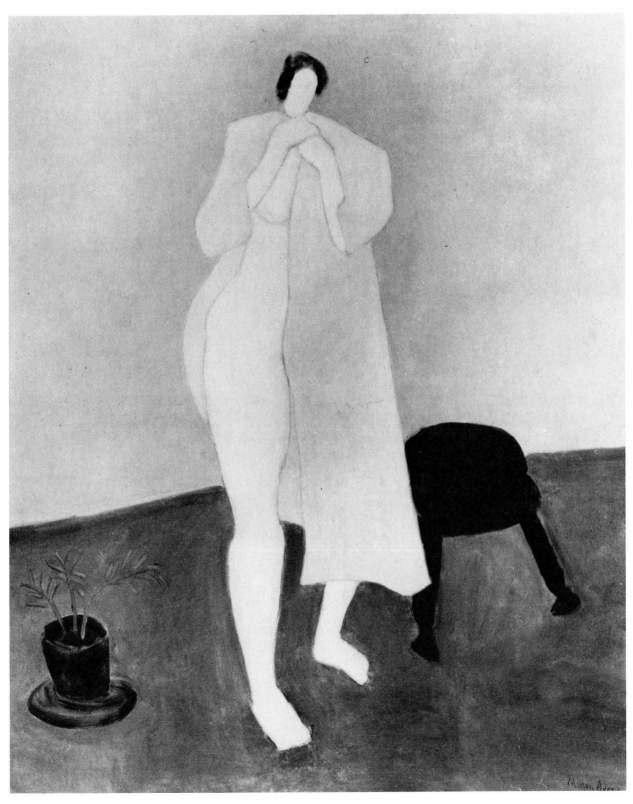

140.
Robed Nude, 1960
Oil on canvas, 68 x 58 inches (172.7 x 147.3 cm). Collection of Dr. and Mrs. Sidney Merians

141.
Mountain and Meadow, 1960
Oil on canvas, 60 x 68 inches (152.4 x 172.7 cm). Collection of Sally M. Avery

142.
White Umbrella, 1961
Oil on canvas, 40 x 50 inches (101.6 x 127 cm). Collection of Mr. and Mrs. Martin Lederman

143.
Self Portrait—Feeling Old, 1961
Oil on canvas board, 12 x 9 inches
(30.5 x 22.9 cm). Collection of
Albert Padover

144.
Dark Trees, Pale Mountain, 1962
Oil on paper, 23 x 35 inches
(58.4 x 88.9 cm). Collection of
Sally M. Avery

145.
Dark Mountain, Light Mountain, 1962
Oil on paper, 23 x 35 inches
(58.4 x 88.9 cm). Richard Gray
Gallery, Chicago

and scope of his late work, and the exhibition did not generate the outpour-
ing of wildly enthusiastic reviews such as might have been expected after
the recent praise lavished on his Provincetown paintings. He was still not
considered to be on a par with the leading Abstract Expressionists, but rath-
er with the other artists—such as Lee Gatch, Andrew Dasburg, Karl Schrag,
and Hugo Robus—who had received American Federation of Arts retro-
spectives, a situation exacerbated by the fact that Avery's retrospective, at
the Whitney Museum, was presented jointly with Gatch's. The art market

reflected this disparity in prestige: Avery's large Provincetown paintings were valued at only one third of similarly scaled Rothkos. Still, Avery had a substantial number of important and influential supporters, among them Hilton Kramer, who wrote the first book on Avery in 1962.

The summer following the AFA retrospective, the Averys were back in Provincetown. Milton remained optimistic; despite failing health he produced another major group of large paintings. But that October, while still on the Cape, Avery suffered his second heart attack. Although he lived for four more years, he remained frail, rarely going outside except for occasional walks in Central Park, and rarely moving far from the oxygen tanks that he

146.
Two Poets, 1963
Oil on canvas, 50 x 60 inches
(127 x 152.4 cm). Milton Avery Trust,
New York

needed to get through the night. Sally encouraged him to paint as much as possible, but his weakened condition made it difficult to control the brush and he became depressed at his inability to translate into oil what he believed would have been the most profound images he had yet created. The feeling of crazed helplessness reflected in *Self Portrait—Feeling Old* (143), executed a few years before his death, was typical of his last group of works.[87]

Sally arranged for them to spend the summers of 1962 and 1963 in Lake Hill, New York, several miles north of Woodstock. Unable to paint on

147.
White Nude #2, 1963
Oil on canvas, 50 x 40 inches
(127 x 101.6 cm). Collection of
Allen M. Turner

a large scale yet desperately anxious to keep working, Avery turned to oils on paper (144, 145). Having reduced his compositions in previous decades to simple shapes, he now purified them even of color, limiting himself to gradations of black. His decision to work on paper was necessitated by his restricted physical capabilities, but his choice of palette—given his prior commitment to high-intensity color—must be attributed at least in part to the depression caused by his helplessness and his awareness of imminent death. These black-and-white oils can be seen as symptomatic not only of his physical condition but of his state of mind as well; they convey a mood more somber and foreboding than any Avery had portrayed before.

During the winter of 1962–63, Avery managed to execute a few paintings on canvas—interior figures which he treated as large, angular shapes. No longer physically able to blend multiple layers of color into uniform fields, Avery allowed thinly applied single hues to delineate forms. The result—as in *Two Poets* (146) and *White Nude #2* (147)—was a much more transparent, brushier effect than in previous work.

Finally, in February 1964 Avery became so sick that Sally was forced to take him to Montefiore Hospital, where he remained for ten months, virtually unconscious, in intensive care. On January 3, 1965, he died in his sleep. His death came at a time when a rising generation of American color painters was looking to his achievement for inspiration for their own work. Yet Avery's art continues to elude categorization. He remains, even today, an independent figure whose works emanate a contemplative serenity that few artists achieve. With highly restrained formal means, he created ineffable color harmonies and relationships between forms which remain compelling and fresh with each successive viewing.

Commemorative Essay

by Mark Rothko

I would like to say a few words about the greatness of Milton Avery.

This conviction of greatness, the feeling that one was in the presence of great events, was immediate on encountering his work. It was true for many of us who were younger, questioning, and looking for an anchor. This conviction has never faltered. It has persisted, and has been reinforced through the passing decades and the passing fashions.

I cannot tell you what it meant for us during those early years to be made welcome in those memorable studios on Broadway, 72nd Street, and Columbus Avenue. We were, there, both the subjects of his paintings and his idolatrous audience. The walls were always covered with an endless and changing array of poetry and light.

The instruction, the example, the nearness in the flesh of this marvelous man—all this was a significant fact—one which I shall never forget.

Avery is first a great poet. His is the poetry of sheer loveliness, of sheer beauty. Thanks to him this kind of poetry has been able to survive in our time.

This—alone—took great courage in a generation which felt that it could be heard only through clamor, force and a show of power. But Avery had that inner power in which gentleness and silence proved more audible and poignant.

From the beginning there was nothing tentative about Avery. He always had that naturalness, that exactness and that inevitable completeness which can be achieved only by those gifted with magical means, by those born to sing.

There have been several others in our generation who have celebrated the world around them, but none with that inevitability where the poetry penetrated every pore of the canvas to the very last touch of the brush. For Avery was a great poet-inventor who had invented sonorities never seen nor heard before. From these we have learned much and will learn more for a long time to come.

What was Avery's repertoire? His living room, Central Park, his wife Sally, his daughter March, the beaches and mountains where they summered; cows, fish heads, the flight of birds; his friends and whatever world strayed through his studio: a domestic, unheroic cast. But from these there have been fashioned great canvases, that far from the casual and transitory implications of the subjects, have always a gripping lyricism, and often achieve the permanence and monumentality of Egypt.

I grieve for the loss of this great man. I rejoice for what he has left us.

Memorial address delivered at the New York Society for Ethical Culture, 2 West Sixty-fourth Street, on January 7, 1965.

NOTES

Citations of conversations with Sally Avery were extrapolated from the author's countless discussions with her in New York City over a three-year period, from 1979 through 1981. These were not formal interviews but rather an ongoing dialogue in which ideas and issues were rediscussed and clarified. Descriptions of the Averys' relationship, and of Milton Avery's attitudes and his responses to personal and professional situations, if otherwise unreferenced, derive from these discussions.

1. Quoted in Adelyn D. Breeskin, *Milton Avery,* exhibition catalogue (Washington, D.C.: National Collection of Fine Arts, Smithsonian Institution, 1969), unpaginated.

2. Avery's father has been previously identified as Russell Eugene Avery. However, he is listed as Russell N. in his obituaries (*Hartford Daily Times,* January 18, 1905; *Pulaski* [N.Y.] *Democrat,* January 25, 1905, p. 1); in the *February 18, 1892, Election District Record for the Town of Albion,* p. 5; in his death certificate (Windsor Town Hall records, catalogued: 1905, Avery); and in the death certificates of his wife and children (State of Connecticut, Bureau of Vital Statistics: registration #279, Fabian E. Avery [son] December 10, 1913; and registration #356, Esther J. Avery [wife] December 30, 1926). At no time is he identified as Russell Eugene. The confusion might have arisen because his grandson—Milton's nephew—was in fact named Russell Eugene Avery.

3. The age problem in Milton Avery literature is complex. Avery's birth date has always been given as 1893. Although his birth certificate was destroyed in the 1918 fire which consumed all the official documents of Sand Bank, New York, according to all extant documents he was born in 1885: *February 18, 1892, Election District Records for the Town of Albion*, p. 5, lists Avery as being seven years old at that time, one year before his later biographers credit him with being born; the Windsor, Connecticut, federal census report of 1900 lists his birth date as 1885. This date is supported circumstantially by the fact that Avery began working full time in 1901—which would make him eight years old had he been born in 1893, but a more plausible sixteen if the documented birth date of 1885 is accepted. When Milton and Sally were married he listed his age as thirty-six (City of New York, Office of the City Clerk, Marriage Register #HD5895-26 lm). This would give Avery a birth date of 1890. It is not known when, or for what reason, he took off an additional three years to arrive at the 1893 birth date that always appears in the critical literature. The earliest mention of the 1893 birth date is in Hugo Weisgall, *Advancing American Art* (Prague: U.S. Information Service, 1947), unpaginated.

4. Information about the Avery family was obtained chiefly from the Population Schedules for Albion, New York, and from *Avery Notes and Queries: A Quarterly Magazine Devoted to the History of the Groton Averys,* nos. 1–18 (February 1898–May 1902). Early nineteenth-century members of the Avery family were listed in these documents as doctors, judges, and lawyers.

5. See Chronology and notes 2 and 3, above, for specific birth and death dates of Avery family members.

6. Fires had destroyed the tanneries in Sand Bank a number of times prior to 1900. Rebuilding of the tanneries was becoming increasingly impractical by the turn of the century as local supplies of tanning bark became scarce. This, as well as the introduction of new chemical agents, contributed to the closing of the factories. Information from *Sandy Creek* (N.Y.) *News,* January 22, 1975, p. 4; further information on tanning in New York State from conversations with Richard Wiles, Professor of Economics, Bard College, Annandale-on-Hudson, New York, July 1981.

7. Previous Avery texts have given 1905 (the year of Russell Avery's death) as the year the Avery family moved to Connecticut. However, according to Russell Avery's obituaries (see note 2, above), the family had moved

there in 1898, seven years before. This is confirmed by the 1900 federal census (see note 3, above), which records the Avery family as living in Wilson Station, Connecticut, a small village in the township of Windsor.

8. *Pulaski* (N.Y.) *Democrat,* January 25, 1905, p. 1; *Hartford Daily Times,* January 18, 1905.

9. The records indicating the exact date of George Avery's death were burned, along with all other official documents, in the Sand Bank fire of 1918. He was listed in the 1892 election records but was not included in the 1900 federal census (see note 3, above), indicating he died sometime between those dates.

10. Information on the occupations of Avery's brother and brother-in-law was obtained from their respective death certificates. For Fabian, see note 2, above; for George E. Sargent, May 31, 1915, State of Connecticut, Bureau of Vital Statistics: registration #122. For specifics of Milton Avery's employment history between 1901 and 1924, see Chronology; information from the *Hartford City Directories,* courtesy of the Connecticut Historical Society, Hartford, Elizabeth Abbe, Librarian.

11. See Chris Ritter, "A Milton Avery Profile," *Art Digest,* 27 (December 1, 1952), p. 11.

12. For additional information on the League, see "Amusing and Serious Experiences of Local Art Students League," *Hartford Courant,* November 28, 1920, p. X7; and "Nomads of Palette and Brush," *Hartford Courant Sunday Magazine,* January 29, 1922, p. 4.

13. James G. McManus, who succeeded Jones as director of the League in 1919, taught there during Jones' tenure and could also have been Avery's teacher.

14. There are two different accounts of Avery's switch from the lettering class to the drawing class. In one version, which appears in most major texts, the lettering class was full (see, for example, Frederick S. Wight, *Milton Avery,* exhibition catalogue [Baltimore: The Baltimore Museum of Art, 1952], p. 4; and Breeskin, *Milton Avery,* unpaginated). In the second account, the lettering class was discontinued after one month and Avery switched to the drawing class while waiting for it to be resumed (see Ritter, "A Milton Avery Profile," p. 11).

15. *Hartford City Directories* (see note 10, above).

16. The nine women were: Mabel Avery and her daughter; Minnie Sargent and her five daughters; and Esther Avery.

17. Interview with Sally M. Avery. She further reported Avery's theory of inspiration: "If you go ahead and start to work, inspiration will come."

18. Interview with Sally M. Avery. Avery's jingle is a version of John 9:4—"I must work the works of him that sent me, while it is day: the night cometh when no man can work."

19. The Averys' house was located on the main road leading into Hartford, a few blocks from the center of East Hartford. The town history states that in 1915 gypsies were living on the block, and that the block was a den of crime. By 1920 a number of car dealers had established businesses there and the block was known as Automobile Row. Information from Lee Paquette, *Only More So: The History of East Hartford, 1783–1976* (East Hartford, Conn.: Raymond Library Company, 1976), pp. 213–14.

20. Dan Raymond (Administrator, Personnel Administration Department, The Travelers Insurance Companies, Hartford, Conn.), letter to the author, July 10, 1981.

21. Avery won the Mrs. Stanley Edwards Prize for best work in the portrait class and the Mrs. Arthur P. Day Prize for best drawing in the life class. Each prize was ten dollars. Albertus E. Jones, Avery's former instructor at the Connecticut League of Art Students, was the instructor in drawing, painting, and composition and in *plein-air* painting at the School of the Art Society of Hartford. His presence at the School could have been a factor in encouraging Avery to enroll.

22. This overview of the School of the Art Society of Hartford was provided by former student Aaron Berkman in an interview with the author, New York City, June 1981.

23. Avery's attraction to Lawson's art was confirmed in an interview with Sally M. Avery. A discussion also appears in Marla Price, *Milton Avery, Early and Late,* exhibition catalogue (Annandale-on-Hudson, N.Y.: Edith C. Blum Art Institute, Milton and Sally Avery Center for the Arts, Bard College, 1981), p. 7.

24. "At first I painted very thickly, rubbing the paint with my finger after it was set, until the colors were blended and took on a shiny, seductive quality. People noticed that enamel-like surface mostly, and since that wasn't what I wanted to say in my painting, I quit it" (quoted in Ritter, "A Milton Avery Profile," p. 12).

25. Interview with Louis Kaufman, Los Angeles, February 1981. Also see "Modern Art View Explained by Artists," *Hartford Courant,* January 3, 1931, p. 32, in which Avery defended modern art by saying that the only difference between it and art of other periods lay in the use of color rather than outline to develop form.

26. The description of their courtship is based on discussions with Sally M. Avery.

27. On the question of Avery's birth date, see note 3, above.

28. Wallace Putnam (a painter friend from Hartford) and Sally's sister were their witnesses. Interview with Wallace Putnam, New York City, September 1981.

29. Wight, *Milton Avery,* p. 8.

30. Beginning in 1915, many important French artists—Marcel Duchamp, Francis Picabia, and Jacques Villon, for example—had become familiar figures in the Lincoln Arcade. When the Averys arrived, Stuart Davis had a studio next door; see James Johnson Sweeney, *Stuart Davis,* exhibition catalogue (New York: The Museum of Modern Art, 1945), p. 13.

31. Interview with Sally M. Avery.

32. Avery told Nathan Halper, owner of the HCE Gallery in Provincetown, that he refrained from showing the portrait to Hartley because he felt it revealed too accurately the feminine side of Hartley's character. Interview with Nathan Halper, New York City, April 1981.

33. Two examples of Avery's humor: During a medical checkup, Avery's doctor announced that he planned to take up painting when he retired. "When I retire," Avery responded, "I'm going to take up medicine" (quoted in Bob Niss, "Payson Gallery Exhibit of Avery Works Is a 'Coup,'" Portland (Maine) Evening Express, June 15, 1978, p. 40). Someone once asked Avery if there were a reason why his paintings' space was reminiscent of Eastern art. "Yes, I used to paint in East Hartford" (quoted in Florence Berkman, "Ex-Hartford Painter's Exhibit Emphasizes Color, Simplicity," Hartford Times, February 13, 1960, p. 3).

34. The Opportunity Gallery, run by Louise Gupferd, was located in the Art Center, on Fifty-sixth Street. The gallery gave little-known artists a chance to show their work; the exhibition which included Avery was the second for the gallery.

35. The two artists were introduced by the violinist Louis Kaufman. Kaufman, who had known Rothko in Portland, Oregon, and his wife became strong supporters of Avery's work during these lean years. Interview with Louis Kaufman, Los Angeles, February 1981.

36. Henry McBride, "It is highly important . . . ," New York Sun, March 15, 1927; Henry McBride, "Varied Gallery Attractions," New York Sun, May 11, 1929, Art section, p. 9.

37. Interview with Sally M. Avery.

38. Henry McBride, "Independent Artists Again at the Grand Central Palace," New York Sun, April 15, 1933, p. 9.

39. Henry McBride, "Attractions in Other Galleries," New York Sun, February 29, 1936, Art section, p. 14.

40. Edward Alden Jewell, "Now It Can Be Told," New York Times, May 12, 1929.

41. Edward Alden Jewell, "Art in Review," New York Times, April 18, 1932, p. 13.

42. Interview with Sally M. Avery.

43. See Ritter, "A Milton Avery Profile," p. 11.

44. Quoted in Charlotte Willard, "In the Art Galleries," New York Post, January 10, 1965, p. 46. The gatherings at Avery's house are described in Wight, Milton Avery, p. 13: "According to [Adolph] Gottlieb, Avery's views revolved around 'picture making' . . . his comments were in line with this intention. 'That white jumps out, doesn't hold its place in the picture.' General ideas, sophisticated ideas, an awareness of what was going on in the world, familiarity with current exhibitions, in short, a wide view: this is what the young Gottlieb found in Avery."

45. Interview with Sally M. Avery.

46. Alfred Jensen to Edward Downe; recounted by Downe in a conversation with the author, New York City, July 1981.

47. Gottlieb's description of the interaction of these artists in Gloucester is quoted in Miriam Roberts, Adolph Gottlieb Paintings, 1921–1956, exhibition catalogue (Omaha, Nebr.: Joslyn Art Museum, 1980), p. 8: "While he was painting a lot of portraits of his wife, I painted my wife. We'd paint scenes of Gloucester Harbor. I got into the habit of working the way he did, but that was sort of natural for me because I had always worked from sketches. We'd go out and make sketches of Gloucester Harbor or people on the beach up at Gloucester and then go home and paint them."

48. Dudensing purchased fifty paintings in 1935 for 1,500 dollars; in 1939 he purchased twenty for 1,000 dollars. He arranged to give Avery ten percent of the purchase price when paintings were sold, but since few had been sold by the time Avery left the gallery in 1943, he received little more than the initial purchase price. Shortly after Avery's departure from the gallery, Dudensing sold the thirty-five paintings that remained to Roy R. Neuberger for 5,000 dollars. Avery himself never benefited financially from these sales.

49. Henry McBride, "Attractions in the Galleries," New York Sun, March 16, 1935, p. 32.

50. Quoted in Charles Rosen, Arnold Schoenberg (New York: The Viking Press, 1975), p. 11.

51. Henry McBride was the first major critic to publicly compare Avery's work to Matisse's, in his review of the Avery/Hartl show at the Valentine Gallery in 1940. See "Hartl and Avery: Two American Artists Who Paint for Painters," New York Sun, February 24, 1940, Art section, p. 8. This comparison continued to haunt Avery throughout his career. After 1940, almost all writers on his work felt compelled to discuss it in relation to Matisse's, if only to point out the differences between the two artists.

52. Interview with Sally M. Avery. Avery's response is also quoted in Frank Crotty, "He Paints Like Matisse," Worcester Sunday Telegram, February 26, 1961, p. 21: "Some critics like to pin Matisse on me . . . but I don't think he has influenced my work."

53. Quoted in Alfred H. Barr, Jr., Matisse: His Art and His Public, reprint (New York: Arno Press for The Museum of Modern Art, 1966), p. 122.

54. Interview with Alex Katzman (Rosenberg's gallery director at that time), New York City, June 1981.

55. Avery's arrangement with Rosenberg was that he purchase twenty-five unframed paintings for a nominal sum each year, giving the artist thirty percent of the selling price when the paintings were sold.

56. Maude Riley, "Milton Avery Fills an International Gap," Art Digest, 19 (January 15, 1945), p. 10.

57. Reported in Ritter, "A Milton Avery Profile," p. 12.

58. Interview with Roy Neuberger (a major collector of Avery's work), New York City, June 1981.

59. Interview with Sally M. Avery.

60. Although the Whitney Museum of American Art was not interested in Avery's oil paintings, it did support his watercolors and had included several in prior Whitney Museum Biennials: the 1933 watercolor and print Biennial; the 1936 watercolor and pastel Biennial. The oil selected for the 1944 painting Biennial was *Fencers* (66). Information from Artists' Files and Registrar's Files, Whitney Museum of American Art, New York.

61. Interview with Sally M. Avery.

62. Telephone interview with Paul Rosenberg's son, Alexandre Rosenberg, July 1981.

63. Interview with Sally M. Avery.

64. "I do not use linear perspective, but achieve depth by color—the function of one color with another" (quoted in Ritter, "A Milton Avery Profile," p. 28).

65. Hans Hofmann, interview with Frederick S. Wight, 1952; notes from the interview are in the Archives of the Whitney Museum of American Art, New York.

66. Sally received 100 dollars a week for illustrating a column called "Child and Parent" in the *New York Times Magazine.*

67. Interview with Sally M. Avery.

68. Interview with March Avery Cavanaugh, New York City, June 1981.

69. The impetus for doing monotypes came from Avery's friend Boris Margo, who was also in Florida at the time and was using printer's ink in his own work; interview with Sally M. Avery. For a discussion of Avery's monotypes and their relation to his paintings, see Bonnie Lee Grad, *Milton Avery Monotypes,* exhibition catalogue (Princeton, N.J.: Firestone Library, Princeton University, 1977).

70. Interview with Sally M. Avery.

71. In a telephone interview, July 1981, Alexandre Rosenberg suggested that his father had used the excuse of moving to Venezuela as a way of extricating himself from the responsibility of handling Avery's work. However, Alexandre Rosenberg had taken over most of the control of Paul Rosenberg & Co. by that time and it is likely that it was his—not his father's—dissatisfaction with Avery that caused the break.

72. Clement Greenberg, "Art—Charles Burchfield, Milton Avery, Eugene Berman," *The Nation,* November 13, 1943, p. 565.

73. Clement Greenberg, "'American-Type' Painting," reprinted in *Art and Culture: Critical Essays* (Boston: Beacon Press, 1961), pp. 208–29.

74. Avery's personal relationship with Rothko had begun to deteriorate in the 1940s. Although Rothko remained a fervent supporter of Avery's art, in 1945 he had remarried and had stopped seeing many of the people who were associated with his first wife. According to Sally Avery, he was also something of a hypochondriac and could not bear being around anyone who was sick; his frequent visits to the Avery household ceased after Avery's first heart attack.

75. Interview with March Avery Cavanaugh, New York City, June 1981.

76. Interview with Sally M. Avery.

77. Quoted in Ritter, "A Milton Avery Profile," p. 28.

78. Quoted in *Contemporary American Painting,* exhibition catalogue (Urbana, Ill.: College of Fine and Applied Arts, University of Illinois, 1951), p. 159.

79. Quoted in Laurie Lisle, *Portrait of an Artist: A Biography of Georgia O'Keeffe* (New York: Seaview Books, 1980), p. 278.

80. Wight, *Milton Avery,* p. 16.

81. Ritter, "A Milton Avery Profile," p. 28.

82. Quoted in E. C. Goossen, *Stuart Davis* (New York: George Braziller, Inc., 1959), p. 16.

83. For example, see George Ferguson, *Signs and Symbols in Christian Art* (New York: Oxford University Press, 1966), pp. 12–13; *Funk and Wagnalls Standard Dictionary of Folklore* (New York: Funk and Wagnalls Co., 1949), vol. I, p. 142; Carl Jung, *The Structure and Dynamics of the Psyche,* trans. R. F. Hull (New York: Pantheon Books, 1960), p. 438.

84. Quoted in Henry Geldzahler, *The Sea by Milton Avery,* exhibition catalogue (Keene, N.H.: Louise E. Thorne Memorial Art Gallery, Keene State College, 1971), unpaginated.

85. Clement Greenberg, "Milton Avery," *Arts,* 32 (December 1957), p. 45.

86. The other artists selected were: Lee Gatch, Andrew Dasburg, José de Creeft, Mauricio Lasansky, Carl Morris, William Pachner, Walter Quirt, Abraham Rattner, Hugo Robus, Karl Schrag, and Everett Spruce.

87. Avery told Donald and Florence Morris after his second heart attack, "My hair felt electric and my head crazy. I have funny feelings inside my head." Quoted in Marsha Miro, "A Milton Avery Seashore Helps Ban the Winter," *Detroit Free Press,* January 21, 1979, p. 20D.

CHRONOLOGY

1885

March 7. Milton Clark Avery born to Russell N., a tanner, and Esther March Avery in Sand Bank (later Altmar), a town in north-central New York inland from Lake Ontario on the Salmon River. Youngest of four children: George (born 1877), Fabian E. (born 1881), and Minnie (born 1883).

1898

The Averys move into a two-family house in Wilson Station, Connecticut, near East Hartford, in the township of Windsor. Father continues to work as tanner. Family now includes Minnie's husband, George Sargent.

1900

August 2. Birth of first of five daughters to Minnie and George Sargent. The Sargents and Averys all live together in the same house in Wilson Station.

1901

Milton begins work at the Hartford Machine and Screw Company; employed for next two years, first as an aligner, then as an assembler.

1904

Finds job at the Underwood Manufacturing Company, where he works for the next six years as an assembler, a latheman, and finally as a mechanic.

1905

January 17. Father dies.

1905-11

Sometime during this period, Avery briefly enrolls in a lettering class at the Connecticut League of Art Students, Hartford, after seeing magazine ad promising that one can "Make money lettering." Class discontinued after one month; persuaded to transfer to life-drawing class for rest of term by League director, Charles Noel Flagg. Remains at the League until 1918.

1910

February 5. Fabian marries Mabel Anson; daughter born October 1910, son March 1912.

1911

Avery sufficiently committed to art by this time to list his occupation as that of artist.

1913

December 9. Fabian dies.

1915

February. First public exhibition of his work (*Glimpse of Farmington,* c. 1914; whereabouts unknown) in "Fifth Annual Exhibition of Oil Paintings and Sculpture," Annex Gallery, Wadsworth Atheneum, Hartford, Connecticut.

May 31. Brother-in-law, George Sargent, dies. Family moves into a four-family house at 98 Connecticut Boulevard, in a lower middle-class neighborhood of East Hartford.

1916
Resumes job as assembler at the Underwood Manufacturing Company.

1917
May. Begins working as a file clerk at the Travelers Insurance Companies; remains for the next five years in the Liability Claim Department; takes 6 P.M. to midnight shift in order to paint in the daytime.

1918
Transfers from the Connecticut League of Art Students to the School of the Art Society of Hartford.

1919
Wins top honors in portrait and life-drawing classes at the School of the Art Society of Hartford.

1920
Visits Gloucester, Massachusetts, for first time.

1921
Summer. Returns to Gloucester, where he spends the next several summers.

1923
Begins working at United States Tire and Rubber Company.

1924
Employed as construction worker in East Hartford.

Becomes member of the Connecticut Academy of Fine Arts.

Summer. Meets Sally Michel in Gloucester.

1925
May. Moves to New York City with artist friend Wallace Putnam, in order to be with Sally. After sev-

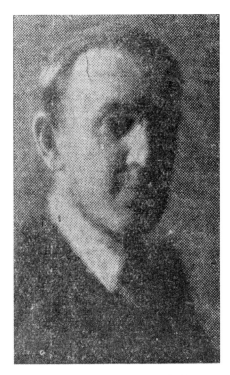

Milton Avery, 1924. Photo: *Hartford Courant*, 1924.

eral months of living with Putnam, takes a free room with another friend on Staten Island for a year.

1926
May 1. Marries Sally Michel; they go to Hartford for honeymoon.

Summer. Gloucester.

Couple lives in a one-room apartment in Lincoln Arcade, a studio complex at 1931 Broadway on the corner of Sixty-fifth Street. Social life revolves around artists in the building; occasional recreation consists of circus and burlesque shows, boxing matches, and swimming at Coney Island.

Attends Art Students League sketch class several evenings a week, a practice he continues through 1938.

Sally works as a freelance illustrator for *Progressive Grocer,* which her sister edits, in order to allow Avery to paint full time; later she illustrates ads for Macy's department store.

December 29. Mother dies.

1927

March. Included in Independents exhibition, his first exhibition in New York City.

Summer. Executes watercolors and gouaches on half sheets of dark construction paper.

1928

November. Bernard Karfiol selects two paintings by Avery from among 200 submissions for an Opportunity Gallery group show; other participants include Mark Rothko.

Beginning of friendship between Avery and Rothko.

1929

March. Awarded the Atheneum Prize of 200 dollars for *Brooklyn Bridge* (1929; whereabouts unknown) in the annual Connecticut Academy of Fine Arts exhibition.

October. First painting to enter a museum collection: Duncan Phillips purchases *Winter Riders* (1929) for the Phillips Memorial Gallery, Washington, D.C., out of a group exhibition at the Morton Galleries, New York.

Meets Adolph Gottlieb through Rothko.

1930

June. Finds a house for the summer in Collinsville, Connecticut, after abandoning rental on Friendship Island, Maine, because of inadequate accommodations.

December. Awarded Mr. and Mrs. Frank G. Logan Prize of 250 dollars for *White Horse* (1930; whereabouts unknown) in the annual watercolor exhibition at the Art Institute of Chicago.

1931

Summer. Gloucester.

1932

Summer. Gloucester; vacations with Gottlieb, Rothko, and Barnett Newman.

October 12. Birth of daughter, March.

Makes drypoints with discarded copperplates picked up from the printer of *Progressive Grocer.* Works in this medium until 1948.

1933

Summer. Gloucester.

1934

Summer. Gloucester; Rothkos join Averys.

1935

Joins the Valentine Gallery. First one-man show there in March. Dr. Albert Barnes purchases *The Nursemaid* (1934; Barnes Foundation, Merion, Pa.) out of the exhibition.

Summer. Jamaica, Vermont.

1936

Summer. Jamaica, Vermont.

1937

Summer. Rawsonville, Vermont, five miles from Jamaica. The Gottliebs and Newmans come for visits.

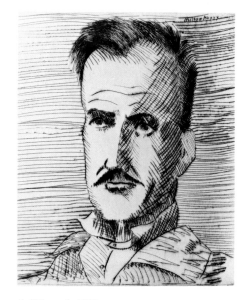

Self Portrait, 1937
Drypoint, edition of 60; 7 15/16 x 6½ inches (20.1 x 16.5 cm). Associated American Artists, Inc., New York

1938

Works briefly in the Easel Division of the Works Progress Administration/Federal Art Project; stops because he resents signing the obligatory pauper's oath.

Summer. Travels to the Gaspé Peninsula, Quebec, Canada; rents a cabin for two months at Rivière-au-Renard ("River of the Fox").

Moves to 294 West Eleventh Street in Greenwich Village so that March can attend the Little Red School House, a grammar school popular among artists and intellectuals.

Stops attending the Art Students League; instead, Averys and friends hire a model several times a week and sketch at each other's homes.

1939

Summer. Rawsonville, Vermont.

1940

Sally gets a job as illustrator for the "Child and Parent" column in the *New York Times Magazine.*

Summer. Rawsonville, Vermont.

1941

Summer. Drives cross-country to California; stops in Yellowstone and Glacier national parks on the way. Stays one month in Laguna Beach, California.

1942

Summer. Stays in New York because of wartime gas rationing.

November. Last show with the Valentine Gallery.

1943

Spring. Leaves the Valentine Gallery and joins Paul Rosenberg & Co.; has first show there in June. On Rosenberg's advice, begins dating pictures on front of canvas.

Milton Avery, 1944.

The Valentine Gallery sells Roy Neuberger its inventory of thirty-five Avery paintings.

Summer. Gloucester. The Gottliebs and Rothkos are daily guests.

1944

January. His first one-man museum exhibition opens at the Phillips Memorial Gallery, Washington, D.C.

Summer. Gloucester.

1945

January. Concurrent exhibitions at the Rosenberg and Durand-Ruel galleries; shows with both dealers for next five years.

Summer. Gloucester.

1946

Summer. Travels in Mexico for three months; stays six weeks in San Miguel de Allende.

1947

February. "My Daughter, March" exhibition, his first retrospective survey, opens at the Durand-Ruel Galleries, New York.

Summer. Canada. Visits a collector near Toronto to deliver a painting; stays three weeks before proceeding to the Canadian Northwest and Oregon.

1948
Summer. Pemaquid Point, Maine.

Laurel Gallery publishes a portfolio of five of his drypoints in an edition of 100.

December. Receives first prize for the watercolor *Sea and Rocks* (1944; whereabouts unknown) in the "Baltimore National Watercolor Exhibition," the Baltimore Museum of Art. Health very poor; advised by doctor to remain at home.

Milton Avery sketching, with his daughter, March, and their dog, Picasso, in Woodstock, New York, 1950.

Winter. Health still poor; spends winter at the Research Art Colony for writers and painters in Maitland, Florida, near Orlando.

Experiments with monotypes; executes over 200 during the next two years.

Milton Avery, Pemaquid Point, Maine, 1948.

1949
January. Suffers a major heart attack; in hospital for six weeks. Last show with Paul Rosenberg & Co.

Summer. Recuperates from heart attack at a friend's house in Millbrook, New York.

Milton Avery and his wife, Sally, in their studio, Woodstock, New York, 1950.

1950

April. Returns to New York.

Spring. Rosenberg and Avery terminate their association; Rosenberg sells his fifty Avery paintings to Roy Neuberger.

Summer. Woodstock, New York.

Winter. Returns to the Research Art Colony, Maitland, Florida.

Makes lithographs this year and next for fund-raising ball sponsored by Artists Equity Association of New York.

1951

Joins the newly opened Grace Borgenicht Gallery; has first exhibition there in October.

Summer. Woodstock.

The Avery family, Woodstock, New York, 1951.

1952

Summer. Visits Europe for the first time; travels to London, Paris, and the French Riviera.

Executes woodcuts; works in this medium until 1955,

when the physical effort of cutting and printing becomes too taxing.

December. Retrospective exhibition opens at the Baltimore Museum of Art.

Milton and Sally Avery in their Eleventh Street apartment, 1953.

1953

Summer. Residency at the MacDowell Colony, Peterborough, New Hampshire; both Milton and Sally given studios.

1954

June. Daughter, March, graduates from college and marries Philip Cavanaugh.

Summer. MacDowell Colony.

1955

Summer. Invited to spend summer at Yaddo, an art colony near Saratoga Springs, New York.

1956

Summer. MacDowell Colony.

1957

Summer. Provincetown, Massachusetts. Executes first large-format canvases.

December. Clement Greenberg publishes a major article on Avery in *Arts.*

1958
Summer. Provincetown.

August. Exhibits large-format paintings at the HCE Gallery in Provincetown.

1959
Summer. Provincetown.

November. Health deteriorating; takes nitroglycerin every day for pains in his chest. Moves to a Central Park West apartment because of difficulty walking up the stairs to Greenwich Village apartment.

Winter. Doctor recommends going to a warm climate for his health. Sally quits her job and hires chauffeur to drive them to Florida; finds house in Key West for the winter.

Milton Avery's studio in the Averys' Central Park West apartment, 1960.

1960
February. Retrospective exhibition opens at the Whitney Museum of American Art, New York, under the auspices of the American Federation of Arts.

Summer. Provincetown.

October. Suffers second heart attack; returns to New York in an ambulance.

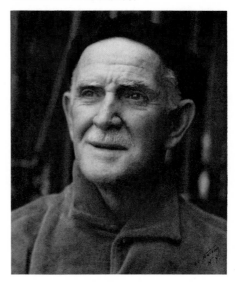

Milton Avery, November 1960.

1961
Recuperating from heart attack. Requires constant nursing; needs oxygen at night.

Summer. Remains in New York because of health.

1962
Hilton Kramer writes the first book on Avery, *Milton Avery: Paintings, 1930–1960.*

Summer. Lake Hill, New York.

1964
February. Executes last painting.

March 6. Enters Montefiore Hospital; remains there in intensive care.

1965
Dies on January 3.

January 7. Memorial service held at the Society for Ethical Culture, New York. Buried in Artists Cemetery, Woodstock, New York.

BIBLIOGRAPHY & EXHIBITION HISTORY

Because much of the literature on Milton Avery takes the form of exhibition reviews, the bibliography and exhibition history have been combined into one chronological list. Books and articles unrelated to specific exhibitions are given first in each year, followed by a listing, in italics, of the year's exhibitions; an asterisk denotes a one-man exhibition. Catalogues are cited within data on individual exhibitions; reviews are listed immediately following each exhibition, and are indented.

Many reviews of Avery's exhibitions have appeared in small newspapers across the country. Some of them exist in the form of clippings in museum and gallery files or in Sally Avery's notebooks (now on deposit at the Archives of American Art). Every effort has been made to trace these reviews to their sources. In some cases, however, precise page numbers or other bibliographical data could not be obtained. When the title of a review is unknown, the first words of the clipping are given.

1915
Annex Gallery, Wadsworth Atheneum, Hartford, Conn. "The Connecticut Academy of Fine Arts: Fifth Annual Exhibition of Oil Paintings and Sculpture." February 15-28. Brochure: checklist.

1917
Annex Gallery, Wadsworth Atheneum, Hartford, Conn. "The Connecticut Academy of Fine Arts: Seventh Annual Exhibition of Oil Paintings and Sculpture." February 12-26. Brochure: checklist.

Annex Gallery, Wadsworth Atheneum, Hartford, Conn. "The Connecticut Academy of Fine Arts: First Exhibition of Water Colors and Pastels." November 5-19. Brochure: checklist.

1920
Annex Gallery, Wadsworth Atheneum, Hartford, Conn. "The Connecticut Academy of Fine Arts: Tenth Annual Exhibition of Oil Paintings and Sculpture." April 19-May 2. Brochure: checklist.

1921
Annex Gallery, Wadsworth Atheneum, Hartford, Conn. "The Connecticut Academy of Fine Arts: Eleventh Annual Exhibition of Oil Paintings and Sculpture." April 18-May 1. Brochure: checklist.

1922
Annex Gallery, Wadsworth Atheneum, Hartford, Conn. "The Connecticut Academy of Fine Arts: Twelfth Annual Exhibition of Oil Paintings and Sculpture." April 17-30. Brochure: checklist.

1923
Wadsworth Atheneum, Hartford, Conn. "Milton Avery, Owen Smith, Wallace Putnam, James Conlon." March 10-18.

"Art Lovers Urged to Attend Exhibit: Paintings Shown at Annex of Wadsworth Atheneum—Subjects Varied." *Hartford Times,* March 11, 1923.

The Clubhouse, Gloucester Society of Artists, Gloucester, Mass. "Opening Exhibition." July 7-30.

The Clubhouse, Gloucester Society of Artists, Gloucester, Mass. Group exhibition. July 30-September.

Wiley Gallery, Hartford, Conn. "Francis H. Storrs, Cornelia Vetter, Milton C. Avery, and Owen E. Smith." October.

[Putnam, Wallace]. "Four Artist Exhibition at Wiley Gallery." *Hartford Courant,* October.

1924
Annex Gallery, Wadsworth Atheneum, Hartford, Conn. "The Connecticut Academy of Fine Arts: Fourteenth Annual Exhibition of Oil Paintings and Sculpture." April 14-30. Brochure: checklist.

The Clubhouse, Gloucester Society of Artists, Gloucester, Mass. Group exhibition. July.

**Green Gate Studio, Hartford, Conn. "Milton Avery." November.*

Ringius, Carl. "Hartford." *Art News,* 23 (November 8, 1924), p. 8.

Old Gate Studio, Hartford, Conn. Group exhibition. December.

[Putnam, Wallace]. "Art." *Hartford Courant,* 1924.

Ringius, Carl. "Hartford." *Art News,* 23 (December 20, 1924), p. 9.

"Studio Windows." (Clipping.)

1925
Annex Gallery, Wadsworth Atheneum, Hartford, Conn. "The Connecticut Academy of Fine Arts: Fifteenth Annual Exhibition of Oil Paintings and Sculpture." April 13-30. Brochure: checklist.

1926
Annex Gallery, Wadsworth Atheneum, Hartford, Conn. "The Connecticut

Academy of Fine Arts: Sixteenth Annual Exhibition of Oil Paintings and Sculpture." April 12–25. Brochure: checklist.

The Clubhouse, Gloucester Society of Artists, Gloucester, Mass. Group exhibition. July.

"Art and Theatre Notes." Cape Ann Shore, July 17, 1926, p. 3.

1927

Waldorf-Astoria Hotel, New York, N.Y. "The 11th Annual Exhibition of the Society of Independent Artists." March 11–April 3.

McBride, Henry. "It is highly important. . . ." New York Sun, March 15, 1927.

Annex Gallery, Wadsworth Atheneum, Hartford, Conn. "The Connecticut Academy of Fine Arts: Seventeenth Annual Exhibition of Oil Paintings and Sculpture." April 16–May 1. Brochure: checklist.

1928

Waldorf-Astoria Hotel, New York, N.Y. "The 12th Annual Exhibition of the Society of Independent Artists." March 9–April 1.

Mannes, Marya. "Gallery Notes." Creative Art, 2 (April 1928), p. VIII.

Morgan Gallery, Morgan Memorial, Hartford, Conn. "The Connecticut Academy of Fine Arts: Eighteenth Annual Exhibition of Oil Paintings and Sculpture." March 17–April 1. Brochure: checklist.

*Frank K. M. Rehn Gallery, New York, N.Y. "Milton Avery: Watercolors." November.

"Exhibitions." International Studio, November 1928, p. 82.

"Attractions in the Local Galleries." New York Sun, November 17, 1928, p. 7.

Opportunity Gallery, New York, N.Y. Group exhibition. November 15–December 8. Artists selected by Bernard Karfiol.

"Attractions in the Local Galleries." New York Sun, November 17, 1928, p. 7.

Pemberton, Murdock. "Marin and Others." Creative Art, 3 (December 1928), p. 45.

—————. "The Art Galleries." The New Yorker, December 1, 1928, p. 105.

Opportunity Gallery, New York, N.Y. Group exhibition. December.

McBride, Henry. "Various Attractions in the Galleries." New York Sun, January 12, 1929, p. 12.

1929

Morgan Gallery, Morgan Memorial, Hartford, Conn. "The Connecticut Academy of Fine Arts: Nineteenth Annual Exhibition of Oil Paintings and Sculpture." March 16–April 1. Brochure: checklist.

"Jury Safe This Time." Hartford Courant, March 12, 1929.

Frank K. M. Rehn Gallery, New York, N.Y. "All Figure." May.

Jewell, Edward Alden. "Now It Can Be Told." New York Times, May 12, 1929.

Morton Galleries, New York, N.Y. "Review of 1928–1929." May 5–29.

Breuning, Margaret. "Group Exhibitions Feature the Week and Indicate the Closing of Art Season." New York Post, May 11, 1929, p. S-5.

McBride, Henry. "Varied Gallery Attractions." New York Sun, May 11, 1929, Art section, p. 9.

Morton Galleries, New York, N.Y. "Portraits." October 7–28.

Breuning, Margaret. "The Art World Decidedly Alive Again with Opening Exhibitions." New York Evening Post, October 12, 1929, p. M5.

Goodrich, Lloyd. "The Opening Season: A Portrait Group." The Arts, 16 (October 1929), pp. 121–22.

Jewell, Edward Alden. "French Art Finds the Latch String Out Chez Nous: Other Exhibitions of the Week Commented Upon." New York Times, October 13, 1929, p. 12x.

"Noted in New York Galleries." Parnassus, 1 (December 1929), pp. 3–5, 9.

College Art Association, Chicago, Ill. Group exhibition. November. Traveled to: Yale University, New Haven, Conn.; Princeton University, Princeton, N.J.; Cornell University, Ithaca, N.Y.; Dartmouth College, Hanover, N.H.

"College Art Show Opens in Chicago." Art News, 23 (November 8, 1929), p. 9.

Morton Galleries, New York, N.Y. "Ten Young American Painters." November–December.

Breuning, Margaret. "Water Color Exhibitions Predominate in Openings of the Local Galleries." New York Evening Post, November 30, 1929, p. M5.

Burrows, Carlyle. "News and Exhibitions of the Week in Art." New York Herald Tribune, December 1, 1929, pp. 8, 11.

Harris, Ruth Green. "In Various Galleries." New York Times, December 1, 1929, p. 22.

"The Morton Galleries. . . ." New York Sun, November 27, 1929.

"Noted in New York Galleries." Parnassus, 1 (December 1929), pp. 3–5, 9.

1930

McMahon, Audrey. "A Perspective on the New York Season." Parnassus, 2 (May 1930), pp. 3–7.

The Murai Gallery, New York, N.Y. "American Moderns." March–April.

Burrows, Carlyle. "News and Exhibitions of the Week in Art." New York Herald Tribune, March 23, 1930, p. 11.

Eddy, Frederick W. "Modern Painters Seen in Notable Group." New York World, March 30, 1930, p. 9M.

Harris, Ruth Green. "Further Comment on Exhibitions of the Week: Seen in the Galleries." New York Times, March 30, 1930, p. 13.

"Hartford Artists Exhibit in New York." Hartford Times, March 23, 1930.

McBride, Henry. "Attractions in Various Galleries." New York Sun, March 29, 1930, Art section, p. 6.

Morton Galleries, New York, N.Y. "Paintings: Milton Avery, Clara Lea Cousins." March 24–April 7.

Breuning, Margaret. "Milton Avery, who is. . . ." New York Evening Post, March 29, 1930.

Burrows, Carlyle. "News and Exhibitions of the Week in Art." New York Herald Tribune, March 30, 1930, p. 11.

Klein, Jerome. "The good people of Connecticut. . . ." Chicago Evening Post, April 8, 1930.

Upton, Melville. "Attractions in Various Galleries." *New York Sun,* March 26, 1930, p. 19.

Vaughan, Malcolm. "New Exhibitions of This Week." *New York American,* March 31, 1930, p. M-11.

Frank K. M. Rehn Gallery, New York, N.Y. Group exhibition. October.

Klein, Jerome. "American Scene Interpreted in Paint." *Chicago Evening Post,* October 14, 1930.

Morton Galleries, New York, N.Y. "Watercolors by Contemporary Americans." October 15–November 20.

Bignou, Etienne, "Gallery Notes." *Parnassus,* 3 (November 1930), p. 18.

Breuning, Margaret. "The Art Season Shows Signs of Rapidly Getting into Usual Stride." *New York Evening Post,* October 11, 1930, p. 7.

Klein, Jerome. "Mrs. Morton opens. . . ." *Chicago Evening Post,* November 18, 1930.

Upton, Melville. "Milton Avery, a grizzled veteran. . . ." *New York Sun,* October 11, 1930.

The Art Institute of Chicago, Chicago, Ill. "11th Annual Exhibition." December.

"Avery Captures Prize at Chicago." *Hartford Times,* December 1930.

"Milton Avery Wins Art Prize in Chicago." *Hartford Times,* December 1930.

Morgan Memorial, Wadsworth Atheneum, Hartford, Conn. "Avery, Berkman, Cheney, O'Callahan." December 21–January 11, 1931. Brochure: checklist.

" 'Modern' Art View Explained by Artists: Milton Avery and Aaron Berkman Discuss Own Paintings at Morgan Memorial." *Hartford Times,* January 3, 1931, p. 5.

"Modern Exhibit Opens at Museum." *Hartford Times,* December 22, 1930, p. 27.

"Modern Exhibit Opens on Monday." *Hartford Times,* December 20, 1930.

1931

Morgan Memorial, Hartford, Conn. "The Connecticut Academy of Fine Arts: Twenty-first Annual Exhibition of Oil Paintings and Sculpture." March 7–25. Brochure: checklist.

Morton Galleries, New York, N.Y. "Oils and Watercolors by Young Americans." May 1–June 30.

Morton Galleries, New York, N.Y. "Recent Watercolors." October 17–31.

Jewell, Edward Alden. "New Morton Gallery Opens." *New York Times,* October 13, 1931, p. 32.

Sterne, Katherine Grant. "In the exhibition. . . ." *Gotham Life,* October 18, 1931.

————— . "In the New York Galleries: Six Watercolors at Morton Galleries." *Parnassus,* 4 (November 1931), pp. 8–9.

Vaughan, Malcolm. "Young Americans at Morton Gallery." *New York American,* October 18, 1931, p. M5.

1932

Dudensing Gallery, New York, N.Y. "Portraits of Young People by Contemporary Artists." January.

Glassgold, Adolph. "Around the Galleries." *Creative Art,* 10 (February 1932), p. 138.

Gallery 144 West 13th Street, New York, N.Y. "Eight Landscapes by Eight Americans." January.

**Gallery 144 West 13th Street, New York, N.Y. "Milton Avery: Gouache Paintings." January 16–31.*

McBride, Henry. "Attractions in Other Galleries." *New York Sun,* January 23, 1932, p. 5.

N[irdlinger], V[irginia]. "On View in the New York Galleries." *Parnassus,* 4 (February 1932), p. 17.

Sterne, K[atherine] G[rant]. "Avery Finds a Formula." *New York Times,* January 23, 1932, p. 13.

Vaughan, Malcolm. "In the Parade of Exhibitions This Week." *New York American,* January 24, 1932, p. M5.

Morton Galleries, New York, N.Y. "Watercolors." January 18–31.

Gallery 144 West 13th Street, New York, N.Y. "Choice Examples of Living Art." February 13–March 4.

"In the group show at the Gallery 144 West Thirteenth Street, Milton Avery has. . . ." (Clipping.)

Glassgold, Adolph. "Around the Galleries." *Creative Art,* 10 (February 1932), pp. 141, 143.

**Gallery 144 West 13th Street, New York, N.Y. "Paintings: Milton Avery." April 16–May 6. Brochure: checklist.*

Breuning, Margaret. "Other Art Events." *New York Evening Post,* April 30, 1932, p. 53.

Burrows, Carlyle. "Art News and Comment: Milton Avery." *New York Herald Tribune,* April 24, 1932, section 7, p. 9.

Fisher, Rose Mary. "At 144 West 13th Street Milton Avery. . . ." *Chicago Evening Post,* April 26, 1932.

Jewell, Edward Alden. "Art in Review." *New York Times,* April 18, 1932, p. 13.

Pemberton, Murdock. "The Art Galleries." *The New Yorker,* May 7, 1932, pp. 43–44.

Shelley, Melvin Geer. "At the Galleries: Gallery 144 West 13th Street." *Creative Art,* 10 (June 1932), p. 476.

Upton, Melville. "Just what esoteric. . . ." *New York Sun,* April 21, 1932.

Gallery 144 West 13th Street, New York, N.Y. "John Kane, Judson Smith, Ben Benn, Milton Avery, Moses Soyer, Nicholas Vasilieff, Paul Rohland." September.

Jewell, Edward Alden. "Art: Two Downtown Exhibits." *New York Times,* September 13, 1932, p. 19.

Shelley, Melvin Geer. "At the Galleries: Gallery 144 West 13th Street." *Creative Art,* 11 (October 1932), p. 149.

Gallery 144 West 13th Street, New York, N.Y. "Watercolors." November.

Jewell, Edward Alden. "Art in Review: An Exhibition of Watercolors." *New York Times,* November 6, 1932, p. 37.

1933

"Among the Artists." *Allied Art Bulletin,* August 1933.

"Modern Art Akin to Classic Music." *Oregon Sunday Journal,* October 29, 1933, p. 3.

Gallery 144 West 13th Street, New York, N.Y. "Milton Avery: Recent Watercolors." January 27-February 16. Catalogue: ill., checklist.

> Breuning, Margaret. "Group Exhibitions and One-Man Shows Bring New Works to Local Galleries." *New York Evening Post,* February 11, 1933, p. 8.
>
> Burrows, Carlyle. "Notes on Art Exhibitions: Water Colors by a Modern Painter." *New York Herald Tribune,* February 5, 1933, section 7, p. 8.
>
> McBride, Henry. "Attractions in the Galleries." *New York Sun,* February 4, 1933, p. 9.

Grand Central Palace, New York, N.Y. "The 17th Annual Exhibition of the Society of Independent Artists." April 13–May 6.

> McBride, Henry. "Independent Artists Again at the Grand Central Palace." *New York Sun,* April 15, 1933, p. 9.

Whitney Museum of American Art, New York, N.Y. "First Biennial Exhibition of Contemporary American Sculpture, Watercolors, and Prints." December 5–January 11, 1934. Catalogue: ill., checklist; Foreword by Juliana Force.

1934

Grand Central Palace, New York, N.Y. "The 18th Annual Exhibition of the Society of Independent Artists." April 13–May 6.

> "Propaganda and Freedom Mark Independents." *Art Digest,* 8 (April 15, 1934), p. 7.

Rockefeller Center, New York, N.Y. "The First Municipal Art Exhibition." May.

> Shelley, Melvin Geer. "Fifty-seventh Street." *Studio News,* 5 (May 1934), p. 23.

Mellon Galleries, Philadelphia, Pa. "Avery and Orr." May 1–17.

> Bonte, C. H. "Avery and Orr Paintings Arouse Much Enthusiasm." *Philadelphia Inquirer,* May 6, 1934.

Boyer Galleries, Philadelphia, Pa. "Milton Avery." June.

> "At Boyer Galleries." *Philadelphia Evening Public Ledger,* June 8, 1934.
>
> Bailey, Weldon. "Boyer Galleries." *Philadelphia Record,* June 10, 1934.
>
> Bonte, C. H. "A New Print Exhibition and Milton Avery Work." *Philadelphia Inquirer,* June 10, 1934.

Theodore A. Kohn Gallery, New York, N.Y. "Gouaches by Milton Avery." July 11–21.

> Burrows, Carlyle. "A Three Part Show of Modern Paintings." *New York Herald Tribune,* July 15, 1934, p. 6-V.
>
> Genauer, Emily. "Violent art. . . ." *New York World Telegram,* July 1934.
>
> Goodsoe, Robert Ulrich. "The Art Marts." (Clipping.)
>
> Jewell, Edward Alden. "New York Exhibitions." *New York Times,* July 15, 1934, section 10, p. 7.

1935

Stavola Galleries, Hartford, Conn. "Milton Avery, Aaron Berkman, Irwin Hoffman." March.

> Murray, Marian. "Art Show Gives Fling to Youth." *Hartford Times,* March 1935.

T. H. P. "Two Former Local Artists Exhibit Here." *Hartford Courant,* March 26, 1935, p. 20.

Valentine Gallery, New York, N.Y. "Milton Avery." March. Brochure: checklist.

> Breuning, Margaret. "Valentine Gallery." *New York Post,* March 16, 1935, p. 24.
>
> Burrows, Carlyle. "Notes and Commentary on Events in Art: A Display by Milton Avery." *New York Herald Tribune,* March 17, 1935, p. 10-V.
>
> Devree, Howard. "A Reviewer's Notebook: Briefs on Twenty Shows." *New York Times,* March 17, 1935, section 8, p. 7.
>
> McBride, Henry. "Attractions in the Galleries." *New York Sun,* March 16, 1935, p. 32.
>
> Morrell, Mary. "Exhibitions in New York." *Art News,* 33 (March 16, 1935), p. 14.

Valentine Gallery, New York, N.Y. "American Exhibition." September.

> Burrows, Carlyle. "Notes and Comments on Events in Art: Eight Americans at Valentine's." *New York Herald Tribune,* September 15, 1935, p. 8-V.
>
> Genauer, Emily. "His Charms Not Obvious." *New York World Telegram,* September 14, 1935, section 2, p. 26.
>
> Jewell, Edward Alden. "In the Local Spotlight." *New York Times,* September 15, 1935, section 9, p. 7.

1936

Choate School, Wallingford, Conn. "The Chrysler Collection." January 17–February 13.

> Dulles, C. A. "The Walter P. Chrysler Art Collection." *The Choate News,* January 18, 1936, p. 3.

Whitney Museum of American Art, New York, N.Y. "Second Biennial Exhibition, Part II: Watercolors and Pastels." February 18–March 18. Catalogue: ill., checklist; Foreword.

> McB[ride], H[enry]. "American Watercolors on View: Whitney Museum's Second Biennial Exhibition Devoted to Them." *New York Sun,* February 22, 1936, p. 26.
>
> ———. "Attractions in Other Galleries." *New York Sun,* February 29, 1936, Art section, p. 14.

Valentine Gallery, New York, N.Y. "Milton Avery Watercolors." February 24–March 7.

> Burrows, Carlyle. "Notes and Comment on Events in Art: Milton Avery." *New York Herald Tribune,* March 1, 1936, section 9, p. 10.
>
> Genauer, Emily. "Milton Avery at Valentine." *New York World Telegram,* February 29, 1936, p. 12B.
>
> J[ewell], E[dward] A[lden]. "Solo Exhibitions by Nine Artists." *New York Times,* March 1, 1936, p. X-9.
>
> McBride, Henry. "Attractions in Other Galleries." *New York Sun,* February 29, 1936, Art section, p. 14.
>
> Klein, Jerome. "Milton Avery Shows Finesse in His Work." *New York Post,* February 29, 1936, p. 24.
>
> Simonton, Thomas. "Cézanne and Renoir in Harriman Show: Other Exhibitions." *New York American,* February 29, 1936, p. 16.

1937

The Detroit Institute of Arts, Detroit, Mich. "Selected Exhibition of the Walter P. Chrysler, Jr., Collection." October.

1938

Boswell, Peyton. "Comments: The Burden of Proof." *Art Digest,* 12 (May 1, 1938), p. 3.

*Valentine Gallery, New York, N.Y. "Milton Avery." April 11–30. Brochure: checklist.

 Bird, Paul. "The Fortnight in New York: A Question of Drawing." *Art Digest,* 12 (May 1, 1938), p. 18.

 Genauer, Emily. "Art Joins War on Slums: Two Different Shows Alike." *New York World Telegram,* April 16, 1938.

 Klein, Jerome. "Taubes Shows Fine Technique in Bold Strokes." *New York Post,* April 16, 1938, p. 12.

 McBride, Henry. "Attractions in the Galleries." *New York Sun,* April 16, 1938, p. 12.

 "Milton Avery Makes a Three-Year Report." *Art Digest,* 12 (April 15, 1938), p. 10.

 "New Exhibitions of the Week." *Art News,* 36 (April 16, 1938), p. 15.

Avery Memorial Hall, Wadsworth Atheneum, Hartford, Conn. "50th Anniversary Show." December 12–24.

 Murray, Marian. "League of Art Students Show at Museum—Range of Interest Over 50 Years Seen in Exhibition: Paintings on Similar Subjects on Exhibition at Avery." *Hartford Times,* December 17, 1938, p. 7.

1939

Portland Art Museum, Portland, Oreg. "An Exhibition of Contemporary Paintings." September 15–October 29. Catalogue: ill., checklist; text by Stephen Bourgeois.

1940

Valentine Gallery, New York, N.Y. "Leon Hartl and Milton Avery." February 19–March 2. Catalogue: checklist.

 Breuning, Margaret. "In the World of Art: Milton Avery." *New York American,* February 25, 1940, p. 6M.

 Devree, Howard. "A Reviewer's Notebook." *New York Times,* February 25, 1940, section 9, p. 10.

 Frost, Rosamund. "Art." *Town and Country,* February 1940.

 J. W. L. "New Exhibitions of the Week." *Art News,* 38 (February 24, 1940), p. 11.

 Klein, Jerome. "Two Americans." *New York Post,* February 24, 1940, Art section, p. 10.

 McBride, Henry. "Hartl and Avery: Two American Artists Who Paint for Painters." *New York Sun,* February 24, 1940, Art section, p. 8.

 ——————. "Nature with Variations Seen Through Milton Avery's Personality: It Gets Itself Across." *New York Sun,* March 1940.

American Fine Arts Building, New York, N.Y. "The 24th Annual Exhibition of the Society of Independent Artists." April 18–May 12.

 G[enauer], E[mily]. "Dawn of the Renaissance to the New Independents." *New York World Telegram,* April 27, 1940, p. 34.

 Breuning, Margaret. "In the Art World." *New York American,* April 28, 1940, p. 6-M.

Portland Art Museum, Portland, Oreg. "20th Century Figure Painting." July 15–September 15. Catalogue: checklist, essay.

1941

Millier, Arthur. "The Arts and Artists: The Art Thrill of the Week." *Los Angeles Times,* August 10, 1941, section 3, p. 8.

1942

Phillips Memorial Gallery, Washington, D.C. "American Paintings and Watercolors." March 15–31. Catalogue: ill., checklist.

Marquié Gallery, New York, N.Y. Group exhibition. October 17–November 4.

 "Varied Moderns." *Art Digest,* 17 (October 15, 1942), p. 22.

*Valentine Gallery, New York, N.Y. "Milton Avery." November 30–December 26. Catalogue: checklist; text by Samuel M. Kootz.

 Farber, Manny. "Chaim Gross, Milton Avery, and William Steig." *Magazine of Art,* 36 (January 1943), pp. 10–15.

 F[rost], R[osamund]. "Milton Avery, American Fauve." *Art News,* 41 (December 15, 1942), p. 28.

1943

"An Interview with Milton Avery." *Art Students League Bulletin,* April 1943.

Kootz, Samuel M. *New Frontiers in American Painting.* New York: Hastings House, Publishers.

Phillips Memorial Gallery, Washington, D.C. "Six Loan Exhibitions." January 17–February 15. Catalogue: checklist; essay by C. L. W.

*Paul Rosenberg & Co., New York, N.Y. "Recent Paintings by Milton Avery." June 1–26.

 Genauer, Emily. "Milton Avery Gains in Stature." *New York World Telegram,* June 5, 1943, p. 4.

 Jewell, Edward Alden. "In the Realm of Art: Spring Slows to a Decorous Pace." *New York Times,* June 6, 1943, p. 9.

 "The Passing Shows." *Art News,* 42 (June/July 1943), p. 44.

 R[iley], M[aude]. "Milton Avery." *Art Digest,* 17 (July 1, 1943), p. 20.

 Upton, Melville. "Art Gallery Doings." *New York Sun,* June 4, 1943, p. 26.

*Paul Rosenberg & Co., New York, N.Y. "Recent Watercolors by Milton Avery." October 15–November 15. Catalogue: checklist.

 Genauer, Emily. "Art and Antiques: Milton Avery's New Work Shows Amazing Changes." *New York World Telegram,* October 23, 1943, p. 6.

 Greenberg, Clement. "Art—Charles Burchfield, Milton Avery, Eugene Berman." *The Nation,* November 13, 1943, pp. 565–66.

 McBride, Henry. "Attractions in the Galleries." *New York Sun,* October 22, 1943, p. 25.

 "The Passing Shows." *Art News,* 42 (November 1, 1943), pp. 21, 22.

 Riley, Maude. "Fifty-seventh Street in Review." *Art Digest,* 18 (November 1, 1943), p. 20.

Whitney Museum of American Art, New York, N.Y. "1943–44 Annual Exhibition of Contemporary American Art: Sculpture, Paintings, Watercolors, and Drawings." November 23–January 4, 1944. Brochure: checklist; Introduction by Juliana Force.

1944

Sweeney, James Johnson. "Five American Painters." *Harper's Bazaar,* 78 (April 1944), pp. 76–77.

Taylor, Tim. "Artists Irked by Sale of Canvases for Junk." *New York World Telegram*, February 21, 1944, p. 16.

Museum of Art, Rhode Island School of Design, Providence, R.I. "American Painters of the Present Day." *January 7-February 14. Catalogue: bio., ill., checklist.*

Phillips Memorial Gallery, Washington, D.C. "Watercolors by Milton Avery." January 9-31. Catalogue: checklist.

Paul Rosenberg & Co., New York, N.Y. "Recent Paintings: Milton Avery." February 15-March 11. Catalogue: checklist.

Breuning, Margaret. "Fecund Milton Avery." *Art Digest*, 18 (March 1, 1944), p. 20.

Coates, Robert M. "The Art Galleries: In Black and White." *The New Yorker*, February 26, 1944, pp. 63-65.

Devree, Howard. "From a Reviewer's Notebook: Brief Comments on Some Recently Opened Group and One Man Shows." *New York Times*, February 20, 1944, section 2, p. 6.

Genauer, Emily. "Some Good Solo Exhibits." *New York World Telegram*, February 19, 1944, p. 6.

McBride, Henry. "Attractions in the Galleries." *New York Sun*, February 19, 1944, p. 9.

"The Passing Shows." *Art News*, 43 (March 15, 1944), p. 19.

Grand Central Art Galleries, New York, N.Y. "The American-British Good Will Exhibition of Contemporary Art." March 8-18. Traveled to Hertford House, London, England. Organized by Artists for Victory, Inc. Curated by Hobart Nichols, Leon Kroll, and Max Weber.

Juta, Jan. "Showing Britain U.S. Art Today." *Art News*, 43 (March 1, 1944), pp. 9-12.

Durand-Ruel Galleries, New York, N.Y. "Milton Avery." April-May.

Arts Club of Chicago, Chicago, Ill. "Evsa Model, James Thurber, Milton Avery." May 2-31.

"The Arts Club last. . . ." (Clipping.)

Bulliet, C. J. "Artless Comment on the Seven Arts." *Chicago Sun*, May 6, 1944.

"Evsa Model, along with. . . . " (Clipping.)

Department of Fine Arts, Carnegie Institute, Pittsburgh, Pa. "Painting in the United States, 1944." October 12-December 10. Catalogue: checklist.

Durand-Ruel Galleries, New York, N.Y. "Kelekian: As the Artist Sees Him." October 15-November 4.

V[aughan], M[alcolm]. "Kelekian's Face: Artists Pay Tribute." *Art News*, 43 (October 15, 1944), p. 14.

The Bertha Schaefer Gallery, New York, N.Y. "George Constant, Milton Avery." November.

R[iley], M[aude]. "Avery and Constant." *Art Digest*, 19 (November 15, 1944), p. 14.

Whitney Museum of American Art, New York, N.Y. "1944 Annual Exhibition of Contemporary American Painting." November 14-December 12. Catalogue: checklist.

Frost, Rosamund. "The Whitney Does It Again: Artists Rally Round a Well Known Banner in the Outstanding Show to Date." *Art News*, 43 (November 15, 1944), p. 9.

Jewell, Edward Alden. "Art: The Whitney Stress on Fantasy in the Annual Show of Painting—Americans, Modigliani." *New York Times*, November 19, 1944.

1945

Soyer, Moses. "For many years. . . ." *NM*, February 13, 1945. (Clipping.)

Whitney Museum of American Art, New York, N.Y. "1945 Annual Exhibition of Contemporary American Sculpture, Watercolors, and Drawings." January 3-February 8. Catalogue: checklist.

Paul Rosenberg & Co., New York, N.Y. "Recent Gouaches by Milton Avery." January 8-February 3. Catalogue: checklist.

Genauer, Emily. "This Week in Art." *New York World Telegram*, January 13, 1945, p. 9.

G. M. W. "Expositions Milton Avery." *France-Amérique*, January 21, 1945.

Jewell, Edward Alden. "Art: Diverse Shows—Avery and Carroll." *New York Times*, January 14, 1945, section 2, p. 8.

L[ouchheim], A[line] B. "Double Perspective on Milton Avery." *Art News*, 43 (January 15, 1945), p. 24.

McBride, Henry. "Attractions in the Galleries." *New York Sun*, January 13, 1945, p. 19.

Riley, Maude. "Milton Avery Fills an International Gap." *Art Digest*, 19 (January 15, 1945), p. 10.

Durand-Ruel Galleries, New York, N.Y. "Paintings by Milton Avery." January 9-February 3. Catalogue: checklist.

For reviews, see preceding exhibition.

Wildenstein & Co. Inc., New York, N.Y. "The Child Through Four Centuries." February 28-March 28.

McBride, Henry. "Children in Art." *New York Sun*, March 3, 1945, p. 9.

University of Nebraska Art Galleries, Lincoln, Nebr. "Annual Exhibition of Contemporary Art." March 4-April 1.

Paul Rosenberg & Co., New York, N.Y. "Paintings by Avery, Hartley, Hélion, Rattner, Weber." July.

Wolf, Ben. "Modern Americans at Rosenberg." *Art Digest*, 19 (July 1, 1945), p. 21.

17th Regiment Armory, New York, N.Y. "Arts and Antiques Show." September 24-30.

Salpeter, Harry. "The Armory, 1945." *Art News*, 44 (October 1, 1945), pp. 13, 32-34.

Institute of Contemporary Art, Boston, Mass. "Works by 59 Members of the Federation of Modern Painters and Sculptors." October 6-November 11.

1946

Frankfurter, Alfred M. "American Art Abroad: The State Department's Collection." *Art News*, 45 (October 1946), p. 25.

Durand-Ruel Galleries, New York, N.Y. "Modern Religious Painting." January 8-31.

Burrows, Carlyle. "Art of the Week." *New York Herald Tribune*, January 13, 1946, p. V-7.

Frankfurter, Alfred M. "Investigating a Dilemma: Modern Religious Art." *Art News*, 44 (January 1, 1946), pp. 21-22.

Jewell, Edward Alden. "Religious Art Seen in Modern Display." *New York Times*, January 9, 1946, p. 21.

————— . "Religion, Theatre, Pearls." *New York Times*, January 13, 1946, section 2, p. 7.

Durand-Ruel Galleries, New York, N.Y. "Water Colors by Milton Avery." February 4-28.

Wolf, Ben. "Twin Avery Shows." *Art Digest,* 20 (February 1, 1946), p. 13.

"The Passing Shows." *Art News,* 44 (February 1946), p. 90.

Paul Rosenberg & Co., New York, N.Y. "Recent Paintings by Milton Avery." February 4-28.

For reviews, see preceding exhibition.

Samuel M. Kootz Gallery, New York, N.Y. "Modern American Paintings from the Collection of Mr. and Mrs. Roy R. Neuberger." April 15-May 4.

Tate Gallery, London, England. "American Painting from the 18th Century to the Present Day." June-July.

Walker Art Center, Minneapolis, Minn. "136 American Painters." August 25-September 22.

Lawrence Art Museum, Williams College, Williamstown, Mass. "Modern Paintings from the Collection of Mr. and Mrs. Roy R. Neuberger." September 5-October 14.

**The Metropolitan Museum of Art, New York, N.Y. "Advancing American Art." October 4-27. Catalogue: ill.; text by Hugo Weisgall. Traveled in Europe.*

Frankfurter, Alfred M. "American Art Abroad." *Art News,* 45 (October 1946), p. 25.

Colorado Springs Fine Arts Center, Colorado Springs, Colo. "Milton Avery Paintings." November 27-December 31.

1947
Brown, Milton. "Forces Behind Modern U.S. Painting." *Art News,* 46 (August 1947), pp. 16-17, 34-35.

**Durand-Ruel Galleries, New York, N.Y. "My Daughter, March." February 4-March 1. Catalogue: ill., checklist; note by Marchal E. Landgren.*

Genauer, Emily. "This Week in Art: Paintings of Daughter." *New York World Telegram,* February 8, 1947, p. 5.

Jewell, Edward Alden. "Watercolors 1947: My Daughter, March." *New York Times,* February 9, 1947, section 2, p. 9.

McBride, Henry. "The Durand-Ruel Galleries." *New York Sun,* February 1947.

"Reviews and Previews." *Art News,* 45 (February 1947), p. 42.

Wolf, Ben. "Twin Averys Grow." *Art Digest,* 21 (February 15, 1947), p. 11.

**Portland Art Museum, Portland, Oreg. "Milton Avery Paintings." March 3-30.*

"Exhibition of Milton Avery's Paintings Opens at Museum." *Portland* (Oreg.) *Journal,* March 1947.

Whitney Museum of American Art, New York, N.Y. "1947 Annual Exhibition of Contemporary American Sculpture, Watercolors, and Drawings." March 11-April 17. Catalogue: ill., checklist.

Paul Rosenberg & Co., New York, N.Y. "Paintings by Avery, Knaths, Rattner, Weber." April.

Lansford, Alonzo. "Four Americans." *Art Digest,* 21 (April 15, 1947), p. 21.

Dwight Art Memorial, Mount Holyoke College, South Hadley, Mass. "Modern Paintings from the Collections of Mr. and Mrs. James Thrall Soby of Farmington, Connecticut, and Mr. and Mrs. Roy R. Neuberger of New York City." October 3-26.

1948
Paris, Leonard A. "Six Artists and a Model." *Colliers,* July 31, 1948, p. 20.

Virginia Museum of Fine Arts, Richmond, Va. "Contemporary American Paintings." April 11-May 9. Catalogue: checklist; Foreword by Thomas C. Colt, Jr.

Colorado Springs Fine Arts Center, Colorado Springs, Colo. "New Accessions, USA." July 12-September 5. Catalogue: ill., checklist, Introduction.

A.C.A. Galleries, New York, N.Y. "An American Group." November 7-13.

Lansford, Alonzo. "An American Group." *Art Digest,* 23 (November 1, 1948), p. 11.

The Baltimore Museum of Art, Baltimore, Md. "Baltimore National Watercolor Exhibition." December 3-January 9, 1949.

"Baltimore Watercolors." *Art Digest,* 23 (December 15, 1948), p. 11.

The Jewish Museum, New York, N.Y. "American Artists for Israel." December 21-January 30, 1949. Brochure: checklist, Foreword.

Reed, Judith Kaye. "American Art Destined for Israeli Museums." *Art Digest,* 23 (January 15, 1949), p. 16.

1949
Lowengrund, Margaret. "Field of Graphic Arts: Head of March." *Art Digest,* 23 (August 1, 1949), p. 16.

Paul Rosenberg & Co., New York, N.Y. "Still Lifes." January 10-29.

Breuning, Margaret. "Still Life with International Accent." *Art Digest,* 23 (January 15, 1949), p. 17.

"Reviews and Previews." *Art News,* 47 (January 1949), p. 52.

Institute of Contemporary Art, Boston, Mass. "Milestones of American Painting in Our Century." January 20-March 1. Catalogue: bibl., ill., checklist; Preface and essay by Frederick S. Wight. Traveled to: Colorado Springs Fine Arts Center, Colorado Springs, Colo.; M. H. de Young Memorial Museum, San Francisco, Calif.; Los Angeles County Museum, Los Angeles, Calif.; The Cleveland Museum of Art, Cleveland, Ohio.

Vassar College Art Gallery, Poughkeepsie, N.Y. "Selections from the Collection of Roy and Marie Neuberger." April.

**Durand-Ruel Galleries, New York, N.Y. "Paintings by Milton Avery." April 18-May 12.*

Devree, Howard. "Elder Modernist: Paintings of the Last Decade by Villon—Christian Bérard—Milton Avery: Avery's Recent Work." *New York Times,* May 1, 1949, section 2, p. 9.

H[ess], T[homas] B. "Reviews and Previews." *Art News,* 48 (May 1949), p. 44.

McBride, Henry. "Attractions in the Galleries: Durand-Ruel Gallery." *New York Sun,* April 29, 1949, p. 23.

R[eed], J[udith] K[aye]. "Fifty-seventh Street in Review." *Art Digest,* 23 (May 1, 1949), p. 19.

The United Nations Art Club, New York, N.Y. "Five Americans." June. Included Avery, Marsden Hartley, Abraham Rattner, Max Weber, and Karl Knaths.

Crane, Jane Watson. "Five Modernists Show a Way." *Washington Post,* June 19, 1949, p. 3L.

The George Baer Gallery, Salisbury, Conn. "Works by Milton Avery and George Constant." July.

"New Exhibition Opening Tomorrow at Baer Gallery." *Lakeville* (Conn.) *Journal,* July 14, 1949, p. 13.

1950

"*Vogue* Presents: 53 Living American Artists." *Vogue*, February 1, 1950, pp. 150–53.

College of Fine and Applied Art, University of Illinois, Urbana, Ill. "Contemporary American Painting." February 26–April 2. Catalogue: chron., ill., checklist; essay by Allen S. Weller, bio. by Edwin C. Rae.

Smith College Museum of Art, Northampton, Mass. "Contemporary American Paintings from the Collection of Roy Neuberger." September 27–October 22.

Paul Rosenberg & Co., New York, N.Y. "Paintings by Avery, Knaths, Rattner, Weber." December 4–30. Catalogue: checklist.

**Laurel Gallery, New York, N.Y. "Milton Avery Monotypes." December 12–30.*

> B[reuning], M[argaret]. "Fifty-seventh Street in Review." *Art Digest*, 25 (December 15, 1950), p. 17.

> "Modern Paintings and Prints." *Art News*, 49 (December 1950), p. 50.

> H[olliday], B[etty]. "Reviews and Previews." *Art News*, 49 (December 1950), p. 50.

1951

Lewison, Warren. *Milton Avery: A Painter's World* (film). Released by Walter Lewison Associates: 16 mm, color, 14 minutes.

College of Fine and Applied Art, University of Illinois, Urbana, Ill. "Contemporary American Painting." March 4–April 15. Catalogue: ill., checklist; essay by Allen S. Weller; chron., bio. by Edwin C. Rae.

The Brooklyn Museum, Brooklyn, N.Y. "International Watercolor Exhibition." May 9–June 24.

> McBride, Henry. "Watercolors Gigantic." *Art News*, 50 (May 1951), pp. 26–27, 67.

**Grace Borgenicht Gallery, New York, N.Y. "Milton Avery: Recent Paintings." October 15–November 4. Catalogue: checklist.*

> B[reuning], M[argaret]. "Fifty-seventh Street in Review." *Art Digest*, 26 (October 15, 1951), p. 21.

> Burrows, Carlyle. "Art: Marcks, a Sculptor of Stature—Other Events." *New York Herald Tribune*, October 21, 1951, section 4, p. 6.

> Devree, Howard. "Diverse Modernism." *New York Times*, October 21, 1951, section 2, p. X9.

> Goossen, E. C. "The New York Letter." (Clipping.)

> P[orter], F[airfield]. "Reviews and Previews." *Art News*, 50 (October 1951), p. 48.

1952

College of Fine and Applied Art, University of Illinois, Urbana, Ill. "Contemporary American Painting." March 2–April 13. Catalogue: ill., checklist; essay by Allen S. Weller; chron., bio. by Edwin C. Rae.

Whitney Museum of American Art, New York, N.Y. "1952 Annual Exhibition of Contemporary American Sculpture, Watercolors, and Drawings." March 13–May 4. Catalogue: ill., checklist; Foreword by Hermon More.

Dallas Museum of Fine Arts, Dallas, Tex. "Some Business Men Collect Contemporary Art." April 6–27.

Walker Art Center, Minneapolis, Minn. "Contemporary American Painting and Sculpture from the Collection of Mr. and Mrs. Roy R. Neuberger." May 24–August 10. Catalogue: checklist; Foreword by H. H. Arnason; Introduction by Marie and Roy Neuberger.

Whitney Museum of American Art, New York, N.Y. "The Edith and Milton Lowenthal Collection." October 1–November 2. Catalogue: ill., checklist;

Foreword by Hermon More. Traveled to: Walker Art Center, Minneapolis, Minn.

Whitney Museum of American Art, New York, N.Y. "1952 Annual Exhibition of Contemporary American Painting." November 6–January 4, 1953. Catalogue: ill., checklist; Foreword by Hermon More.

**Grace Borgenicht Gallery, New York, N.Y. "Milton Avery: Retrospective and Recent Paintings." December 8–27.*

> A[shton], D[ore]. "Fifty-seventh Street in Review." *Art Digest*, 27 (December 1, 1952), p. 17.

**The Baltimore Museum of Art, Baltimore, Md. "Milton Avery." December 9–January 18, 1953. Catalogue: chron., biblio., ill., checklist; Foreword by Adelyn D. Breeskin, essay by Frederick S. Wight. 85 works shown in Baltimore; a 40-work version traveled to: The Phillips Collection, Washington D.C.; Wadsworth Atheneum, Hartford, Conn.; Lowe Gallery, Coral Gables, Fla.; Delaware Art Center, Wilmington, Del.; Institute of Contemporary Art, Boston, Mass.*

> Adlow, Dorothy. "Paintings by Milton Avery." *Christian Science Monitor*, September 21, 1953, p. 6.

> "An Artist's Life: Twenty-five Years in Paintings." *Quick*, 7 (December 29, 1952), p. 51.

> "The Compleat Avery." *Art Digest*, 27 (December 1, 1952), p. 14.

> Driscoll, Edgar J. "Boston One-Man Show of Milton Avery's Work." *Boston Globe*, September 1953.

> "4 One-Man Art Shows Held with Yule Greens." *Baltimore Evening Sun*, December 30, 1952, p. 1.

> Hay, Jacob. "Avery Is a Silent Man—His Art Talks for Him." *Baltimore Evening Sun*, December 11, 1952.

> Minard, Ralph H. "Milton Avery Greeted: Museum Shows His Art." *Hartford Times*, March 6, 1953, p. 25.

> Ritter, Chris. "A Milton Avery Profile." *Art Digest*, 27 (December 1, 1952), pp. 11–12, 28.

> Seckler, Dorothy Gees. "A Very Nice Avery." *Art News*, 51 (December 1952), pp. 31, 60–61.

> Taylor, Robert. "Milton Avery: A Thoreau in the Midst of the Gold Rush." *Boston Sunday Herald*, September 20, 1953, section 1, p. 3.

> T. H. P. "Avery Art to Be Seen Here Today." *Hartford Courant*, March 5, 1953, p. 8.

1953

"Fine Art Makes Broker 'Bullish' About World." *Look*, November 3, 1953, pp. 72–74.

American Federation of Arts traveling exhibition. "Contemporary American Paintings in India." Opened May. Traveled in India.

> Spaeth, Eloise. "Synthesis of Arts in America: Contemporaries." *Hindustan Times*, May 6, 1953.

Whitney Museum of American Art, New York, N.Y. "1953 Annual Exhibition of Contemporary American Painting." October 15–December 6. Catalogue: ill., checklist; Foreword by Hermon More.

1954

**Grace Borgenicht Gallery, New York, N.Y. "Milton Avery: Recent Paintings." March 29–April 17. Brochure: checklist.*

> B[reuning], M[argaret]. "Fortnight in Review." *Art Digest*, 28 (April 1, 1954), p. 22.

> B[urrows], C[arlyle]. "The New Averys." *New York Herald Tribune*, April 4, 1954, section 4, p. 8.

P[orter], F[airfield]. "Reviews and Previews." *Art News*, 53 (April 1954), p. 44.

Preston, Stuart. "New Shows Keep Art Season Alive." *New York Times*, March 29, 1954, section L+, p. 24.

Rudolph Galleries, Coral Gables, Fla. Group exhibition. May.

"Rudolph Holds New Art for May 29." (Clipping.)

Brooks Memorial Art Gallery, Memphis, Tenn. "An Exhibition of 8 Moderns." May 16–June 30.

Northrop, Guy, Jr. "Avant-Garde Again Shown by Art Today." *Memphis* (Tenn.) *Commercial Appeal*, May 16, 1954.

Colorado Springs Fine Arts Center, Colorado Springs, Colo. "New Accessions, USA." July 1–September 5. Catalogue: bio., ill., checklist; Foreword by James B. Byrnes.

Whitney Museum of American Art, New York, N.Y. "Roy and Marie Neuberger Collection: Modern American Painting and Sculpture." November 17–December 19. Catalogue: ill. checklist; Foreword by John I. H. Baur. Introduction by Roy and Marie Neuberger. Traveled to: Arts Club of Chicago, Chicago, Ill.; Art Gallery, University of California, Los Angeles, Calif.; San Francisco Museum of Art, San Francisco, Calif.; The St. Louis Art Museum, St. Louis, Mo.; Cincinnati Art Museum, Cincinnati, Ohio; The Phillips Collection, Washington, D.C.

Devree, Howard. "Art and Artists: Show at the Whitney—Neuberger Collection Paintings Displayed." *New York Times*, November 17, 1954, section L, p. 32.

Coe College, Cedar Rapids, Iowa. "Exhibition of 20 of the Greatest Contemporary American and European Artists." December.

Pinney, Dick. "Paintings of AFA Showing at Coe Today." *Cedar Rapids* (Iowa) *Gazette*, December 12, 1954.

1955

College of Fine and Applied Art, University of Illinois, Urbana, Ill. "Contemporary American Painting and Sculpture." February 27–April 3. Catalogue: ill., checklist; essay by Allen S. Weller, bio. by Edwin C. Rae.

Duke University, Durham, N.C. "Loan Exhibition." March.

Brandeis University, Waltham, Mass. "Contemporary Painting and Sculpture from the Collection of Joseph H. Hirshhorn." June 1–17.

Red Men's Hall, Rockport, Mass. "Tenth Annual Exhibition of Cape Ann Society of Modern Artists." July. Brochure: checklist.

American Federation of Arts traveling exhibition. "Collectors' Choice." Opened October. Itinerary: Hackley Art Gallery, Muskegon, Mich.; Winston-Salem Library, Winston-Salem, N.C.; Dayton Art Institute, Dayton, Ohio; Coe College, Cedar Rapids, Iowa; Texas Western College, El Paso, Tex.; Atlanta Public Library, Atlanta, Ga.; Nashville Artists Guild, Nashville, Tenn.; The Canton Art Institute, Canton, Ohio; Colorado State College, Greeley, Colo.; University of Kansas, Lawrence, Kans.

1956

Pousette-Dart, Nathaniel, ed. *American Painting Today*. New York: Hastings House, Publishers.

Institute of Contemporary Art, Boston, Mass. "20th Century American Paintings from the Collection of Mr. and Mrs. Roy Neuberger." March 13–April 8.

**Grace Borgenicht Gallery, New York, N.Y. "Milton Avery Paintings." April 16–May 5. Brochure: checklist.*

Burrows, Carlyle. "3 'Well Knowns' Compete Again." (Clipping.)

———. "Avery Work Displayed." *New York Herald Tribune Book Review*, April 22, 1956, p. 12.

Coates, Robert M. "The Art Galleries." *The New Yorker*, April 28, 1956. p. 115.

M[ellow], J[ames] R. "In the Galleries." *Arts*, 30 (April 1956), p. 50.

M[unro], E[leanor] C. "Selecting from the Flow of Spring Shows." *Art News*, 55 (April 1956), pp. 24, 95.

Preston, Stuart. "French and American Artists." *New York Times*, April 22, 1956, section 2, p. 11.

Seckler, Dorothy Gees. "Season's Landmarks." *Art in America*, 44 (Spring 1956), pp. 58–59.

Whitney Museum of American Art, New York, N.Y. "1956 Annual Exhibition of Sculpture, Watercolors, and Drawings." April 18–June 10. Catalogue: ill., checklist.

Mead Art Gallery, Amherst College, Amherst, Mass. "Thirteen Artists—Forty Years." May 2–28.

Colorado Springs Fine Arts Center, Colorado Springs, Colo. "New Accessions, USA." June 3–August 5. Catalogue: ill., checklist; Introduction by Fred S. Bartlett.

"What the Museums Are Buying." *Time*, June 25, 1956, pp. 72–75.

**The Santa Barbara Museum of Art, Santa Barbara, Calif. "Milton Avery." June 5–July 8.*

Seldis, Henry J. "DuCasse and Avery Show Difference in Spirit." *Santa Barbara News-Press*, June 10, 1956.

**Texas National Bank, Houston, Tex. "Milton Avery." Sponsored by The Museum of Fine Arts, Houston, Tex. June 12–July 6. Brochure: checklist; text by Lee Malone.*

The Gallery, Katonah Village Library, Katonah, N.Y. "Paintings from the Collection of Mr. and Mrs. Roy R. Neuberger." September 9–October 5.

**Felix Landau Gallery, Los Angeles, Calif. "Milton Avery." October 22–November 10. Brochure: ill., checklist; text by Frederick S. Wight.*

Whitney Museum of American Art, New York, N.Y. "Annual Exhibition: Sculpture, Paintings, Watercolors, Drawings." November 14–January 6, 1957. Catalogue: ill., checklist.

**Mills College, Oakland, Calif. "Milton Avery Drawings." November 18–December 31.*

P[orter], F[airfield]. "Reviews and Previews." *Art News*, 55 (December 1956), p. 10.

Y[oung], V[ernon]. "In the Galleries." *Arts*, 31 (January 1957), p. 50.

1957

Berkman, Florence. "Milton Avery in 'Faces in American Art.'" (Clipping.)

Greenberg, Clement. "Milton Avery." *Arts*, 32 (December 1957), pp. 40–45.

Randolph-Macon Woman's College, Lynchburg, Va. "Paintings from the Collection of Mr. and Mrs. Roy R. Neuberger." February 3–March 3.

Institute of Contemporary Art, Boston, Mass. "Portraiture: The 19th and 20th Centuries." March 1–November 1. Traveled to: Munson-Williams-Proctor Institute, Utica, N.Y.; The Baltimore Museum of Art, Baltimore, Md.; Dallas Museum of Fine Arts, Dallas, Tex.; Colorado Springs Fine Arts Center, Colorado Springs, Colo.

College of Fine and Applied Art, University of Illinois, Urbana, Ill. "Contemporary American Painting and Sculpture." March 3–April 7. Catalogue: ill., checklist; essay by Allen S. Weller, bio. by Edwin C. Rae.

Kramer, Hilton. "Notes on the Illinois Biennial." *Arts*, 31 (April 1957), pp. 30–33.

Wadsworth Atheneum, Hartford, Conn. "Collected in Three Years: A Museum within a Museum." March 20–May 5.

Poindexter Gallery, New York, N.Y. "The 30's: Painting in New York." June 3–29. Catalogue: ill.; text by Edwin Denby, artists' statements edited by Patricia Passloff.

> Greenberg, Clement. "New York Painting Only Yesterday." *Art News*, 56 (Summer 1957), pp. 58–59, 84–86.

> P[ollet], E[lizabeth]. "In the Galleries." *Arts*, 31 (June 1957), p. 56.

The Minneapolis Institute of Arts, Minneapolis, Minn. "American Paintings, 1945–1957." June 18–September 1. Catalogue: checklist.

Felix Landau Gallery, Los Angeles, Calif. "New York School, Second Generation." July.

> Millier, Arthur. "Exhibition of 'N.Y. School' Features Wide Use of Color." *Los Angeles Times*, July 21, 1957.

Contemporary Arts Center, Cincinnati, Ohio. "An American Viewpoint: Realism in Twentieth Century American Painting." October 12–November 17. Traveled to: Dayton Art Institute, Dayton, Ohio.

**Grace Borgenicht Gallery, New York, N.Y. "Milton Avery." October 28–November 16. Brochure: checklist.*

> Burrows, Carlyle. "Art: New Exhibitions." *New York Herald Tribune Book Review*, November 3, 1957, p. 14.

> Devree, Howard. "From Far and Near: Modern to Primitive in the New Shows." *New York Times*, November 3, 1957, section 2, p. 15.

> G[enauer], E[mily]. "In the Galleries." *Arts*, 32 (November 1957), p. 52.

> P[orter], F[airfield]. "Reviews and Previews." *Art News*, 56 (November 1957), p. 10.

Whitney Museum of American Art, New York, N.Y. "1957 Annual Exhibition: Sculpture, Paintings, Watercolors." November 20–January 12, 1958.

1958

"Avery, Milton (Clark)." *Current Biography*, 19 (June 1958).

Seckler, Dorothy Gees. "Problems of Portraiture: Painting." *Art in America*, 46 (Winter 1958–59) pp. 22, 37.

Esther Robles Gallery, Los Angeles, Calif. "Artists Invite Artists." February 14–March 1.

Whitney Museum of American Art, New York, N.Y. "The Museum and Its Friends: A Loan Exhibition—Twentieth Century Art from Collections of the Friends of the Whitney Museum." April 30–June 15. Catalogue: ill., checklist; Foreword by Flora Whitney Miller.

Colgate Art Gallery, Colgate University, Hamilton, N.Y. "Selections from the Collection of Mr. and Mrs. Roy R. Neuberger." May 26–June 18.

**HCE Gallery, Provincetown, Mass. "Milton Avery." August 1–12.*

> Berkman, Florence. "Avery Paints Music, Poetry, and Humor." *Hartford Times*, September 30, 1958.

> "Seaside Painting." *Time*, September 15, 1958, p. 72.

Downer College, Milwaukee, Wis. "Avery and Ernst." September 15–October.

> F. G. "Ernst and Avery in Downer Show." *Milwaukee Journal*, September 14, 1958.

Wadsworth Atheneum, Hartford, Conn. "Directions in Modern American Painting and Sculpture." October 6–November 15.

American Federation of Arts traveling exhibition. "Crosscurrents." Opened October. Itinerary: Time Inc., New York, N.Y.; Winston-Salem Public Library, Winston-Salem, N.C.; Vassar College Art Gallery, Poughkeepsie, N.Y.; Southern Illinois University, Carbondale, Ill.; Art Alliance, Philadelphia, Pa.; Alabama College, Montevallo, Ala.; Monticello Rotary Club, Monticello, N.Y.; Montclair Art Museum, Montclair, N.J.; Cornell University, Ithaca, N.Y.; Eastern Illinois University, Charleston, Ill.

**Otto Seligman Gallery, Seattle, Wash. "Milton Avery: Oils and Watercolors." October 18–November 15.*

> Callahan, Kenneth. "Avery's Work Is Sincere, Individualistic." *Seattle Times*, October 1958.

> Faber, Ann. "Seligman Gallery Has Avery Exhibition." *Seattle Post-Intelligencer*, October 24, 1958, p. 22.

Little Red School House, New York, N.Y. "Milton Avery, Moses Soyer and Jack Levine." November 14–16.

> "Art Show Set Up to Help School." *New York Times*, November 14, 1958, p. 29.

**Grace Borgenicht Gallery, New York, N.Y. "Milton Avery: Paintings." November 18–December 13. Brochure: checklist.*

> B[enn], B[en]. "In the Galleries." *Arts*, 33 (December 1958), p. 55.

> Berkman, Florence. "Subtle Color, Charm Mark Avery Art in Gotham." *Hartford Times*, November 19, 1958, p. 46.

> C[ampbell], L[awrence]. "Reviews and Previews." *Art News*, 57 (November 1958), p. 13.

> Schiff, Bennett. "In the Art Galleries." *New York Post*, November 30, 1958, p. M-12.

Whitney Museum of American Art, New York, N.Y. "1958 Annual Exhibition: Sculpture, Paintings, Watercolors, Drawings." November 19–January 4, 1959. Catalogue: checklist.

> Kramer, Hilton. "Month in Review: This Year's Whitney Annual." *Arts*, 33 (December 1958), pp. 46–49.

1959

Swenson, May. "Milton Avery." *Arts Yearbook*, 3 (1959), pp. 108–13.

American Federation of Arts traveling exhibition. "Ten Modern Masters of American Painting." Opened January. Itinerary: Coe College, Cedar Rapids, Iowa; Quincy Art Club, Quincy Ill.; Des Moines Art Center, Des Moines, Iowa; E. B. Crocker Art Gallery, Sacramento, Calif.; Nashville Artists' Guild, Nashville, Tenn.; Roanoke Fine Arts Center, Roanoke, Va.; Time Inc., New York, N.Y.; Columbia Museum of Art, Columbia S.C.; Joslyn Art Museum, Omaha, Nebr.; Nelson Gallery, Kansas City, Mo.; Fort Lauderdale Art Center, Fort Lauderdale, Fla.; John Herron Art Institute, Indianapolis, Ind.

**Art Alliance, Philadelphia, Pa. "Milton Avery: Watercolors." February 4–March 8.*

Brooks Memorial Art Gallery, Memphis, Tenn. "The Roy and Marie Neuberger Collection: 21 American Paintings, 1944–1956." February 13–March 1.

Rudolph Galleries, Coral Gables, Fla. "Two Husband and Wife Painting Teams." March.

> Reno, Doris. "Husband-Wife Art Teams Show Refreshing Talent." *Miami Herald*, March 22, 1959, p. 5-J.

College of Fine and Applied Art, University of Illinois, Urbana, Ill. "Contemporary American Painting and Sculpture." March 1–April 5. Catalogue: ill., checklist; essay by Allen S. Weller, bio. by Edwin C. Rae.

The New York Coliseum, New York, N.Y. "Art: USA." April 4–18.

Genauer, Emily. "$1,000 Prizes Awarded to 4 American Artists." *New York Herald Tribune*, April 4, 1959, p. 9.

"2,500 at Art Show." *New York Times*, April 4, 1959, p. 11.

*Felix Landau Gallery, Los Angeles, Calif. "Milton Avery." September.

*HCE Gallery, Provincetown, Mass. "Milton Avery: Preview." September 1.

Fort Wayne Museum of Art, Fort Wayne, Ind. "Twenty-four Paintings by Contemporary American Artists from the Collection of Mr. and Mrs. Roy R. Neuberger." September 13–October 20.

World House Galleries, New York, N.Y. "Trustees' Choice." September 15–October 3. Circulated by The American Federation of Arts.

The New York Society for Ethical Culture and the Fieldston-Ethical Alumni Association, New York, N.Y. "Second Annual Exhibition and Sale of Contemporary Paintings, Sculpture, and Graphic Arts." October 22–25.

St. Louis Art Museum traveling exhibition. "25 Years of American Painting." November–October 1960. Circulated in Europe by the United States Information Agency.

Poindexter Gallery, New York, N.Y. "To Nell Blaine." December 1–19.

"Homage to Nell Blaine." *Art News*, 58 (December 1959), pp. 34–35.

1960

Pollack, Peter. "Fifteen Self-Portraits by American Artists." *American Artist*, 24 (Summer 1960), pp. 30–33, 92–97.

*Grace Borgenicht Gallery, New York, N.Y. "Milton Avery: Recent Paintings." February 3–20.

Berkman, Florence. "Ex-Hartford Painter's Exhibit Emphasizes Color, Simplicity." *Hartford Times*, February 13, 1960, p. 13.

C[ampbell], L[awrence]. "Reviews and Previews." *Art News*, 58 (February 1960), p. 12.

Tillim, Sidney. "Month in Review." *Arts*, 34 (February 1960), pp. 52–53.

*Whitney Museum of American Art, New York, N.Y. "Milton Avery." February 3–March 13 (in conjunction with the exhibition "Lee Gatch"). Catalogue: bio., bibl., ill., checklist; essay by Adelyn D. Breeskin. Circulated by the American Federation of Arts to: Bennington College, Bennington, Vt.; Bradford Junior College, Bradford, Mass.; Heckscher Museum, Huntington, N.Y.; Everhart Museum, Scranton, Pa.; Swain School of Design, New Bedford, Mass.; Bowdoin College, Brunswick, Maine; Lyman Allyn Museum, New London, Conn.; Art Department, Pennsylvania State College, Indiana, Pa.; The Baltimore Museum of Art, Baltimore, Md.; Art Department, University of Kentucky, Lexington, Ky.; University of Minnesota, Minneapolis, Minn.; Krannert Art Museum, University of Illinois, Urbana, Ill.; Flint Institute of Arts, Flint, Mich.; Southern Illinois University, Carbondale, Ill.; University of Wisconsin, Madison, Wis.; Oklahoma Art Center, Oklahoma City, Okla.; The Santa Barbara Museum of Art, Santa Barbara, Calif.

Adlow, Dorothy. *Christian Science Monitor*, July 19, 1960.

"Art Exhibit." *Flint* (Mich.) *Journal*, August 6, 1961.

"Art Exhibit at Heckscher Museum." *Suffolk County* (N.Y.) *Watchman*, June 2, 1960.

"Avery Art Show." *Baltimore Morning Sun*, January 29, 1961.

"Avery Retrospective Exhibit Due Today." *Santa Barbara* (Calif.) *News-Press*, January 28, 1962.

Berkman, Florence. "Avery Paintings Chosen for Two-Year Show Tour." *Hartford Times*, September 5, 1959, p. 18.

——————. "Ex-Hartford Painter's Exhibit Emphasizes Color, Simplicity." *Hartford Times*, February 13, 1960, p. 13.

Breuning, Margaret. "Gatch and Avery at Whitney." *Arts*, 34 (March 1960), p. 52

C[ampbell], L[awrence]. "Reviews and Previews." *Art News*, 58 (February 1960), p. 12.

Coates, Robert M. "The Art Galleries: Milton Avery and Lee Gatch." *The New Yorker*, February 20, 1960, pp. 123–24, 126–27.

"Ex-Hartford Painter Honored with Exhibit." *Hartford Times*, February 3, 1960, p. 25.

"Exhibit of Avery Work to Open at Heckscher Museum." *Long Island* (N.Y.) *Press*, June 5, 1960.

Genauer, Emily. "2 Retrospective Exhibits Open at Whitney Museum." *New York Herald Tribune*, February 4, 1960.

——————. "Who Said the Past Was All Perfect?" *New York Herald Tribune*, February 7, 1960, section 4, p. 6.

Guest, Barbara. "Avery and Gatch: Lonely Americans—Whitney Retrospectives." *Art News*, 59 (March 1960), pp. 42–44, 57.

Levick, L. E. "Whitney Honors 2 U.S. Painters: Avery, Gatch." *New York Journal American*, February 6, 1960, p. 7.

"Milton Avery." *Baltimore Evening Sun*, February 8, 1961.

"Milton Avery and Lee Gatch." *Pictures on Exhibit*, 23, (February 1960).

"Milton Avery: Retrospective Exhibition Is June Display at Heckscher Museum." *The Long Islander* (N.Y.).

"Next Week at the Museum." *Scranton* (Pa.) *Times*, July 23, 1960.

Poole, Duane E. "Art Exhibit." *Flint* (Mich.) *Journal*, August 6, 1961.

Preston, Stuart. "Art: Two Retrospective Exhibitions—Work of Milton Avery and Lee Gatch Seen." *New York Times*, February 3, 1960, p. 36.

——————. "Artists' Progress: Avery and Gatch at Whitney Museum—Contemporaries Elsewhere." *New York Times*, February 7, 1960, section 2, p. 19.

Schiff, Bennett. "In the Art Galleries." *New York Post*, February 7, 1960, p. M-12.

*Park Gallery, Detroit, Mich. "Milton Avery Exhibition." April 24–May 7. Brochure: checklist.

Broner, Robert. *Detroit Free Press*, April 24, 1960.

Driver, Morley. "Milton Avery's World on Exhibit at Park." *Detroit Free Press*, May 1, 1960.

Hakanson, Joy, "Yankee 'Mystic' Solos at New Park Gallery." *Detroit News*, April 24, 1960, p. 14–F.

Rudolph Galleries, Woodstock, N.Y. "An Exhibition of Fine Paintings and Sculptures by Outstanding American Artists." May.

Makler Gallery, Philadelphia, Pa. "The Nude." May 3–June 11. Brochure: ill., checklist.

State University of Iowa, Ames, Iowa. "Main Currents in Contemporary American Painting." May 26–August 7.

M. Knoedler & Co., Inc., New York, N.Y. "American Art, 1910–1960: Selections from the Collection of Mr. and Mrs. Roy R. Neuberger." June 8–September 9.

Adlow, Dorothy. *Christian Science Monitor*, July 19, 1960, p. 8.

Richardson, John. "Exhibition Preview: The Neuberger Collection." *Art in America*, 48 (Summer 1960), pp. 86–88.

Colorado Springs Fine Arts Center, Colorado Springs, Colo. "New Accessions, USA." July 7–September 7. Catalogue: ill.; Introduction by William Henning.

*Haydon Calhoun Gallery, Dallas, Tex. "Milton Avery." September 11–October 9. Brochure: checklist.

Reed College, Portland, Oreg. "Kaufman Memorial Collection of Modern Paintings." October.

Downer College, Milwaukee, Wis. "Contemporary Miniatures." October 2–December 11.

> Key, Donald. "Miniature Art Makes Imposing Exhibition at Downer College." Milwaukee Journal, October 2, 1960.

French & Co. Inc., New York, N.Y. "An Art Collection for a Small School-Community Museum." October 27–November 5.

*The Galerie Internationale, Washington D.C. "Milton Avery." December.

> Ahlander, Leslie Judd. "Thoreau in the Midst of a Gold Rush." Washington Post, December 11, 1960, section G, p. 7.

1961

Crotty, Frank. "He Paints Like Matisse." Worcester Sunday Telegram, February 26, 1961, p. 21.

Greenberg, Clement. "Milton Avery" (1958). Art and Culture: Critical Essays. Boston: Beacon Press.

*Grace Borgenicht Gallery, New York, N.Y. "Milton Avery: Figure Paintings, 1960." January 3–21.

> C[ampbell], L[awrence]. "Reviews and Previews." Art News, 59 (January 1961), p. 10.

> Preston, Stuart. "1961 Rings in the Old, Rings in the New." New York Times, January 8, 1961, section 2, part 1, p. 11.

> Raynor, Vivien. "In the Galleries." Arts, 35 (January 1961), p. 54.

Art Gallery, McCormick Place, Chicago, Ill. "The Roy R. Neuberger Collection." January 5–March 1.

Des Moines Art Center, Des Moines, Iowa. "Six Decades of American Painting of the Twentieth Century." February 10–March 12. Catalogue: ill., checklist; Foreword by Thomas S. Tibbs.

*Shore Galleries, Boston, Mass. "Milton Avery." February 11–28. Brochure: ill.; note by Robert Campbell.

> Adlow, Dorothy. "Canvases by a Neo-Impressionist: The 'Pure Painting' Style of Milton Avery." Christian Science Monitor, February 15, 1961, p. 7.

> Driscoll, Edward J., Jr. "Avery Gallery Show Subtle, Attractive." Boston Sunday Globe, February 18, 1961.

> Morris, George N. "Art: Milton Avery Show at Boston Gallery." Worcester (Mass.) Telegram, February 17, 1961, p. 9.

> Taylor, Robert, "Events in Art." Boston Sunday Herald, February 19, 1961, section 2, p. 4B.

Krannert Art Museum, University of Illinois, Urbana, Ill. "Contemporary American Painting and Sculpture." February 26–April 2. Catalogue: ill., checklist; essay by Allen S. Weller, bio. by Edwin C. Rae.

Dallas Museum of Fine Arts, Dallas, Tex. "The Roy R. Neuberger Collection." March 19–April 16.

Whitney Museum of American Art, New York, N.Y. "The Theater Collects American Art." April 10–May 16. Catalogue: ill., checklist; Foreword by Eloise Spaeth.

*The Fontana Gallery, Narbeth, Pa. "Milton Avery." May.

> Grafly, Dorothy. "Work of Milton Avery Offered in Exhibit at Fontana Gallery." Philadelphia Sunday Bulletin, May 14, 1961, p. 7.

*Makler Gallery, Philadelphia, Pa. "Milton Avery." October 9–November 4.

> Makler, Paul Todd. "Milton Avery." Prometheus, September 1961, pp. 21–24.

*Felix Landau Gallery, Los Angeles, Calif. "Recent Painting: Milton Avery." October 16–November 4. Catalogue: bio., ill., checklist; text by Louis Kaufman.

> Seldis, Henry J. "Avery Canvases Confirm Stature." Los Angeles Times, October 20, 1961, section 2, p. 2.

Rutgers University, New Brunswick, N.J. "A Selection of Paintings from the Collection of Roy R. Neuberger." November 1–19.

Whitney Museum of American Art, New York, N.Y. "1961 Annual Exhibition of Contemporary American Painting." December 13–February 4, 1962. Catalogue: ill., checklist, Foreword.

1962

Berkman, Florence. "Art of Hartford's Milton Avery in Book and Two English Shows." Hartford Times, April 28, 1962, p. 34.

Kramer, Hilton. Milton Avery: Paintings, 1930–1960, New York: Thomas Yoseloff.

"Milton Avery." Horizon, July 1962.

Nordness, Lee, ed. Art:USA:Now, Lucerne, Switzerland: C. J. Butcher Ltd. Essay on Avery by Barbara Moore.

*Grace Borgenicht Gallery, New York, N.Y. "Milton Avery." January 2–20.

> J[ohnston], J[ill]. "Reviews and Previews." Art News, 60 (February 1962), p. 17.

> Preston, Stuart. "First Moves on the 1962 Exhibition Front." New York Times, January 7, 1962, section 2, p. 23.

> R[aynor], V[ivien]. "Milton Avery." Arts Magazine, 36 (February 1962), p. 39–40.

*Park Gallery, Detroit, Mich. "Paintings by Milton Avery." January 7–27. Catalogue: ill., checklist.

> Driver, Morley. "He Draws the Faces of the Sea." Detroit Free Press, January 7, 1962.

> Hakanson, Joy. "Art in Michigan: Frugal Magic of a Yankee Painter." Detroit News, December 31, 1961, p. 11-B.

*The Carillon, Byrd Park, Richmond, Va. "Milton Avery: An Exhibition of Paintings." February 4–25. Catalogue: bio., ill., checklist.

> "The Avery Show." Richmond News-Leader, February 3, 1962.

> Longaker, Jon D. "Avery Paintings on Display Here." Richmond Times-Dispatch, February 4, 1962.

> ————— . "Carillon Exhibit Pleases the Eye." Richmond Times-Dispatch, February 11, 1962.

United States Embassy, London, England. "Vanguard American Painting." February 28–March 30. Catalogue: bio., ill.

> Wallis, Nevile. "From the New World." London Observer, March 4, 1962, p. 28.

*Rudolph Galleries, Coral Gables, Fla. "Milton Avery." March.

> Reno, Doris. "Dim Detail, Wrong Color—But Avery Hits Target." Miami Herald, March 25, 1962, section J, p. 7.

Herring-Cole Art Center, St. Lawrence University, Canton, N.Y. "Exhibition of 20th Century American Painting." March 14–24.

The Downtown Community School, New York, N.Y. "16th Annual Art Show." April.

Wadsworth Atheneum, Hartford, Conn. "Continuity and Change: 45 American Abstract Painters and Sculptors." April 12–May 26. Catalogue: bio., ill., checklist.

Milwaukee Art Center, Milwaukee, Wis. "Art: USA—The Johnson Collection of Contemporary American Paintings." September 22-October 21. Traveled to: Bridgestone Gallery, Tokyo, Japan; Academy of Arts, Honolulu, Hawaii; Royal Academy of Arts, London, England; Zappeion, Athens, Greece; Haus der Kunst, Munich, West Germany; Casino de Monte-Carlo, Salons Privés, Monte Carlo, Monaco; Congress Hall, West Berlin, West Germany; Liljevalchs Konsthall, Stockholm, Sweden; Civico Padiglione d'Arte Contemporanea, Milan, Italy; Palais des Beaux-Arts, Brussels, Belgium; Municipal Gallery of Art, Dublin, Ireland; Casón del Buen Retiro, Madrid, Spain; Kunstmuseum, Lucerne, Switzerland; Musée d'Art Moderne de la Ville de Paris, Paris, France; Akademie der Bildenden Künste, Vienna, Austria; The Corcoran Gallery of Art, Washington, D.C.; Philadelphia Museum of Art, Philadelphia, Pa; Whitney Museum of American Art, New York, N.Y.; Museum of Art, Rhode Island School of Design, Providence, R.I.; Museum of Fine Arts, Boston, Mass.; The Detroit Institute of Arts, Detroit, Mich.; The Minneapolis Institute of Arts, Minneapolis, Minn; Krannert Art Museum, University of Illinois, Urbana, Ill.; The St. Louis Art Museum, St. Louis, Mo.; Contemporary Arts Center, Cincinnati, Ohio; Joslyn Art Museum, Omaha, Nebr.; The Denver Art Museum, Denver, Colo.; Seattle Art Museum, Seattle, Wash.; California Palace of the Legion of Honor, San Francisco, Calif.; Fort Worth Art Museum, Fort Worth, Tex.; Des Moines Art Center, Des Moines, Iowa; Tennessee Fine Art Center, Nashville, Tenn.; Birmingham Museum of Art, Birmingham, Ala.; Art Gallery of Toronto, Toronto, Ontario; Cornell University, Ithaca, N.Y.; The John and Mable Ringling Museum of Art, Sarasota, Fla.; Columbia Museum of Art, Columbia, S.C. Catalogue: bibl., ill., checklist; essay by William C. Agee.

> Genauer, Emily. "Traveling 'ART: USA' Stops Off." New York Herald Tribune, March 23, 1965, p. 21.
>
> Goodrich Lloyd. "Portrait of the Artist." Woman's Day, February 1965, pp. 37–41, 92.
>
> Russell, John. "One Canvas Each." London Sunday Times, February 17, 1963.

*The Waddington Galleries Ltd., London, England. "Milton Avery." September 25–October 20. Catalogue: bio., ill., checklist; essay by Clement Greenberg, reprinted from Arts, 32 (December 1957).

> "Exhibition That Should Not Be Missed." London Times, October 1, 1962, p. 17.
>
> Gosling, Nigel. "Opposite Worlds in the West End." London Observer Weekend Review, September 30, 1962.
>
> Lambert, Helen. "British Boom Milton Avery as One of Best U.S. Artists." International Herald Tribune (Paris), October 3, 1962, p. 5.
>
> "Milton Avery: Waddington Gallery." The Arts Review, September 22, 1962.
>
> Russell, John. "The Tranquil View." London Sunday Times, September 30, 1962, Magazine section, p. 40.
>
> Stockwood, Jane. "Art: Milton Avery." Queen, October 9, 1962.
>
> Sutton, Denys. "Milton Avery: The Voice of Refinement." Financial Times, October 2, 1962.

*Makler Gallery, Philadelphia, Pa. "Milton Avery." October 9–November 4.

> Makler, Paul Todd. "Milton Avery." Prometheus, September 1962, pp. 17–18.

University of Michigan, Ann Arbor, Mich. "Contemporary American Painting: Selections from the Collection of Mr. and Mrs. Roy Neuberger." October 21–November 18.

American Federation of Arts traveling exhibition. "Paintings from the Joseph H. Hirshhorn Foundation Collection: A View from the Protean Century." Opened November. Catalogue: ill., checklist; essays by H. H. Arnason. Traveled nationally.

*Fort Wayne Museum of Art, Fort Wayne, Ind. "Milton Avery." November 1–30. Brochure: ill., checklist; Introductions by John F. Ross and Theodore B. Fitzwater.

1963

Berger, Michael. "Milton Avery." Master's thesis, University of Pittsburgh.

Forma, Warren. The Americans: Three East Coast Artists at Work (film). Released by Contemporary Films: 16 mm, color, 19 minutes.

Rudolph Galleries, Coral Gables, Fla. "Milton Avery." January.

> Reno, Doris. "Avery's Canvases Filled with Concept of Nature." Miami Herald, January 20, 1963, p. 8-G.

Battle Creek Civic Art Center, Battle Creek, Mich. "Thirty Contemporary American Paintings." February 3–March 3.

Museum of Modern Art (New York, N.Y.) traveling exhibition. "U.S. Government Art Projects: Some Distinguished Alumni." Opened March. Itinerary: Oberlin College, Oberlin, Ohio; Mercer University, Macon, Ga.; University of Nevada, Reno, Nev.; Tacoma Art Museum, Tacoma, Wash.; National Gallery of Art, Washington, D.C.; State University of New York, Oswego, N.Y.; Cranbrook Academy of Art, Bloomfield Hills, Mich.; Carleton College, Northfield, Minn.; Coe College, Cedar Rapids, Iowa; Pomona College, Claremont, Calif.

Krannert Art Museum, University of Illinois, Urbana, Ill. "Contemporary American Painting and Sculpture." March 3–April 7. Catalogue: ill., checklist; essay by Allen S. Weller, bio. by Edwin C. Rae.

*Makler Gallery, Philadelphia, Pa. "Milton Avery." April 1–30.

Columbia Museum of Art, Columbia, S.C. "Ascendancy of American Painting." April 3–June 2.

The Corcoran Gallery of Art, Washington, D.C. "The New Tradition." April 27–June 2.

Portland Art Museum, Portland, Oreg. "20th Century American Paintings." September 25–October 27. Catalogue: ill., checklist; text by Francis J. Newton.

*Associated American Artists, New York, N.Y. "Milton Avery: Etchings and Woodcuts." October 21–November 9. Brochure: bio., ill., checklist; Foreword by Sylvan Cole, Jr.

> B[aker], E[lizabeth] C. "Reviews and Previews." Art News, 62 (October 1963), p. 13.
>
> Levich, L. E. "Art and Artists." New York Journal American, October 26, 1963, p. 7.

*James Goodman Gallery, Buffalo, N.Y. "Milton Avery." October 27–November 16.

*Grace Borgenicht Gallery, New York, N.Y. "Milton Avery." October 29–November 23.

> "Art Tour: The Galleries—A Critical Guide." New York Herald Tribune, November 2, 1963.
>
> Canaday, John. "Milton Avery: His New Work Affirms His High Position." New York Times, November 3, 1963, section 2, p. 13. (Rpt. November 4.)
>
> J[udd], D[onald]. "In the Galleries." Arts Magazine, 38 (December 1963), p. 61.

L[onngren], L[illian]. "Reviews and Previews." *Art News*, 62 (December 1963), p. 10.

"Milton Avery." *Time*, November 15, 1963.

Sandler, Irving. "In the Art Galleries." *New York Post*, November 10, 1963, section 2, p. 14.

The Rye Free Reading Room, Rye, N.Y. "Avery Family Group Show." November.

"Avery Exhibiting Paintings at Rye Library." *Rye Chronicle*, November 21, 1963, p. 6.

Whitney Museum of American Art, New York, N.Y. "1963 Annual Exhibition of Contemporary American Painting." December 11–February 2, 1964. Catalogue: ill., checklist, Foreword.

1964

Gray, Cleve. "Summertime U.S.A.: Print Review." *Art in America*, 52 (June 1964), pp. 102–6.

Columbus Gallery of Fine Arts, Columbus, Ohio. "The Neuberger Collection." January 9–February 23.

**Donald Morris Gallery, Detroit, Mich. "Milton Avery Paintings." March 8–31. Brochure: bio., ill., checklist.*

Hakanson, Joy. "Solos by Yankee Painter, German Sculptor." *Detroit Free Press*, March 8, 1964.

"A Painter Who Keeps Shedding Light." *Detroit Free Press*, March 8, 1964.

Flint Institute of Arts, Flint, Mich. "The Coming of Color." April 2–30. Catalogue: ill., checklist; Foreword by G. Stuart Hodge.

Fine Arts Gallery, Indiana University, Bloomington, Ind. "American Painting, 1910 to 1960." April 19–May 10. Catalogue: bibl., ill.; Foreword by Enyeart Harper, Introduction by Henry R. Hope.

**Wadsworth Atheneum, Hartford, Conn. "Paintings by Milton Avery." May 5–31.*

Berkman, Florence. "Atheneum's Avery Show Honors Hartford Artist." *Hartford Times*, May 9, 1964, p. 28.

Whitney Museum of American Art, New York, N.Y. "The Friends Collect: Recent Acquisitions of the Friends of the Whitney Museum of American Art—7th Friends' Loan Exhibition." May 8–June 16. Catalogue: ill., checklist; Foreword by Hudson D. Walker, essay by Armand G. Erpf.

**3900 Watson Place, Washington, D.C. "Milton Avery." June.*

Getlein, Frank. "24 Superior Milton Avery Paintings on Exhibit in Apartment Lobby." *Washington Sunday Star*, June 14, 1964, p. F-5.

Whitney Museum of American Art, New York, N.Y. "Between the Fairs: 25 Years of American Art, 1939–1964." June 24–September 23. Catalogue: ill., checklist; Foreword by Lloyd Goodrich, Introduction by John I. H. Baur.

**HCE Gallery, Provincetown, Mass. "Milton Avery." August 21–27.*

**Felix Landau Gallery, Los Angeles, Calif. "Paintings: Milton Avery." September 9–26.*

Seldis, Henry J. "71-year-old Avery Recaptures Charm of Youth." *Los Angeles Times*, September 14, 1964, section 4, p. 11.

Virginia Museum of Fine Arts, Richmond, Va. "Randolph-Macon Woman's College Collection." September 11–October 18.

FAR Gallery, New York, N.Y. "Art in America Drawing Show." Organized by Charlotte Willard. October 20–31.

Willard, Charlotte. "Drawing Today." *Art in America*, 52 (October 1964), pp. 49–68.

The High Museum of Art, Atlanta, Ga. "An Anthology of Modern American Painting." October 31–December 6.

The American Federation of Arts Gallery, New York, N.Y. "Ceramic Sculpture." November 30–December 11.

Gray, Cleve. "Ceramics by Twelve Artists." *Art in America*, 52 (December 1964), pp. 27–41.

Roanoke Fine Arts Center, Roanoke, Va. "Randolph-Macon Woman's College Collection." December 6–January 17, 1965.

Wadsworth Atheneum, Hartford, Conn. "Recent Accessions." December 17–January 3, 1965.

1965
Obituaries:

Berkman, Florence. "Milton Avery, 71, Artist, is Dead." *Hartford Times*, January 4, 1965, p. 24.

————— . "Colleagues Memorialize Ex-Hartford Artist." *Hartford Times*, January 8, 1965.

"Died: Milton Avery." *Time*, January 15, 1965, p. 88.

"Died: Milton Avery." *Newsweek*, January 18, 1965, p. 57.

"Milton Avery, 1893–1965." *Arts Magazine*, 39 (January 1965), p. 4.

"Milton Avery: His Art Accepted After 40 Years." *New York Herald Tribune*, January 4, 1965, p. 14.

"Milton Avery, Internationally Known Artist." *Boston Globe*, January 1965.

"Milton Avery, Noted Painter, Dies in New York." *Holyoke* (Mass.) *Transcript-Telegram*, January 4, 1965.

"Milton Avery Service Set." *New York Journal American*, January 4, 1965.

"Milton Avery, 71, Dies: Painter Won Late Fame." *Washington Post*, January 4, 1965, p. B-2.

"Milton Avery, 71, Painter, Is Dead: Pioneer of Abstract Art in U.S. Was Self-Taught." *New York Times*, January 4, 1965, p. 29.

"Milton Clark Avery, 71, Prize-Winning Painter." Garden City (N.Y.) *Newsday*, January 5, 1965, p. 26.

"Obituaries: Milton Avery." *Art News*, 63 (February 1965), p. 6.

Willard, Charlotte. "In the Art Galleries." *New York Post*, January 10, 1965, p. 46.

"On the Beach: Six Artists with a Special Interest." *Art in America*, 53 (June 1965), p. 90.

**St. Joseph College, West Hartford, Conn. "Milton Avery." January 5–13.*

"Avery Work to Be Shown." *Hartford Times*, January 5, 1965, p. 8.

**Allen R. Hite Art Institute, University of Louisville, Louisville, Ky. "Milton Avery." January 9–29. Catalogue: checklist.*

**Richard Gray Gallery, Chicago, Ill. "Milton Avery: Paintings and Drawings." January 18–February 27. Brochure: chron., ill.*

Friedlander, Alberta R. "Just Across the Street but Worlds Apart." *Chicago Tribune*, February 7, 1965.

Moses, Paul. "Milton Avery: An Artist of Honesty and Integrity." *Chicago Daily News*, January 23, 1965.

**Rudolph Galleries, Coral Gables, Fla. "Milton Avery." February.*

Reno, Doris. "Simplicity of Avery's Late Work Is Poetic." *Miami Herald*, February 7, 1965, p. 6-H.

**Makler Gallery, Philadelphia, Pa. "Milton Avery." February 1–27.*

Makler, Paul Todd. "Milton Avery." *Prometheus*, January 1965, p. 4.

Wolf, Ben. "Studio Letter: Milton Avery." *The Jewish Exponent*, February 5, 1965.

The New School for Social Research, New York, N.Y. "Modern Portraits." February 2-27.

H[ess], T[homas] B. "Private Faces in Public Places." *Art News*, 63 (February 1965), pp. 36-38, 62.

Portland Art Museum, Portland, Oreg. "Matching the Masters." February 25-March 28. Brochure: checklist.

Tampa Art Institute, Tampa, Fla. "Two Centuries of American Painting from the Collection of Randolph-Macon's Woman's College." February 27-April 25. Traveled to: Loch Haven Art Center, Orlando, Fla.; University Gallery, University of Florida, Gainesville, Fla.; Cummer Gallery of Art, Jacksonville, Fla.

**The Waddington Galleries Ltd., London, England. "Milton Avery." March 2-27. Catalogue: chron., ill., checklist.*

Burr, J. "Without a Style." *Apollo*, 81 (March 1965), p. 236.

Gosling, Nigel. "Majors and Minors." *London Observer Weekend Review*, March 7, 1965, p. 25.

Mullins, Edwin. "Art." *London Sunday Telegraph*, March 7, 1965.

"The Unique and Purely Visual Art of Milton Avery." *London Times*, March 3, 1965.

The Metropolitan Museum of Art, New York, N.Y. "Three Centuries of American Painting." April 9-October 17. Catalogue: bio., bibl., ill.; Introduction by Robert Beverly Hale and James J. Rorimer, text by Henry Geldzahler.

Kramer, Hilton. "A World of Shadows." *The New Leader*, April 26, 1965, pp. 28-29.

Preston, Stuart. "Art: Three Hundred Years of American Painting." *New York Times*, April 9, 1965, p. 30.

Leeds City Art Gallery, Leeds, England. "American Paintings from the Bloedel Collection." April 10-May 16. Catalogue. Traveled to: Chelsea School of Art, London, England.

**Interlochen Arts Academy, Interlochen, Mich. "Milton Avery." April 25-May 2. Catalogue: bio., checklist.*

**Museum of Modern Art (New York, N.Y.) traveling exhibition. "Milton Avery." Catalogue: ill., checklist; Introduction by Alicia Legg. Opened May. Itinerary: The Phillips Collection, Washington, D.C.; Mercer University, Macon, Ga.; Indiana University, Bloomington, Ind.; Mary Washington College, Fredericksburg, Va.; Michigan State University, East Lansing, Mich.; Coe College, Cedar Rapids, Iowa; Witte Memorial Museum, San Antonio, Tex.; Colorado Springs Fine Arts Center, Colorado Springs, Colo.; Madison Art Center, Madison, Wis.; Munson-Williams-Proctor Institute, Utica, N.Y.*

"American Masters." *Newsweek*, June 21, 1965, p. 88.

Berkman, Florence. "Artist Avery Wins Renown in Washington." *Hartford Times*, May 31, 1965, p. 21.

Getlein, Frank. "Phillips Shows Avery Paintings." *Washington Sunday Star*, May 23, 1965, p. D-6.

Hudson, Andrew. "Avery Has Influenced Abstract in Still-Life." *Washington Post*, January 16, 1966, p. G-9.

"Milton Avery." *Washington Post*, May 23, 1965, p. G-7.

South Junior High School, Great Neck, N.Y. "An Exhibition of 150 Years of American Painting." May 9-22.

**Grace Borgenicht Gallery, New York, N.Y. "Milton Avery." June.*

Willard, Charlotte. "In the Art Galleries." *New York Post*, June 10, 1965.

The Brooklyn Museum, Brooklyn, N.Y. "The Herbert A. Goldstone Collection of American Art." June 15-September 12.

Provincetown Art Association, Provincetown, Mass. "Provincetown Art Association First Show." July.

**Woodstock Artists Association, Woodstock, N.Y. "Milton Avery Memorial Exhibition." September 10-22. Brochure: ill., checklist; commentary by Arnold Blanch.*

"Avery Art on Display in Woodstock." *Albany* (N.Y.) *Times-Union*, September 10, 1965.

"Important Avery Memorial Show at Woodstock Gallery." *Woodstock* (N.Y.) *Week*, September 9, 1965, p. 36.

"M. Avery Memorial Show At WAA Gallery Friday." *Woodstock* (N.Y.) *Record Press*, September 8, 1965.

"Milton Avery Honored with Memorial Exhibition." *Middletown* (Conn.) *Times-Herald*, September 11, 1965.

T. G. "An Avery Tribute." *Woodstock* (N.Y.) *Record Press*, September 15, 1965, p. 37.

Donald Morris Gallery, Detroit, Mich. Group exhibition. October 17-November 16.

Museum of Art, Carnegie Institute, Pittsburgh, Pa. "The Seashore in Paintings of the 19th and 20th Centuries." October 22-December 5, 1965.

1966

Johnson, Una E. *Milton Avery Prints and Drawings*. Brooklyn, N.Y.: The Brooklyn Museum.

Wilson, Patricia Boyd. "The Home Forum." *Christian Science Monitor*, August 26, 1966, p. 8.

**Rudolph Galleries, Coral Gables, Fla. "Milton Avery." February.*

Reno, Doris. "New Shows Up on Walls of 4 Galleries This Week." *Miami Herald*, February 6, 1966, p. 6F.

————— . "One Man, Two Man, Group: Quality Fine in 3 Major Shows." *Miami Herald*, February 13, 1966, p. 6K.

**Donald Morris Gallery, Detroit, Mich. "Milton Avery: Watercolors." February 20-March 19.*

**David Mirvish Gallery, Toronto, Ontario. "Milton Avery." March 17-April 3.*

Hale, Barrie. "A Show of Merit." *Toronto Telegram*, March 19, 1966.

Kritzwiser, Kay. "At the Galleries: Artists Who Set the Scene for the Group of 7." *Toronto Globe and Mail*, March 19, 1966, p. 15.

Malcolmson, Harry. "Harry Malcolmson." *Toronto Telegram*, March 26, 1966.

**The Sheldon Memorial Art Gallery, Lincoln, Nebr. "Lincoln Art Association: Milton Avery Art Show." April 3-May 1. Catalogue: ill., checklist; Introduction by Norman A. Geske, essay by Frank Getlein. Traveled to: Arkansas Arts Center, Little Rock, Ark.*

"Center Will Celebrate." *Stuttgart* (Ark.) *Leader*, April 29, 1966.

"Biggest Arts Center Show Presents Art World Giant." *Little Rock* (Ark.) *Gazette*, May 4, 1966.

Haggie, Helen. "Avery's Art an Experience at 1966 Exhibit." *Lincoln* (Nebr.) *Sunday Journal and Star*, April 19, 1966, Magazine section.

"On the Beach in Nebraska." *The New Republic*, April 16, 1966.

"Sheldon Gallery to Display Half-Million Dollar Collection." *The Daily Nebraskan*, April 6, 1966.

Spence, Holly. "At Sheldon Gallery, Spring Is an Avery Work of Art: Avery 'Highly Personal Artist.'" Lincoln (Nebr.) *Sunday Journal and Star*, April 3, 1966, p. 1D.

Thiessen, Leonard. "Art in the Midlands: Recognition of Eloquent Shape." Omaha (Nebr.) *Sunday World-Herald*, April 17, 1966, Magazine section.

Esther Stuttman Gallery, Washington, D.C. "Milton Avery." April 3–May 1. Brochure: ill., checklist; texts by Adelyn D. Breeskin, John Canaday, and Esther Stuttman.

Getlein, Frank. "Art: Impressive Exhibit of Milton Avery's Work." *Washington Sunday Star*, April 3, 1966, section G, p. 3.

"Seven Decades, 1895–1965: Crosscurrents in Modern Art." April 26–May 21, organized by Peter Selz for the Public Education Association, exhibited in ten New York galleries. Works by Avery shown at M. Knoedler & Co., Inc. Catalogue: ill., checklist; text by Peter Selz.

The Waddington Galleries Ltd., London, England. "Milton Avery: Watercolors." April 26–May 21.

Mullaly, Terence. "Milton Avery Water Colours Show Complete Mastery." *London Daily Telegraph*, April 27, 1966, p. 19.

Rosenthal, T. G. "Quiet American." *London Listener*, May 19, 1966, p. 728.

Rudolph Galleries, Woodstock, N.Y. "An Exhibition of Fine Paintings and Sculpture by Outstanding American Artists." May.

Provincetown Art Association, Provincetown, Mass. "Milton Avery Memorial Exhibit." August 4–31.

"Avery Memorial Exhibition Featured at Provincetown." *Cape Cod Standard Times*, August 10, 1966.

Berkman, Florence. "Art Club Show Honors Avery." *Hartford Times*, August 27, 1966, p. 20.

Driscoll, Edgar J., Jr. "Haven in P-Town." *Boston Globe*, August 14, 1966.

Hickik, Ralph J. "P-town Art Association Is Center of Major Colony." New Bedford (Mass.) *Standard Times*, August 21, 1966.

Kay, Jane. "Avery at Provincetown." (Clipping.)

"Milton Avery Memorial Exhibition at Provincetown Art Association." Provincetown (Mass.) *Advocate*, August 4, 1966, p. 1.

Wilson, Patricia Boyd. "The Home Forum." *Christian Science Monitor*, August 26, 1966, p. 8.

Art and Home Center, New York State Exhibition, Syracuse, N.Y. "125 Years of New York State Painting and Sculpture." August 30–September 5.

Gallery Reese Palley, Atlantic City, N.J. "Milton Avery and Family." September 2–25. Brochure: chron., ill., Introduction by Reese Palley.

Randolph-Macon Woman's College (Lynchburg, Va.) traveling exhibition. "Paintings from the Collection of American Painting at Randolph-Macon Woman's College." Opened October. Itinerary: Wilmington Society of Fine Arts, Wilmington, Del.; Lincoln University, Oxford, Pa.; Montclair Art Museum, Montclair, N.J.; University of North Carolina, Greensboro, N.C.; J.B. Speed Art Museum, Louisville, Ky.; Tennessee Fine Arts Center, Nashville, Tenn.

Makler Gallery, Philadelphia, Pa. "Avery: Oils, Watercolors, and Graphics." November 1–26. Brochure: ill., checklist.

Donohoe, Victoria. "Philadelphia Art Scene: Avery Full Range Displayed at Makler." *Philadelphia Inquirer*, October 30, 1966, section 7, p. 6.

Richard Gray Gallery, Chicago, Ill. "Milton Avery." November 7–December 3. Catalogue: ill., checklist; text by Henry Geldzahler.

The Metropolitan Museum of Art, New York, N.Y. "200 Years of Watercolor Painting in America." December 8–January 29, 1967.

1967

Borsick, Helen. "The Latest Look." *Cleveland Plain Dealer*, September 24, 1967.

Schorr, Burt. "Art Works Produced in Federal Programs in 30's Are Neglected." *Wall Street Journal*, December 21, 1967.

Norton Gallery and School of Art, West Palm Beach, Fla. "A Trio of American Painters." February 10–March 12, Brochure: ill., checklist.

Kutztown State College, Kutztown, Pa. "American Paintings, 1923–1966, from the Michner Collection." March 1–31.

North Carolina Museum of Art, Raleigh, N.C. "American Paintings Since 1900 from the Permanent Collection." April 1–23. Catalogue: bio., ill., checklist.

University of Georgia, Athens, Ga. "American Painting: the 1940's." April 19–May 10. Catalogue: ill., checklist; text by Lester C. Walker, Jr. Circulated by The American Federation of Arts. Traveled to: The Art Club of Erie, Erie, Pa.; Robertson Center for the Arts and Sciences, Binghamton, N.Y.; Everson Museum of Art, Syracuse, N.Y.; Kent Boys' School, Kent, Conn.; Museum of Fine Arts of St. Petersburg, St. Petersburg, Fla.; Bacardi Imports, Miami, Fla.; Greenville County Museum of Art, Greenville, S.C.; Nassau Community College, Garden City, N.Y.

The Waddington Galleries Ltd., London, England. "Milton Avery: Middle Period Paintings, 1935–1953." September 26–October 28. Catalogue: ill., checklist.

Mullins, Edwin. "First of the Americans." *London Sunday Telegram*, October 21, 1967.

Oliver, Paul. "Waddington Galleries." (Clipping.)

Wykes-Joyce, Max. "London." *International Herald Tribune* (Paris), October 3, 1967.

Donald Morris Gallery, Detroit, Mich. "Milton Avery Paintings, 1950–63." October 1–21. Catalogue: ill., checklist.

Broner, Robert. "Avery's Landscapes, Sutton's Rich Figures." *Detroit Free Press*, October 1967.

1968

Robbins, Daniel. "Collector: Roy Neuberger." *Art in America*, 56 (November/December 1968), pp. 46–53.

Rudolph Galleries, Coral Gables, Fla. "Milton Avery." February.

Reno, Doris. "A Look Back at Avery Work Is a Study of Style Changes." *Miami Herald*, February 11, 1968, p. 2-F.

T. G. "Milton Avery: Translation of Insight: Droll Cut-Out Figures in Luminous Color." Palm Springs (Fla.) *Life*, February 1968.

Kent State University, Kent, Ohio. "Second Kent Invitational." February 4–28. Catalogue: ill., checklist; Introduction by Leroy Flint.

Waddington Fine Art Galleries, Montreal, Quebec. Group exhibition. April.

Ayre, Robert. "International Figures at a New Gallery." *Montreal Star*, April 6, 1968, Entertainments section, p. 14.

Grace Borgenicht Gallery, New York, N.Y. "Milton Avery." April 27–May 24. Catalogue: ill., checklist; note by Frederick S. Wight.

Ashton, Dore. "Milton Avery: A Painter's Painter at Borgenicht." *Arts Magazine*, 42 (May 1968), pp. 34–35.

B[enedikt], M[ichael]. "Reviews and Previews." *Art News*, 67 (Summer 1968), p. 13.

Kramer, Hilton. "Art: For Eye and Spirit." *New York Times*, May 11, 1968, p. 30.

K. W. "In the Galleries." *Arts Magazine*, 42 (Summer 1968), p. 59.

Museum of Art, Rhode Island School of Design; Brown University, Providence, R.I. "An American Collection." May 8–June 30. Traveled to: National Collection of Fine Arts, Smithsonian Institution, Washington, D.C.

Frank Oehlschaeger Gallery, Sarasota, Fla. "Works from the Estates of Milton Avery and John Corbino." July.

Paintings of Two In Exhibit." *Sarasota* (Fla.) *Herald Tribune*, June 30, 1968.

**Gallery Reese Palley, San Francisco, Calif. "A Small Retrospective Survey of Paintings, and Drawings by Milton Avery." September. Catalogue: checklist; statement by Adolph Gottlieb, commemorative essay by Mark Rothko, essay by James R. Mellow.*

Albright, Thomas. "Art with a Lyric Vision." *San Francisco Chronicle*, September 11, 1968, p. 44.

"Milton Avery Retrospective in S. F. 'Little Guggenheim.'" *San Francisco Sunday Times Herald*, September 22, 1968.

**The K Gallery, Woodstock, N.Y. "Milton Avery." September.*

"Avery at the 'K.'" September 1968. (Clipping.)

**The Waddington Galleries Ltd., London, England. "Watercolors: Milton Avery." October 1–24.*

Associated American Artists, New York, N.Y. "American Master Prints." October 8–November 2. Catalogue: ill., checklist, commentary.

The New School for Social Research, New York, N.Y. "The Humanist Tradition in Contemporary Painting." October 15–November 23. Catalogue: ill., checklist; Foreword by Paul Mocsany.

**Birmingham Museum of Art, Birmingham, Ala. "Milton Avery, 1893–1965." October 27–November 24. Catalogue: ill., checklist; note by Helen Boswell.*

The New Britain Museum of American Art, New Britain, Conn. "The Milton Avery Family." November. Catalogue: ill., checklist; Foreword by Charles B. Fergeson.

Berkman, Florence. "Hartford's Milton Avery Important Art Influence." *Hartford Times*, November 3, 1968, p. 8-G.

S.V.W.B. "Avery Family and Shapiro Featured at NB Museum." *New Britain* (Conn.) *Herald*, November 1968.

**Makler Gallery, Philadelphia, Pa. "Milton Avery: Oils, Watercolors, and Graphics." December 2–31. Brochure: ill., checklist.*

Donohoe, Victoria. "Avery after 1940: Subjective Harmony." *Philadelphia Inquirer*, December 8, 1968, section 7, p. 6.

**Donald Morris Gallery, Detroit, Mich. "Milton Avery Drawings." December 10–January 4, 1969.*

Hakanson, Joy. "Milton Avery: Colorist in Black and White." *Detroit News*, December 15, 1968, section E, p. 2.

Reed College, Portland, Oreg. "Reed College Permanent Art Collection." December 10–30.

1969

Milkovitch, Michael. "The New University Art Gallery at Binghamton." *Art Journal*, 29 (Winter 1969–70), pp. 204–8.

Rose, Barbara. *American Painting: The Twentieth Century*. Lausanne, Switzerland: Albert Skira, 1969.

Artmobile. "The Randolph-Macon Woman's College Collection of American Art." Organized by Virginia Museum of Fine Arts, Richmond, Va. Traveled to 28 chapters and affiliates of Virginia Museum of Fine Arts and 16 colleges and universities, 1969–70.

**Rudolph Galleries, Coral Gables, Fla. "Milton Avery." January.*

Smith, Griffin. "Avery's Latest Paintings Sing." *Miami Herald*, January 19, 1969, section F, p. 2.

J. Millard Tawes Fine Arts Center, University of Maryland, College Park, Md. "Retrospective for a Critic: Duncan Phillips." February 12–March 16. Catalogue: ill., checklist; Foreword by Senator J. William Fulbright, Preface by George Levitine, Introduction by William H. Gerdts, essay by Bess Hormats.

**David Mirvish Gallery, Toronto, Ontario. "Milton Avery: Land and Seascapes, 1958–60." February 21–March 17. Catalogue: ill, checklist.*

**The Alpha Gallery, Boston, Mass. "Milton Avery." April 5–30. Catalogue: ill., checklist; essay by Frank Getlein (reprinted from University of Nebraska catalogue, 1966).*

**Storm King Art Center, Mountainville, N.Y. "Milton Avery: Monotypes, Watercolors, and Drawings." May 3–July 13. Catalogue: ill., checklist; Foreword by Una E. Johnson.*

The Metropolitan Museum of Art, New York, N.Y. "New York Painting and Sculpture, 1940–1970." Summer. Catalogue: chron., bibl., ill., checklist; essays by Henry Geldzahler, Harold Rosenberg, Robert Rosenblum, Clement Greenberg, William Rubin, and Michael Fried.

Shirey, David L. "N.Y. Painting and Sculpture, 1940–1970: The Year of the Centennial at the Met." *Arts Magazine*, 44 (September/October 1969), pp. 35–39.

Museum of Art, Rhode Island School of Design, Providence, R.I. "The Albert Pilavin Collection: Twentieth Century American Art." October 7–November 23.

University of Texas, Austin, Tex. "Selected Paintings from the Michner Collection." November 2–January 5, 1970.

**National Collection of Fine Arts, Smithsonian Institution, Washington, D.C. "Milton Avery." December 12–January 30, 1970. Catalogue: chron., bibl., checklist; Foreword and Introduction by Adelyn D. Breeskin. Traveled to: The Brooklyn Museum, Brooklyn, N.Y.; Columbus Gallery of Fine Arts, Columbus, Ohio.*

Conroy, Sarah Booth. "Artist's Widow Now in Clover." *Washington Daily News*, December 12, 1969.

Getlein, Frank. "Milton Avery: New England American." *Washington Star*, January 4, 1970, Magazine section, pp. 6–7, 12.

Harris, Helen. "Art Circuit: Milton Avery Retrospective." *Women's Wear Daily*, February 18, 1970, p. 10.

Kramer, Hilton. "Milton Avery: A Confidence of Vision." *New York Times*, January 4, 1970, p. 25D.

———. "Art: The Oeuvre of Avery and Moholy: Retrospectives Offered by Two Museums." *New York Times*, February 21, 1970, section L, p. 27.

Krebs, Betty Dietz. "Milton Avery: A Modern Master." *Dayton* (Ohio) *Leisure*, April 26, 1970, pp. 22–23.

Lichtblau, Charlotte. "Milton Avery." *Arts Magazine*, 44 (March 1970), p. 56.

Marvel, Bill. "The Art Picture: Milton Avery Exhibit Harks Back to Time When Beauty Was Sought." *National Observer*, January 12, 1970, p. 20.

McCaslin, Walter. "Avery's World Easily Recognizable." *Dayton Journal-Herald*, May 2, 1970.

Paris, Jeanne. "Art: Avery Exhibit at Brooklyn Art Museum." *Long Island* (N.Y.) *Press*, March 1, 1970, p. 71.

Perreault, John. "Art: In and On." *The Village Voice*, February 26, 1970, pp. 15–16, 19.

Piper, Frances W. "Art League Stages 60th May Show." *Columbus* (Ohio) *Dispatch*, May 6, 1970.

Powell, Leslie. "Milton Avery at the Brooklyn Museum." *The Villager*, February 26, 1970, p. 8.

"The Quiet One." *Time*, March 16, 1970, pp. 58–59, 61.

Ratcliff, Carter. "New York Letter." *Art International*, 14 (May 1970), p. 76.

Richard, Paul. "Milton Avery's Joy." *Washington Post*, December 28, 1969, p. G7.

Shirey, David. "Motivated by Love." *Newsweek*, December 29, 1969, p. 58.

Stevens, Elizabeth. "The Gallery: Slice of Orange Moon in Brooklyn." *Wall Street Journal*, March 10, 1970, p. 22.

Wasserman, Emily. "New York: Milton Avery, Brooklyn Museum." *Artforum*, 8 (May 1970), pp. 77–78.

Wiegers, Mary. "Avery—Artist of the 30's." *Washington Post*, December 12, 1969, pp. C1–2.

————— . "Avery: An Artist's Tenderness Lives." *Detroit News*, January 4, 1970, p. 4-E.

1970

American Painting, 1900–1970. New York: Time Inc., 1970.

*The Louisiana Gallery, Houston, Tex. "Milton Avery." February.

Holmes, Ann. "Milton Avery's Compelling Concentration." *Houston Chronicle*, February 1970.

The Ackland Art Center, University of North Carolina, Chapel Hill, N.C. "The Charles and Isabel Eaton Collection of American Paintings." February 22–March 22.

"Charles Eaton Collection of Paintings Goes on Exhibit at Ackland Art Center." *Chapel Hill* (N.C.) *Weekly*, February 25, 1970.

"Eatons Show Paintings at Ackland." *Raleigh* (N.C.) *News and Observer*, March 1, 1970, section 5.

David Mirvish Gallery, Toronto, Ontario. Group exhibition. March 2–31.

Indiana University Art Museum, Bloomington, Ind. "The American Scene, 1900 to 1970." April 6–May 17. Catalogue.

*Waddington Fine Art Galleries, Montreal, Quebec. "Milton Avery: Watercolors, Paintings, Drawings." April 7–25. Catalogue: ill., checklist.

Ayre, Robert. "A Quintessence of Nature." *Montreal Star*, April 4, 1970, Art section, pp. 8–9.

Lord, Barry. "Milton Avery: Waddington—Montreal, April 1970." *Artscanada*, 27 (June 1970), p. 61.

*The Washington Art Gallery, Washington, Conn. "Milton Avery." June 13–July 4.

Berkman, Florence, "Avery Never Lost Touch with Nature." *Hartford Times*, June 21, 1970, p. 22-D.

Bruat, J. E. " 'Confidence of Vision' Milton Avery Exhibit." *New Milford* (Conn.) *Times*, June 11, 1970.

Jarvis Gallery, Woodstock, N.Y. "The Avery Family." July 4–31.

"Avery's Family Paintings on Display at Jarvis Gallery." *Kingston* (N.Y.) *Freeman*, July 3, 1970.

*St. Joseph College, West Hartford, Conn. "Milton Avery: Watercolors and Gouaches." August–September.

Goldenthal, Jolene. "Exhibition of Milton Avery Work on View at St. Joseph College." *Hartford Courant*, August 2, 1970.

Miami-Dade Junior College, Miami, Fla. "Campus Show." September.

Smith, Griffin. "Two Superb Oils Lift Campus Show." *Miami Herald*, September 6, 1970, p. 2-H.

David Mirvish Gallery, Toronto, Ontario. "The Opening." September 19–October 10.

Fenton, Terry. "The David Mirvish Opening Show: Toronto, September–October 1970." *Artscanada*, 27 (December 1970/January 1971), pp. 57–58.

La Boetie, Inc., New York, N.Y. "The Still Poetic Moon." September 22–November 15. Catalogue: ill., checklist.

*Grace Borgenicht Gallery, New York, N.Y. "Milton Avery: Drawings." October 31–November 25. Catalogue: ill., checklist.

A[nderson], L[aurie]. "Reviews and Previews." *Art News*, 69 (November 1970), p. 17.

Antironmis. "Reviews: Galleries." *Arts Magazine*, 45 (November 1970), pp. 60–61.

Gruen, John. "The Logical Line." *New York Magazine*, November 23, 1970, p. 79.

Marandel, J. Patrice. "Lettre de New York." *Art International*, 15 (January 20, 1971), p. 71.

Mellow, James R. "Avery: A Childlike Art That Was Far From Naive." *New York Sunday Times*, November 22, 1970, p. D23.

*The Alpha Gallery, Boston, Mass. "Milton Avery: Works on Paper." November 5–December 12. Catalogue: ill., checklist.

Driscoll, Edgar J., Jr. "Avery's Quiet World|in Lovely Harmony." *Boston Globe*, November 17, 1970, p. 40.

Grillic, Jean Bargantini. "Milton Avery: 'The American Matisse.'" (Clipping.)

Koethe, John. "Boston: Avery's Spaces." *Art News*, 69 (January 1971), p. 12.

Loercher, Diana. "American Artists: Two Individualists." *Christian Science Monitor*, December 4, 1970, p. 17.

*Richard Gray Gallery, Chicago, Ill. "Milton Avery: Works on Paper." November 7–December 4. Brochure: checklist.

Glauber, Robert. "Holds Suspense Till Next Week." *Chicago Skyline*, December 9, 1970, p. 11.

Schulze, Franz. "The Remarkable Mr. Rauschenberg." *Chicago Daily News*, December 1970.

1971

*Donald Morris Gallery, Detroit, Mich. "Milton Avery: Paintings, 1941–1949." January 23–February 20. Catalogue: ill.

Hakanson, Joy. "Avery 40's Oils Strongest." *Detroit Sunday News*, January 31, 1971, p. 4-E.

*William Cooper Proctor Art Center, Bard College, Annandale-on-Hudson, N.Y. "Milton Avery: Works on Paper." February 4–28. Catalogue: ill., checklist; essay by Matt Phillips.

"Diverse Talents of Milton Avery on Display in Unusual Exhibit." *Kingston* (N.Y.) *Daily Freeman*, January 30, 1971.

University of California, Irvine, Calif. "Milton Avery: Late Paintings (1958-1963)." February 16–March 14. Catalogue: bibl., ill., checklist; essay by Stephanie Gordon Noland.

Garver, Thomas H. "Los Angeles: Milton Avery—UnC., Irvine." *Artforum*, 9 (April 1971), pp. 86–87.

Howell, Betje. "No Neat Pigeonhole for Avery." *Los Angeles Herald Examiner*, February 28, 1971.

Seldis, Henry J. "Ecumenical Chapel a Fitting Environment for Rothko Canvases: Best of Intentions." *Los Angeles Times*, March 7, 1971, Calendar section, p. 54.

Makler Gallery, Philadelphia, Pa. "Milton Avery." February 26–March 31. Brochure: ill., checklist.

Donohoe, Victoria. "Gallery Tour: The Subtlety and Power of the Late Milton Avery." *Philadelphia Inquirer*, February 26, 1971, section A, p. 14.

University of Texas, Austin, Tex. "Resources from the Michner Collection." March 20–July 18.

The Waddington Galleries Ltd., London, England. "Milton Avery: Paintings." March 31–April 24.

Mullaly, Terence. "Lessons for Artists in Milton Avery's Show." *London Daily Telegraph*, April 6, 1971.

The Louisiana Gallery, Houston, Tex. "Milton Avery." May.

The Museum of Modern Art, New York, N.Y. "Ways of Looking." July 28–November 1.

Mellow, James R. "How It Looks from Cézanne to Pop." *New York Times*, August 15, 1971, section D, p. 17.

Pasadena Art Museum, Pasadena, Calif. "Avery's Late Paintings." August 3–29.

St. James, Ashley. "Less Is More." *Christian Science Monitor*, August 3, 1971, p. 8.

Waddington Fine Art Galleries, Montreal, Quebec. "Milton Avery Prints." August 25–September 11.

Allentown Art Museum, Allentown, Pa. "Paintings by Milton Avery and His Family." September 4–26. Catalogue: ill., checklist; essay by Frank Getlein.

"Avery's 'Cubed Impressions' Created a New Tradition." *Bethlehem* (Pa.) *Globe Times*, August 14, 1971.

"Major Exhibition to Open Art Museum Season." *Allentown* (Pa.) *Sunday Call Chronicle*, August 29, 1971, section F, p. F-8.

University of Texas, Austin, Tex. "Crosscurrents in 20th Century American Art: From the Michner Collection." September 14–October 3.

Louise E. Thorne Memorial Art Gallery, Keene State College, Keene, N.H. "The Sea by Milton Avery." September 26–October 16. Catalogue: ill., checklist; Foreword by Henry Geldzahler. Traveled to: The Currier Gallery of Art, Manchester N.H.; Williams College Museum of Art, Williamstown, Mass.

"Paintings by Avery to Be Seen." *The Monadnock* (Keene State College, Keene, N.H.), September 22, 1971.

The Hudson River Museum, Yonkers, N.Y. "20th Century Painting and Sculpture from the New York University Art Collection." October 1–November 15.

Joslyn Art Museum, Omaha, Nebr. "The Thirties Decade: American Artists and Their European Contemporaries." October 10–November 28.

Associated American Artists, New York, N.Y. "American Master Prints II." November 1–27. Catalogue: ill., checklist, commentary.

Abilene Fine Arts Museum, Abilene, Tex. "Selections from the Michner Collection." November 2–29.

University of Texas, Austin, Tex. "American Social Realism Between the Wars: Its Roots and Ramifications." November 14–21.

La Boetie, Inc., New York, N.Y. "A Selection of 20th Century Master Drawings." November–December.

1972

Chandler, John Noel. "Notes Towards a New Aesthetics." *Artscanada*, 29 (October/November 1972), pp. 16–41.

Grace Borgenicht Gallery, New York, N.Y. "Milton Avery: Watercolors, Monotypes, Oils on Paper." January 4–27. Catalogue: ill., checklist; Foreword by Frank Getlein.

Campbell, Lawrence. "The Monotype." *Art News*, 70 (January 1972), pp. 44–47.

Helfer, Judith. "Kunst: Aus Milton Averys Werk—Ölbilder, Monotypien, Aquarelle." *Aufbau*, January 14, 1972.

Kramer, Hilton. "Avery's Mastery in Paintings on Paper." *New York Times*, January 8, 1972, section L, p. 25.

Mikotajuk, Andrea. "Reviews: In the Galleries." *Arts Magazine*, 46 (February 1972), p. 66.

Rudolph Galleries, Coral Gables, Fla. "Little Gems." February–March.

Smith, Griffin. "A Look at Massin, Avery, and Clarke." *Miami Herald*, February 20, 1972, p. 2-M.

Reynolda House, Winston-Salem, N.C. "Randolph-Macon at Reynolda House." March 17–26.

The Harmon Gallery, Naples, Fla. "American Masters." April 10–29.

"American Masters Exhibit to Close Season, Harmon Gallery to Open Show." *Naples* (Fla.) *Daily News*, April 9, 1972.

Lunn Gallery, Washington, D.C. "Milton Avery: Paintings, Watercolors, and Drawings." April 22–May 17.

Forgey, Benjamin. "Let's Say It Simply: A Beautiful Show." *Washington Star*, April 23, 1972, p. C-7.

"Milton Avery Exhibition at Lunn Gallery." *The Georgetowner*, April 20, 1972.

Richard, Paul. "Steps Along the Path." *Washington Post*, May 13, 1972, p. B11.

Comsky Gallery, Beverly Hills, Calif. "Milton Avery: Works on Paper." May 12–June 12. Catalogue: bio., ill.

S[eldis], H[enry] J. "Art Walk." *Los Angeles Times*, May 16, 1972.

National Collection of Fine Arts, Smithsonian Institution, Washington, D.C. "The Monotype: An Edition of One." July. Catalogue: ill., checklist. Traveled to: University of Connecticut, Storrs, Conn.; Charles H. MacNider Museum, Mason City, Iowa.

"Art Exhibit Set." *Mason City* (Iowa) *Globe-Gazette*, March 20, 1972.

Cutler, Carol. "The Twilight Era of Monotype." *Washington Post*, July 22, 1972, p. D9.

"'An Edition of One' at UCONN Gallery." *Willimantic* (Conn.) *Chronicle*, October 18, 1972.

Forgey, Benjamin. "Four Men & The Monotype: Small in Scale, Large in Appeal." *Washington Star*, July 7, 1972, section E.

"The William Benton Museum of Art." *Norwich* (Conn.) *Bulletin*, October 22, 1972.

"UConn Art Museum Exhibits Monotypes." *Springfield* (Mass.) *Daily News*, October 18, 1972.

Lubin House Gallery, Syracuse University, Syracuse, N.Y. "Milton Avery Drawings." November 21–December 15. Brochure: ill., checklist; essay by August L. Freundlich.

University of Texas, Austin, Tex. "The Michner Collection: American Paintings of the 20th Century." November 22–March 1, 1973.

Louisiana Gallery, Houston, Tex. Group exhibition. December.

"Art Circle Pictures for Every Taste and Pocketbook." *Houston Chronicle*, December 1, 1972.

1973
Makler, Paul Todd. "Milton Avery." *Prometheus Bound*. Philadelphia: Paul Todd Makler.

Comsky Gallery, Beverly Hills, Calif. "Milton Avery: Paintings, Watercolors, and Prints." January 26–February 24.

S[eldis], H[enry] J. "A Critical Guide to the Galleries—Beverly Hills." *Los Angeles Times*, January 26, 1973, section 4, p. 8.

Associated American Artists, New York, N.Y. "Milton Avery (1893–1965): The Complete Collection of Etchings, Lithographs, and Woodcuts from 1933–1955." January 29–February 17.

Brown, Gordon. "Reviews: New York." *Arts Magazine*, 47 (March 1973), p. 86.

Mellow, James R. "Avery—A Modern Master?" *New York Times*, February 11, 1973, section D, p. 25.

Shirey, David L. "Reviews and Previews." *Art News*, 72 (March 1973), pp. 80, 84.

The Corcoran Gallery of Art, Washington, D.C. "The Graphic Work of Milton Avery." January–February. Catalogue: chron., bibl., ill., checklist; Introduction by Harry Lunn, Jr., essays by Frank Getlein and Alan Fern. Organized by the Lunn Gallery, Washington, D.C.; circulated by the International Exhibitions Foundation to: Indianapolis Museum of Art, Indianapolis, Ind.; Portland Museum of Art, Portland, Maine; Telfair Academy of Arts and Sciences, Inc., Savannah, Ga.; St. Paul's School, Concord, N.H.; Fogg Art Museum, Harvard University, Cambridge, Mass.; Hopkins Center, Dartmouth College, Hanover, N.H.; Hunter Museum of Art, Chattanooga, Tenn.; Fort Lauderdale Museum of the Arts, Inc., Fort Lauderdale, Fla.; Dulin Gallery of Art, Knoxville, Tenn.; Theodore Lyman Wright Art Center, Beloit College, Beloit, Wis.; California State University Art Gallery, Northridge, Calif.; The Mint Museum of Art, Charlotte, N.C.; Beaumont Art Museum, Beaumont, Tex.; Colorado Springs Fine Arts Center, Colorado Springs, Colo.; The Baltimore Museum of Art, Baltimore, Md.; Hackley Art Museum, Muskegon, Ill.; Western Illinois University Art Gallery, Macomb, Ill.; LSU Union, Louisiana State University, Baton Rouge, La.; Albrecht Art Museum, St. Joseph, Mo.; Art Gallery, University of Southern Maine, Gorham, Maine; Pratt Graphics Center, New York, N.Y.; Art Gallery, Camden College of Arts and Sciences, Rutgers University, Camden, N.J.; Art Gallery, Owens Hall, Virginia Polytechnic Institute and State University, Blacksburg, Va.; Art Gallery of Hamilton, Hamilton, Ontario; W. R. Harper College, Palatine, Ill.; Glenbow-Alberta Institute, Calgary, Alberta; Mt. Hood Community College, Gresham, Oreg.; Tyler Museum of Art, Tyler, Tex.; Art Exhibition Program, St. Edward's University, Austin, Tex.; Southern Alleghenies Museum of Art, Loretto, Pa.; Art Gallery, Towson State College, Towson, Md.

Dunbar, Jill. "When Avery's Physician Prescribed Graphics and Benton Painted Walls." *The Villager*, June 23, 1977, p. 11.

Garrett, Kathy. "Horizons: Art—Milton Avery Prints at the Fogg." *Crimson Review* (Harvard University, Cambridge Mass.), April 1974.

"Imagery Shown in Print Collection." *Beaumont* (Tex.) *Journal*, July 17, 1975.

Lewis, Jo Ann. "An Updating on the Corcoran." *Washington Star-News*, January 18, 1972.

Weinstein, Ann. "Avery's Work Quiet, Monumental, with a Rhythm." *Roanoke* (Va.) *Times & World News*, September 18, 1977.

Rudolph Galleries, Coral Gables, Fla. "The Graphic Work of Milton Avery, 1933–1955." February.

Smith, Griffin. "Milton Avery's 1933–1955 Graphics." *Miami Herald*, February 11, 1973, p. 8-F.

Grace Borgenicht Gallery, New York, N.Y. "Still Life: Avery and the European Masters." February 3–March 1.

Mellow, James R. "Avery—A Modern Master?" *New York Times*, February 11, 1973, section D, p. 25.

Lowe Art Museum, University of Miami, Miami, Fla. "The American Prophets." February 22–March 25. Catalogue: ill., checklist; Preface by John J. Barratte, Introduction by Paul E. Thompson, essay by Robert M. Doty.

Grace Borgenicht Gallery, New York, N.Y. "Milton Avery: Oil Crayons." March 31–April 26. Catalogue: ill., checklist.

Baker, Kenneth. "Making Abstract Art Work." *Christian Science Monitor*, May 18, 1973, p. 17.

Kramer, Hilton. "New Avery Aspects: Paintings on Paper." *New York Times*, April 14, 1973, section L, p. 29.

Schwartz, Sanford. "New York Letter." *Art International*, 17 (April 1973), p. 51.

Tannenbaum, Judith. "New York Galleries: Milton Avery." *Arts Magazine*, 48 (September/October 1973), p. 70.

Waddington Fine Art Galleries, Montreal, Quebec. "Milton Avery." March 31–April 21.

"L'hesitation d'Avery." *La Presse* (Montreal), April 7, 1973.

Tirca Karlis Gallery, Provincetown, Mass. "Milton Avery." July.

Grace Borgenicht Gallery, New York, N.Y. Group exhibition. July–August.

The Waddington Galleries Ltd., London, England. "Milton Avery." September 18–October.

Marle, Judy. "Reviews: Milton Avery at the Waddington Gallery." *Studio International*, 186 (November 1973), pp. 199–200.

The Alpha Gallery, Boston, Mass. "Milton Avery." October 5–30. Catalogue: ill., checklist.

André Emmerich Gallery, New York, N.Y. "Milton Avery: The Gaspé Peninsula, Summer, 1938." October 21–November 14.

Campbell, Lawrence. "Reviews and Previews." *Art News*, 72 (December 1973), pp. 94, 96.

Derfner, Phyllis. "New York." *Art International*, 18 (January 20, 1974), pp. 18–20.

Kramer, Hilton. "Modern Master Drawings Are Shown." *New York Times*, November 10, 1973, section L, p. 27.

Loercher, Diana. "The Lyrics of an Artist." *Christian Science Monitor*, December 14, 1973, p. 25.

Housatonic Museum of Art, Housatonic Regional Community College, Bridgeport, Conn. "Milton Avery Drawings." November. Catalogue: chron., bibl., ill., checklist; essay by Burt Chernow.

M. Knoedler & Co., Inc., New York, N.Y. "19th & 20th Century Art." November.

*Makler Gallery, Philadelphia, Pa. "Milton Avery." November 1–30. Catalogue: ill., checklist.

Donohoe, Victoria. "Practicing the Fine Arts of Diplomacy." Philadelphia Inquirer, June 24, 1973, section G, p. 11.

"Milton Avery at Makler." (Clipping.)

A.C.A. Galleries, New York, N.Y. "20th Century Americans." December. Catalogue: ill.

Makler Gallery, Philadelphia, Pa. "Christmas Show: Works on Paper." December 1–22.

1974

*Rudolph Galleries, Coral Gables, Fla. "Milton Avery." January–February.

Smith, Griffin. "Zuñiga, Appel, Avery on Display Here." Miami Herald, January 27, 1974, p. 11-L.

Grace Borgenicht Gallery, New York, N.Y. "The Figure: Avery and the European Masters." February 2-28.

Mellow, James R. "2nd Show Pits Avery's Art Against European Works." New York Times, February 9, 1974, section L, p. 25.

Tannenbaum, Judith. "Arts Reviews." Arts Magazine, 48 (April 1974), p. 69.

Associated American Artists, New York, N.Y. "American Master Prints III." March 25–April 18. Catalogue: bibl., ill., checklist, commentary.

Wildenstein & Co., Inc., New York, N.Y. "Selections from the Cone Collection." March 29-May 4.

Kramer, Hilton. "Collecting Picasso and Matisse." New York Times, March 31, 1974, section D, p. 27.

*Lunn Gallery, Washington, D.C. "Milton Avery: Paintings, Watercolors & Drawings." May 4-June 18. Catalogue: bio., ill., checklist; note by Hilton Kramer.

Forgey, Benjamin. "Painterly Virtuosity for Its Own Sake: Too Tempting." Washington Star News, May 13, 1974, p. D-4.

Richard, Paul. "Museum-Quality Show." Washington Post, May 15, 1974, p. C9.

Andrew Crispo Gallery, New York, N.Y. "Ten Americans: Masters of Watercolor." May 17-June 30. Catalogue: ill.; Foreword by Andrew Crispo, essay on Avery by George Albert Perret.

Frackman, Noel. "The Enticement of Watercolor." Arts Magazine, 48 (June 1974), pp. 46-48.

Kramer, Hilton. "Art: Water-Color Mastery." New York Times, May 25, 1974, section L, p. 25.

Mellow, James R. "A Hundred Years of American Masters of Watercolor." New York Times, June 2, 1974, section D, p. 19.

The Marianne Friedland Gallery, Toronto, Ontario. "Group Showing." May.

Jarvis Gallery, Woodstock, N.Y. "Avery Family Exhibition." July.

University of Texas, Austin, Tex. "20th Century Painting: The First Five Decades—From the Michner Collection." July 22-January 5, 1975.

Brentano's Gallery, New York, N.Y. "The Nude." September.

Hirshhorn Museum and Sculpture Garden, Smithsonian Institution, Washington D.C. "Inaugural Exhibition." October 1-September 15, 1975.

Berkman, Florence. "The Hirshhorn Spectacular Opens." Hartford Times, October 6, 1974.

*Louisiana Gallery, Houston, Tex. "15 Years: A Retrospective Exhibit Featuring the Paintings of Milton Avery." October–November.

The Harmon Gallery, Naples, Fla. "Twelfth Annual Opening Group Exhibition." November.

Bennet, Gale. "See a So-So $38,000 Watercolor." Fort Myers (Fla.) News-Press, November 22, 1974.

The Alpha Gallery, Boston, Mass. "Modern Master Graphics." November 1–26.

William Zierler Inc., New York, N.Y. "American Works on Paper, 1944–1974." November 2-30. Catalogue.

1975

*David Gallery, Pittsford, N.Y. "Milton Avery Paintings and Drawings." January 3–24.

*Comsky Gallery, Beverly Hills, Calif. "Milton Avery." January 10-February 3.

Grace Borgenicht Gallery, New York, N.Y. "The Landscape: Avery and the European Masters." February 1-27.

Russell, John. "Art: Not So Much the Glasses as the Light." New York Times, February 22, 1975, section L, p. 23.

Tannenbaum, Judith. "Arts Reviews." Arts Magazine, 49 (March 1975), pp. 14-15.

Museo Nacional de Bellas Artes, Universidad de Chile, Santiago, Chile. "American Paintings of the 20th Century: Selections From the Michner Collection." February 2-December 28. Traveled to: Museo de Arte Italiano, Lima, Peru; Museo Nacional de Bellas Artes, Buenos Aires, Argentina; Biblioteca Luis-Angel del Banco de la Republica, Bogotá, Colombia; Museu Nacional de Belas Artes, Rio de Janeiro, Brazil; Instituto Guatemalteca-Americano de Cultura, Guatemala City, Guatemala; Museo de Arte Moderno, Mexico City, Mexico.

Kennedy Galleries, New York, N.Y. "The Hundredth Anniversary Exhibition of Paintings and Sculptures by 100 Artists Associated with the Art Students League of New York." March 6-29. Catalogue: ill., checklist; Introduction by Lawrence Campbell, commentary on Avery by Michael Fried.

*David Mirvish Gallery, Toronto, Ontario. "Milton Avery." March 15–April 8.

London Public Library and Museum, London, Ontario. "Selections from the Corcoran Gallery." April 4-May 5. Catalogue: ill., text.

*The Alpha Gallery, Boston, Mass. "Milton Avery: Works on Paper." April 26-May 24.

Taylor, Robert. "A Rare Milton Avery Exhibit." Boston Globe, May 15, 1975, p. 33.

Webb and Parsons Gallery, Bedford, N.Y. "The Avery Family: Milton, Sally, and March." May 10-June 14. Brochure: checklist.

Amerika Haus, West Berlin, West Germany. "Form and the Creative Process: Selections from the Michner Collection." May 15–June 30.

The Cleveland Museum of Art, Cleveland, Ohio. "Landscapes, Interior and Exterior: Avery, Rothko, and Schueler." July 9-August 31. Catalogue: chron., bibl., ill., checklist; Preface, Introduction, and commentary on Avery by Edward B. Henning.

Portland Art Museum, Portland, Oreg. "American Paintings from the Collection." August 8-31. Catalogue: ill., checklist; text by Joseph McDonald.

Associated American Artists, New York, N.Y. "By the Sea, By the Sea, By the Beautiful Sea." August 11-September 13.

Phillips Collection (Washington, D.C.) traveling exhibition. "American Art from the Phillips Collection: A Selection of Paintings, 1900-1950." Opened September. Catalogue. Itinerary: University of Wyoming, Laramie, Wyo.; Utah State University, Logan, Utah; Brigham Young University, Provo, Utah; The Denver Art Museum, Denver, Colo.; University of New Mexico, Albuquerque, N.M.; The Phillips Collection, Washington, D.C.

Donald Morris Gallery, Detroit, Mich. "Modern Mavericks, African Masters." October.

 Colby, Joy Hakanson. "Celebration, Survival at Birmingham Gallery." Detroit News, October 5, 1975, p. 2-H.

 "Modern Mavericks, African Masters at Morris Gallery." Detroit Free Press, October 5, 1975.

Museum of Fine Arts, St. Petersburg, Fla. "Figure as Form: American Painting, 1930-1975." November 25-January 4, 1975. Catalogue: ill., checklist; essay by Margaret Miller. Traveled to: Florida Center for the Arts, Tampa, Fla., Columbus Museum of Arts and Sciences, Inc., Columbus, Ga.

André Emmerich Gallery, New York, N.Y. "Works on Paper." December 6-January 6, 1976.

Whitney Museum of American Art, New York, N.Y. "Young Americans: A Selection of Paintings from the Collection of the Pennsylvania Academy of the Fine Arts." December 11-February 12, 1976. Catalogue: bibl., ill., checklist; Preface by John McCoubrey; Introductions by Louise W. Lippincott and Richard J. Boyle.

1976

Kramer, Hilton. "The Guggenheim's Sense of History Is Askew." New York Times, November 28, 1976, section D, p. 39.

Russell, John. "The Artist Before the Camera." New York Times, February 15, 1976, section D, p. 35.

The Katonah Gallery, Katonah, N.Y. "American Painting, 1900-1976." January 17-March 14. Catalogue: bio., ill., checklist; Foreword by Ellen R. Cabell, Introduction and essay by John I. H. Baur.

*Tibor de Nagy Gallery, New York, N.Y. "Milton Avery." January 24-February 12.

 Lorber, Richard. "Arts Reviews." Arts Magazine, 50 (April 1976), p. 20.

 Kramer, Hilton. "Art: Avery's Seascapes and the Masters." New York Times, January 31, 1976, section L, p. 21.

Grace Borgenicht Gallery, New York, N.Y. "The Seascape: Avery and the European Masters." January 31-February 26.

 Kramer, Hilton. "Art: Avery's Seascapes and the Masters." New York Times, January 31, 1976, section L, p. 21.

 Tannenbaum, Judith. "Arts Reviews." Arts Magazine, 50 (April 1976), p. 28.

Roko Gallery, New York, N.Y. "Memorial to Michael." February.

 Bourdon, David. "Why Photographers Like Artists." The Village Voice, February 23, 1976, p. 39.

Louisiana Gallery, Houston, Tex. "Avery, Picasso, Léger: An American and Two European Masters." March.

*The William Benton Museum of Art, University of Connecticut, Storrs, Conn. "Milton Avery and the Landscape." March 15-April 16. Catalogue: ill., checklist; essay by Stephanie Terenzio.

 Berkman, Florence. "The Landscapes of Milton Avery Are on View at the Benton Museum." Hartford Times, March 21, 1976, pp. 32, 34.

 "Exhibit Records Artist's Northeast Travels." University of Connecticut Chronicle, March 15, 1976, p. 3.

 Goldenthal, Jolene. "Avery's Sculptured Landscapes." Hartford Courant, March 28, 1976, p. 10F.

 Goldring, William. "Avery and Schofield: Two Views of New England." Hartford Chronicle, March 13, 1976.

 Trimel, Suzanne. "Breathless Ride on Landscape Carousel." Connecticut Daily Campus, April 8, 1976, p. 8.

Makler Gallery, Philadelphia, Pa. "Works on Paper." March 22-April 17. Catalogue: ill., checklist.

*Marianne Friedland Gallery, Toronto, Ontario. "Milton Avery." April 10-May 5.

 "Important Milton Avery Show at Marianne Friedland." Toronto Calendar Magazine, March 26, 1976.

 Purdie, James. "Avery and Brooker Acclaimed at Last." Toronto Globe and Mail, April 24, 1976.

*Makler Gallery, Philadelphia, Pa. "Milton Avery." April 19-May 22. Catalogue: checklist.

 Donohoe, Victoria. "Gallery Highlights." Philadelphia Inquirer, May 2, 1976, p. 11-G.

*Richard Gray Gallery, Chicago, Ill. "Milton Avery: Prints." May 29-August 10.

Andrew Crispo Gallery, New York, N.Y. "Important Paintings, Drawings, Sculpture and Graphics of the 19th and 20th Centuries." July 1-August 31.

The Brooklyn Museum, Brooklyn, N.Y. "American Watercolors and Pastels from the Museum Collection." July 3-September 19.

University of Texas, Austin, Tex. "20th Century American Figurative Paintings in the Michner Collection." July 4-August 1.

Jarvis Gallery, Woodstock, N.Y. "Third Annual Avery Family Exhibit." August 1-31.

 "Third Annual Avery Family Show at Jarvis Gallery." Woodstock (N.Y.) Times, July 29, 1976.

Associated American Artists, New York, N.Y. "Let Us Entertain You." August 2-September 11.

*Michael Berger Gallery, Pittsburgh, Pa. "Milton Avery: 23 Works on Paper." September 18-October 17.

The Museum of Modern Art, New York, N.Y. "The Natural Paradise: Painting in America, 1800-1950. October 1-November 30. Catalogue: ill., checklist; essays by Barbara Novak, Robert Rosenblum, and John Wilmerding.

Rutgers University Art Gallery, New Brunswick, N.J. "Mr. Kreeger's Collection." October.

 Shirey, David. "Two Exhibitions at Rutgers." New York Times, October 10, 1976, section NJ, p. 38.

*Center Gallery, University of Maine at Portland-Gorham, Gorham, Maine. "Milton Avery Prints from 1933 to 1955." October 6-November 5.

Northern Virginia Community College, Annandale, Va. "A Sampler of American Painting." October 10-November 18.

Associated American Artists, New York, N.Y. "American Master Prints III." October 11-30. Catalogue: bio., bibl., ill., checklist; Introduction by Sylvan Cole, Jr.

Esther Robles Gallery, San Francisco, Calif. "Some Aspects of the American Scene: Paintings and Drawings, 1913-1976." October 18-December 11. Catalogue.

James Yu Gallery, New York, N.Y. "Seven Decades of MacDowell Artists." October 24-28. Catalogue: ill.; Preface by Thomas Messer, Introduction by Russell Lynes.

Yares Gallery, Scottsdale, Ariz. Group exhibition. October–November.

The Museum of Modern Art, New York, N.Y. "Print Acquisitions." November 23–February 20, 1977.

> Russell, John. "Art: Quality and Acrobats in Prints." New York Times, December 31, 1976, section L, p. C-16.

*University of Texas Art Museum, Austin, Tex. "Milton Avery: Drawings and Paintings." December 5–February 6, 1977. Catalogue: bibl., ill., checklist; Introduction by Earl A. Powell III, essay by Harvey S. Shiply Miller. Traveled to: Summit Art Center, Summit N.J.; The Phillips Collection, Washington, D.C.

> Forgey, Benjamin. "Milton Avery Is All Around Town." Washington Post, June 21, 1977, pp. 20–21.

> Richard, Paul. "Avery: Ally of the Weekend Painter." Washington Post, May 21, 1977, pp. C1, C10.

> Shirey, David L. "Visual Works of Milton Avery." New York Times, April 10, 1977, p. 16.

*Hirshhorn Museum and Sculpture Garden, Smithsonian Institution, Washington, D.C. "Milton Avery: Selections from the Collection." December 13–November 17, 1977.

1977

Wallach, Alan. "Trouble in Paradise." Artforum, 15 (January 1977), pp. 28–35.

Vassar College Art Gallery, Poughkeepsie, N.Y. "Woodstock: An American Art Colony, 1902–1977." January 23–February 4. Catalogue.

Grace Borgenicht Gallery, New York, N.Y. "The Nude: Milton Avery and the European Masters." February 5–March 3.

> B. C. "Milton Avery and the European Masters." Art/World, February 1977.

> Harnett, Lile. "Exhibiting the Nude." Cue, February 18, 1977, p. 28.

> Karlins, N. F. "Gallery Guide: Milton Avery." East Side Express, February 17, 1977, p. 17.

> Ratcliff, Carter. "Remarks on the Nude." Art International, 21 (March/April 1977), pp. 60–65, 73.

> Tannenbaum, Judith. "Arts Reviews." Arts Magazine, 51 (April 1977), p. 30.

*Yares Gallery, Scottsdale, Ariz. "Milton Avery." February 6–28

*Louisiana Gallery, Houston, Tex. "Milton Avery." March.

Everson Museum of Art, Syracuse, N.Y. "Provincetown: A Painter's Place." April 1–June 26. Catalogue: ill., checklist; Foreword by Ronald A. Kuchta, essay by Dorothy Gees Seckler. Traveled to: Provincetown Art Association, Provincetown, Mass.

> "Everson Surveys East Coast Art Colony." Syracuse (N.Y.) Downtowner, April 10, 1977, p. 11.

The Harmon Gallery, Naples, Fla. "20th Century American Masters Exhibition." April 4–30.

> "Harmon Gallery Presents Winter Season Finale." Naples (Fla.) Daily News, March 31, 1977.

Whitney Museum of American Art, New York, N.Y. "Selections from the Lawrence H. Bloedel Bequest and Related Works from the Permanent Collection of the Whitney Museum of American Art." April 5–June 19. Catalogue: ill., checklist; essays by Tom Armstrong and Irwin Shainman.

The Brooklyn Museum, Brooklyn, N.Y. "Artists' Lives in American Prints and Drawings," April 9–May 15.

Yares Gallery, Scottsdale, Ariz. "Prints and Works on Paper." April 10–30.

*Graphics Arts Collection, Firestone Library, Princeton University, Princeton, N.J. "Milton Avery Monotypes." May 7–June 30. Catalogue: ill., checklist; Foreword by O. J. Rothrock, essay by Bonnie Lee Grad.

*Lunn Gallery, Washington, D.C. "Milton Avery: Paintings, Watercolors & Drawings." May 21–July 9.

> Forgey, Benjamin. "Milton Avery Is All Around Town." Washington Post, June 21, 1977, pp. 20–21.

> Richard, Paul. "Milton Avery: Ally of the Weekend Painter." Washington Post, May 21, 1977, pp. C1, C10.

*Middendorf Gallery, Washington, D.C. "Milton Avery: Monotypes, Prints." May 21–July 9.

> Forgey, Benjamin. "Milton Avery Is All Around Town." Washington Post, June 21, 1977, pp. 20–21.

The Museum of Fine Arts, Houston, Tex. "Modern American Painting, 1910–1940." July 1–September 25. Catalogue: ill., checklist; Foreword and essay by William C. Agee.

*The Katonah Gallery, Katonah, N.Y. "Milton Avery: The Late Years." July 17–September 4. Brochure: checklist; memorial address by Mark Rothko.

> Beals, Katherine. "Milton Avery at Katonah Gallery." Westchester (N.Y.) Weekend, July 15, 1977.

> Chernow, Burt. "Avery: Everywhere Was His Studio." Fairfield (Conn.) Fairpress, August 10, 1977, p. B7.

Whitney Museum of American Art, New York, N.Y. "Twentieth Century American Art from Friends' Collections." July 27–September 27. Catalogue: checklist; essay by Tom Armstrong.

The Edmonton Art Gallery, Edmonton, Alberta. "The Fauve Heritage." September 9–October 30. Brochure: checklist.

Whitney Museum of American Art, New York, N.Y. "Paintings and Sculpture Promised to the Whitney Museum of American Art by Mrs. Percy Uris." September 9–October 7. Catalogue: ill., checklist; essay by Patterson Sims.

Montgomery Gallery, Pomona College, Claremont, Calif. "Works on Paper, 1900–1960, From Southern California Collections." September 18–October 27. Catalogue: ill., checklist; Introduction by Frederick S. Wight, text by David W. Steadman. Traveled to: M. H. de Young Memorial Museum, San Francisco, Calif.

Indianapolis Museum of Art, Indianapolis, Ind. "Perceptions of the Spirit in Twentieth Century American Art." September 20–November 27. Catalogue: bio., ill., checklist.

*The John and Mable Ringling Museum of Art, Sarasota, Fla. "Milton Avery Restrospective." September 23–October 31.

> "Art Sketches: Milton Avery Lecture." Saint Petersburg (Fla.) Times, October 24, 1977.

> Benbow, Charles. "The Pale, Simplistic Isolation of Milton Avery." Saint Petersburg (Fla.) Times, October 15, 1977.

> Busk, Pat. "Critic at Large." Sarasota (Fla.) Herald Tribune, October 2, 1977.

> Deats, Gordon. "Avery Show Demonstrates His Fondness for Riddles." Tampa (Fla.) Tribune, October 12, 1977.

> "Exhibit Features Work by Avery." Punta Gorda (Fla.) Herald News, October 4, 1977.

> Fottler, Martha. "Ringling Spectrum." Sarasota (Fla.) Herald Tribune, October 2, 1977.

Marger, Mary Ann. "Art Sketches: Milton Avery Retrospective." *Saint Petersburg* (Fla.) *Times,* September 23, 1977.

Greenberg Gallery, Clayton, Mo. Group exhibition. October.

Peters, John Brod. "Contemporary Group Show at Greenberg." *St. Louis Globe Democrat,* October 1, 1977.

Associated American Artists, New York, N.Y. "Milton Avery Monotypes." October 3-28. Catalogue: ill., checklist; essay by Sylvan Cole, Jr., memorial address by Mark Rothko.

Betz, Margaret. "New York Reviews." *Art News,* 76 (December 1977), pp. 136-37.

United States Embassy, Ottawa, Ontario. "Eighteen Contemporary Masters." November.

The Union League Club, New York, N.Y. "American Watercolor Treasures: A Tribute to the Brooklyn Museum." November 1-30.

Parsons School of Design, New York, N.Y. "New York City WPA Art: Then (1934-1943) and . . . Now (1960-1977)." November 8-December 10. Catalogue: bio, ill., checklist.

Kramer, Hilton. "Art: Projects of WPA Revisited." *New York Times,* November 18, 1977, p. C22.

"The WPA, Then and Now." *New York Times,* December 6, 1977.

Hirshhorn Museum and Sculpture Garden, Smithsonian Institution, Washington, D.C. "The Animal in Art." November 17-January 15, 1978. Catalogue: ill., checklist.

The Grey Art Gallery and Study Center, New York University, New York, N.Y. "New Deal for Art." November 18-December 10.

Kramer, Hilton. "Art: Projects of WPA Revisited." *New York Times,* November 18, 1977, p. C22.

Edwin A. Ulrich Museum of Art, Wichita State University, Wichita, Kans. "Milton Avery: Paintings and Prints." November 30-January 15, 1978.

Yares Gallery, Scottsdale, Ariz. "The Landscape: Lawrence Calcagno/The Figure: Milton Avery." December 4-31. Catalogue: ill., commentary.

Makler Gallery, Philadelphia, Pa. "Drawings." December 5-31.

1978

Kramer, Hilton. "Rothko: Art as Religious Faith." *New York Times,* November 12, 1978, section 2, pp. 1, 35.

Ratcliff, Carter. "Prints: Avery's Monotypes: Color as Texture." *Art in America,* 66 (January/February 1978), pp. 48-49.

Wolff, Theodore. "Dispatches from Avery's Frontier." *Christian Science Monitor,* December 15, 1978, p. 20.

The Art Center, South Bend, Ind. "Twentieth Century American Masters: Inaugural Exhibition." January 14-February 26. Catalogue: bio., ill., checklist.

Grace Borgenicht Gallery, New York, N.Y. "Milton Avery and His Friends." January 28-February 24. Catalogue: ill., checklist; essay by David L. Shirey, statement by Sally M. Avery.

Frank, Peter. "Milton Avery and His Friends." *Art News,* 77 (April 1978), p. 158.

Ratcliff, Carter. "New York Letter." *Art International,* 22 (February 1978), pp. 79-80.

Rosenberg, Harold. "The Art World: The Last Exiles." *The New Yorker,* April 3, 1978, pp. 108-11.

Russell, John. "Art: Milton Avery and His Friends." *New York Times,* February 17, 1978, section L, p. C23.

Senie, Harriet. "Artview: A Breathtakingly Beautiful Exhibition: Moodscapes." *New York Post,* February 11, 1978, p. 17.

Tannenbaum, Judith. "Arts Reviews." *Arts Magazine,* 52 (April 1978), p. 36-37.

The Society of the Four Arts, Palm Beach, Fla. "Milton Avery." February 4-March 5.

Calhoun, Charles. "For Milton Avery's Art: Take Time, Peace of Mind." *Palm Beach* (Fla.) *Post,* February 9, 1978.

King, Leone. "Four Arts Exhibition Splendid." *Palm Beach* (Fla.) *Daily News,* February 4, 1978, p. 6.

Associated American Artists, Philadelphia, Pa. "American Master Prints VI." February 20-March 18, Catalogue: bio., bibl., ill., checklist; Introductions by Sylvan Cole, Jr., and Margo Dolan.

University of Texas, Austin, Tex. "People and Their Spaces: Selections from the Michner Collection." March 12-26.

Yares Gallery, Scottsdale, Ariz. "Nine Major Painters." March 12-April 8.

Marianne Friedland Gallery, Toronto, Ontario. "Milton Avery." April 10-May 4.

Joseloff Gallery, The Hartford Art School, West Hartford, Conn. "The Hartford Art School: The Early Years." April 26-May 18. Catalogue: ill., checklist; essay by Nicholas Fox Weber.

Joan Whitney Payson Gallery, Westbrook College, Portland, Maine. "Milton Avery, 1893-1965." July 9-September 10. Catalogue: ill.; Foreword by Martin Dibner, commentaries by Edward Albee and John Canaday. Traveled to: Colby College Museum of Art, Waterville, Maine; Lamont Gallery, Phillips Exeter Academy, Exeter, N.H.; William A. Farnsworth Library and Art Museum, Rockland, Maine; Plymouth State College Art Galleries, Plymouth, N.H.; St. Paul's School, Concord, N.H.

B[radford], K[athy]. "The Avery Show Sets New Standards of Excellence." *Maine Times,* July 21, 1978, p. 33.

Dibner, Martin. "Profile." *Vision,* 1 (October/November 1978), p. 5.

Hingston, Rebecca. "At the Payson Gallery." *Vision,* 1 (October/November 1978), pp. 4-5.

Isaacson, Phillip. "Show of the Year." *Maine Sunday Telegram,* August 1978.

Landry, Barbara. "Milton Avery Painted in Maine." *Portland* (Maine) *Evening Express,* June 15, 1978.

Niss, Bob. "Payson Gallery Exhibit of Avery Works Is a 'Coup.'" *Portland* (Maine) *Evening Express,* June 15, 1978, p. 40.

————. "Milton Avery: A 'First' For the Payson Gallery." *Maine Sunday Telegram,* July 16, 1978.

"Overview: A Brilliant Celebration of a Great American Artist." *Westbrook College News and Views,* 1978, pp. 10-11.

The Edmonton Art Gallery, Edmonton, Alberta. "Milton Avery." September 22-October 22. Catalogue: ill., checklist; note by Robert Ouellet. Traveled to: Walter Phillips Gallery, Banff, Alberta; Windsor Art Gallery, Windsor, Ontario; Mendel Art Gallery, Saskatoon, Saskatchewan; Art Gallery of Hamilton, Hamilton, Ontario.

Delamora, Richard. "Admiring Milton Avery." *Artmagazine,* September/October 1979.

Makler Gallery, Philadelphia, Pa. "Milton Avery." October 2-31. Brochure: ill., checklist.

Makler, Paul Todd. *Prometheus,* Fall 1978, pp. 1, 3-4.

Yares Gallery, Scottsdale, Ariz. Group exhibition. November-December.

*Esther Robles Gallery, Los Angeles, Calif. "Milton Avery: Paintings, Drawings, Prints." December 1–January 20, 1979. Brochure: checklist.

 Howell, Betje. "Perspectives on Art: First California Exhibit for Milton Avery." Santa Monica Evening Outlook, January 13, 1979.

 M[uchnic], S[uzanne]. "Art Walk: A Critical Guide to the Galleries." Los Angeles Times, December 15, 1978, section 4, pp. 6–7.

1979

Hyams, Barry. Hirshhorn: Medici from Brooklyn. New York: E. P. Dutton & Co., Inc.

*Donald Morris Gallery, Detroit, Mich. "Milton Avery." January 20–28.

 Colby, Joy Hakanson. "Canvas Rife with Quirky Vision." Detroit News, February 1979, p. 5-F.

 Miro, Marsha. "A Milton Avery Seashore Helps Ban the Winter." Detroit Free Press, January 21, 1979, p. 20D.

 Zucker, Helen. "Recognition Builds Slowly: A Quiet Artist, Avery Captured Everything's Essence." The Eccentric, February 1, 1979.

*Grace Borgenicht Gallery, New York, N.Y. "Milton Avery in the Forties." February 3–March 1. Catalogue: ill.; essay by Carter Ratcliff.

 Gibson, Eric. "New York Letter: Milton Avery." Art International, 23 (April 1979), p. 46.

University of Texas, Austin, Tex. "Mainstreams in 20th Century Painting: Selections from the Michner Collection." February 8–May 20.

*Louisiana Gallery, Houston, Tex. "Paintings by Milton Avery." March.

 Crossley, Mimi. "Review: Art—'Paintings by Milton Avery.'" Houston Post, March 7, 1979, p. 14AA.

*Marianne Friedland Gallery, Toronto, Ontario. "Milton Avery: Works on Paper." March 31–April 24.

 Dault, Gary Michael. "Visionary Artist Captures Reality." Toronto Star, April 21, 1979, p. D6.

 Purdie, James. "Gallery Reviews." Toronto Globe and Mail, March 31, 1979, p. 40.

The Alpha Gallery, Boston, Mass. "Early 20th Century American Landscape Painting." April 29–June 15.

*Western Electric Corporate Education Center, Hopewell, N.J. "Milton Avery." June 11–29. Organized by the Princeton Gallery of Fine Art, Princeton University, Princeton, N.J.

Hirshhorn Museum and Sculpture Garden, Smithsonian Institution, Washington, D.C. "Images of Children." August 17–November 4.

Gallery 10, Aspen, Colo. "Contemporary American Masters." August 23–September 9.

Amarillo Art Center, Amarillo, Tex. "Selections from the James Michner Collection." September 1–October 21.

Krasner Gallery, New York, N.Y. Group exhibition. October.

*The Alpha Gallery, Boston, Mass. "Milton Avery: Works from the 1940's." October 27–November 20.

*Harcus Kracow Gallery, Boston, Mass. "Milton Avery." November.

Makler Gallery, Philadelphia, Pa. "Drawings." December 3–30.

1980

Teltsch, Kathleen. "A Milton Avery Foundation Will Benefit Artists." New York Times, July 3, 1980, section L, pp. B-1, B-5.

*Yares Gallery, Scottsdale, Ariz. "Milton Avery: Paintings and Drawings, 1930–1963." February. Catalogue: ill., checklist, essay.

*Grace Borgenicht Gallery, New York, N.Y. "Milton Avery: Paintings of the Thirties." February 2–28. Catalogue: ill., checklist.

 Nisselson, Jane. "Milton Avery." Arts Magazine, 54 (March 1980), p. 7.

*Stephen Wirtz Gallery, San Francisco, Calif. "Milton Avery: Complete Graphic Works." February 2–March 1. Brochure: ill.

*College of Creative Studies, University of California, Santa Barbara, Calif. "Milton Avery: Paintings on Paper." February 5–March 9. Catalogue: ill., checklist.

 Lorenz, Mindy. "Milton Avery in Black and White." Artweek, February 23, 1980.

Hirshhorn Museum and Sculpture Garden, Smithsonian Institution, Washington, D.C. "The Intimate Scale." February 14–July 28.

Hirshhorn Museum and Sculpture Garden, Smithsonian Institution, Washington, D.C. "Still Lifes from the Collection." March 1–May 18.

*San Francisco Museum of Modern Art, San Francisco, Calif. "Milton Avery: Drawings." March 25–April 26.

 Albright, Thomas. "A Rare Look at a Unique American Modernist." San Francisco Sunday Examiner and Chronicle, April 6, 1980, p. 34.

*Gallery Paule Anglim, San Francisco, Calif. "Milton Avery." March 26–May 3.

 For review, see previous exhibition.

*University Art Museum, University of California, Berkeley, Calif. "Milton Avery." March 26–May 4. Brochure: ill., checklist, Foreword by Michael Auping.

 For review, see previous exhibition.

*The Dolly Fiterman Gallery, Minneapolis, Minn. "Milton Avery." March–April.

*Wooster College, Wooster, Ohio. "Milton Avery: Works on Paper." May 18–June 10.

 Willers, Karl E. "Milton Avery: Works on Paper." Dialogue: The Arts Journal of Ohio, May/June 1980, pp. 16–17.

Hirshhorn Museum and Sculpture Garden, Smithsonian Institution, Washington, D.C. "The Fifties: Aspects of Painting in New York." May 22–September 21. Catalogue: chron., ill.; Foreword by Abraham Lerner, essay by Phyllis Rosenweig.

*Sterling and Francine Clark Art Institute, Williams College, Williamstown, Mass. "Milton Avery: Works on Paper." May 30–July 23. Traveled to: The William Benton Museum of Art, University of Connecticut, Storrs, Conn.; Mt. Holyoke College Art Museum, South Hadley, Mass.; Dartmouth College Museum and Galleries, Hanover, N.H.

Whitney Museum of American Art, New York, N.Y. "50th Anniversary Gifts." June 3–August 31.

*The Waddington Galleries Ltd., London, England. "Milton Avery." June 4–28. Catalogue: bio., ill.

Portland Art Museum, Portland, Oreg. "The Phillips Taste in Portland." July 25–August 31. Catalogue: ill., checklist; Foreword by Donald Jenkins, essay by William Chiego.

*Akron Art Institute, Akron, Ohio. "Milton Avery: The Late Paintings." September 13–November 2.

 Herr, Marcianne. "Milton Avery: The Late Paintings." Dialogue: The Arts Journal of Ohio, September/October 1980, p. 52.

*Makler Gallery, Philadelphia, Pa. "Milton Avery: Oils, Watercolors, Prints." October 1–November 1.

Makler, Paul Todd. *Prometheus*, September 1980, pp. 1, 3–4.

Museo de Bellas Artes, Mexico City, Mexico. "Painting in the United States from Public Collections in Washington, D.C." October 1–January 6, 1981.

The Metropolitan Museum of Art, New York, N.Y. "The Painterly Print: Monotypes from the Seventeenth to the Twentieth Century." October 16–December 7. Catalogue: bibl., ill., checklist; Foreword by Phillippe de Montebello and Jan Fontain, essay by Colta Ives. Traveled to: Museum of Fine Arts, Boston, Mass.

The Chrysler Museum, Norfolk, Va. "American Figurative Painting, 1950–1980." October 17–November 30. Catalogue: ill., checklist; essay by Thomas W. Styron.

1981
Gibson, Thomas. *Milton Avery: Figures from the Forties*. London: Thomas Gibson Fine Art Ltd.

Grad, Bonnie Lee. *Milton Avery*. Royal Oak, Mich.: Strathcona Publishing Co.

Miro, Marsha. "The Artist's Spirit Is Captured in Print." *Detroit Free Press*, March 26, 1981, p. 1C.

Russell, John. "Fantasy Stamps and Other Art." *New York Times Book Review*, May 31, 1981, pp. 14, 49–50.

*Charles H. Scott Gallery, Emily Carr College of Art, Vancouver, British Columbia. "Milton Avery: Major Paintings and Graphics." January 5–31. Brochure: ill., bio., bibl., checklist; essay by E. Theodore Lindberg.

Kangas, Matthew. "Infinity Beach: Milton Avery." *Vanguard Magazine*, April 1981, pp. 6–9.

Marianne Friedland Gallery, Toronto, Ontario. "Gallery Selection." January 10–February 4.

*Frans Wyans Gallery, Vancouver, British Columbia. "Milton Avery: Works on Paper." January 19–February 20.

International Exhibitions Foundation traveling exhibition. "The Lawrence H. Bloedel Collection." Opened February. Itinerary: The Society of the Four Arts, Palm Beach, Fla.; Oklahoma Museum of Art, Oklahoma City, Okla.; Arkansas Arts Center, Little Rock, Ark.; Krannert Art Center, University of Illinois, Champaign, Ill.; Columbus Museum of Art, Columbus, Ohio; Seattle Art Museum, Seattle, Wash.; Honolulu Academy of Arts, Honolulu, Hawaii. Catalogue: ill., checklist; Forewords by Tom Armstrong and S. Lane Faison, Introduction by Rick Stewart.

*Southern Methodist University, Dallas, Tex. "Milton Avery." March 1–April 5. Brochure: ill., checklist; essay by William Jordan.

Associated American Artists, New York, N.Y. "American Master Prints VII." March 17–April 22. Catalogue: bio., bibl., ill., checklist; Introduction by Sylvan Cole, Jr.

The Brooklyn Museum, Brooklyn, N.Y. "Modernistic Art from the Edith and Milton Lowenthal Collection." March 21–May 10. Catalogue: ill., checklist; Foreword by Michael Botwinick, essay by John R. Lane.

*Art Gallery of Hamilton, Hamilton, Ontario. "Milton Avery: Large Late Paintings." March 31–April 22.

The Santa Barbara Museum of Art, Santa Barbara, Calif. "American Modernism, 1910–1945." April 4–26. Brochure: ill., checklist; Foreword by Kathleen Monaghan.

*Grace Borgenicht Gallery, New York, N.Y. "Milton Avery." April 15–May 9. Catalogue: ill., checklist.

Kramer, Hilton. "Avery: Our Greatest Colorist." *New York Times*, April 12, 1981, p. D37.

*The Greenberg Gallery, St. Louis, Mo. "Milton Avery." April 15–May 31. Brochure: ill., checklist.

*Richard Gray Gallery, Chicago, Ill. "Milton Avery: Important Paintings." April 18–May 31. Catalogue: ill., checklist; essay by Dennis Adrian.

Artner, Alan G. "Fragile Beauty on Display in Avery Collection." *Chicago Tribune*, May 8, 1981.

Haydon, Harold. "A Fine Look at the Art of Milton Avery." *Chicago Sun-Times*, May 8, 1981.

*Gallery Paule Anglim, San Francisco, Calif. "Milton Avery: Works on Paper." April 29–June 6.

Morch, Al. *San Francisco Examiner*, May 11, 1981, p. E6.

State Capitol, Albany, N.Y. "Twelve Americans from the Metropolitan Museum of Art." May 5–June 20. Catalogue: ill.; Introduction by William S. Lieberman.

*Lunn Gallery, Washington, D.C. "Milton Avery." May 16–June 30. Catalogue: ill., checklist; commentary reprinted from various published sources.

Lewis, Joann. "Avery's Come of Age." *Washington Post*, May 23, 1981, p. C9.

Forgey, Ben. "Unexpected Beauty in the Work of Edward Kienholz." *Washington Star*, June 12, 1981, section D, p. 1.

*Edith C. Blum Art Institute, Milton and Sally Avery Center for the Arts, Bard College, Annandale-on-Hudson, N.Y. "Milton Avery, Early and Late." May 29–July 31. Catalogue: chron., ill.; Introduction by Leon Botstein and Wendy Shepard, essay by Marla Price.

Drogseth, Dennis. "Milton Avery's Art Finds a Home at Bard." *Poughkeepsie* (N.Y.) *Journal*, June 5, 1981.

Glueck, Grace. "Critics' Choices." *New York Times*, June 7, 1981, Guide section, p. 3.

Hanson, Bernard. "Milton Avery: Rich Survey at Bard." *Hartford Courant*, June 14, 1981, p. G2.

Marianne Friedland Gallery, Toronto, Ontario. "Works on Paper." May 30–June 23.

*Clarke-Benton Gallery, Santa Fe, N.M. "Milton Avery: Paintings, Drawings, Prints." July 25–August 19. Brochure: ill.; essay by William Benton.

*Museo de Arte Moderno (Mexico City, Mexico) traveling exhibitions. "Avery in Mexico and After." Catalogue (bilingual): ill., checklist; chron. and bibl. by Marla Price, Introduction by Sally M. Avery, essays by Dore Ashton, Fernando Gamboa, Carla Stellweg, and Salvador Elizondo. Opened August. Itinerary: Sarah Campbell Blaffer Gallery, University of Houston, Houston, Tex.; Museo de Arte Moderno, Mexico City, Mexico; Museo de Monterrey, Monterrey, Mexico; Museo de Bellas Artes, Caracas, Venezuela; Newport Harbor Art Museum, Newport Beach, Calif.

Crossley, Mimi. "Art Review: 'Avery in Mexico and After.'" *Houston Post*, September 5, 1981, p. 2F.

Marvel, Bill. "Avery's Art Enmeshes Time in Fields of Color." *Dallas Times Herald*, March 11, 1981, p. E1.

"Milton Avery Exhibition of Mexican Works Opens." *Mexico City News*, October 23, 1981, p. 21.

The Dolly Fiterman Gallery, Minneapolis, Minn. "Monotypes by Milton Avery and Matt Phillips." August 12–31.

California Palace of the Legion of Honor, San Francisco, Calif. "Impressionism and the Modern Vision: Master Paintings from the Phillips Collection." September 4–November 1. Traveled to Dallas Museum of Fine Arts, Dallas, Tex.; The Minneapolis Institute of Arts, Minneapolis, Minn.; The High Museum of Art, Atlanta, Ga.

*Gallery Paule Anglim, San Francisco, Calif. "Milton Avery: Paintings and Works on Paper." September 9-October 3.

Museum of Art, Rhode Island School of Design, Providence, R.I. "Rhode Island Collects." October 3-November 15.

*The Alpha Gallery, Boston, Mass. "Milton Avery: Works on Paper." October 10-November 4.

*Marianne Friedland Gallery, Toronto, Ontario. "Milton Avery: Works on Paper." October 17-November 11. Catalogue: ill.; essay by Marianne Friedland.

*The Waddington Galleries Ltd., London, England. "Milton Avery." November 4-27. Catalogue: chron., ill., checklist.

Whitney Museum of American Art, New York, N.Y. "American Prints: Process & Proofs." November 25-January 24, 1982. Catalogue: ill., bibl., checklist; Foreword by Tom Armstrong, text by Judith Goldman.

1982
Hartley, Marsden. "On the Persistence of the Imagination: The Painting of Milton Avery, American Imaginative" (n.d.). In Marsden Hartley: On Art, edited by Gail R. Scott. New York: Horizon Press.

Price, Marla. "The Paintings of Milton Avery." Ph.d. dissertation, University of Virginia.

*Yares Gallery, Scottsdale, Ariz. "Milton Avery: The Transcending Years, 1921-1941." January. Catalogue: ill., checklist; commentary by Sally M. Avery, essay.

*Boca Raton Center for the Arts, Boca Raton, Fla. "Milton Avery: Major Works." January 5-29. Catalogue: ill., checklist; Introductions by Dolly Fiterman, Sally M. Avery, and Marla Price.

Rutgers University Art Gallery, New Brunswick, N.J. "Realism and Realities: The Other Side of American Painting, 1940-1960." January 17-March 26. Catalogue: ill., checklist; text by Jeffrey Wechsler and Greta Berman. Traveled to: Montgomery Museum of Fine Arts, Montgomery, Ala.; Art Gallery, University of Maryland, College Park, Md.

Grace Borgenicht Gallery, New York, N.Y. "The Gloucester Years." February 6-March 4. Catalogue: ill., checklist; essay by Carter Ratcliff.

 Daxland, John. "Landscape Art of Massachusetts." New York Daily News, February 12, 1982, p. 18.

 Helfer, Judith. "Kunst: Kunst aus Gloucester—von einst." Aufbau, February 19, 1982, p. 26.

 Kachur, Lewis. "America's Argenteuil: Artists at Gloucester." Arts Magazine, 56 (March 1982), pp. 138-39.

 Kramer, Hilton. "Art: From Glouchester, the Bypassed Haven." New York Times, February 5, 1982.

 Larson, Kay. "Art: American Modern." New York, March 1, 1982.

*The Harmon Gallery, Naples, Fla. "Milton Avery Retrospective: Paintings, Drawings, Graphics." March 14-April 3.

INDEX

Italicized numbers refer to reproductions. The works of critics who have made significant contributions to the Avery literature, as itemized in the Bibliography & Exhibition History, are indicated by the year of publication, followed (in parentheses) by the number of citations in that year, if more than one.

PHOTOGRAPH CREDITS

Photographs have generally been provided by owners or custodians, as cited in captions. Additional acknowledgment is due for the following. Figure numbers are used unless otherwise indicated.

Sally M. Avery: page 190, top
Baker Photo: 77
Dirk Bakker: 12, 53, 61, 71, 89, 103, 104, 125, 129, 133, 134, 135, 139
Benyas-Kaufman Photographers, Inc.: 63, 97, 143
Yvan Boulerice: 117
Dan Brinzac: 73
Jacob Burckhardt: 126, 137
Geoffrey Clements: 5, 13, 25, 59, 62, 108, 144
Prudence Cuming Associates Ltd.: 35, 36, 76, 96, 118, 122, 123
Roy M. Elkind: 16, 54, 58, 124, 141
Mark Friedland: 44, 45, 57, 78, 114
Hartford Art School, University of Hartford: 1, 2
Peter A. Juley & Son: 51
Consuelo Kanaga: page 189
Kate Keller: 31, 84
Robert E. Mates and Mary Donlon: 37
Bill McLemore Photography: 7, 8, 10, 15, 28
T. E. Moore: 138
Bert and Richard Morgan Studio: 101
Otto E. Nelson: 9, 32, 38, 48, 119, 127, 131, 140, 146, page 192
Biagio Pinto: 74, 92
Eric Pollitzer: 33, 115
Quiriconi-Tropea Photographers: 147
Percy Rainford: 14
Arthur Rothstein: page 190, bottom
Sunami: 69
Frank J. Thomas: 86
Tincher Photo: 20
Rodney Todd-White and Son: 87, 94
Malcolm Varon: 18, 21, 22, 34, 39, 40, 72, 88, 98, 106, 109, 113, 120, 136
Waintrob-Budd: page 191, top

CHECKLIST OF THE EXHIBITION

The following works are included in the exhibition "Milton Avery." Parenthetical numbers correspond to the figures in this book. Complete entries refer to works which are in the exhibition but not illustrated. An asterisk denotes a work on exhibition only at the Whitney Museum of American Art.

Sun Worshippers, 1931 (**10**); *Sitters by the Sea*, 1933 (**18**); *Barbershop*, 1936 (**19**); *Acrobats*, 1931 (**20**); *Gaspé—Pink Sky*, 1940 (**21**); *Spring in Vermont*, c. 1935 (**22**); *Gaspé Landscape*, 1938 (**23**); *Self Portrait*, 1941 (**26**); *Portrait of Marsden Hartley*, 1943 (**27**); *Two Figures at Desk*, 1944 (**31**); *Mother and Child*, 1944 (**33**); *Seated Girl with Dog*, 1944 (**34**); *Green Chair*, 1944 (**35**); *Ping Pong*, 1944 (**36**); *Autumn*, 1944 (**39**); *Lavender Sea*, 1944 (**40**); *Feeding*, 1944 (**42**); *Pink Tablecloth*, 1944 (**43**); *Secluded Beach*, 1941 (**44**); *Sparkling Blue Inlet*, 1938 (**45**); *Seated Blonde*, 1946 (**46**); *Oregon Coast*, 1947 (**47**); *Burlesque*, 1936 (**48**); *Crucifixion*, 1946 (**49**); *Prayers*, 1946–55 (**50**); *White Sea*, 1947 (**52**); *Autumn in the Rockies*, 1948 (**53**); *March in Red*, 1950 (**55**); *Maternity*, 1950 (**56**); *Pink Rocks, Green Sea*, 1944 (**57**); *Red Rock Falls*, 1947 (**60**); *Sketchers by the Stream*, 1951 (**61**); *Bridge to the Sea*, 1944 (**62**); *Sunset*, 1952 (**64**); *Hint of Autumn*, 1954 (**65**); *Fencers*, 1944 (**66**); *Nude Combing Hair*, 1954 (**67**); *Shapes of Spring*, 1952 (**68**); *Morning Call*, 1946 (**70**); *Green Seascape*, 1954 (**71**); *Waterfall*, 1954 (**72**); *Beach Umbrellas*, 1944 (**73**); *White Wave*, 1954 (**75**); *Walkers by the Sea*, 1954 (**76**); *Reader by the Sea*, 1945 (**78**); *Green Sea*, 1954 (**80**); *Sea and Sand Dunes*, 1955 (**81**); *Studious Sketcher*, 1945 (**82**); *The Card Players*, 1945 (**83**); *Sea Grasses and Blue Sea*, 1958 (**84**); *Dunes and Sea II*, 1960 (**85**); *White Gull*, 1958 (**87**); *Moon Path*, 1958 (**88**); *Rocks by Ebbing Sea*, 1944 (**89**); *Speedboat's Wake*, 1959 (**90**); *Sailfish in Fog*, 1959 (**91**); *Hills by the Sea*, 1960 (**94**); *Black Sea*, 1959 (**95**); *Artist at Work*, 1950 (**96**); *Hammock Reader*, 1951 (**97**); *Bathers by the Sea*, 1960 (**98**); *Tangerine Moon and Wine Dark Sea*, 1959 (**99**); *Rosey Nude Asleep*, 1950 (**100**); *Offshore Island*, 1958 (**102**); *Plunging Gull*, 1960 (**103**); *Black Goat, White Goat*, 1951 (**104**); *Sandbar and Sea*, 1958 (**105**); *Red Sea*, 1960 (**106**); *Excursion on the Thames*, 1953 (**107**); *Mountain Lake*, 1960 (**109**); *Spring Orchard*, 1959 (**110**); *Breaking Sea*, 1952 (**111**); *The White Wave*, 1956 (**112**); *Lone Bather*, 1960 (**113**); *Dunes and Dune Grass*, 1960 (**114**); *Double Wave*, 1955 (**115**); *Beach Blankets*, 1960 (**116**); *Sand, Sea and Sky*, 1960 (**117**); *March in Brown*, 1954, (**119**); *Dunes and Sea I*, 1958 (**120**); *Conversation*, 1956 (**121**); *Two Figures by the Sea*, 1963 (**122**); *Dark Inlet*, 1963 (**123**); *Maine Coast*, 1956 (**125**); *Interlude*, 1960 (**127**); *Onrushing Wave*, 1958 (**131**); *Flight*, 1959 (**134**); *Dark Forest*, 1958 (**135**); *Red Nude*, 1954 (**137**); *Sunset Sails*, 1960 (**138**); *Sea, Moon and Stars*, 1960 (**139**); *Robed Nude*, 1960 (**140**); *Mountain and Meadow*, 1960 (**141**); *White Umbrella*, 1961 (**142**); *Dark Trees, Pale Mountain*, 1962 (**144**); *Dark Mountain, Light Mountain*, 1962 (**145**).

PAINTINGS

Sea Gulls—Gaspé, 1938. Oil on canvas, 30 x 40 inches (76.2 x 101.6 cm). Addison Gallery of American Art, Phillips Academy, Andover, Massachusetts

Summer Reader, 1950. Oil on canvas, 34 x 44 inches (86.4 x 111.8 cm). Collection of Mrs. Ruth Bernstein

Sea Gull, 1955. Oil on canvas, 36 x 28 inches (91.4 x 71.1 cm). Collection of Maurice and Margo Cohen

Seated Nude, 1955. Oil on canvas, 54 x 42 inches (137.2 x 106.7 cm). Collection of Sally M. Avery

Sailboat Race, 1957. Oil on canvas, 42 x 50 inches (106.7 x 127 cm). Collection of Andrew Crispo

Sails in Sunset Sea, 1960. Oil on canvas, 72 x 52 inches (182.9 x 132.1 cm). Grace Borgenicht Gallery, New York

WORKS ON PAPER

Jugglers, 1932. Gouache on black paper, 12 x 18 inches (30.5 x 45.7 cm). The Eason Gallery, Santa Fe, New Mexico

Basket of Fish, 1938. Gouache on paper, 22 x 30 inches (55.9 x 76.2 cm). Private collection

Dark Inlet, 1938. Watercolor on paper, 22 x 30 inches (55.9 x 76.2 cm). Private collection

Many Hued Trees, 1939. Watercolor on paper, 22 x 30 inches (55.9 x 76.2 cm). Private collection

Many Colored Rocks, 1944. Watercolor on paper, 22 x 30 inches (55.9 x 76.2 cm). Private collection

Churning Bay, 1945. Watercolor on paper, 22 x 30 inches (55.9 x 76.2 cm). Collection of Dr. and Mrs. Jack Birnbaum

Dark Cove, Pale Dunes, 1945. Watercolor on paper, 22½ x 30¼ inches (57.2 x 76.8 cm). Private collection

Female Artist, 1945. Watercolor on paper, 22 x 30 inches (55.9 x 76.2 cm). Collection of Sally M. Avery

Girl in a Brown Hat, 1945. Gouache on paper, 31 x 22½ inches (78.7 x 57.2 cm). Collection of Mr. and Mrs. Robert Rosenberg

Pink Umbrella, 1945. Watercolor on paper, 22 x 30 inches (55.9 x 76.2 cm). Collection of Robert Fleming & Co., Ltd., London

Watchers by the Sea, 1945. Watercolor on paper, 22 x 30 inches (55.9 x 76.2 cm). Private collection; Courtesy of Andrew Crispo Gallery, New York

Morning Sea, 1948. Watercolor on paper, 22 x 30 inches (55.9 x 76.2 cm). Collection of Mr. and Mrs. Newman T. Halvorson

Orange Rocks, Orange Sea, 1948. Gouache on paper, 22 x 30 inches (55.9 x 76.2 cm). Collection of Sally M. Avery

Pemaquid Point, 1948. Watercolor on paper, 23 x 30 inches (58.4 x 76.2 cm). Collection of Mrs. Louis Sosland

Red Sea, 1948. Watercolor and pencil on paper, 22¼ x 30½ inches (56.5 x 77.5 cm). The Grey Art Gallery and Study Center, New York University; Gift of Mr. and Mrs. William Peyton Marin

Blue Faced Woman, 1950. Monotype, 21½ x 16 inches (54.6 x 40.6 cm). Associated American Artists, New York

Myself in Blue Beret, 1950. Monotype, 22 x 17 inches (55.9 x 43.2 cm). Collection of Mr. and Mrs. Anthony Woodfield

Pink Nude, 1950. Monotype, 22 x 17 inches (55.9 x 43.2 cm). Collection of Sally M. Avery

Birds and Ruffled Sea, 1951. Monotype, 18 x 24 inches (45.7 x 61 cm). Private collection

Edge of the Forest, 1951. Monotype, 17 x 22 inches (43.2 x 55.9 cm). The Metropolitan Museum of Art, New York; Purchase, by exchange

Dark Road, 1953. Watercolor on paper, 22 x 30 inches (55.9 x 76.2 cm). Collection of Henry and Margaret Demant

Two Birches, 1956. Monotype, 24 x 18 inches (61 x 45.7 cm). Private collection

Black Sea, 1959. Watercolor on paper, 21 x 30 inches (53.3 x 76.2 cm). Private collection